PHOTO BY
BOB EAST

PHOTO BY
MAX PETER HAAS
39 W. 32nd St., New York 1
NOT FOR REPRODUCTION
EXCEPT BY SPECIAL AUTHORIZATION

Credit:
LEE LOCKWOOD
from BLACK STAR

CREDIT MUST BE GIVEN AS FOLLOWS:
PHOTO

147-47 VILLAGE ROAD
JAMAICA 2 - NEW YORK
R-6280

Photo by
Darlene Hammond
1416 Belfast Drive
Hollywood 46, Calif.
L.R. 10747

MANFRED KREINER

THIS PHOTOGRAPH CANNOT LEGALLY BE
REGISTERED UNTIL THE CREDIT COPY-

MANFRED L. KREINER, NEW YORK

LOOK MAGAZINE
Division of Cowles Magazines, Inc.
488 Madison Avenue, New York 22, N.Y.
NOTICE
This picture is the property of Cowles Magazines, Inc.
for its reproduction for ONE time only and to the extent,
by the owner in writing. It must not be used in such man-
violate the rights of any person or be pictures of wide use, or
or be used for advertising or be the subject of known is first ob-
consent of each living person whose is known the rights of a
licensee's use shall be claimed as void the rights of a
agrees to hold Cowles Magazines, Inc. harmless from
The following credit MUST be printed
© LOOK MAGAZINE

PHOTOGRAPH BY
Gene Grauber
40 MONROE ST., NEW YORK 2, N.Y.
BE 3-8354

PLEASE CREDIT PHOTO
PAUL SIA
THIS PHOTOGRAPH IS HELD FOR ONE
TIME ONLY AND MUST BE RETURN
PHIL BURCHAM
130 W. 42nd ST. • N.Y.C. • OXford

CREDIT
GORDON PARKS

ART WEGMAN
PHOTO

Please Credit
JOE COUDERT
162 East 61st St.
k 21, N.Y.
on 2-9075

Ben & Sid Ross
P. O. Box 87
CONEY ISLAND STATION
BROOKLYN 21, N. Y.
Feature - Advertising
Publicity - Color
Photography

PLEASE CREDIT
PHOTO BY
Nat Dallinger
FROM
GILLOON AGENCY

PLEASE CREDIT
Eve Arnold
MAGNUM PHOTOS INC
15 W.
New York

RETURN TO
TIME
FEB 24 1953
HOLD FOR FILE
FILE TIME

USED IN
SINCE

PHOTO PLAY
PHOTO BY
STERLING SMITH

Credit must read
Photograph by
DICK MILLER – GLOBE

ARTHUR FELLIG
5 CENTER MARKET PLACE
NEW YORK CITY

PLEASE CREDIT
WEEGEE
FROM
PHOTO-REPRESENTATIVES

Photo by
Paul Schumach
Metropolitan Photo Service
1264 Broadway, N.Y.C. PL-7-7494

PLEASE CREDIT PHOTO BY:
PARIS MATCH

PHOTO BY
PIX INCORPORATED
236 EAST 46th ST., N.Y. 17, N.Y.
Yukon 6-7540
Please Credit: LAWRENCE SCHILLER – P.
A LICENSE IS WHICH THIS PHOTOGRAPH IS SENT
TION TO REPRODUCE FOR ONE TIME ONLY THE PIC-
TURE APPEARING ON THIS PRINT. IT MUST NOT
BE LOANED, SYNDICATED OR USED FOR AD-
VERTISING PURPOSES WITHOUT WRITTEN PER-
MISSION.

USE ONLY
CATION
Y. - OX 5-03

Wm. Woodfield

Marilyn Monroe

Credit:
GENE DANIELS
BLACK

ONE REPRODUCTION ON
CREDIT

EXPLODE PHOTO

SCH 12

REPRODUCTION INTERDITE SANS LA MENTION:
CREDIT MUST BE GIVEN AS FOLLOWS:
PHOTO
NICK DE MORGOLI
LA PUBLICATION A LAQUELLE CETTE PHOTOGRAPHIE
EST REMISE EST AUTORISEE A REPRODUIRE UNE FOIS
SEULEMENT ET A LA SEULE APPARAISANT SUR CE TIRAGE
CETTE PHOTOGRAPHIE NE PEUT ETRE NI CEDEE A DES
FINS PUBLICITAIRES NI PRETEE OU TIERCES, A UNE AUTRE
CEDEE, PRETEE OU TIERCES, A UNE AUTRE
PUBLICATION SANS AUTORISATION ECRITE DE L'
AUTEUR.
A LICENSE IS GRANTED ONLY TO THE PUBLICATION
TO WHICH THIS PHOTOGRAPH IS SENT TO REPRODUCE
FOR ONE TIME ONLY THE PICTURE APPEARING ON
THIS PRINT. IT MUST NOT BE SYNDICATED OR USED
FOR ADVERTISING PURPOSES WITHOUT WRITTEN
PERMISSION.
147-47 VILLAGE ROAD
JAMAICA 2 - NEW YORK
R-6280

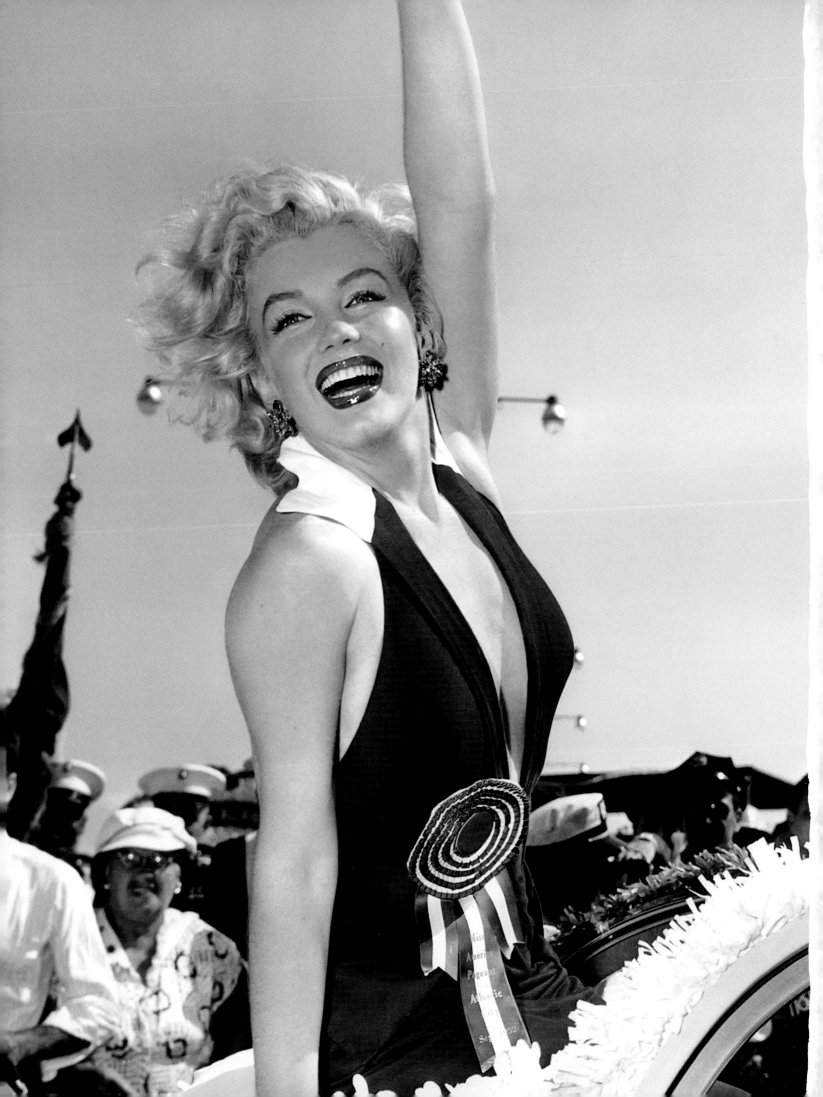

MARILYN

IN THE FLASH

Her Love Affair with the Press 1945–1962

DAVID WILLS

FOREWORD BY ROBERT J. WAGNER

DESIGNED BY STEPHEN SCHMIDT

DEY ST.

AN IMPRINT of WILLIAM MORROW *PUBLISHERS*

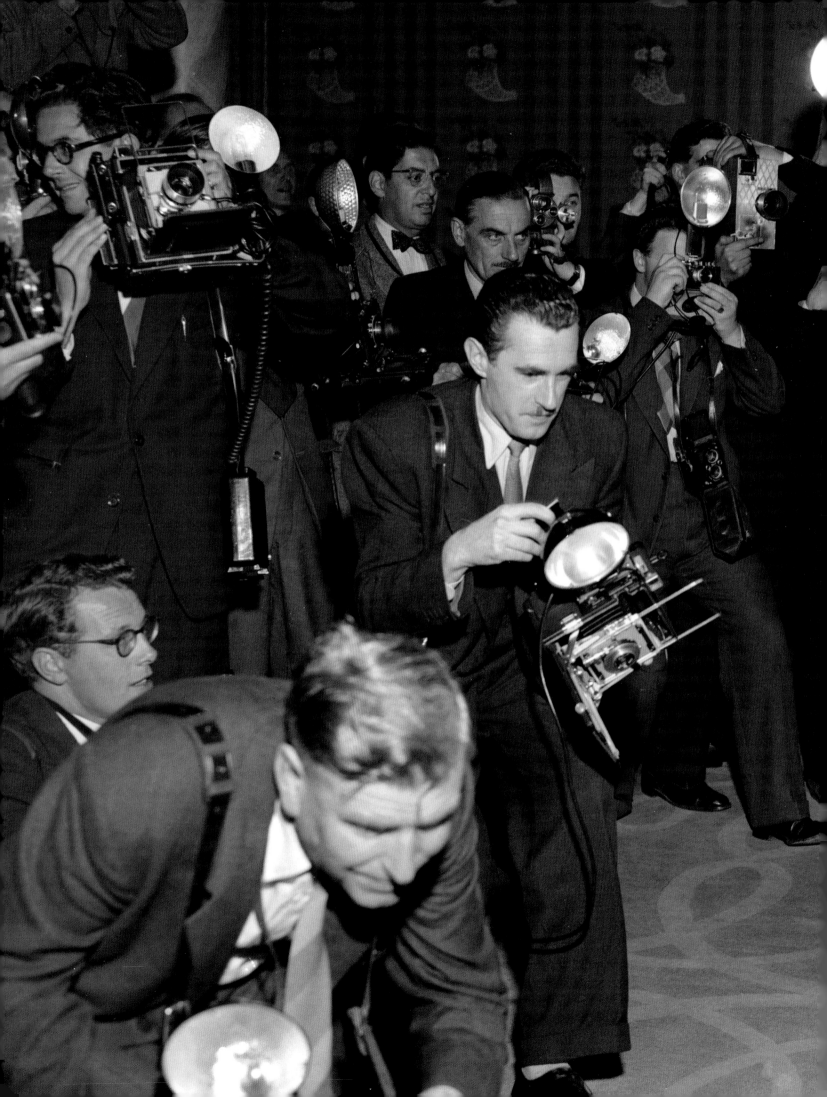

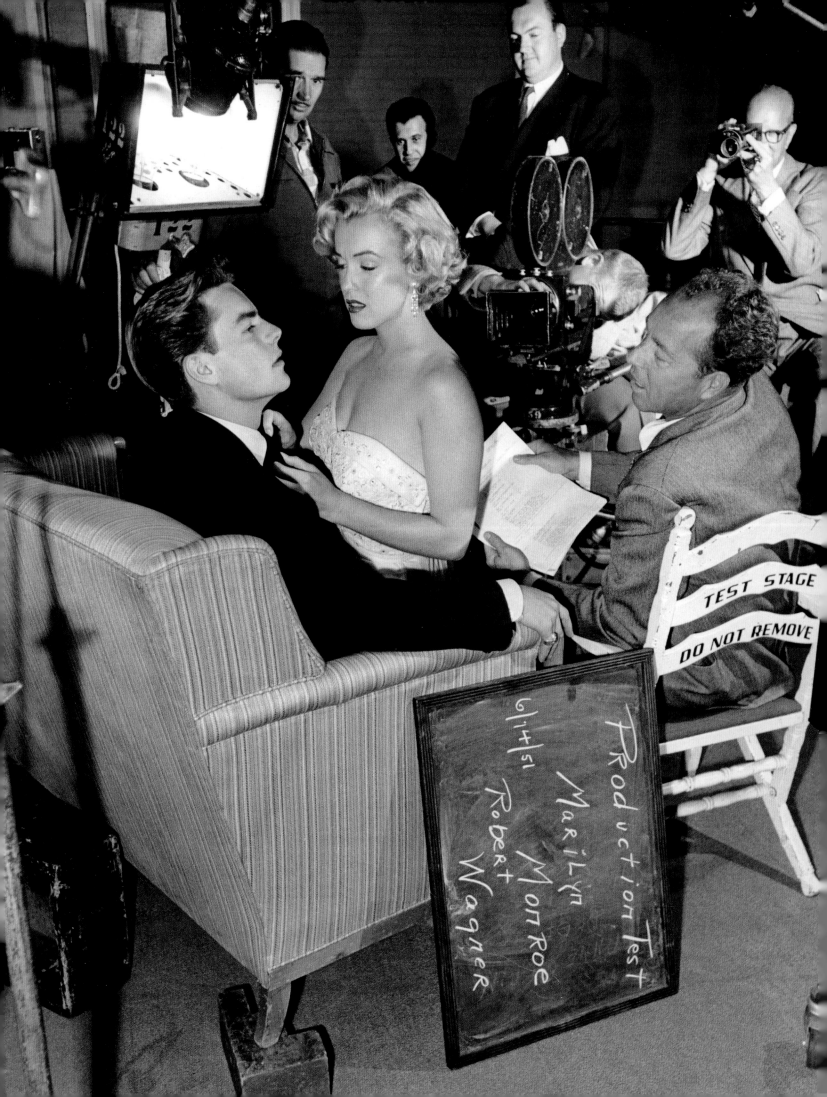

Production Test 6/14/51 Marilyn Monroe Robert Wagner

TEST STAGE DO NOT REMOVE

FOREWORD BY ROBERT J. WAGNER

My earliest memory of Marilyn is from around 1950. In those days we were both contract players at Twentieth Century-Fox. Each year the studio signed about 25 to 30 new actors and actresses contingent on studio head Darryl F. Zanuck's approval of their screen test. You received $75 a week (take-home: $55) and you were in the movies. New contract players were encouraged to take advantage of all the schooling made available to them, which included lessons in everything from acting, dancing, and elocution to fencing, horse riding, and general deportment. My drama coach was Helena Sorrell, whose office on the Fox lot was directly across the hall from another drama coach, Natasha Lytess. Every now and then I would see this beautiful blond girl coming out of Ms. Lytess's office. Her name was Marilyn Monroe. We became friends and often had lunch together at the Fox studio commissary. I would also sometimes see her at the home of studio executive Joe Schenck, as she was his girlfriend around that time.

People always ask me, "What was she like?" She was sweet, very gentle, and almost impossibly pretty. Not beautiful in an exotic way—more peaches and cream. She had the most wonderful smile, and when she laughed the room lit up. Fellow contract player (and later my wife) Marion Marshall told me that when she and Marilyn were modeling in the late 1940s, if Marilyn walked into a magazine call all the other models immediately knew she had the job. We all recognized her unique quality, that indefinable magic, that "it" factor, but absolutely none of us, in those days, had any idea of what was to come.

Early in my time at Fox I was eager for exposure and became known as the "test boy." That is, I would play the male lead opposite any actress being screen-tested for a potential contract. I tested with Marilyn twice: once when she first got her contract at Fox, and another time in 1951, when we costarred in *Let's Make It Legal*. Marilyn and I had no actual scenes together in the final film, but during our test she seemed slightly nervous. She was very focused and you could tell it was important to her to do her best. By then she had begun to create that "Marilyn Monroe" character. It was really something she made by herself. She made it her own. And boy, the camera loved her. And she loved the camera. She really knew what she was doing. She was also surprisingly shrewd when it came to the business of acting, and was certainly extraordinarily driven.

Our careers took off around the same time and a lot of this was due to exposure in

(Opposite) Robert Wagner and Marilyn on the set of *Let's Make It Legal*, June 14, 1951.

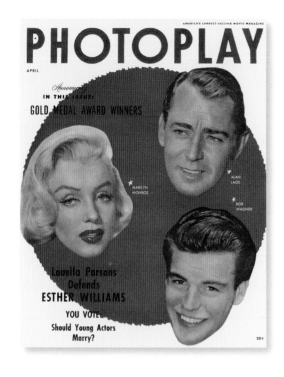

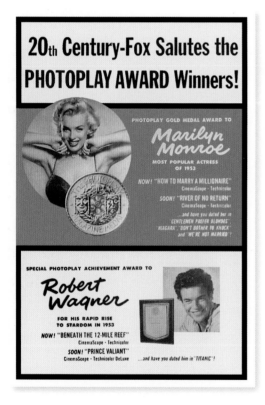

the fan magazines. At one point Marilyn and I were both receiving close to 5,000 fan letters a week. The movie studios, the fan magazines, and the advertisers worked together and formed a mutually beneficial triumvirate: Hollywood studios wanted publicity for their films, advertisers wanted celebrity endorsements for their products, and magazines wanted advertisers and photos of movie stars for increased circulation. Each studio had its own publicity department and was usually most interested in promoting the picture, not the personality. The fan magazines, however, were separate entities and made stars of actors like me, Tab Hunter, Rock Hudson, and Tony Curtis. And they certainly helped Marilyn considerably along the way.

Columnists Walter Winchell, Hedda Hopper, Louella Parsons, Sidney Skolsky, Earl Wilson, and Sheilah Graham monopolized print publicity in the 1950s, and their power to destroy a star's career could not be underestimated. As a result, studios always had a publicist sit in on interviews, and questions were usually submitted in advance. Contract players were sometimes coached on the art of the interview and on public decorum in general. For example, it was suggested that a young actress should place a napkin over her alcoholic beverage before being photographed by the press. Young actors were told not to dine together in pairs—only in groups of three or more, should no female companions be present. It all seems so silly now.

It has been said that a press agent is really a suppress agent. Studio publicity heads like Howard Strickling (at MGM) and Harry Brand (at Fox) were known as "fixers" charged with covering up potential scandals. It was their responsibility to protect the studio talent. Once Marilyn and I were in New York at the same time, staying at the

(Top) *Photoplay*, April 1954. (Bottom) 20th Century-Fox Photoplay Award advertisement, 1954.

Sherry-Netherland Hotel, and we both received death threats. It was my first experience of the downside of fame, and a sign of what was to come for future celebrities. I'm sure it was even worse for Marilyn. She always seemed to be surrounded by people who wanted something from her. It must have been soul-destroying to constantly have that doubt about people's intentions.

One of Fox's top publicists, Roy Craft, was absolutely besotted with Marilyn. He really believed she was the greatest thing that ever happened, and pushed her to do as many public appearances as possible—parades, parties, charity events. Later, when the traditional studio system was dissolving and stars were beginning to employ independent public relations companies, Marilyn worked with the highly respected publicist Pat Newcomb.

I followed Marilyn's rise all through the decade, as did the rest of the world. Her comic performances in *Gentlemen Prefer Blondes* and *The Seven Year Itch* were so fresh and natural and instinctual. I always felt her involvement with the Actors Studio wasn't the best influence. In many ways her best dramatic performances are still the earlier ones, like *The Asphalt Jungle* and *Don't Bother to Knock*. Though I must say she was awfully good in *Bus Stop*, and *The Misfits* remains my favorite of all her films. I know how much working opposite Clark Gable meant to her.

Over the years our paths would cross. At some point I bought a car from her, a black Cadillac that I drove for quite a while. I still have a photo she gave me at the time: Marilyn sitting in that car. I really don't recall our last meeting. It was probably in New York. Then, in August 1962, I was in Montecatini, Italy, at the same time as columnist Sheilah Graham. I was resting on the terrace of my hotel when she leaned out a window and screamed, "Marilyn Monroe died! Marilyn Monroe died!" That's how I learned of her passing.

Today, in 2015, I am continually astonished by what her legend has become. Undoubtedly one of the most popular film stars in Hollywood history, she is now more revered and recognizable than most contemporary actors and actresses. She is everywhere, constantly copied and emulated—on posters, on T-shirts, in advertisements, her image remains an inspiration to countless artists, her portrait hangs in museums.

I often remember the simple blond girl all those years ago, coming out of Natasha Lytess's office, talking about her dream to "make it" as an actress. I wonder if she could ever have imagined the happiness she would bring to millions of people, and the indelible impact she would leave on this world.

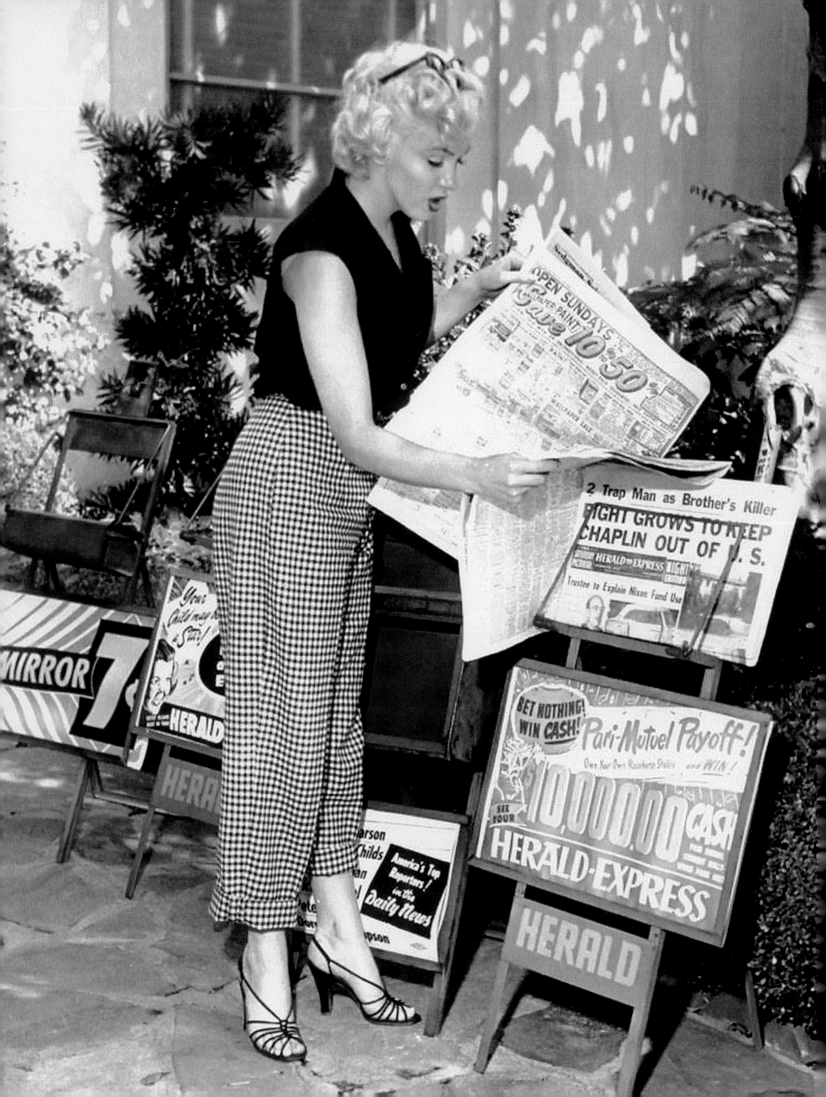

MARILYN AND THE PRESS

BY DAVID WILLS

"Look, I have all the newspapers each day and I was generally on the front page. But now I see that Marilyn Monroe is on the front page. Well, somebody has pushed me off! Can you please tell me who Marilyn Monroe's publicity agent is?"

WALLIS SIMPSON (The Duchess of Windsor, to her publisher Charles Pick, 1955)

The ubiquitous Monroe, in 1955, didn't really need a publicity agent, other than the publicists at Twentieth Century-Fox, who promoted her movies. Marilyn attracted attention and press just by entering a room.

Even from the early years, before Norma Jeane fashioned her alter ego, the young model's cherubic face and pleasing figure filled stock photo files and adorned magazine covers. A little success encouraged the ambitious Norma Jeane to set out on the path of her life's work: selling "Marilyn." With the help of the press, who fostered her from day one, Marilyn fully enjoyed and participated in her star buildup. Her affinity for the still camera was her ticket beyond her beginnings, and what she didn't feel instinctively for the photographic process, she learned quickly and put to thrilling use. By the early 1950s she was a page-one headliner, a columnist's dream, and a press photographer's best friend.

Marilyn was at her most electrifying at public events. She was as spectacular in the posed candids of news photographers as in studio portraits or on the movie screen. And it's in these press photos—taken at the street level, without the benefit of studio props or staged lighting—that her charisma really shines. Her image explodes. Marilyn made any candid photograph a work of art simply by being in it.

Trying to distill the essence of charisma into an objective formula is impossible. She was of course extraordinarily photogenic—a magic that occurs between subject and lens as light is reflected off the planes of the face and is captured on film. Forming a cosmetic masterpiece of trompe l'oeil, Marilyn's features translate like caricature on film and are very easily processed by the viewer. Photographer Elliott Erwitt confirms, "There was never any secret to get a good picture of Marilyn: Just aim the camera, shoot and let Providence do the rest."

Today, the Monroe legend can sell almost anything, from magazines to merlot. The name and the image continue to nurture intense interest and fresh profits. And the presses have yet to stop rolling.

In Living Color

Almost from the first flicker across a shaky screen, as Hollywoodland made itself essential to a new industry, newspapers, magazines, and their columnists and photographers made reporting on the show and business of filmed entertainment a necessity. The moving picture factories sponsored the development of fan magazines—*Motion*

(Opposite) Marilyn, Twentieth Century-Fox studios, September 20, 1952.

Picture, *Photoplay*, *Movie World*, *Screen Stories*, *Silver Screen* among them—as promotional tools and publicity pipelines whose content could be tightly controlled, and whose every issue would be widely circulated, then tossed aside to make way for a new issue.

The rise and fall of the traditional movie magazine format was tied directly to the success and falter of the original Hollywood studio star system. In the early 1950s, the legendary power of the moguls abated as the stars increasingly became independent contractors, moving among the various studios instead of being bound to one. The advent of television changed the habits of the audience, whose nights out were giving way to evenings in. The magazines, which had begun asserting their own independence from studio control, scaled back in view of shrinking newsstand sales and subscriber losses.

It was just prior to this uncertain business landscape that a shy but attractive local girl took her first steps toward the limelight. Norma Jeane Baker was spotted by U.S. Army Air Forces photographer David Conover, who had been tasked with taking "morale-boosting shots of pretty girls" for *Yank* magazine, in June 1945. Impressed with the results, Conover encouraged Norma Jeane to try modeling, which the young newlywed pursued while her husband was deployed to the South Pacific.

Next stop was the Blue Book Modeling Agency, whose proprietor, Emmeline Snively, recommended a lovely new girl to freelance photographer André de Dienes. Norma Jeane's figure was a perfect model size, "except in one place," Ms. Snively remembered. "The blouses were always too tight across the front." Swimsuits, however, were shown off superbly.

In later years, Marilyn's body would be studied by doctors and experts, who hailed it as a genetic marvel of feminine proportion. Her beautifully shaped legs were given the illusion of length by a very short distance from her waist to upper thigh. She also had an incredibly narrow back and rib cage but large breasts. What made her body so extraordinary, though, was the approximately 13-inch difference between her breast and hip measurements and her waist. At 5' 5½" tall, her figure generally measured 36-22-34 (today her dress size would be either a 2 or a 4), and though her weight fluctuated throughout her adult life (from 118 to 140 pounds), she always maintained that exceptional hourglass ratio. Photographer Eve Arnold explained that because of this dynamic, even when Marilyn was heavier, "she would photograph ten pounds lighter which is against every rule in the book."

Norma Jeane's whipped-cream complexion and naively sexy curvature in front of the camera made her a very successful model, and she in turn became versed in lighting technique and photo composition, not just in striking the pose. Photographers like de Dienes, Laszlo Willinger, Bernard of Hollywood, William Carroll, Potter Hueth, and others filled roll after roll with spec portraits that were irresistible fodder for Wide World Photos, Globe Photos, Pictorial Parade, and King Features Syndicate.

In the 1940s, the look of the movie/fan magazines was undergoing a transformation. Black-and-white photos, pale color-washed portraits, and illustrations were replaced by shots of the stars in vibrant color against brilliant backgrounds. Magazine glamour took on another dimension just as Technicolor was super-charging the movie experience. Vivid color portraits of Norma Jeane found frequent exposure fronting special interest magazines and men's titles like *See*, *Tempo*, *Quick*, *Gala*, and *Laff*. Many of the shots took advantage of the special properties of the Kodachrome film process, with its sharp brilliance, lasting saturated color, and broad applications in

reproduction and publication. Prints made from Kodachrome, however, couldn't be conveniently retouched, and some professionals (most famously Richard C. Miller) used the complicated carbro printing process, which allowed for much easier retouching. Its rich, almost surreal tonality was used to spectacular effect.

In 1946, anxious about an upcoming shoot for a shampoo advertisement, Norma Jeane considered lightening her hair to heighten the blue of her eyes. Over the course of the year, she gradually coaxed her curly brown locks into honey-blond waves. With her new hair and wardrobe, she presented herself as "Jean Norman," a captivating Kodachrome blue-eyed blonde. But such changes proved upsetting to her husband, Jim Dougherty, who signed divorce papers in the fall of Norma Jeane's transformative year.

Now on her own and occasionally struggling, the starlet accepted photographer Tom Kelley's proposal of fifty dollars for a nude photo session in 1949. Kelley positioned his camera high above a swath of red velvet upon which Marilyn stretched sensually, fingertip to toe, her desirability nearly vibrating across the scarlet folds. Just four years later, Hugh Hefner, in a canny maneuver to launch his new magazine, *Playboy*, paid five hundred dollars to acquire the negatives from that shoot, which Kelley insisted were stolen from his archive. In December 1953, Marilyn appeared as the world's first centerfold; the teasing cover line boasted: "FIRST TIME in any magazine, FULL COLOR."

Star-Maker Machinery

An intimate friendship with agent and man-about-Hollywood Johnny Hyde brought Norma Jeane to the attention of Harry Brand, the head of talent at Twentieth Century-Fox. With publicity chief Roy Craft standing by, the fresh find was screen-tested in late summer 1946. Cinematographer

Leon Shamroy declared, "This girl will be another Harlow!" Norma Jeane was swiftly endowed with a name in accord with her own endowments: the mellifluous, alliterative "Marilyn Monroe," a perfect alias to promote in a provocative whisper.

Twentieth Century-Fox production chief Darryl Zanuck, however, was not convinced of Marilyn's talent and box office potential, and ordered that she be cast only in bit parts and small featured roles. However, the publicity department continued full speed ahead in their efforts to promote the photogenic starlet. Pat Newcomb, Marilyn's publicist from 1960 to 1962, explains: "Generally speaking, the publicist was there to protect the client and come up with ideas to promote whatever film they were working on. Studios had their own in-house publicity departments, but if a film needed special attention they brought on independent publicists to help. Studios only did this for their films—not for their contracted stars."

According to the anonymous "Flack Jones," a senior publicist at Fox in the early fifties, the best-known Hollywood photographers were solicited with the hard sell: "We think this girl has a great future; she's beautiful, her chassis is great, and are you interested?" These professionals were awarded carte blanche to glamorize the new "It Girl," and lined up to take their best shots. *Life* photographer Philippe Halsman recalled that Marilyn "would try to seduce the camera as if it were a human being . . . [knowing] that the camera lens was not just a glass eye but a symbol for the eyes of millions."

The grooming, polishing, and parading of the new starlet was set in motion. Flack Jones marveled at the near-instant response: "Once we got her rolling, it was like a tidal wave." The first release of photographs, shot by expert studio lensmen Frank Powolny, John Florea, and Gene Kornman, among others, generated keen interest from papers all over the country and around the

world. The photo syndicates couldn't get enough; the ravenous magazines were right behind them. And all of this before Miss Monroe had a single major role in a Fox picture.

Laszlo Willinger, who photographed Marilyn early on for stock files and magazines, noted that "even if a star wasn't working, the publicity machine kept going. There were four hundred newspapers across the country, each with two pages of shots a day. The only thing that was expected of me was to make images that the press would choose to print over everyone else's. . . . To get printed, yours had to be the best." And if Marilyn's was the face in the viewfinder, "the best" was always a stimulating possibility, just a shutter click away.

A pivotal role in *The Asphalt Jungle* (1950) for MGM, and a now-classic showcase in *All About Eve*, released the same year, convinced Hollywood that this newcomer had a radiant screen presence as well as extraordinary still-camera magic.

Fox publicity continued to build up this starlet steamroller, who seemed ready to remake the face of Hollywood. Flack Jones remembers that "the picture division, the magazine division, the fan-magazine division, the planters who plant the columnists, [and] the radio planters" all worked on Monroe, "each specialist making a contribution to the personality we're creating in the public's mind."

Marilyn was escorted to the most beneficial cocktail parties to be introduced to editors, columnists, and representatives from radio. For one magazine soiree, Marilyn took charge of her own PR, showing up late wearing a spectacular red gown—one size too small—and making a knockout entrance. The magazine's publisher and the host of the evening shook her hand, lingered, and announced to an associate editor, "We ought to have a picture of this little girl in our book." Gazing at her once more, he added, "Possibly we should have her on the cover."

The new cover girl was unofficially crowned Miss Cheesecake of 1951 by *Stars and Stripes*, whose editors placed her on the front page of every issue of 1952; from there, it was a short trip to the locker doors and garage walls of male fans everywhere. Marilyn became a boon to fan-magazine sales as the public's fascination with Hollywood's newest star grew more enthusiastic—and more intrusive.

The demand for content from the print media of all genres (news daily, monthly, pictorial, digest, movie, fan, special interest, women's, men's, and later scandal and tabloid) ramped up not only the volume but the speed at which photos were processed, sometimes nearly remade, for publication. Marilyn was a textbook blank canvas: striking, symmetrical, her nearly flat facial features making it easy to photograph her without obtrusive shadows. Especially when a cover was in the offing, though, photo retouchers had free rein to alter an image to fit their needs. The original photo could be flipped, right to left or vice versa, to accommodate the title logo. It could be retouched for unacceptable flaws; beauty marks could be eliminated, even moved; black-and-white photos could be colorized, color photos altered, making a yellow garment orange or red. In the days before Photoshop, all of this was done by hand, piece by piece. Photo retouchers used "clipping paths," an essential technique whereby extraneous background visuals (including other figures) were literally cut or painted out of a picture to be placed on a solid color, or to make room for text. The resulting image—a forceful single portrait—then became coverworthy, a perfect enticement to buy the magazine and the article inside.

As television gained force, the studios, the magazines, and the advertisers maintained an intimate triangle of reciprocity. Studios like Fox

were still dependent on the promotional pipeline; magazines such as *Modern Screen* were hungry for news and photos; and advertisers like Procter & Gamble placed ads featuring stars endorsing products such as Max Factor cosmetics (often throwing in a plug for the studio's current production: "Marilyn Monroe, currently appearing in 20th Century-Fox's *Love Nest*"). It was a highly effective situation, a win-win-win situation, with star faces, star news, and star product as the common currency.

Marilyn was still being given minor parts in mediocre Fox films, but commercial endorsements opened more doors to the fame she sought and the synergy Fox publicists desired. Marilyn posed for ads for shampoo, soap, liquid makeup, hair color, even garden umbrellas and patio furniture. In one example of cross promotion, Marilyn was the face of Tru-Glo cosmetics from the Westmores of Hollywood in late 1952, and hype for the release of *Niagara* was included in the ad's copy.

Marilyn Monroe's screen persona was the result of considerable forethought, the skill of expert hands—two of them her own—and a significant dose of fear. She was never ready for the motion picture cameras until she was "ready" in face, form, and psyche. The cast and crew would wait and wait some more. George Masters, one of Marilyn's favored hairstylists, recalled: "Whenever she was being made up and I was doing her hair that extraordinary platinum, some incredible change occurred and she became 'Marilyn Monroe.' Her voice changed, her hands and body motions altered and suddenly she was a different woman from the plain girl I'd seen a few moments before. She was brilliant."

British critic Gavin Lambert took passing note of this dynamic in his 1953 review of *Niagara*: "This well-formed but rather mysterious girl... does not fit into any of the cinema's established categories for blondes." Then Mr. Lambert saw

a little more. In the film's memorable 116-foot promenade toward and away from the camera—it must have set some sort of movie record—Marilyn walked "as if the whole earth were a tightrope on which she has to balance." But Lambert also noticed a quieter undertone that others may have missed: "for all the wolf calls she gets and deserves, there is something mournful about Miss Monroe. She lacks the pin-up's cheerful grin."

Next was the picture that truly established Marilyn as a movie star. In *Gentlemen Prefer Blondes* (1953), she countered her sadness with the touch of a deft comedienne, and the sizzle of a sexy nightclub entertainer. In the *New York Herald Tribune*, Otis Guernsey mused, "Marilyn looks as if she would glow in the dark, and her version of the baby-faced blonde whose eyes open for diamonds and close for kisses is always as amusing as it is alluring."

How to Marry a Millionaire arrived in theaters the same year. Hyped as the "Most Glamorous Entertainment of Your Lifetime—In CinemaScope," it inspired Otis Guernsey to pose the question on many minds: "How does Marilyn Monroe look stretched across the broad screen. . . ?" Guernsey wrote that seeing her at such scale was like being "smothered in baked Alaska," and the movie was another frothy success. Marilyn was bringing big bang to the movies—and big bucks to her studio.

Rumor Has It

James Bacon, Hollywood columnist for the *Los Angeles Herald-Examiner*, encountered the unknown Marilyn Monroe at Columbia Studios, where she worked briefly between her two contractual stints at Fox. "Holy God!" he wrote. "She's so exciting! There was something about this girl. The moment you met her you knew she was going to make it." There followed fevered pronouncements from the gossip mavens of the day.

The public wanted clever reports about Marilyn's exotic hair, pearly skin, her private life, her man, her men. The entertainment press obliged, expanding column inches devoted to the star, and adding seconds of precious airtime on the columnists' weekly radio programs.

Twentieth Century-Fox took note and opened its gates for Marilyn to return and boost its bottom line, especially since a good deal of all that publicity was free. The columnists—Earl Wilson, Sheilah Graham, Walter Winchell, Sidney Skolsky—were drawn like moths to her brand of breathy, unexpected wit. Asked about her success, she quipped, "Fame is like caviar, you know—it's good to have caviar but not when you have it at every meal."

"Marilyn loved Sidney Skolsky," remembers Pat Newcomb. "The columnists would call my office to get information to write a story. If they asked a question I didn't want to answer I would just say, 'I don't know.' It was always the best response. I spoke to Walter Winchell many times, when necessary. Earl Wilson was very involved with covering show business. I was the only one in our office who could deal with both Hedda Hopper and Louella Parsons. I think they trusted me. I used to go to Louella's Christmas parties and her living room would be absolutely filled with presents—from the studios and stars—from one end of the room to the other."

Hedda and Louella, the "duel" queens of Hollywood gossip, often wrote positive articles about the stars, except when a star crossed them, or the studios wanted an insubordinate actor publicly punished. Marilyn made it known that she was very unhappy with the low pay and the stringent parameters of her seven-year contract with Fox, and was sharply criticized for overreaching, for biting the hand that nurtured her fame. Louella, not Hedda, soft-pedaled the issue, and Marilyn returned the favor, citing her as "one of my first friends in Hollywood, and I've never forgotten."

Robert Wagner, like Marilyn a graduate of the studio star system in its twilight years, reminisced, "Hedda was a far more intimidating person than Louella, but it was best not to mess with either of them." In a 1966 interview, Marlon Brando weighed in: "People don't realize that a press item—a news item—is money. The news is hawked...and it becomes a sellable item. When you don't cooperate with those merchandising systems, people who sell news, like Hedda [Hopper]...it's sort of an unwritten code that...you've broken the rule and you have to be publicly chastised for it."

The first scandal Marilyn faced as a new star was the surfacing of one of the Tom Kelley nudes on the "Golden Dreams" calendar in 1952. Fox executives urged denial, but Marilyn made a simple statement to Aline Mosby of United Press International. "Marilyn Monroe Admits She's Nude Blonde of Calendar," read the headline. When Mosby asked "Why?" Marilyn replied, "Hunger." "What did you have on?" "The radio."

Hollywood correspondent Erskine Johnson made a deft segue from one front-page story to the next, killing two scandalous birds with this one wire dispatch: "Marilyn Monroe—Hollywood's confessin' glamour doll who made recent headlines with the admission that she was a nude calendar cutie—confessed again today. Highly publicized...as an orphan waif who never knew her parents, Marilyn admitted she's the daughter of a one-time RKO studio film cutter, Gladys Baker....Said Hollywood's new glamour queen: 'Unbeknown to me as a child, my mother spent many years in a state hospital...but since I've become grown and able to help her, I have contacted her.' The news that Marilyn's mother is alive...came as an eyebrow-lifting surprise." Hedda Hopper, a bit out of character, sympathized with Marilyn and suggested, "Let's give Marilyn Monroe the benefit of the doubt."

Movie fans had a wide array of sources to

satisfy their need to be in the know about their idols' offscreen doings. Fan magazines would oblige up to a point, beyond which the secrets would be kept. But readers still wanted info on life in Hollywood, in *all* its aspects—"from raising Cain to raising children," as *Photoplay* publisher Frederick Klein put it. "Cain raising" became the focus of the scandal magazines, the most notorious being *Confidential*, which Robert Harrison first published in 1953, promising to "tell the facts and name the names."

In 1955, *Confidential* looked back at a 1953 incident that it dubbed "The Wrong Door Raid," a classic tabloid tale involving Marilyn, a companion Hal Schaefer, and baseball hero Joe DiMaggio. In a noisy case of busting and entering, Joltin' Joe, in jealous pursuit of the "cheating" couple, burst into the wrong apartment, doing damage and scaring the resident. As a result of the published story, civil charges were filed and the proceedings in an LA courtroom laboriously reported.

Sparked by the success of *Confidential*, other scandal rags appeared on newsstands, with titles like *Hush-Hush, Whisper, Top Secret*, and *Exposed*. Star lifestyle and its glamorous facade took a big hit, compounded when some of the traditional fan magazines started to mimic the sleazy tone of *Confidential* with more explicit cover story headlines.

Joe DiMaggio took a small but significant part in a Marilyn escapade ripe for scandalous spin when Fox publicity's Roy Craft put together a stunt to land *The Seven Year Itch* on the front page before it was even completed. In the late summer of 1954, with director Billy Wilder and crew, Marilyn arrived in New York City to shoot exteriors. On the night of September 15, Marilyn took her place on Lexington Avenue over a subway grate. While hundreds of fans and members of the press looked on, gusts of air billowed her pleated white skirt to shoulder height, suggesting the wings

of a risqué angel in flight, and revealing a little too much. Marilyn performed excitedly for the crowds, even though the camera was empty of film (the scene was later restaged and shot in Los Angeles); but the legendary night made for bewitching imagery, reproduced for all media, in all formats, in all dimensions. Photographer George Zimbel remembers, "There was a police line separating the crowd from the photographers and film apparatus. There were of course 'Hey, Marilyns' from the crowd, and she handled them with friendly waves. The warm-up over the subway grille served as a vehicle for the still photographers to get their work done. She played to the still photographers and she knew how to do it par excellence. Her dress was the perfect design for that scene, and it did wondrous things as she moved."

That night DiMaggio was brought reluctantly to the scene by the columnist Walter Winchell, catching the scent of a juicy story. Horrified by his wife's exhibition, Joe left in a simmering rage. The brazen yet glorious stunt wrenched Marilyn and Joe finally apart, presenting the press with another gift: The Divorce of the Year.

Black and White

Cinematic memories of Marilyn are often recalled ablaze with color, but much of her photographic legacy is preserved in black, white, and shades of gray. Her relationship with the press photographers was unique. Without the pressures of being on a studio set, or having to remember lines, Marilyn was able to freely enjoy posing in public situations. Her face and body were in constant motion, a ballet of exuberant expression: She waves, she laughs, she feigns surprise, she throws her head back to flash that perfect smile. Marilyn more than lights up a photograph, she consumes it. Photographer and friend Sam Shaw remembered, "She was the most photographed motion picture star. . . and she loved being photographed. She gave all of herself to the

camera whether the photographer was a teenage fan or a wire service staffer or one of the high fashion magazines' aces. The only photographer she ever ducked was one from *Paris Match* who intruded on her honeymoon with Arthur Miller." Pat Newcomb adds, "Marilyn rarely took direction from a press photographer, as this generally wasn't done. But she always wanted to look her best so was therefore very open to suggestions regarding a pose—to make a better photograph. Some stars won't do this, and most actresses instinctively know how to look their best in a photograph anyway. The most frequent direction I ever recall Marilyn receiving from a press photographer was simply, 'Hey Marilyn, look here!'"

When Joe and Marilyn wed at the San Francisco city hall on January 14, 1954, the *New York Times* ran a photo of their subsequent kiss on the front page. The paper's photo editor was demoted the next morning because, as Gay Talese told it, "the photo had caused a great flap.... [Photo editor John] Randolph could not believe that Miss Monroe's open-mouth French kiss would so offend the sensitivities of ... whoever may have registered an objection in the publisher's office." That photo may have been black-and-white, but the romance was red hot.

Another monochromatic medium was the newsreel, the appetizer for the main-course movie at the neighborhood cinema. The gold standard for these newsy shorts was Movietone News, produced by Twentieth Century-Fox. Other reel presenters included Paramount News, RKO's Pathé News, Hearst Metrotone News, Hollywood on Parade, and Screen News Digest. With some faux immediacy, Movietone planted publicity items in between segments of hard news. Narrator Lowell Thomas's memorable voiceover narrated the films, provided color commentary for the black-and-white footage, and even offered some home-studio cheerleading when Marilyn was sent off to promote her new Fox picture of the moment.

By 1954, Movietone News could not get enough of Marilyn. She was captured with Joe in their few moments of married bliss, and *Photoplay* presented Marilyn with the Most Popular Actress of the Year Award, with Lowell Thomas setting the scene: "The glamorous bombshell of the currently showing CinemaScope production *How to Marry a Millionaire* and who will soon be seen in another CinemaScope triumph *River of No Return*..." Later, in 1956, Movietone cameras were there to archive the command performance gala in London as Marilyn, wearing a deep-dish strapless gown, was presented to Queen Elizabeth II.

Television, no longer a novelty but still as black and white as the daily news, welcomed Marilyn for a few choice appearances. In September 1953, she guest-starred on *The Jack Benny Program*, promoting *Gentlemen Prefer Blondes*, singing and performing a sketch with Benny. Showbiz gadabout Faye Emerson gushed, "Let's face it, girls, here is the champ! She glistened from the top of her platinum head all the way down her famous torso."

A much more anticipated TV event was Edward R. Murrow's April 8, 1955, visit with Marilyn and her hosts Milton Greene (photographer and Marilyn's producing partner) and his wife, Amy, via *Person to Person* on CBS. Murrow referenced the just-formed Marilyn Monroe Productions, and Marilyn nervously spoke of her wish "to contribute to help making good pictures." The episode was the show's most-watched installment.

What's the Buzz?

Marilyn loved a parade: the thrill of the crowd, the vocal adulation, the slow-motion wave, the blowing of kisses. In 1952, she was flown to Atlantic City to promote *Monkey Business* as grand marshal of the Miss America boardwalk procession, posing

with each contestant. Fox then lined up a parade, with bands and banners and majorettes, just for Marilyn; the movie's premiere took place that evening, cameras clicking Hollywood-style.

By then, she was an old hand at such things. In 1949, United Artists had recruited Marilyn to headline an eight-city promotional tour to publicize *Love Happy*, the last Marx Brothers comedy caper. Having only a bit part in the movie, Marilyn was thrilled to take on the junket solo. In 1954, she made a triumphant USO helicopter tour of South Korea, highlighted by her performance in a skimpy dress in the February chill for thousands of boisterous troops.

That event was just for the boys, but the PR was priceless, as it came at the time of her much-publicized refusal to star in *The Girl in Pink Tights* for Fox and her marriage to DiMaggio. The newlyweds traveled to Tokyo where they were met by hundreds of reporters for a press conference at the Haneda Airport. This big gathering was meant to focus on the baseball great, but the reporters swooned over Marilyn. One journalist wanted to know what type of fur she was wearing. "Fox," she replied quickly, "and not the 20th Century kind."

In October 1954, a three-way battle was waged on the lawn of the house Joe and Marilyn were renting in Beverly Hills: Marilyn versus Joe, a divorce announcement expected that day; Marilyn versus Fox, which wanted Marilyn to show for work at the studio, and to let the studio control her press; and reporter versus photographer, in raucous near-combat for access. Into the fray stepped Marilyn, all in black, saying only: "I can't say anything today. I'm sorry. I'm so sorry."

The host of NBC's *Today* show, Dave Garroway, got Marilyn out of bed early on June 12, 1955, for a chat. Garroway began awkwardly, "I heard you were smart, but I didn't know." Marilyn laughed,

then responded, "It's interesting that people, if you happen to have blonde hair—naturally or not naturally—you're considered dumb. It's a very limited view."

The same year, Marilyn and the Greenes threw a cocktail party in New York City to announce the formation of Marilyn Monroe Productions, and in the parlance of the press, "the emergence of the New Monroe," who was rejuvenated and ready to work after her famous sessions at the Actors Studio. Marilyn was more than an hour late, provoking reporters to declare her "the same old Monroe," while the *Los Angeles Times* added, "and that's plenty."

This news event had a second chapter when Marilyn flew to Los Angeles to begin filming *Bus Stop*, the first picture with Marilyn as a producing partner. She called a press conference at the airport and paid special attention to Florabel Muir, a syndicated correspondent, who wished to know which was Marilyn's home, Manhattan or Hollywood?

In February 1956, back in New York, columnists and reporters gathered to cover the formal announcement of the teaming of Marilyn Monroe, as star and producer, with Laurence Olivier, as costar and director, for a filmed adaptation of the play *The Sleeping Prince* (released the following year as *The Prince and the Showgirl*). This conference took an unusual turn as a shoulder strap tore from Marilyn's black velvet sheath, causing a bit of prurient interest. Film critic Judith Crist offered a safety pin and assistance, while one reporter insinuated that the incident had been staged with publicity in mind.

Marilyn gave magazine interviews reluctantly unless issued in tandem with a photo session by a favored photographer. Pete Martin of the *Saturday Evening Post* spoke with Marilyn at the Actors Studio, for the May 5, 1956, edition, the story accompanied by portraits by Cecil

Beaton. Marilyn expressed her desire to avoid "telling everyone who interviews me the same thing. I want them all to have something new, different, exclusive."

Two hastily arranged press conferences occurred in June 1956, to deal with increasing chatter about an Arthur Miller/Marilyn Monroe marriage. The first took place outside Marilyn's Sutton Place apartment in New York, the other at Miller's home in Roxbury, Connecticut. The intent to wed was confirmed; the date was not, due in part to the ongoing saga surrounding Miller and the House Un-American Activities Committee's indictment and investigation. Pat Newcomb recalls, "Marilyn liked to keep up with politics on TV. She picked that up from Arthur Miller. She was almost fired from *The Prince and the Showgirl* because she wouldn't leave Washington when Miller was subpoenaed by the House Un-American Activities Committee. She risked her career for him." Walter Winchell was still using his column to discredit the couple with blind, item references and much innuendo, adding to the frenzied atmosphere of the events. Pat Newcomb adds, "Blind items could be very creative. They gave just enough information to know who the article was being written about without actually saying their name." Miller's passport was at last returned, the "egghead and the hourglass" were married, and they flew to London for the filming of *The Prince and the Showgirl*. Marilyn charmed the English press. Bosley Crowther, film critic for the *New York Times*, wrote of his disappointment in the final film: "Miss Monroe mainly has to giggle, wiggle, breathe deeply and flirt."

Iconography

Richard Avedon had an inspiration: What if he photographed Marilyn as extravagant impersonations of five twentieth-century sex symbols? *Life* published the breathtaking results, "Fabled Enchantresses," on December 22, 1958, alongside a special tribute by Arthur Miller: "My Wife, Marilyn." The magazine was an instant collector's item. Pat Newcomb explains: "Sometimes independent press photographers were hired by the studios to cover stars at public events or film premieres. It was also common, at the end of a production, to hire a name photographer—like Avedon or Milton Greene—to do special photography to help promote a film. Richard Avedon was a wonderful man. He really made everyone he photographed look the very best they could be."

A professionally inactive period followed, although Marilyn was never out of sight of the public and the minds of the press. The *Harvard Lampoon* trumped up a special acknowledgment: "The Thank You Award: To Marilyn Monroe who in a sweeping public service has made no movies this year."

But an expert movie farce came next, the one-of-a-kind classic *Some Like It Hot* (1959). Director Billy Wilder pushed aside his apprehensions, casting the difficult but irreplaceable Monroe as Sugar Kane, the cloudy but soulful singer in an all-girl band. Truly funny, touchingly so, Marilyn glows from within, and so thoroughly that one might think the film was actually in color. Critic A. H. Weiler chimed in with his praise: "Miss Monroe . . . contributes more assets than the obvious ones to this madcap romp. . . . She proves to be . . . a talented comedienne." And, like "Jell-O on springs," Marilyn bounced back onto the A-list. Even the boys at the *Lampoon* must have approved.

The photographer/illustrator Jon Whitcomb arranged a series of interviews with "the New Monroe" on the set of *Some Like It Hot* in September 1958. She posed for what would be the cover illustration for the March 1959 issue of *Cosmopolitan*. Thrilled "at last to be a Whitcomb

girl," Marilyn gave her new friend free rein, but was somewhat dismayed with some of the topics the article discussed: Marilyn's slip from the list of the top twenty-five most popular stars; her return to work classified as a "comeback"; and rumors of pregnancy with Miller's child, with subsequent denials, then confirmations, and denials again. Whitcomb wrote that "her symptoms seemed very much like those of a mother-to-be."

Marilyn failed to conjure her customary magic in *Let's Make Love* (1960), a Broadway-set romance with comedy. She played another singer/dancer—her specialty—opposite newcomer Yves Montand, already a star in France. While the film was still in production, the media did much speculating about an adulterous liaison: A weeklong series in the *New York Post* claimed to have the "Inside Story of a Romance: Marilyn's Man," while Montand placed himself in Hedda Hopper's hands to tell his side, much to Marilyn's detriment.

Arthur Miller wrote the screenplay for *The Misfits* for his wife, giving her one more fragile character to inhabit on film. Clark Gable and Montgomery Clift signed to costar, John Huston to direct, but the Millers were near the end of their union and Marilyn seemed to be losing her battle with ill health.

In 1960, Magnum, a photographers' consortium, sent its best to the arid Nevada location to record with their still cameras the history likely to unfold. Henri Cartier-Bresson, Eve Arnold, Inge Morath, Elliott Erwitt, Bruce Davidson, Erich Hartmann, Ernst Haas, and Dennis Stock in turn shot photos on and off the set. Haas sadly observed, "All the people who were on the film were misfits—Marilyn, Monty, John Huston, all a little connected to catastrophe." Nevertheless, the Magnum photographers could claim a collective masterpiece with their documentation of the troubled company of moviemakers.

With a third Golden Globe (for World Film Favorite, 1961, awarded in 1962) in hand, Marilyn began filming on *Something's Got to Give*, the movie to be the last in her contractual obligation to Fox. Her features and body transformed by a twenty-five pound weight loss, she appears breathtaking in the film's surviving footage. Pat Newcomb confirms, "If Marilyn's change in image, to something more understated and elegant for her role as a wife and mother in *Something's Got to Give* was a planned strategy, then that would have come from Twentieth Century-Fox and not her PR company. She just wore what the studio told her—what was appropriate for the character. Whitey Snyder did her makeup from day one, and Sydney Guilaroff always did her hair—and so beautifully."

She flew to New York in May to whisper-sing the birthday song to President Kennedy, believing she had the greenlight to miss an entire day of shooting. Pat Newcomb remembers, "You couldn't really plan anything with Marilyn. You could mutually decide in advance the best way to handle a situation, but then at the last minute she would just go off and do her own thing. Like when she flew to New York to sing 'Happy Birthday' to President Kennedy in the middle of filming *Something's Got to Give*. Twentieth Century-Fox was furious about that." Shortly after, and over her costar Dean Martin's insistence that a fine performance was in the making, Marilyn was fired from the project—but not before a last strategic tour de force.

On May 23, Marilyn, in a flesh-toned bodysuit, began a well-orchestrated publicity dip in the movie's "backyard" pool; soon she stripped off the suit and continued her swim, naked, for Lawrence Schiller's camera. The daring photo stunt was amazingly successful, knocking the Elizabeth Taylor/Richard Burton *Cleopatra* affair off front pages. Marilyn, anxiously ecstatic, couldn't wait "to see all those covers with me on them and not Liz." The legend had added another shocking page to her scrapbook.

Not of This World

By the summer of 1962, Marilyn had reasons to be optimistic. In addition to a small flurry of good press, the talents of George Barris and Bert Stern were enlisted for some fabled photographs. New plans as well as renewed interest in delayed or canceled projects were in the works. Even Fox made an offer for her to return and complete filming on *Something's Got to Give*. And Marilyn had the first home she could call her own.

She gave a significant interview to Richard Meryman of *Life* magazine in early July 1962 with accompanying photos by Allan Grant. The conversation took place at Marilyn's new home in Brentwood, and she appeared well prepared but relaxed, speaking with some spontaneity. Marilyn addressed that year's troubles, including her frequent illness, her recovery from her divorce, and her dismissal from her latest film and her longtime studio. When Meryman asked what kept her going, her answer was careful yet wistful: "It was the creative part. . . . And I guess I've always had too much fantasy to be only a housewife." Marilyn received much congratulation when the magazine came out on August 3, 1962, the day before her final day.

Marilyn had become acutely aware of the unyielding status of her other self, the character she shaped and adopted as her brand in the movie marketplace. The press colluded in the dynamic. Publicity painted her, and the portrait beguiled the fans in a dazzle of artificial light. Still, the simple girl was always present within her, always visible below the surface. Even as the ink on her death notice was still drying, Richard Meryman fashioned an epilogue for Marilyn from the material not included in the original published interview. The August 17, 1962, issue of *Life* featured Meryman's retake, titled "A Last Long Talk with a Lonely Girl."

Marilyn's gifts to the world are her films and the thousands of dazzling photographs we continue to enjoy. As time passes, the most tangible evidence of a life on earth—photographs and other two-dimensional ephemera—is always at risk of disappearing forever. But what does survive, by virtue of fate or value, remains in our lives to inspire in the present. Few have provided such an extensive and diverse photographic legacy that continues to increase in popularity with each successive year.

Far from being tragic, Monroe's life is inspiring. She started out with less than most, had a dream, and worked extremely hard—as a factory laborer, a model, and a motion picture actress—to make that dream a reality. Supporting herself for twenty years, from the age of sixteen, Marilyn constantly strove for self-improvement, stood up for what she believed in, challenged the studio for better roles, fought for (and won) director and cinematographer approval on her pictures, and started her own production company at a time when actresses rarely did so. She was a strong woman.

In 2011, French actress Catherine Deneuve talked about Marilyn with Charlie Rose: "For me she's really the example of the perfect actress. I'm not talking about the person, I never met her, but for me she's really the *essence* of the actress. She had a light that belongs only to her. She had something very special. When you see a photo of Marilyn there is something that comes from her that belongs to her, but is beyond even her. It's something that happens when the camera loves you that much."

This book is an appreciation of the many members of the press—journalists and photographers, known and unknown—who nurtured Marilyn's dream, preserved her words, captured her light on film, and allowed her to shine for future generations.

(Opposite) With photographer and friend Bruno Bernard/Bernard of Hollywood at a charity event, Hollywood Bowl, July 1953.

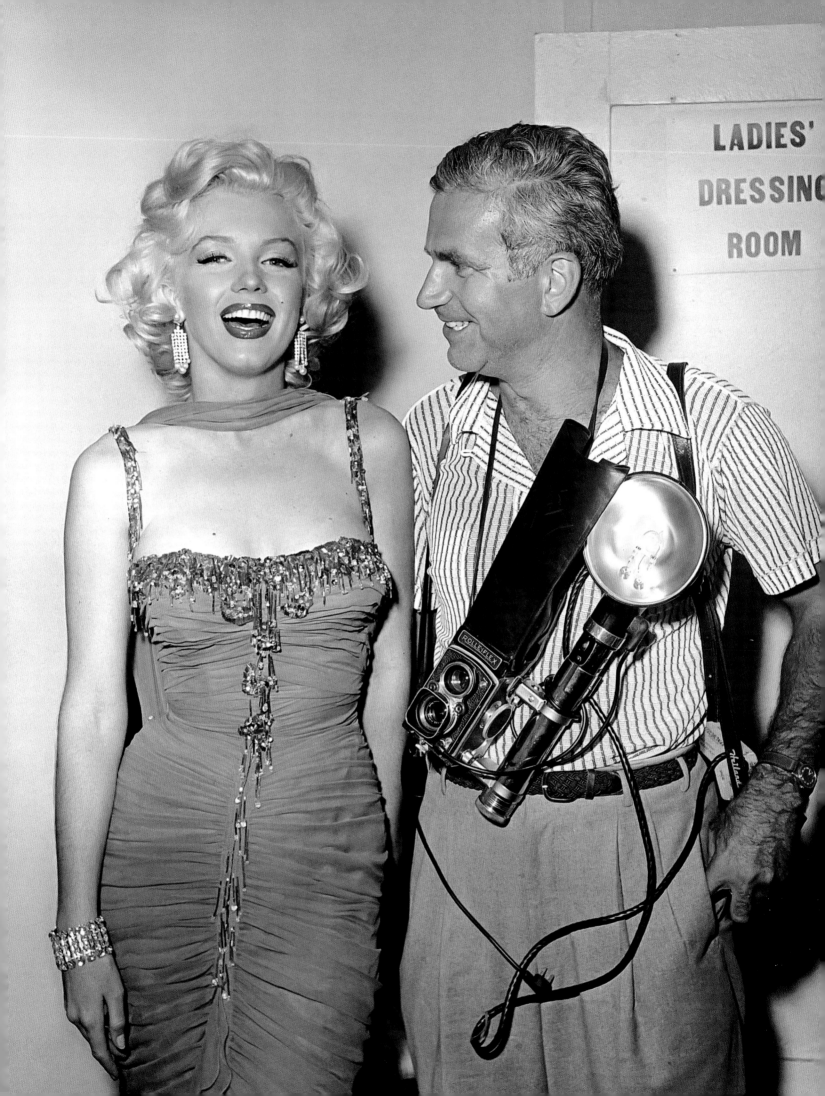

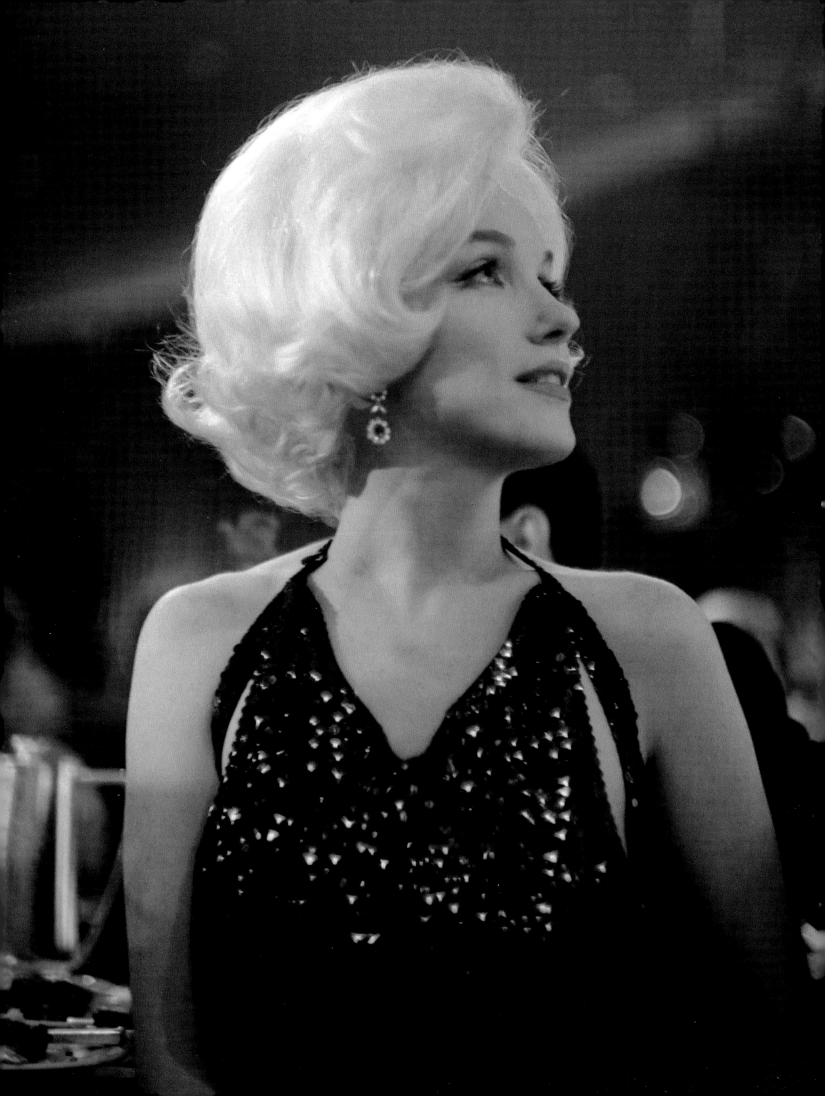

"Marilyn is an even bigger star in print than she is on-screen."

LOUELLA PARSONS (Columnist)

(Opposite) At the Golden Globe Awards, March 5, 1962.

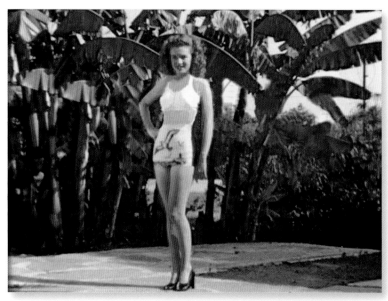

(Left) Norma Jeane's first appearance in print, *Movieland*, December 1945. (Top) First magazine cover, January 1946. (Bottom) Modeling at the Ambassador Hotel, Los Angeles, September 2, 1945. (Opposite) Death Valley, December 1945. Photo by André de Dienes.

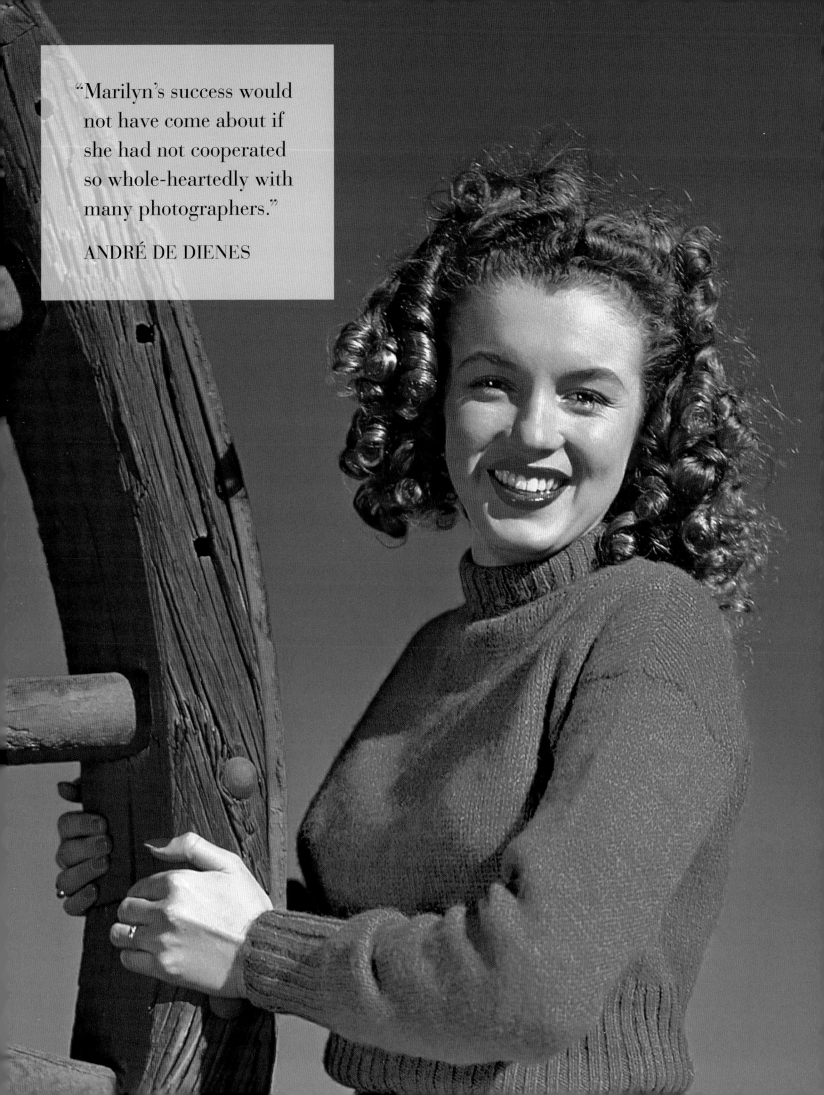

"Marilyn's success would not have come about if she had not cooperated so whole-heartedly with many photographers."

ANDRÉ DE DIENES

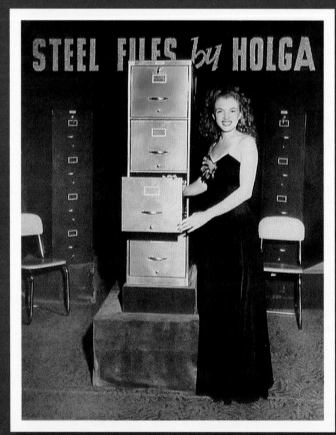

(Top left and right) Norma Jeane had her hair straightened and bleached for the first time at Frank and Joseph's Salon, February 1946. (Bottom left) Working as a hostess/model for the Holga Steel Company, September 1945. (Bottom right) Shampoo advertisement, 1945. Photo by Raphael Wolff. (Opposite) Photo by Bernard of Hollywood, 1946.

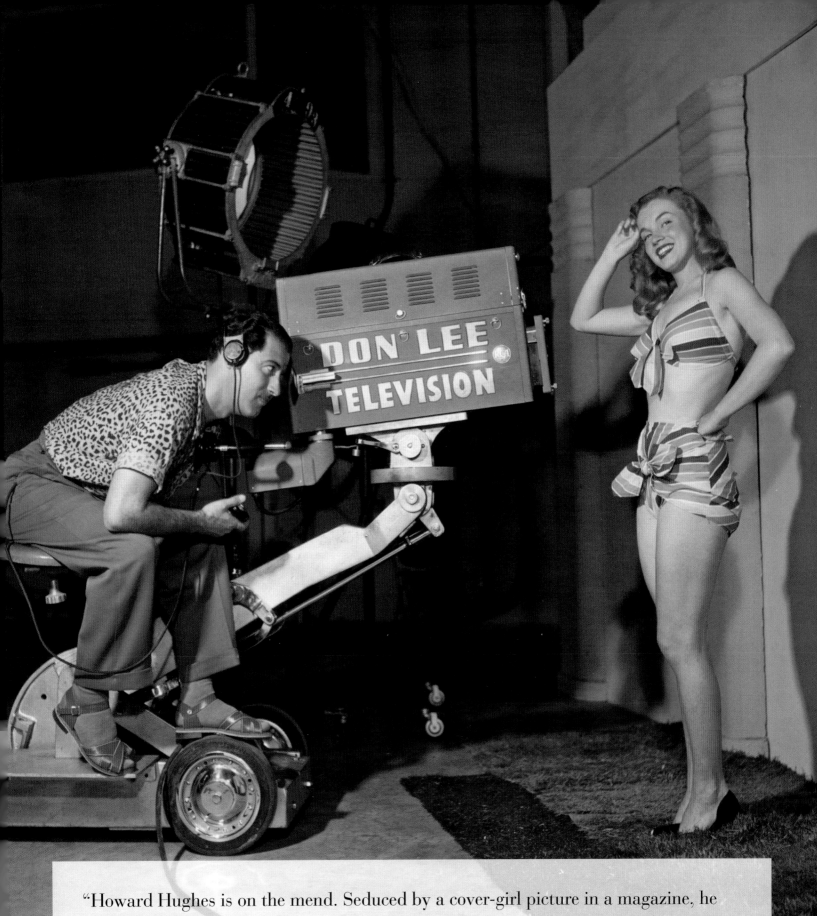

"Howard Hughes is on the mend. Seduced by a cover-girl picture in a magazine, he had immediately given some instructions to sign her to a contract for movies. Her name is Norma Jeane Dougherty, a model."

HEDDA HOPPER (Columnist; Marilyn's first mention in the press, July 29, 1946)

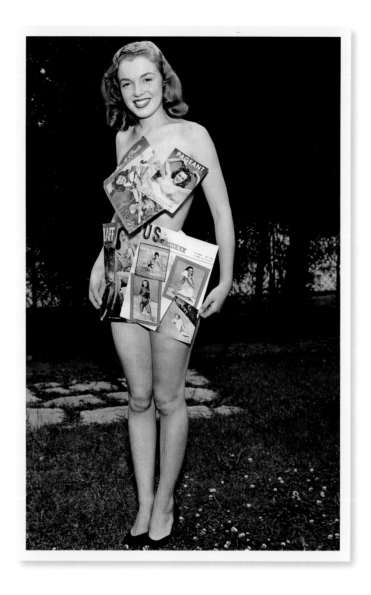

"[Norma Jeane was] very serious, very ambitious, and always pleasant to be with. There was only one problem for her. She did so many covers that for a while she was considered overexposed—the magazine and advertising people had seen so much of her that after a year she couldn't get much work."

LYDIA BODRERO REED (Blue Book Agency model, 1945–1946)

(Above) Norma Jeane proudly displays some of her magazine covers, 1946. (Opposite) Norma Jeane magazine covers, c. 1945–1947.

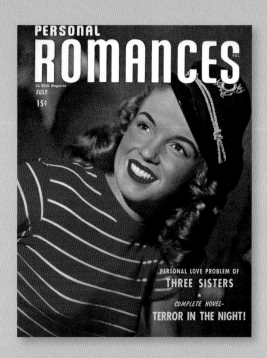

PERSONAL ROMANCES
An IDEAL Magazine
JULY
15¢

PERSONAL LOVE PROBLEM OF
THREE SISTERS
★
COMPLETE NOVEL—
TERROR IN THE NIGHT!

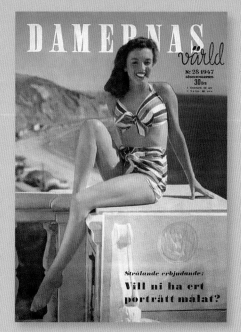

DAMERNAS *värld*
N:r 28 1947
LÖSNUMMERPRIS
30 öre

Strålande erbjudande:
Vill ni ha ert
porträtt målat?

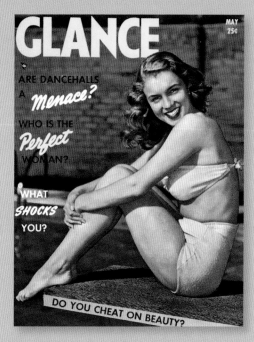

GLANCE
MAY
25¢

ARE DANCEHALLS A *Menace?*

WHO IS THE *Perfect* WOMAN?

WHAT *SHOCKS* YOU?

DO YOU CHEAT ON BEAUTY?

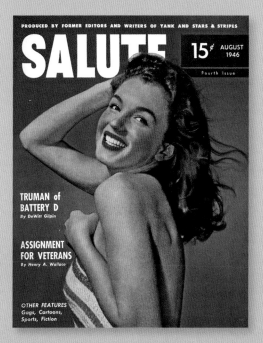

PRODUCED BY FORMER EDITORS AND WRITERS OF YANK AND STARS & STRIPES

SALUTE
15¢ AUGUST 1946
Fourth Issue

TRUMAN of
BATTERY D
By DeWitt Gilpin

ASSIGNMENT
FOR VETERANS
By Henry A. Wallace

OTHER FEATURES
Gags, Cartoons,
Sports, Fiction

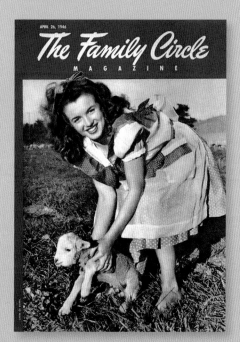

APRIL 26, 1946
The Family Circle
MAGAZINE

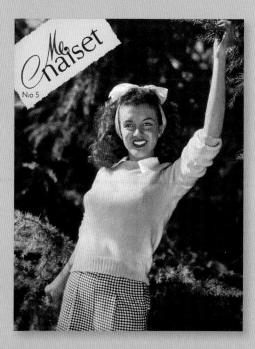

Me naiset
N:o 5

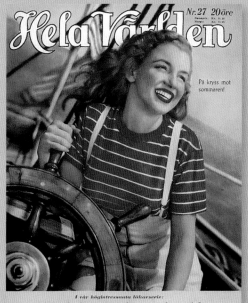

Nr. 27 20 öre
Hela Världen

På kryss mot
sommaren!

I vår högintressanta läkarserie:
Hur farligt är det med sprit?

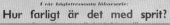

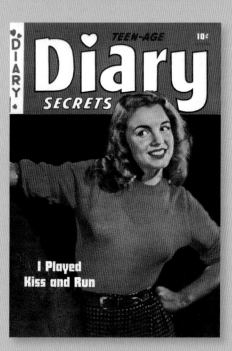

DIARY
TEEN-AGE
Diary
SECRETS
10¢

I Played
Kiss and Run

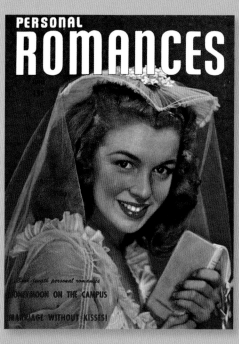

PERSONAL ROMANCES

HONEYMOON ON THE CAMPUS
MARRIAGE WITHOUT KISSES!

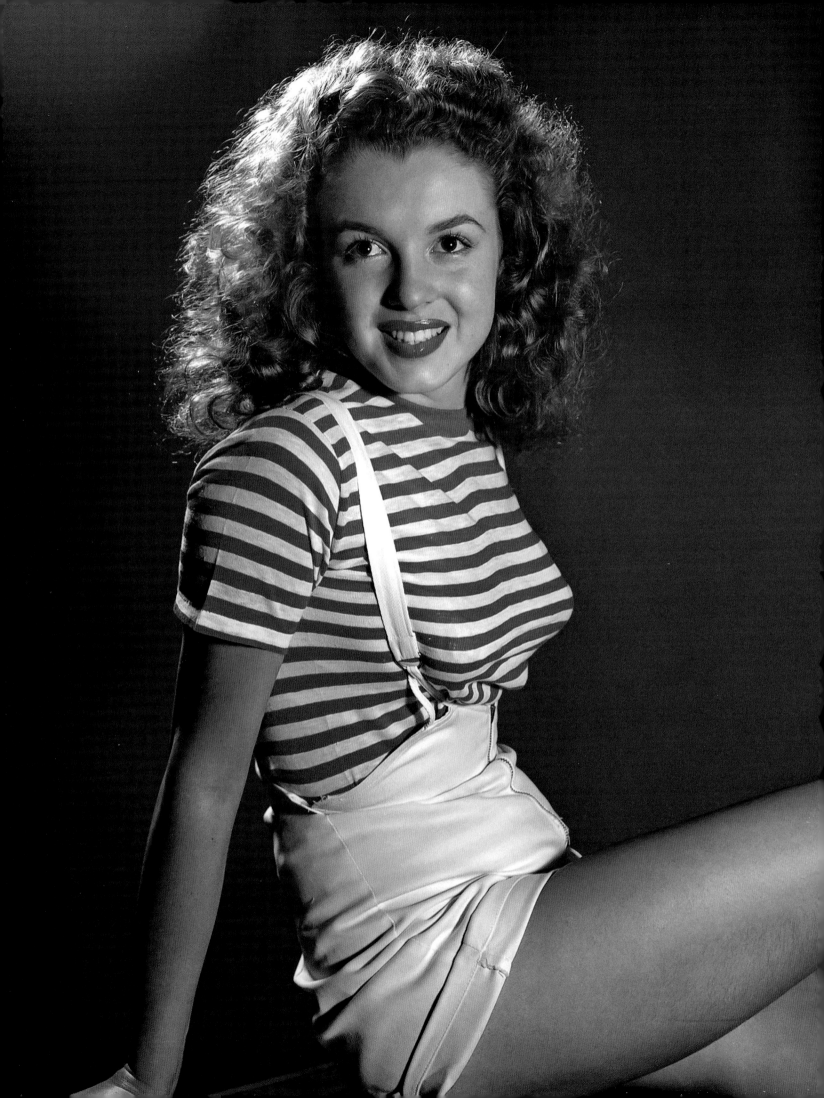

Carbro print from bromides

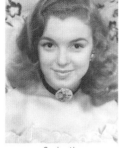
Cyan bromide

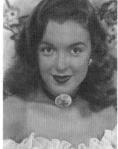
Yellow bromide

Magenta bromide

(Above) Composite showing
tricolor bromides—
in cyan, yellow, and
magenta—with the finished
result. These bromides
were printed from
red, green, and blue
separation negatives,
which could be produced
from a "one-shot" camera,
or from any original
transparency source,
including Kodachrome.

(Right) Carbro photograph
of Norma Jeane Baker
(Marilyn Monroe), 1946,
by Richard C. Miller.
The carbro process
was used extensively
in advertising, as
it allowed for easy
retouching of the
image. The accompanying
grayscale banner was used
to balance color.

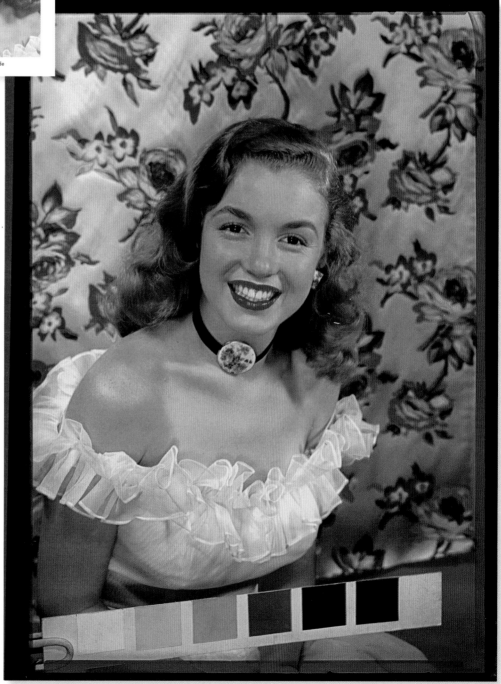

(Opposite) Norma Jeane, c. 1946.

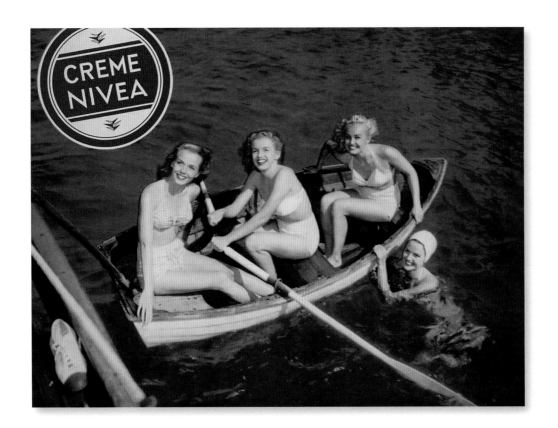

(Clockwise from top left) Nivea ad, late 1940s; Pepsodent ad, *Women and Beauty*, 1947; AlbumColor Prints ad, 1946, photo by Richard C. Miller; Clairol ad, late 1940s.

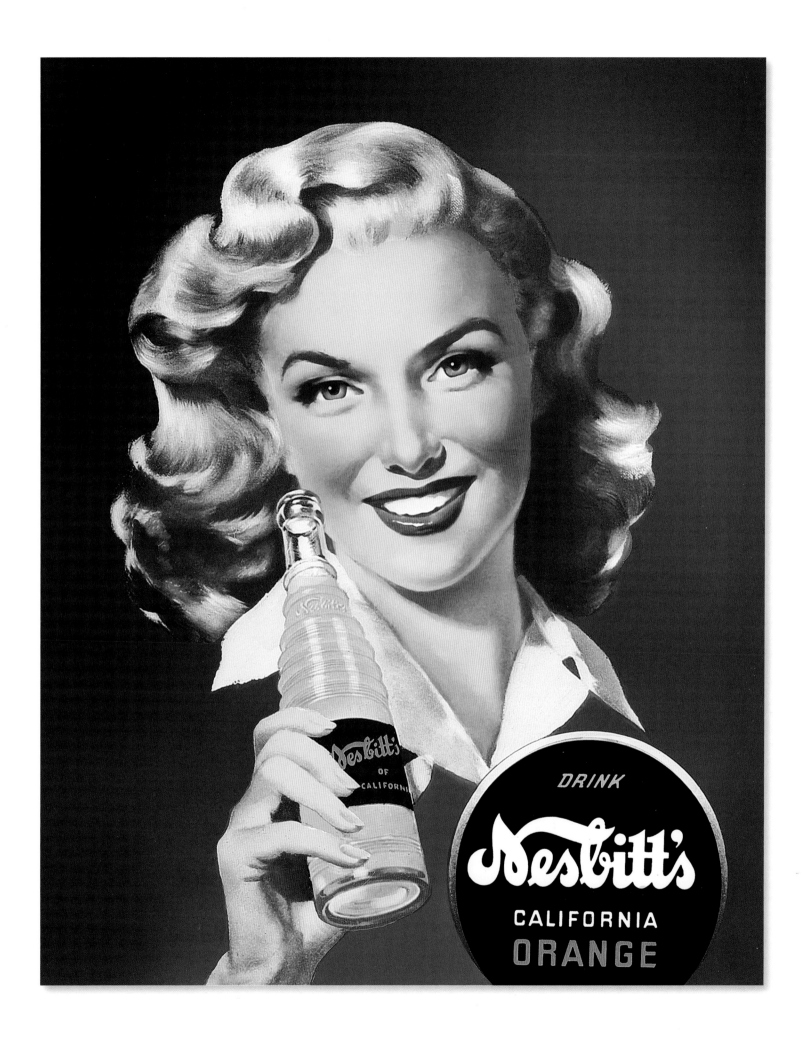

Nesbitt's of California Orange advertisement, 1946.

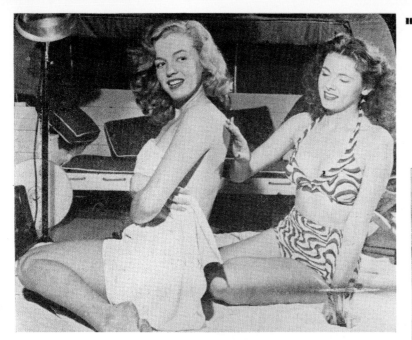

HOLLYWOOD

merry·go·round

Three Starlets From
"Mother Wore Tights" Get
An Off-Season Sun Tan

Sun lamps will do the trick, when even California weather gets a bit chilly for outdoor tanning. Donna Hamilton smooths more lotion on Marilyn Monroe's back.

Bob Landry

OLIVIA de HAVILLAND received a floral good-luck wish when she began work on *The Snake Pit*. It was a huge bouquet from husband Marcus Goodrich. She put the flowers before her dressing-room mirror. "I'd much rather look at them than myself," she said. Incidentally, Olivia tells us that she wants to do a Broadway play, just for variety.

AL JOLSON, say fans all over the country, got too much credit for *The Jolson Story* success; Larry Parks, not enough. So much publicity was turned on Al that Larry was almost lost in the shuffle. But the fans love Larry—you can take our word for it. We read the mail! Turn to page 25 and follow Larry to Mexico.

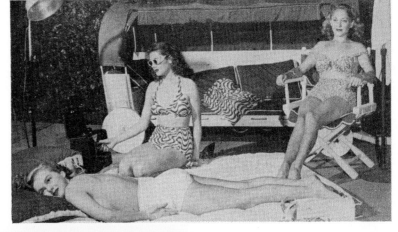

Donna tunes in soft music for Marilyn and their hostess, Marjorie Holliday (right), also from 20th Century-Fox.

ORSON WELLES, recently master-mind on *The Lady From Shanghai*, tells this story on himself: He opened a play one night during a blizzard that tied up traffic; and only eight people showed up. When Orson made his curtain speech, he said, "I am Orson Welles—writer, director, actor, raconteur, painter, sculptor, magician. Isn't it a pity that there are so many of me—and so few of you?"

Fair-skinned Marilyn has to make her sun-lamp sessions short. She is in Betty Grable's *Mother Wore Tights*.

10

CONTINUED ON PAGE 12

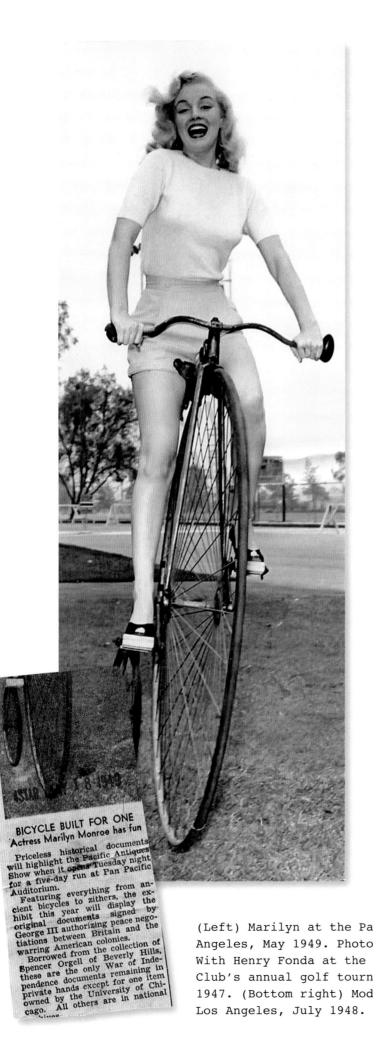

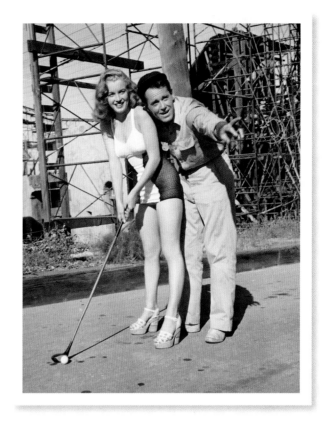

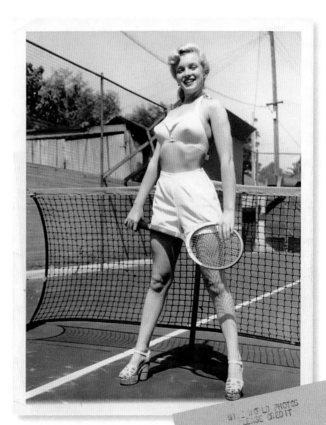

(Left) Marilyn at the Pacific Antiques Show, Los Angeles, May 1949. Photo by Ed Baird. (Top right) With Henry Fonda at the Cheviot Hills Country Club's annual golf tournament, Los Angeles, July 1947. (Bottom right) Modeling, Town House Hotel, Los Angeles, July 1948.

35

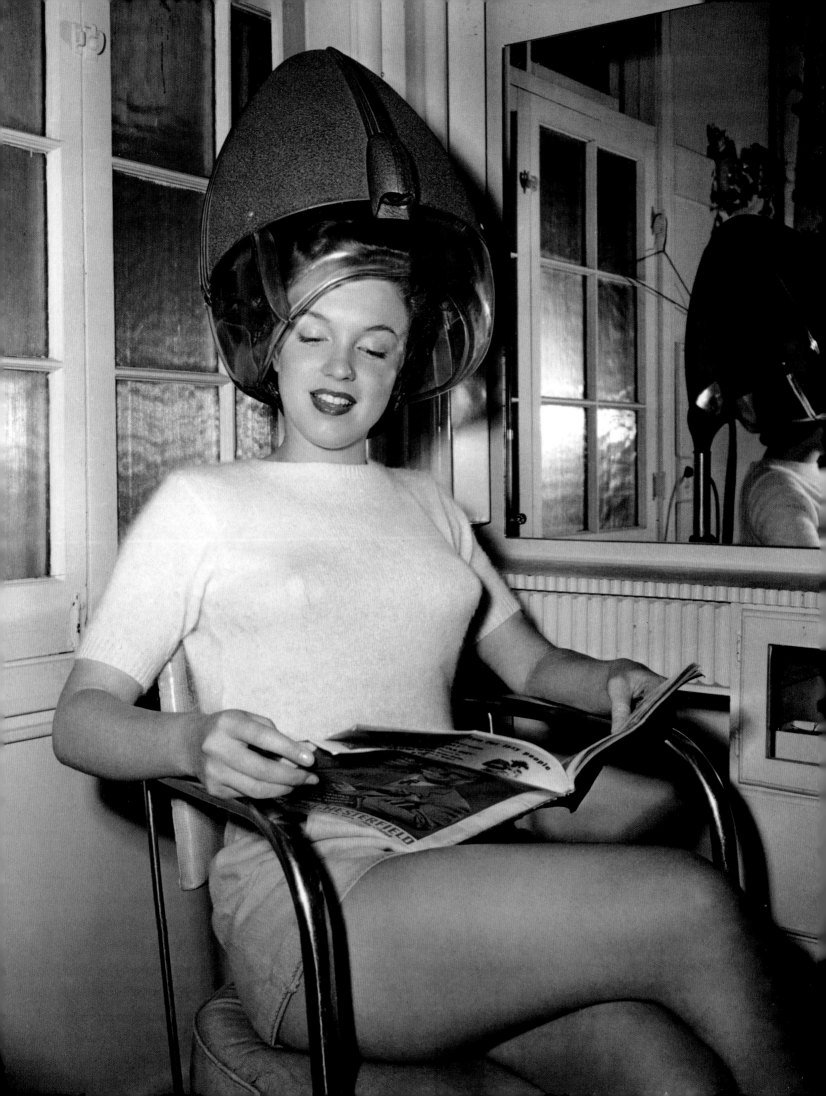

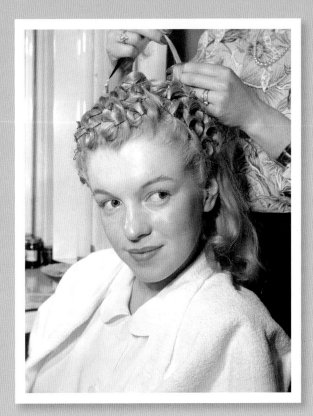

MAKE UP TO BEAUTY .. Marilyn Monroe, ingenue lead in Columbia's "Ladies of the Chorus," shows the proper way to apply powder. The trick is to put a lot of powder on and cover all of the face and neck, in order to absorb every speck of grease in the foundation and maintain a smooth appearance. Powder over the lips prevents the lipstick outline from running. After powdering, the excess is removed by thoroughly brushing with a soft powder brush.

(Marilyn Monroe # 8)

(Opposite) Marilyn at Twentieth Century-Fox studios, 1947. Photo by Ed Baird. (Top) At Columbia Studios, 1948. (Bottom) With George Jessel, Florentine Theatre Restaurant, Hollywood, 1948.

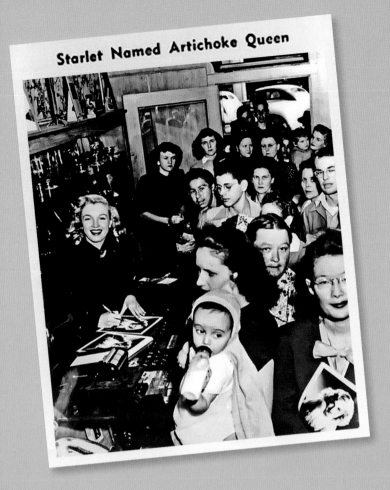

Starlet Named Artichoke Queen

Movie Starlet Goes for Walk in Rain with "Harpo"

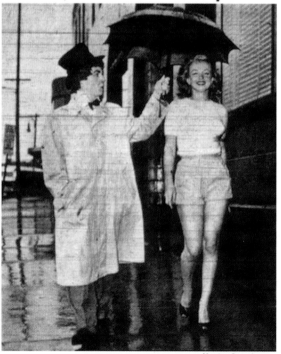

Morning Star photos

Marilyn Monroe, Hollywood starlet, in Rockford for the world premiere of "Love Happy," opening at the State theater today, is pictured at left in her sunsuit and at right as she went for a walk in the rain yesterday afternoon with a "double" for Harpo Marx, one of the stars in the movie. She will appear in the State theater lobby for the next three days.

(Top left) Marilyn named Artichoke Queen, Salinas, California, February 1948. (Top right) With Roddy McDowall at Rickett's nightclub, Chicago, 1949. (Bottom) *Rockford Morning Star*, June 14, 1949. (Opposite) Photo by Laszlo Willinger, 1949.

"Even if a star wasn't working, the publicity machine kept going. There were 400 newspapers across the country, each with two pages of shots a day.... They knew what was expected of them. These stars not only co-operated, they were eager. Some actors didn't understand this, and you never heard from them again.... The only thing that was expected of me was to make images that the press would choose to print over someone else's.... To get printed, yours had to be the best."

LASZLO WILLINGER (Photographer)

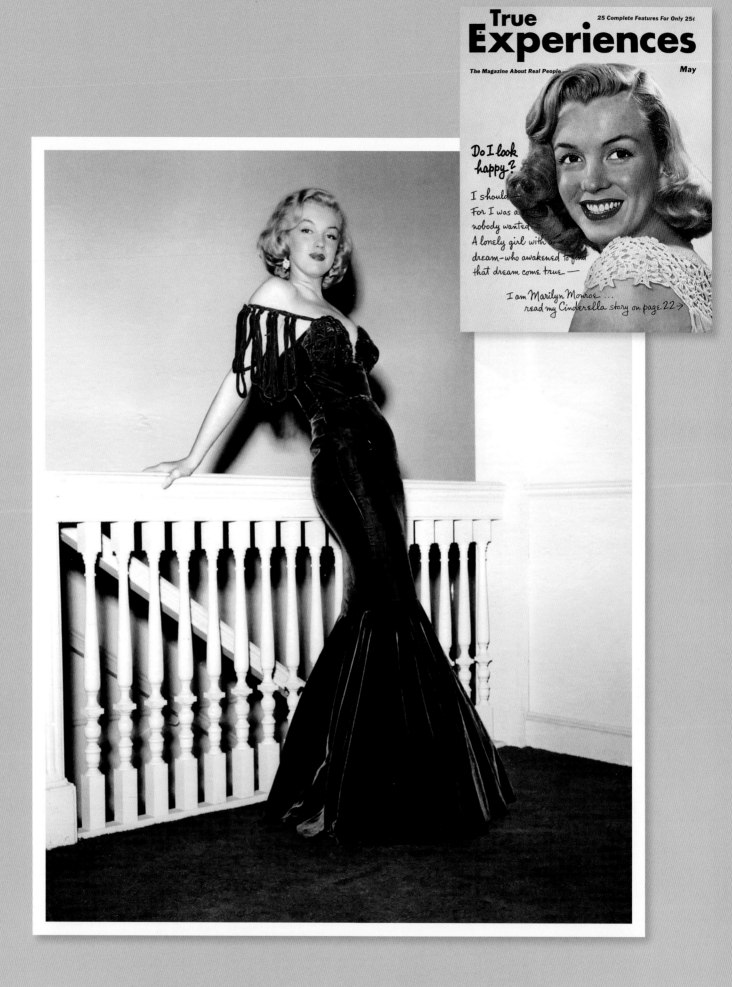

True
Experiences

25 Complete Features For Only 25¢

The Magazine About Real People May

Do I look happy?

I should
For I was a
nobody wanted
A lonely girl with a
dream—who awakened to find
that dream come true—

I am Marilyn Monroe....
read my Cinderella story on page 22 →

(Above left) Marilyn, c. 1950. (Above right) *True Experiences*,
May 1950. (Opposite) Photo by J. R. Eyerman, 1950.

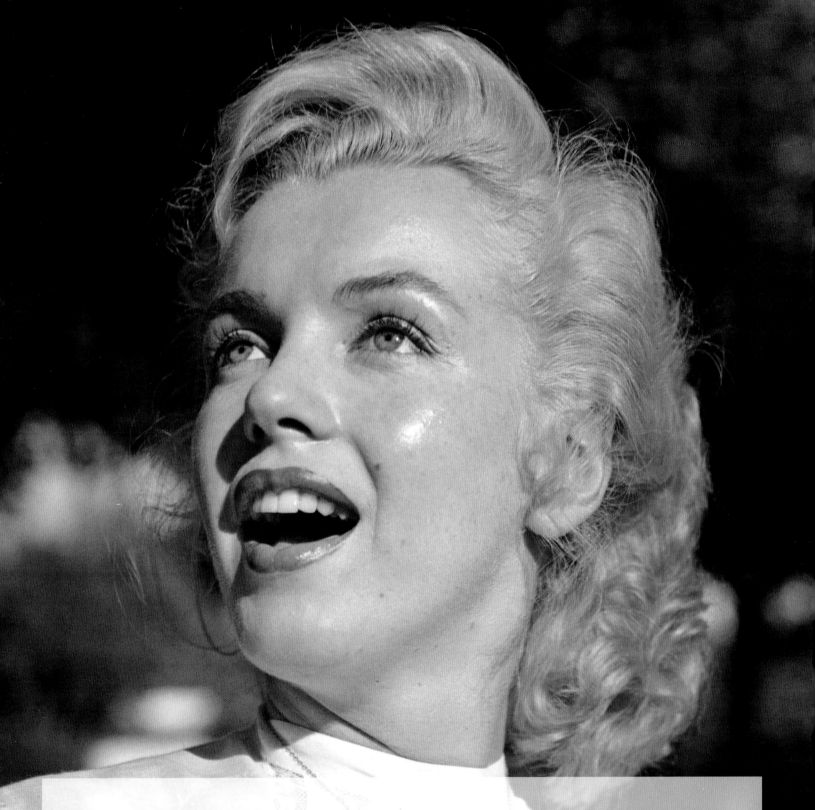

"The still photographers couldn't keep away from her when she was not in front of the movie camera, and she seemed to take great delight in their attentions. No, nobody was jealous of that attention; rather we were amused. We were older in the actual business of acting than she was, so we felt she should get the most publicity that she could. Besides, she was so modest when you spoke to her; I rather liked her."

BETTE DAVIS (On the filming of *All About Eve*)

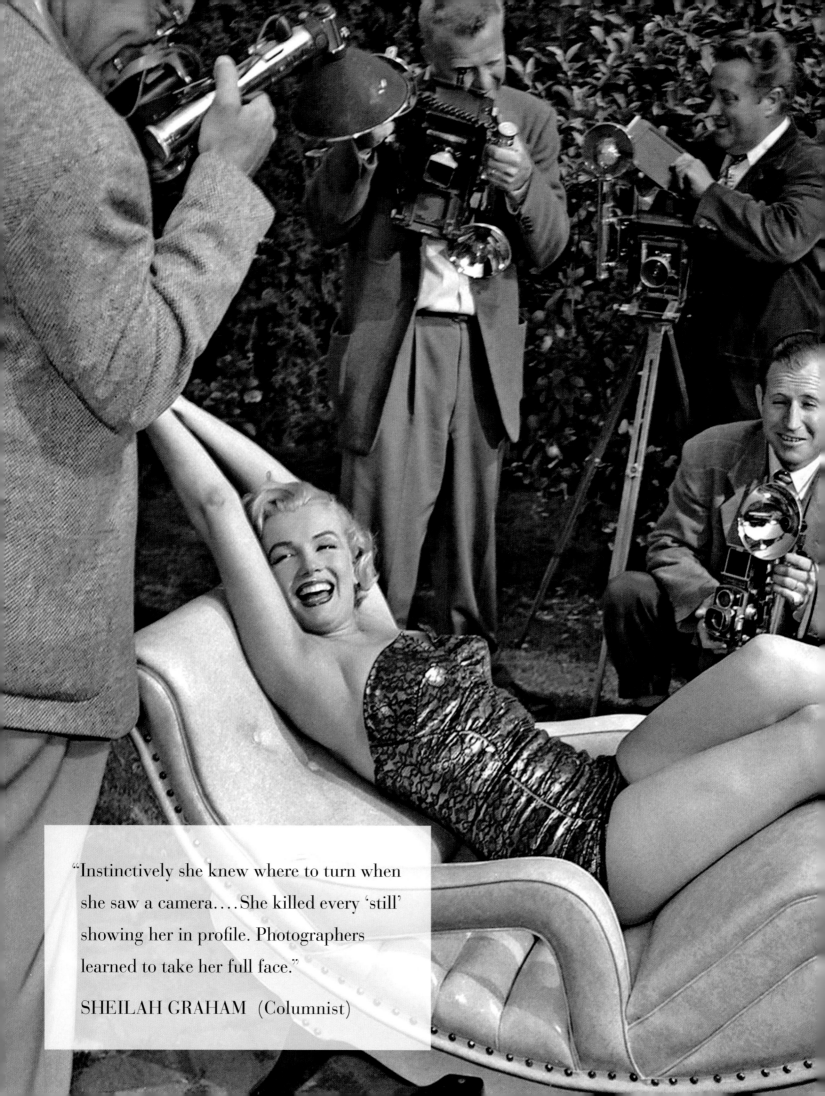

"Instinctively she knew where to turn when she saw a camera.... She killed every 'still' showing her in profile. Photographers learned to take her full face."

SHEILAH GRAHAM (Columnist)

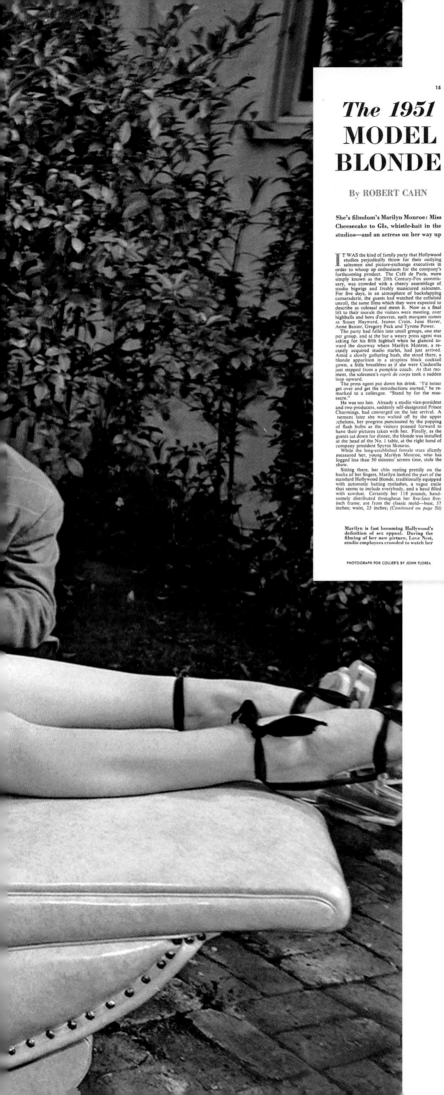

The 1951 MODEL BLONDE

By ROBERT CAHN

She's filmdom's Marilyn Monroe: Miss Cheesecake to GIs, whistle-bait in the studios—and an actress on her way up

IT WAS the kind of family party that Hollywood studios periodically throw for their outlying salesmen and picture-exchange executives in order to whoop up enthusiasm for the company's forthcoming product. The Café de Paris, more simply known as the 20th Century-Fox commissary, was crowded with a cheery assemblage of studio bigwigs and freshly manicured salesmen. For five days, in an atmosphere of backslapping camaraderie, the guests had watched the celluloid unroll, the same films which they were expected to describe as colossal and mean it. Now as a final lift to their morale the visitors were meeting, over highballs and hors d'oeuvres, such marquee names as Susan Hayward, Jeanne Crain, June Haver, Anne Baxter, Gregory Peck and Tyrone Power.

The party had fallen into small groups, one star per group, and at the bar a weary press agent was asking for his fifth highball when he glanced toward the doorway where Marilyn Monroe, a recently acquired studio starlet, had just arrived. Amid a slowly gathering hush, she stood there, a blonde apparition in a strapless black cocktail gown, a little breathless as if she were Cinderella just stepped from a pumpkin coach. At that moment, the salesmen's esprit de corps took a sudden leap upward.

The press agent put down his drink. "I'd better get over and get the introductions started," he remarked to a colleague. "Stand by for the massacre."

He was too late. Already a studio vice-president and two producers, suddenly self-designated Prince Charmings, had converged on the late arrival. A moment later she was wafted off by the upper echelons, her progress punctuated by the popping of flash bulbs as the visitors pressed forward to have their pictures taken with her. Finally, as the guests sat down for dinner, the blonde was installed at the head of the No. 1 table, at the right hand of company president Spyros Skouras.

While the long-established female stars silently measured her, young Marilyn Monroe, who has logged less than 50 minutes' screen time, stole the show.

Sitting there, her chin resting prettily on the backs of her fingers, Marilyn looked the part of the standard Hollywood Blonde, traditionally equipped with automatic batting eyelashes, a vague smile that seems to include everybody, and a head filled with sawdust. Certainly her 118 pounds, handsomely distributed throughout her five-foot five-inch frame, are from the classic mold—bust, 37 inches; waist, 23 inches; (Continued on page 50)

(Continued on page 50)

Marilyn is fast becoming Hollywood's definition of sex appeal. During the filming of her new picture, Love Nest, studio employees crowded to watch her

PHOTOGRAPH FOR COLLIER'S BY JOHN FLOREA

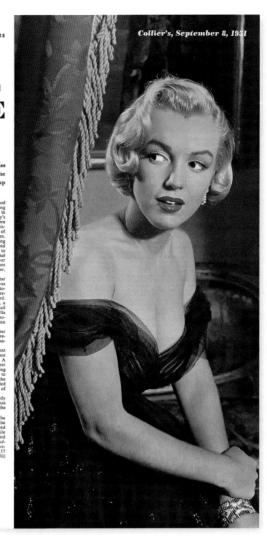

Collier's, September 8, 1951

(Left) Marilyn photographed at the house of Ciro's owner Herman Hover, 1951. Photo by Earl Theisen. (Top) *Collier's*, September 8, 1951. (Bottom) At the 23rd Academy Awards, presenting the Oscar for Best Sound Recording, March 29, 1951.

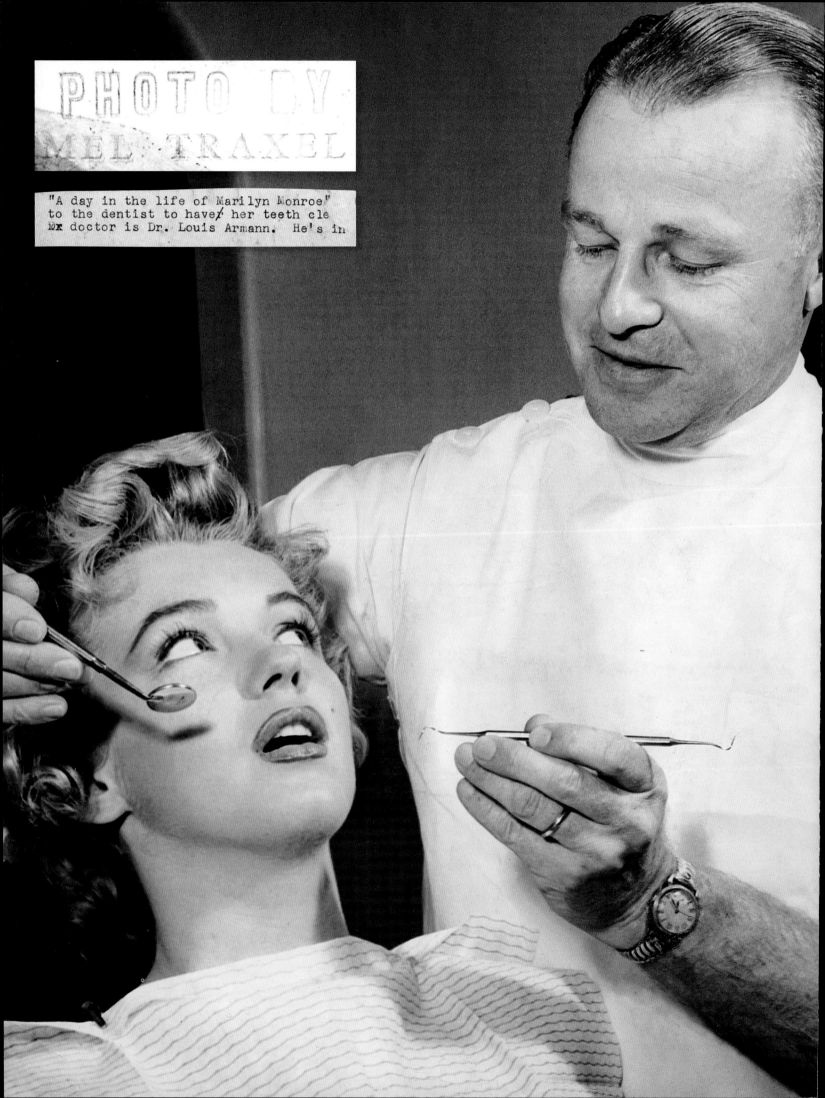

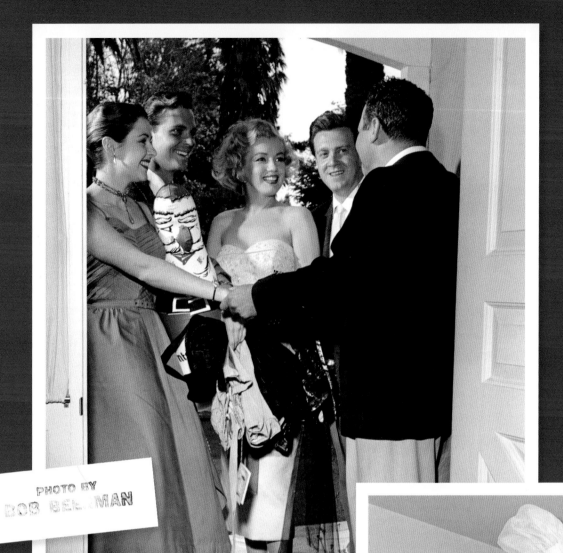

(Opposite) Marilyn with Dr. Louis Armann, February 1952. Photo by Mel Traxel. (Top) Herman Hover greets Marilyn with Marla Powers, Craig Hill, and Nick Savano, 1951. Photo by Bob Beerman. (Right) Marilyn, crowned Miss Cheesecake by *Stars and Stripes* magazine, attends a party given in honor of Michael Gaszynski, a former Polish diplomat who celebrated obtaining his American citizenship at the Farmers Market, Hollywood, August 4, 1951. Photo by Irwin Trees.

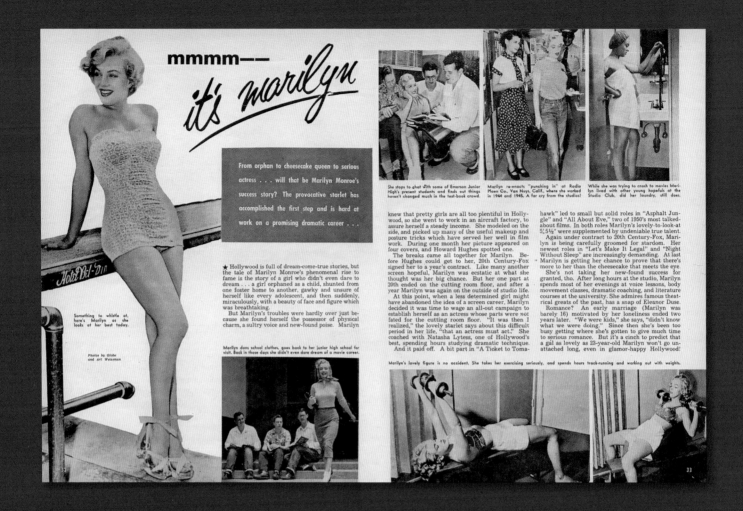

"While the movie studios had yet refused to make this girl their star, the still photographers had made her theirs. Through them she had become better known than many actresses who had been on the screen for ten years or more. Here was a girl nobody could remember having seen in a movie, but men from one end of the country to the other whistled when you mentioned her name."

PHILIPPE HALSMAN (Photographer)

(Above) *Filmland*, April 1952.

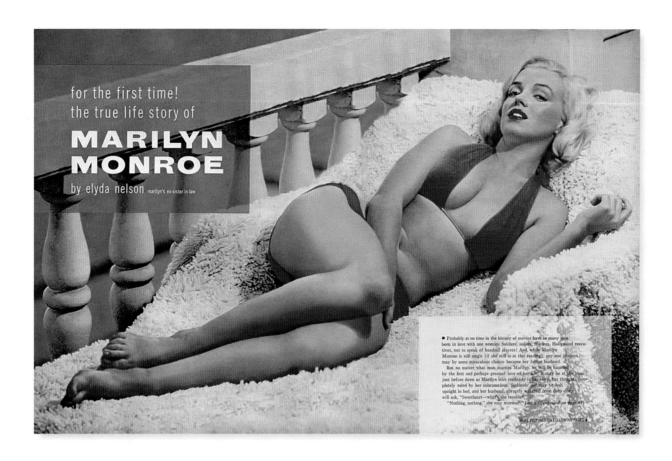

for the first time!
the true life story of

MARILYN MONROE

by elyda nelson *marilyn's ex-sister-in-law*

■ Probably at no time in the history of movies have so many men been in love with one woman: Soldiers, sailors, marines, Hollywood executives, not to speak of baseball players! And, while Marilyn Monroe is still single (if she still is at this reading), any one of them may by some miraculous chance become her future husband.

But no matter what man marries Marilyn, he will be haunted by the first and perhaps greatest love of her life. It may be at the hour just before dawn as Marilyn stirs restlessly in her sleep, her thoughts completely ruled by her subconscious. Suddenly she may sit bolt upright in bed, and her husband, abruptly wakened from deep sleep, will ask, "Sweetheart—what's the trouble?"

"Nothing, nothing," she may murmur. *Just a* (*Continued on page 61*)

MORE PICTURES ON FOLLOWING PAGES ►

I was an Orphan

by Marilyn Monroe

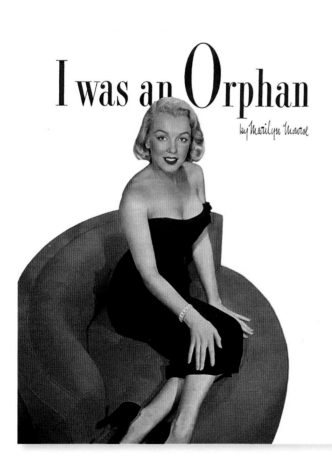

But don't feel sorry for Marilyn— unless you're the kind who weeps over Cleopatra, and pities a girl who has so much glamor that it hurts.

■ Before I was born, my father was killed in an automobile accident during a business trip to New York City. A short time later, my mother became critically ill, and while I was still too young to know much about what was happening, I became an orphan.

Naturally, that fact has greatly influenced my life. I know that often, in moments of loneliness, it has been the cause of deep personal sadness and even, at times, self-pity. But I also like to think that it is responsible, at least in part, for my having been able to realize my greatest ambition—an acting career.

I don't like to dwell on the confused and unsettled part of my childhood. When I was orphaned, the court, as is customary in the state of California, appointed a legal guardian for me. At first I lived with the guardian, but because she had a family of her own, it became necessary for me to live with someone else. I don't suppose I need to remind anyone that the 1930's were difficult times for everybody.

During the years that I was going through grammar school, I lived with a number of different families all over Los Angeles. I'm not sure, but I believe I went to seven different grade schools. And I always attended the church of the faith of the family I was living with at the time.

I don't believe that I ever really gave any trouble to the people I lived with. I was a shy little girl, and while I was still very young, I developed a make-believe world for myself. Every afternoon when I took my naps, I would pretend things. One day, I would be a beautiful princess in a tower. Or a boy with a dog. Or a grandmother with snowy white hair. And at night, I would lie and whisper out, ever so softly, the situations that I had heard on the radio before bedtime. I don't believe that I minded much being alone. In fact, I rather enjoyed it.

I remember a vacant lot that I used to cross on my way home from Bakman Avenue School in North Hollywood. It was just a dirty old lot overgrown with weeds, but from the moment I stepped onto it, it became a magic and private place where I could be all of the people I had (*Continued on page 64*)

Marilyn was a natural as the young temptress in *Asphalt Jungle*. Siren clothes accent her blonde, indoor beauty. She doesn't want to be a mere decoration, though; she's interested in fine acting.

Despite her high-flung aspirations, Marilyn can't deny her more earthy assets which manage to make even shorts and shirt look glamorous. She also dresses up her part in *All About Eve*.

41

(Top) *Modern Screen*, December 1952. (Bottom) *Modern Screen*, February 1951.

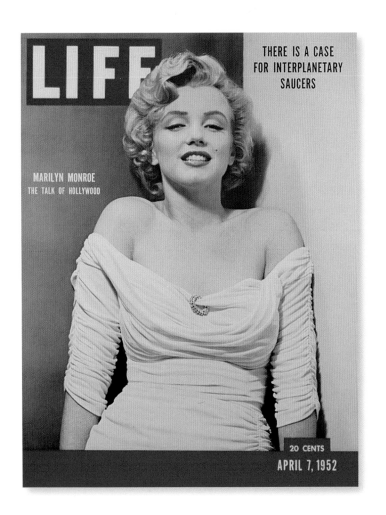

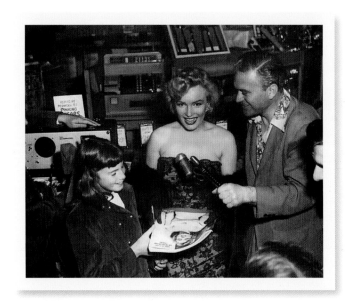

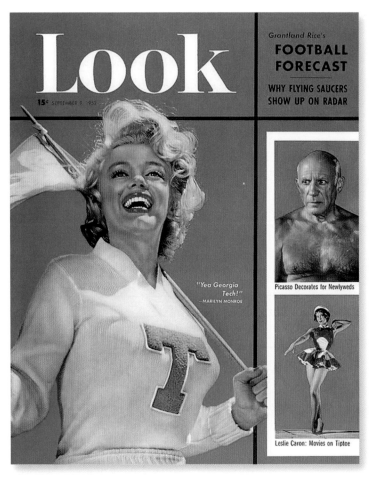

(Clockwise from top left) *Life*, April 7, 1952; signing her *Life* cover at the premiere of *Don't Bother to Knock*, July 18, 1952. Photo by Earl Leaf; *Look*, September 9, 1952; Marilyn with Danny Stradella, New York, September 1952. (Opposite) With James Brown, costar in *The Fireball* (1950), at the *Look* Awards, Beverly Hilton Hotel, Beverly Hills, California, March 6, 1952.

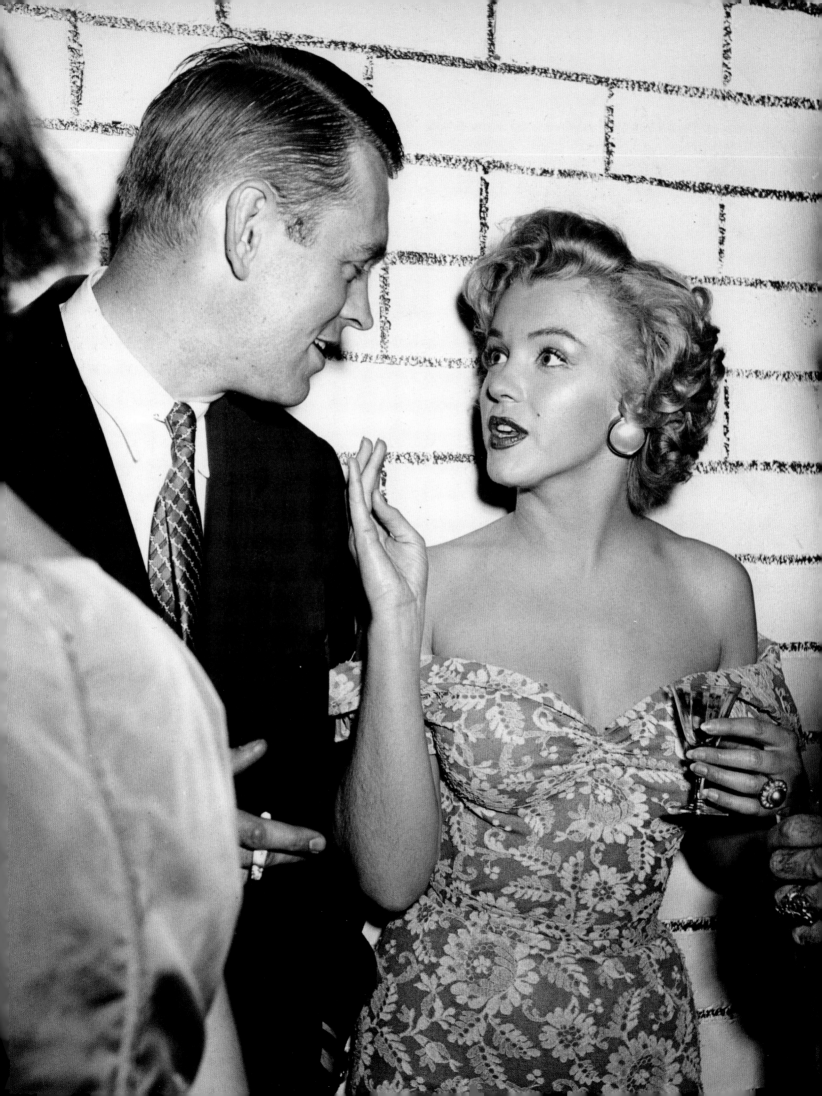

She rose to fame living a lie. Now the girl who never intended to deceive the public is letting the truth be told. For Marilyn, it's a great relief.

BY STEVE CRONIN

the secret life of Marilyn Monroe

■ The scene was a small room in the Cedars of Lebanon Hospital in Hollywood. Marilyn Monroe, her blonde hair in disorder and her pale cheeks wet with tears, lay back against her pillows in the sterile bed and stared dully at the wall. An executive of 20th Century-Fox Studio stood before her, his face set in stern lines. He had just finished telling her that Erskine Johnson, a syndicated columnist, was prepared to blast the story to the world that Marilyn's mother, who had been believed dead since Marilyn's infancy, was alive and living in Hollywood. Unless, of course, Marilyn could come up with some satisfactory explanation of her deceit.

Marilyn didn't speak for a long time. Nor did she look at the studio man. She just lay quietly facing her own conscience and turning over in her mind the big lie she had been living, and the background she had felt made the lie necessary. It was a sad moment for her. But she knew as she lay there that she would at last have to speak the truth, forget her own unhappiness and make a straightforward statement. She would have to explain why she had created the fiction she had been giving to the press and her bosses ever since she started in the movies. She sat up and sipped a drink of water to relieve the awful dryness in her throat.

"It's true," she said at last. "My mother is alive—and I've known it all along."

Because of this incident MODERN SCREEN feels the time has come to bare the complete facts of Marilyn Monroe's life, which we present herewith for the first time.

Marilyn Monroe was born in the Los Angeles County General Hospital, June 26, 1926, which makes her not 23, but 26 years of age this summer. Her mother, a casual film lab worker, who has been employed by both RKO (then Radio Pictures) and Columbia Studio, was, herself, 24 years old when Marilyn was born. (*Continued on page 93*)

42

"Once we got her rolling, it was like a tidal wave. We began to release some photographs of her, and as soon as they appeared in print, we had requests for more from all over the world. We had the newspapers begging for art; then the photo syndicates wanted her; then the magazines began to drool. For a while we were servicing three or four photos to key newspapers all over the world once a week."

FLACK JONES (Fox publicity department)

(Top) *Modern Screen*, September 1952. (Opposite) Photo by Gene Kornman (Twentieth Century-Fox), 1952.

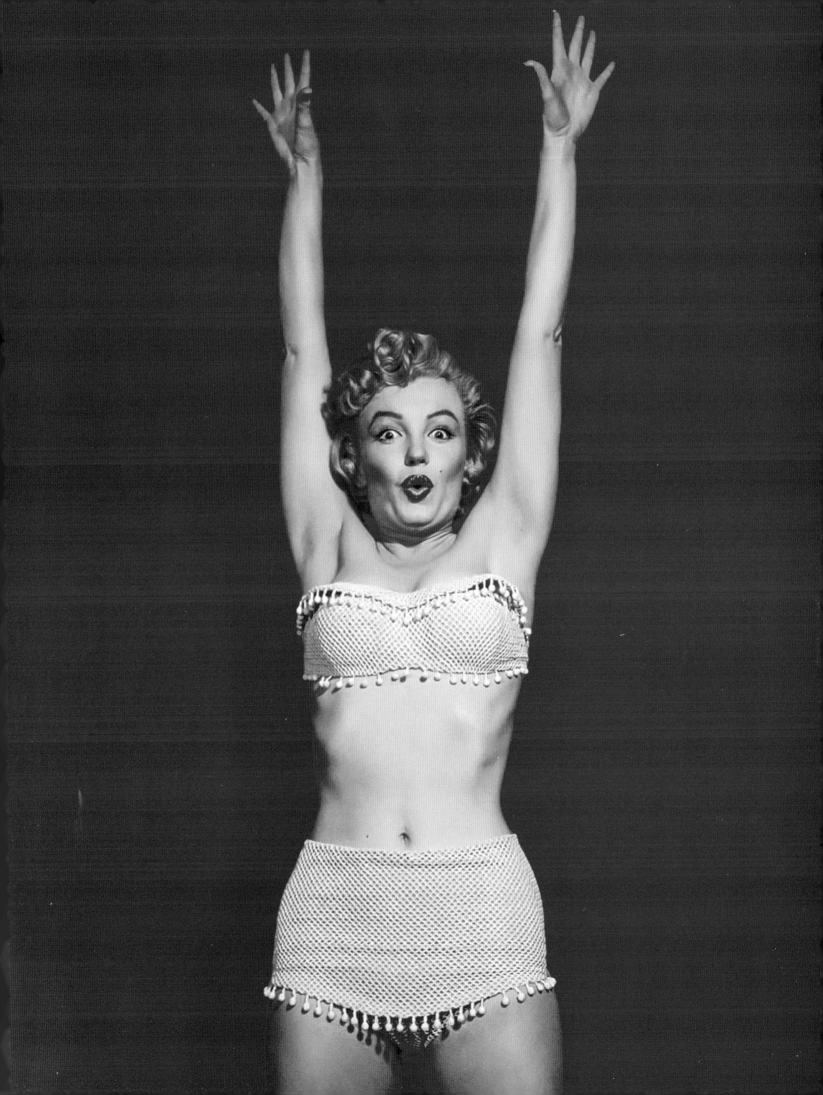

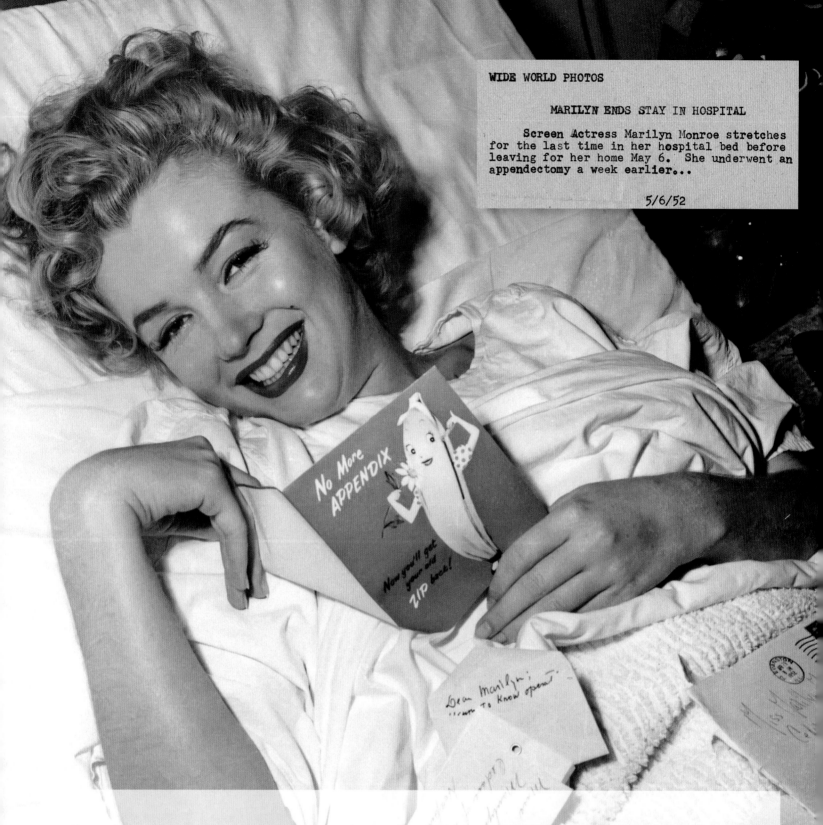

"...an inexpert actress but a talented woman. She is a saucy, hip-swinging 5' 5½" personality who has brought back to the movies the kind of unbridled sex appeal that has been missing since the days of Clara Bow and Jean Harlow. The trademarks of Marilyn's blonde allure... are her moist, half-closed eyes and moist half-opened mouth. She is a movie press agent's dream."

Time (In its first full-page profile of Marilyn, 1952)

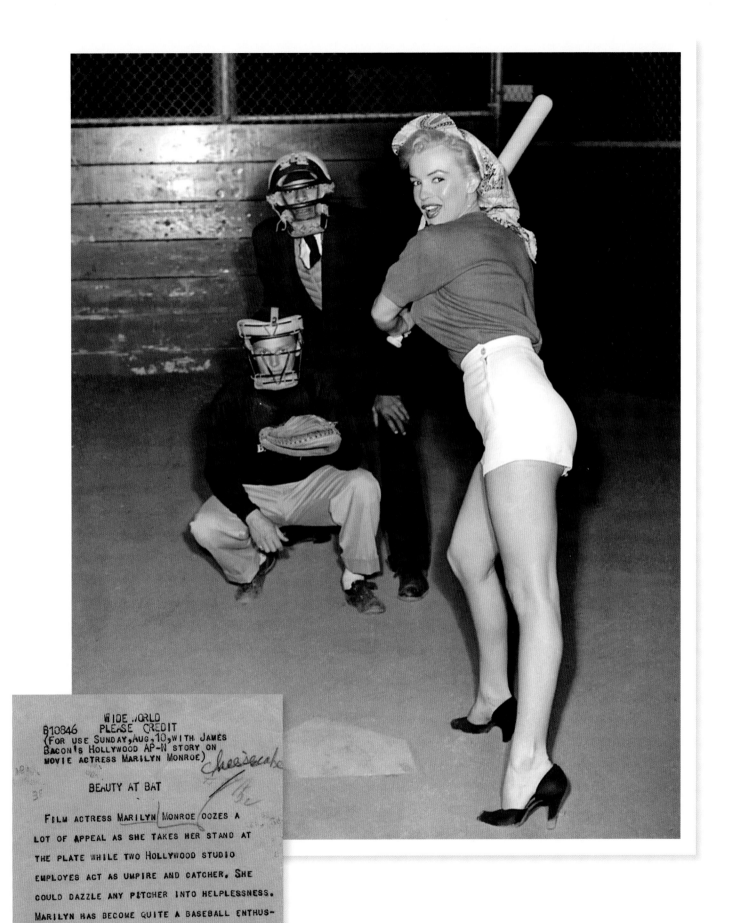

(Opposite) Marilyn recovers from an
appendectomy at Cedars of Lebanon
Hospital of Los Angeles, May 1952.
(Above) Twentieth Century-Fox Studio
League, Hollywood, July 1952.

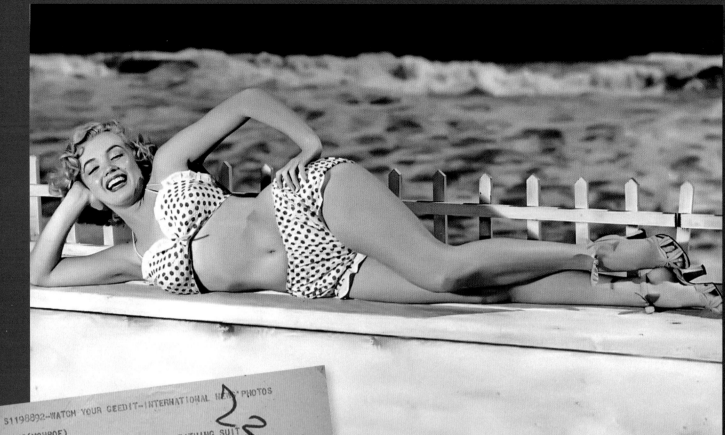

(Above) *Love Nest*, 1951. (Right)
Clash by Night, Monterey,
California, 1952. (Opposite) Marilyn
performing in a *Hollywood Star
Playhouse* radio production, NBC
Studios, August 1952.

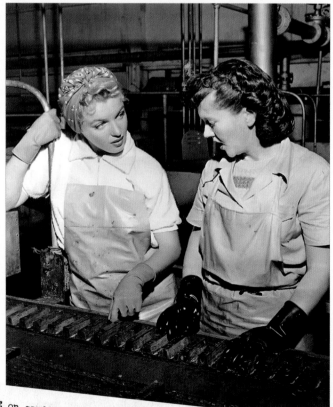

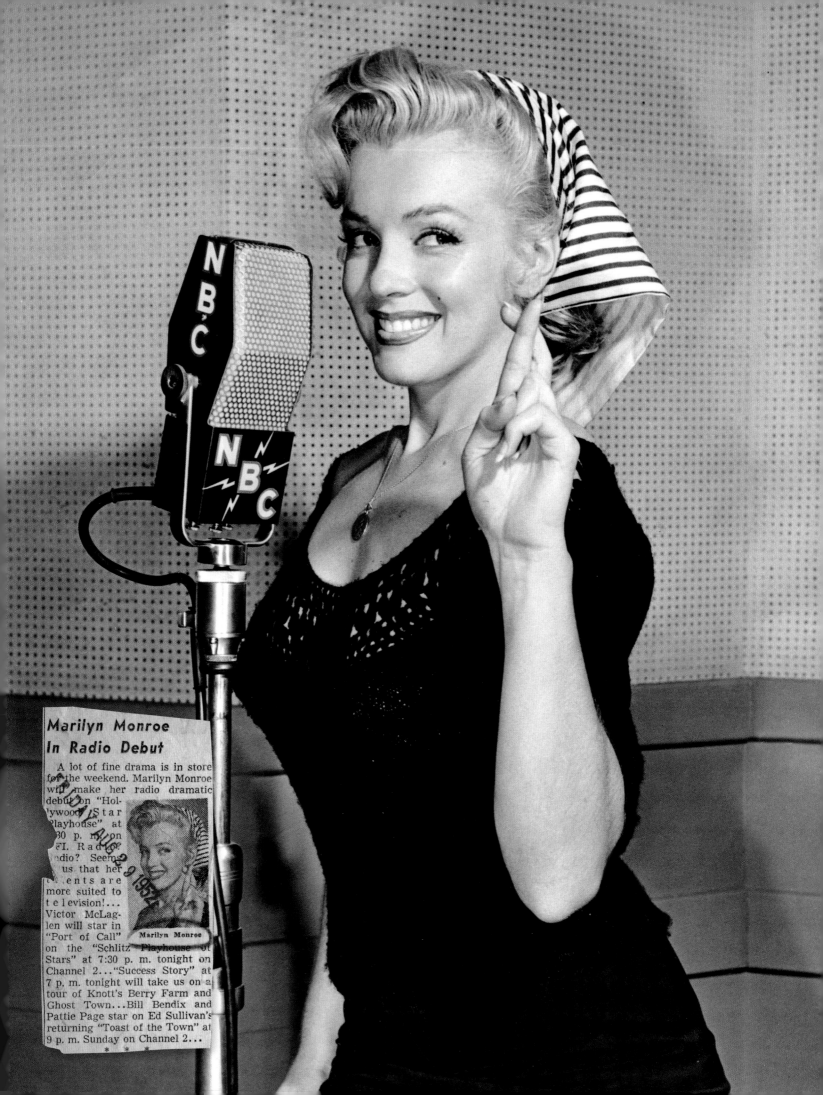

**Marilyn Monroe
In Radio Debut**

A lot of fine drama is in store for the weekend. Marilyn Monroe will make her radio dramatic debut on "Hollywood Star Playhouse" at 30 p. m. on FI Radio. Seems us that her ents are more suited to t e l evision!... Victor McLaglen will star in "Port of Call" on the "Schlitz" Playhouse of Stars" at 7:30 p. m. tonight on Channel 2..."Success Story" at 7 p. m. tonight will take us on a tour of Knott's Berry Farm and Ghost Town...Bill Bendix and Pattie Page star on Ed Sullivan's returning "Toast of the Town" at 9 p. m. Sunday on Channel 2...

Marilyn Monroe

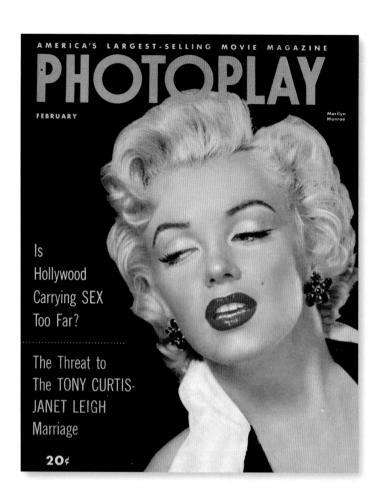

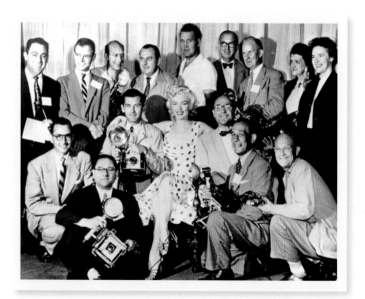

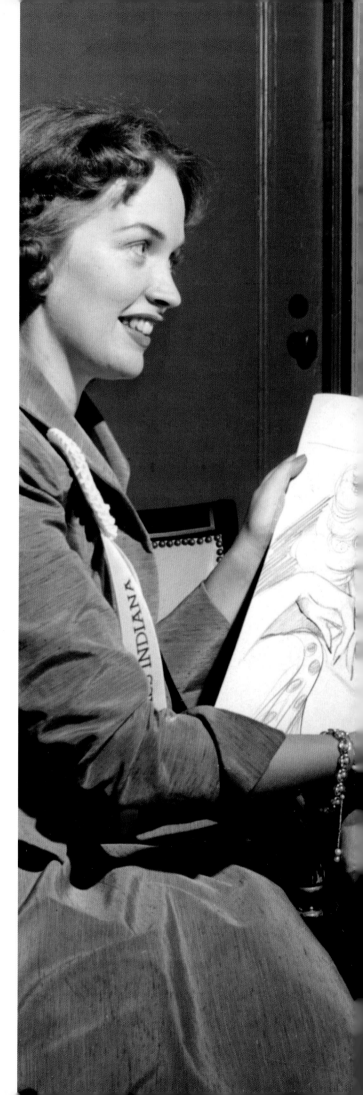

(Top) *Photoplay*, February 1952.
(Bottom) Marilyn with members of
the press, U.S. Armed Forces press
conference, Atlantic City, New Jersey,
September 2, 1952. (Right) With Miss
America contestant Ann Garnier of
Indiana at the U.S. Armed Forces event.

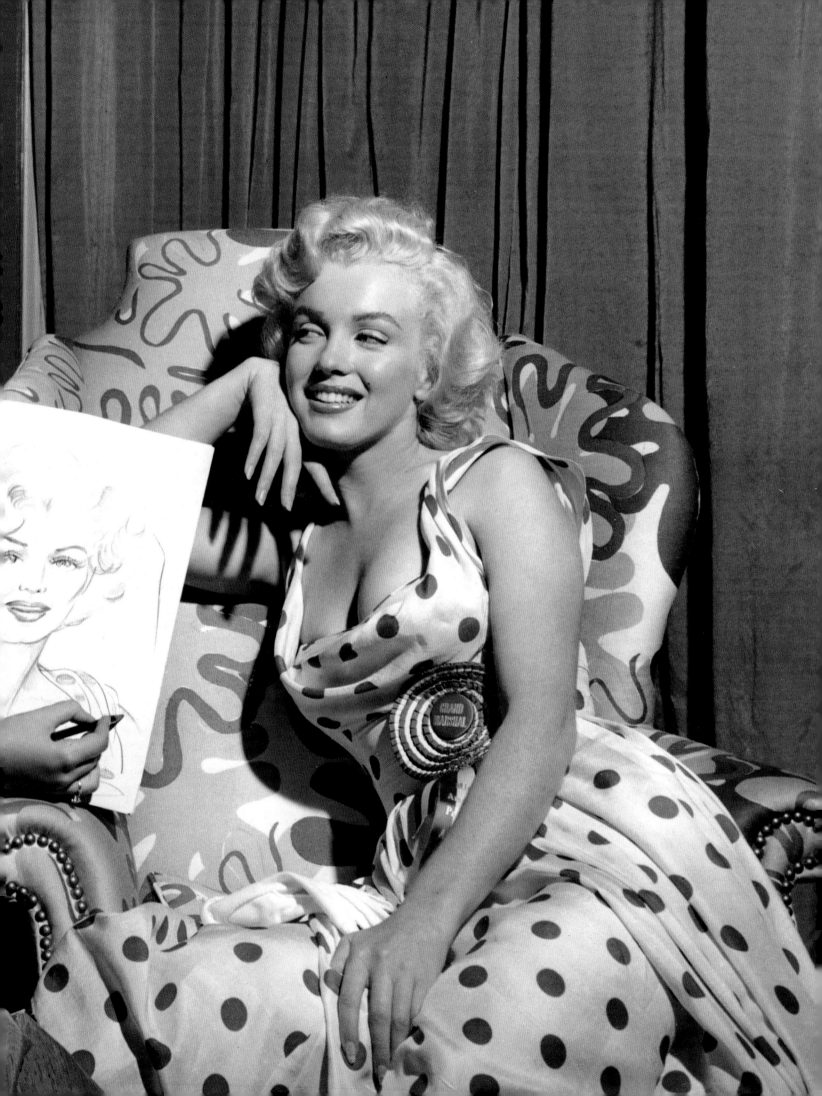

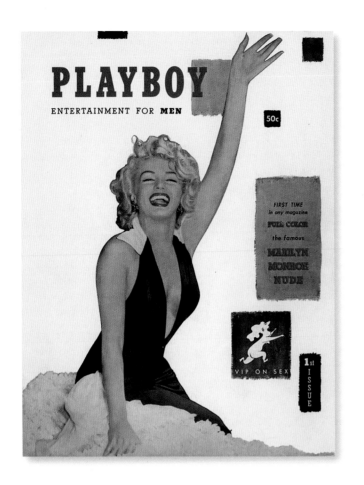

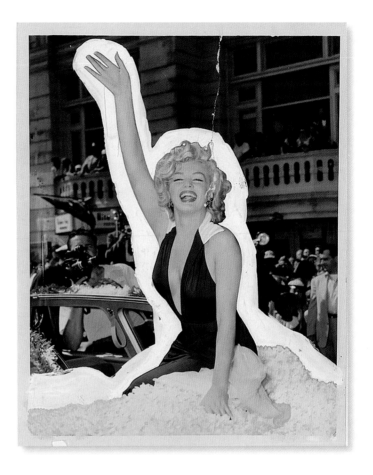

"I had no idea she would become a big star. She seemed very shy and quiet. There was something sad about her. It's difficult for a girl to get used to being chased around all the time by the press. They never really leave you alone."

CARY GRANT (Costar, *Monkey Business*)

(Above left) *Playboy*, December 1953. (Above right) Original UPI photograph of Marilyn taken in Atlantic City, New Jersey, September 12, 1952, featuring hand-rendered clipping path used for the cover design of *Playboy*'s premier issue. (Opposite) ORIGINAL CAPTION: "September 12, 1952, Atlantic City, New Jersey. Marilyn Monroe, currently Hollywood's most explosive blonde, led the classic 'Miss America' pageant down the Boardwalk at Atlantic City this year. Marilyn was not, of course, a contestant, but she garnered the lion's share of the cheers."

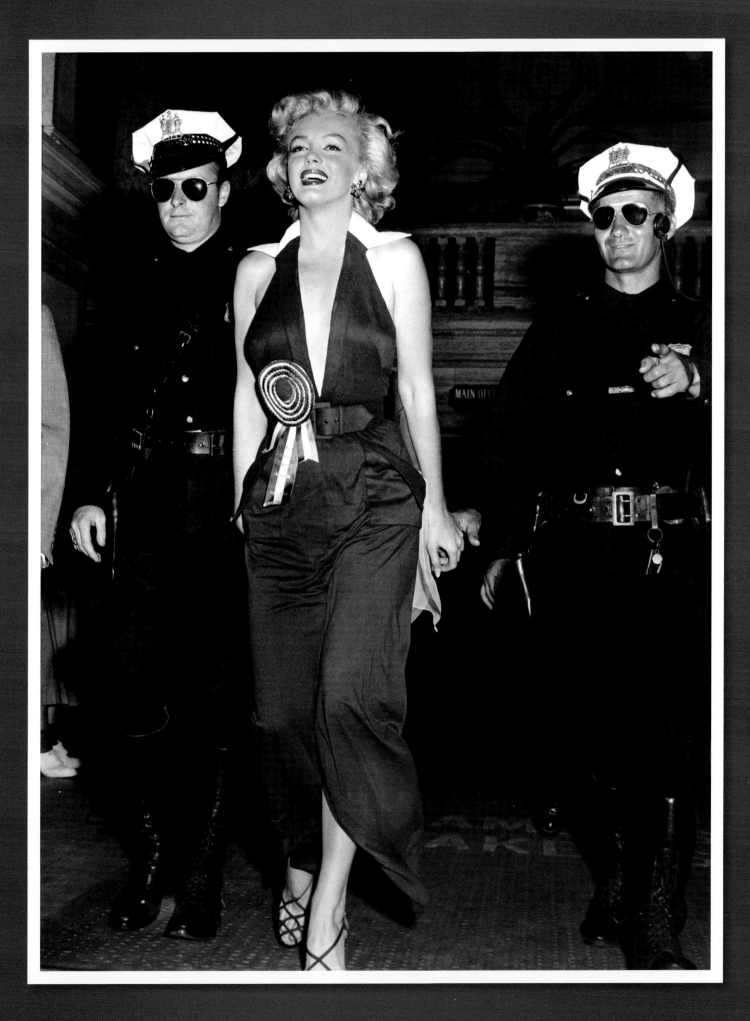

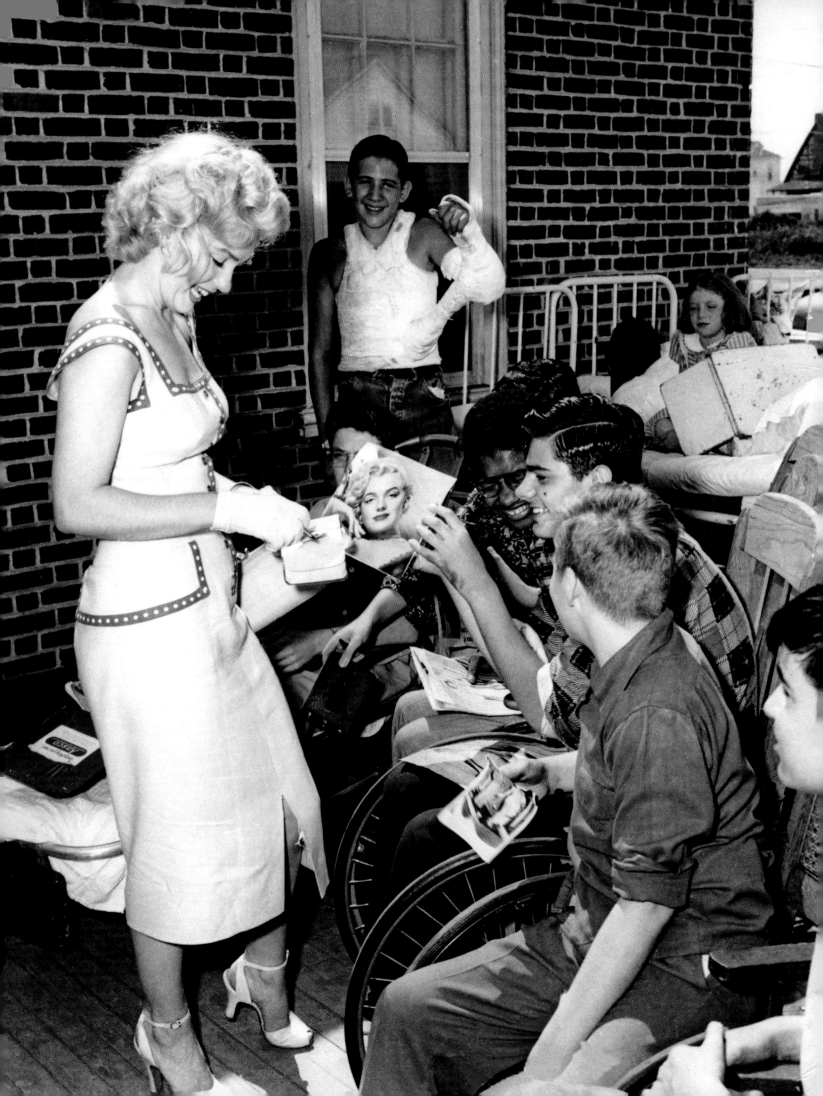

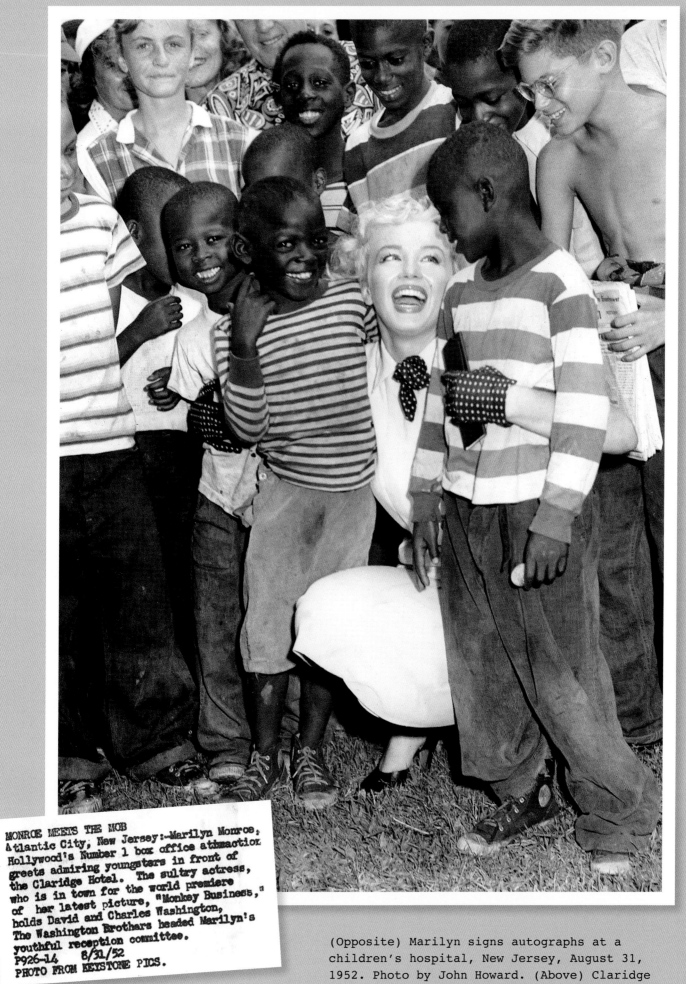

(Opposite) Marilyn signs autographs at a
children's hospital, New Jersey, August 31,
1952. Photo by John Howard. (Above) Claridge
Hotel, Atlantic City, September 1952.

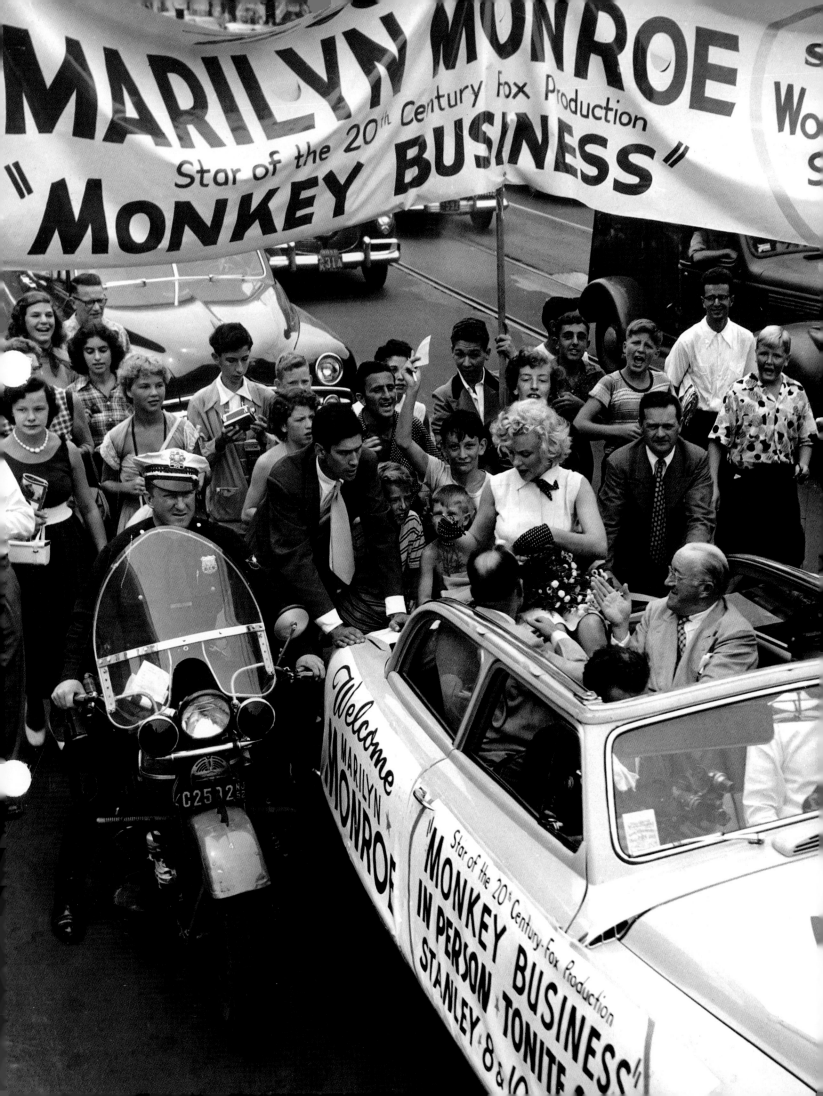

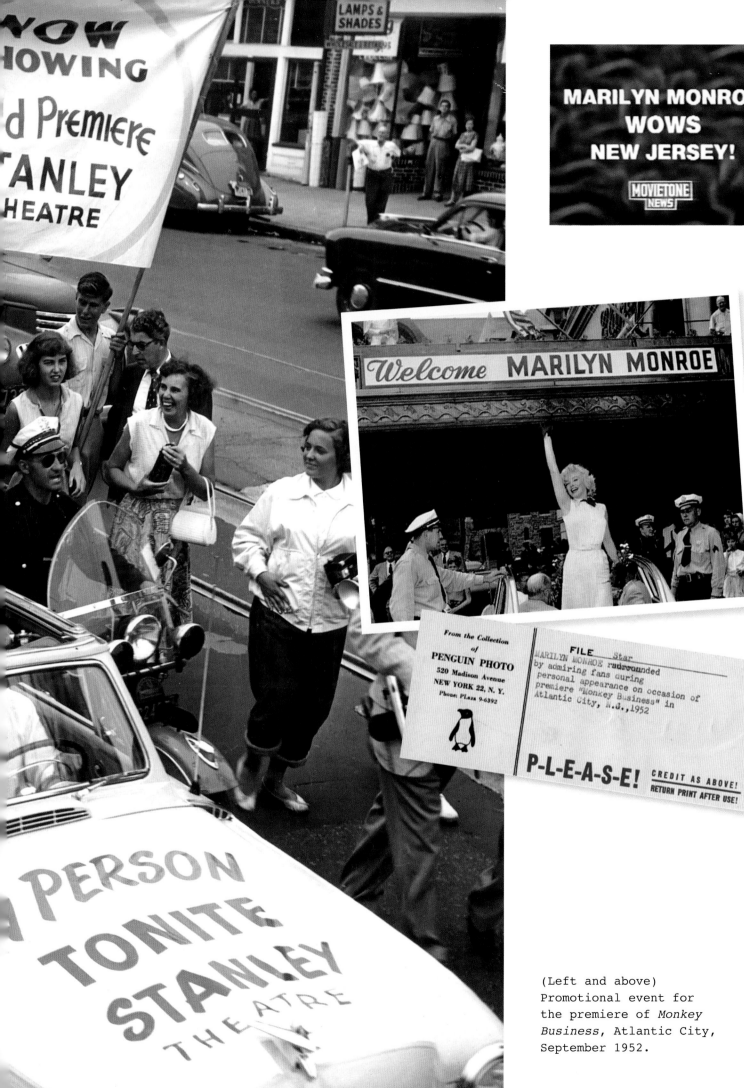

MARILYN MONROE
WOWS
NEW JERSEY!

MOVIETONE NEWS

Welcome MARILYN MONROE

From the Collection
of
PENGUIN PHOTO
520 Madison Avenue
NEW YORK 22, N. Y.
Phone: PLaza 9-6392

FILE Star
MARILYN MONROE surrounded
by admiring fans during
personal appearance on occasion of
premiere "Monkey Business" in
Atlantic City, N.J.,1952

P-L-E-A-S-E! CREDIT AS ABOVE!
RETURN PRINT AFTER USE!

(Left and above)
Promotional event for
the premiere of *Monkey
Business*, Atlantic City,
September 1952.

63

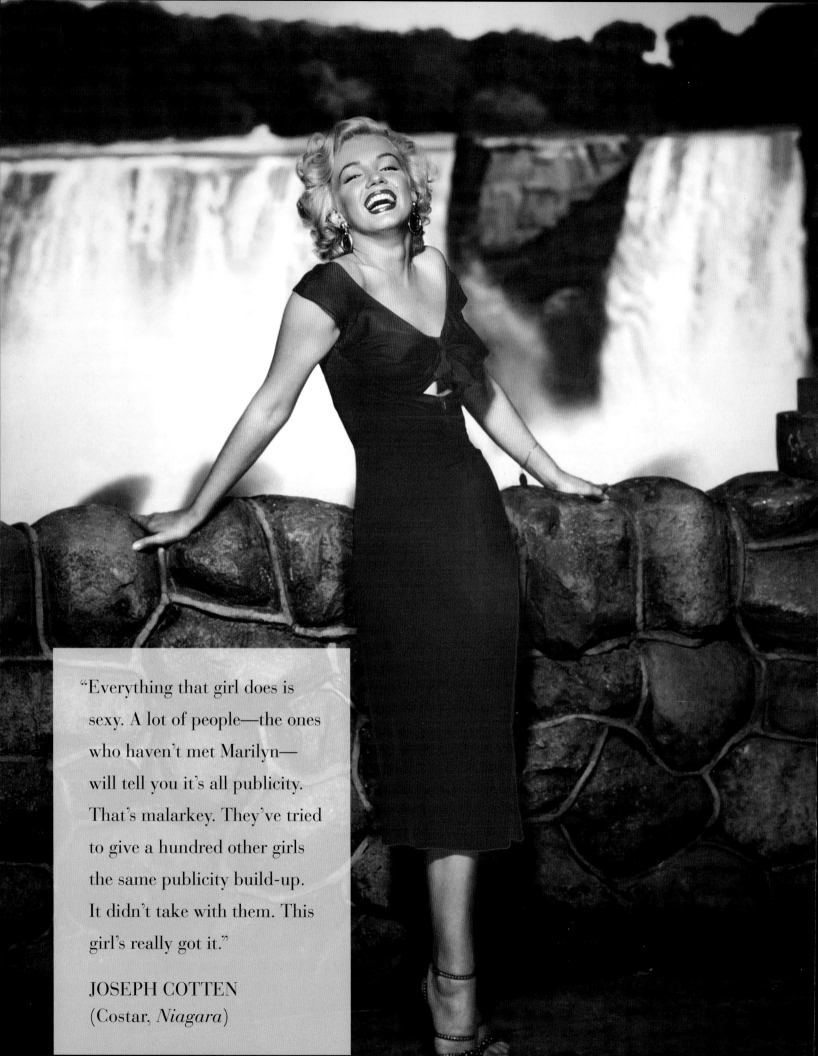

"Everything that girl does is sexy. A lot of people—the ones who haven't met Marilyn—will tell you it's all publicity. That's malarkey. They've tried to give a hundred other girls the same publicity build-up. It didn't take with them. This girl's really got it."

JOSEPH COTTEN
(Costar, *Niagara*)

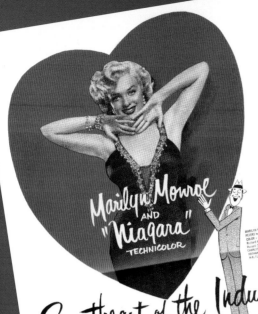

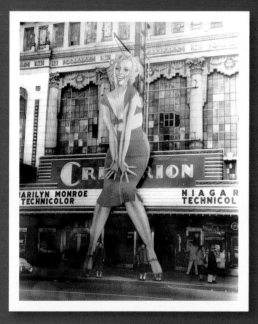

(Opposite) Marilyn as Rose Loomis, *Niagara*, 1953. Photo by Bernard of Hollywood. (Clockwise from top) *Niagara* trade advertisement; one sheet poster; Criterion Theater marquee, Oklahoma City.

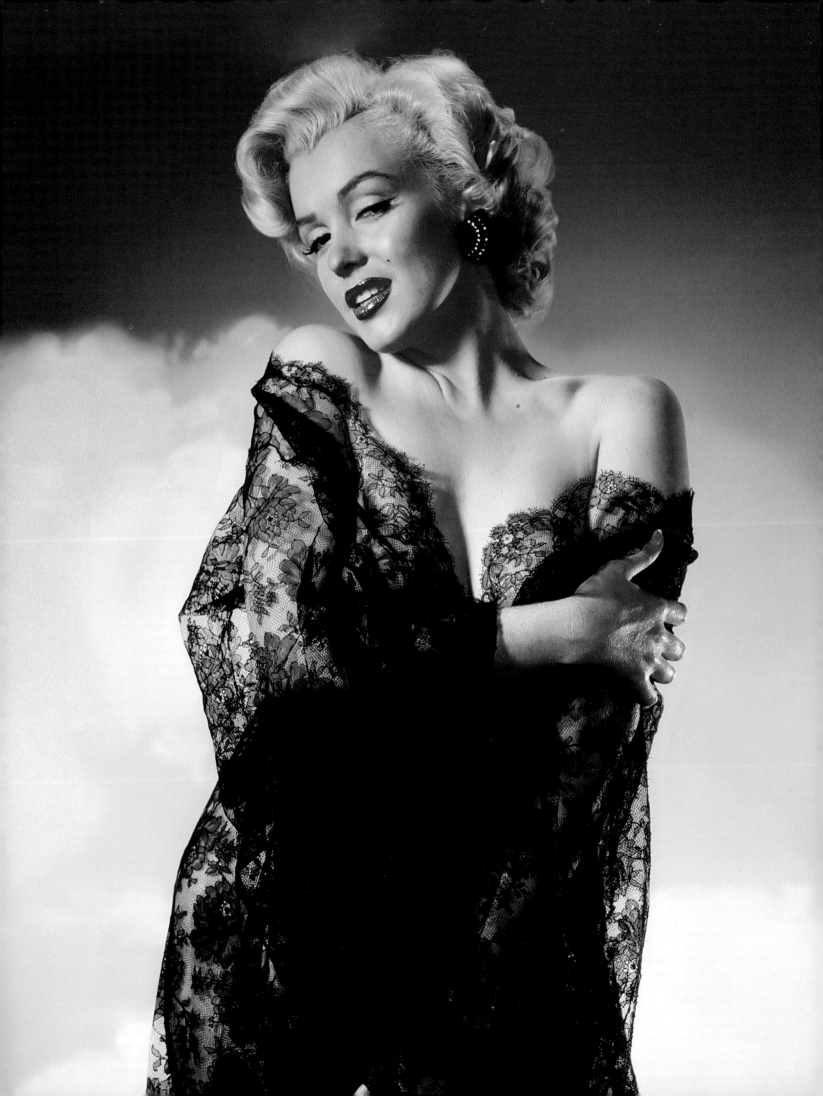

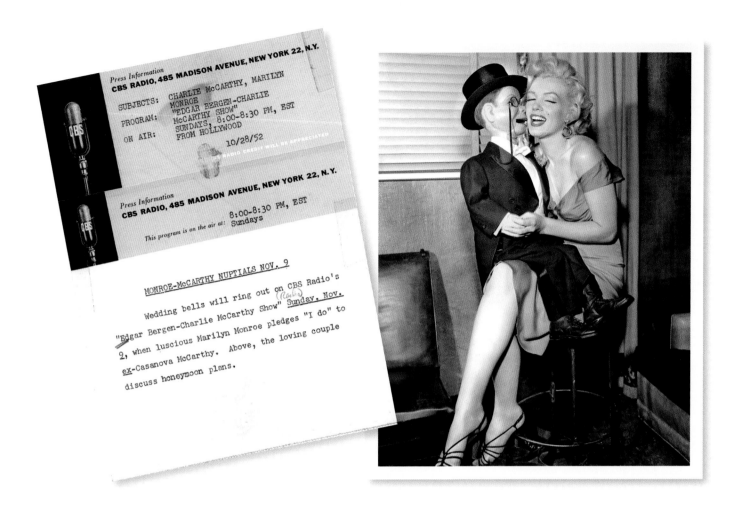

MONROE-McCARTHY NUPTIALS NOV. 9

Wedding bells will ring out on CBS Radio's "Edgar Bergen-Charlie McCarthy Show" Sunday, Nov. 9, when luscious Marilyn Monroe pledges "I do" to ex-Casanova McCarthy. Above, the loving couple discuss honeymoon plans.

MARILYN MONROE calendar racket

BY DON DWIGGINS

(Opposite) Photo by Ernest Bachrach, 1952. (Clockwise from top) The *Edgar Bergen—Charlie McCarthy Show*, October 28, 1952; nude calendar scandal article, c. 1952; Marilyn on the set of *Niagara* with a copy of the *Los Angeles Examiner* featuring a front-page story of her recent appearance in court to testify against two men accused of using her name and doctored image to sell and distribute nude photographs by mail, July 1952.

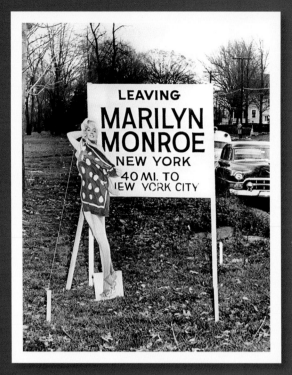

(Top left) At a party, c. 1953. (Top right)
Monroe, New York, 1953. (Bottom) With Ronald
Reagan at Charles Coburn's birthday party,
Beverly Hills Hotel, June 17, 1953, photo by
Bernard of Hollywood. (Opposite) With Jack
Benny, *The Jack Benny Show*, September 13, 1954.

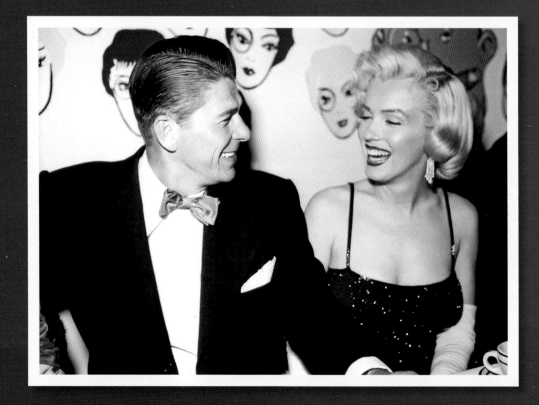

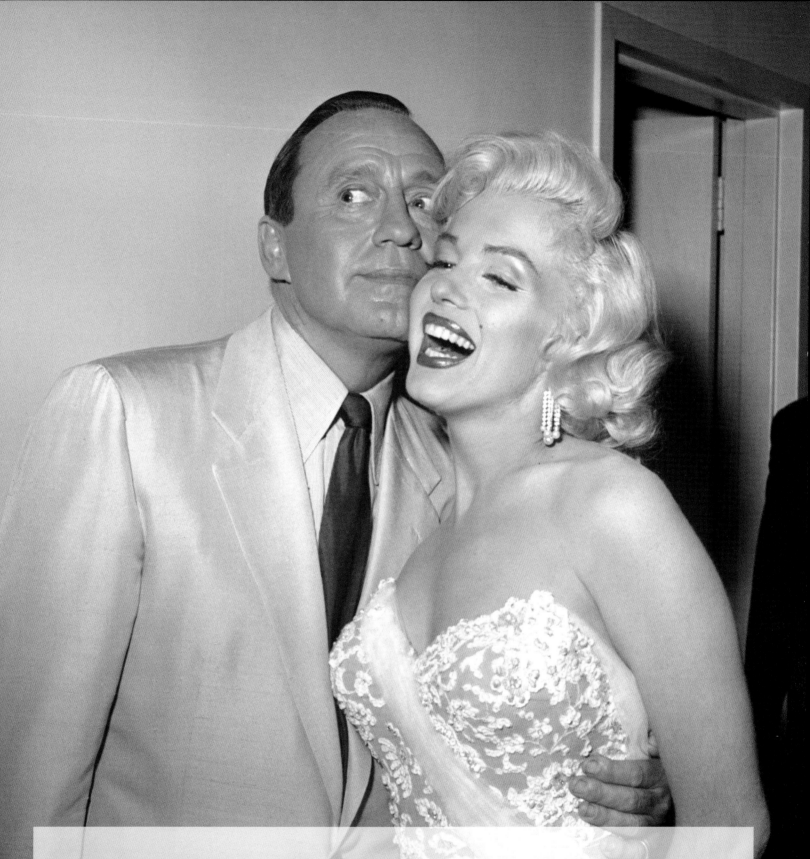

"Let's face it, girls, here is the champ! She's here to stay for a long time. From the moment she ran into our camera until she slithered off with a long last glance . . . this little girl was in charge."

FAYE EMERSON (The First Lady of Television, on Marilyn's appearance on *The Jack Benny Show*)

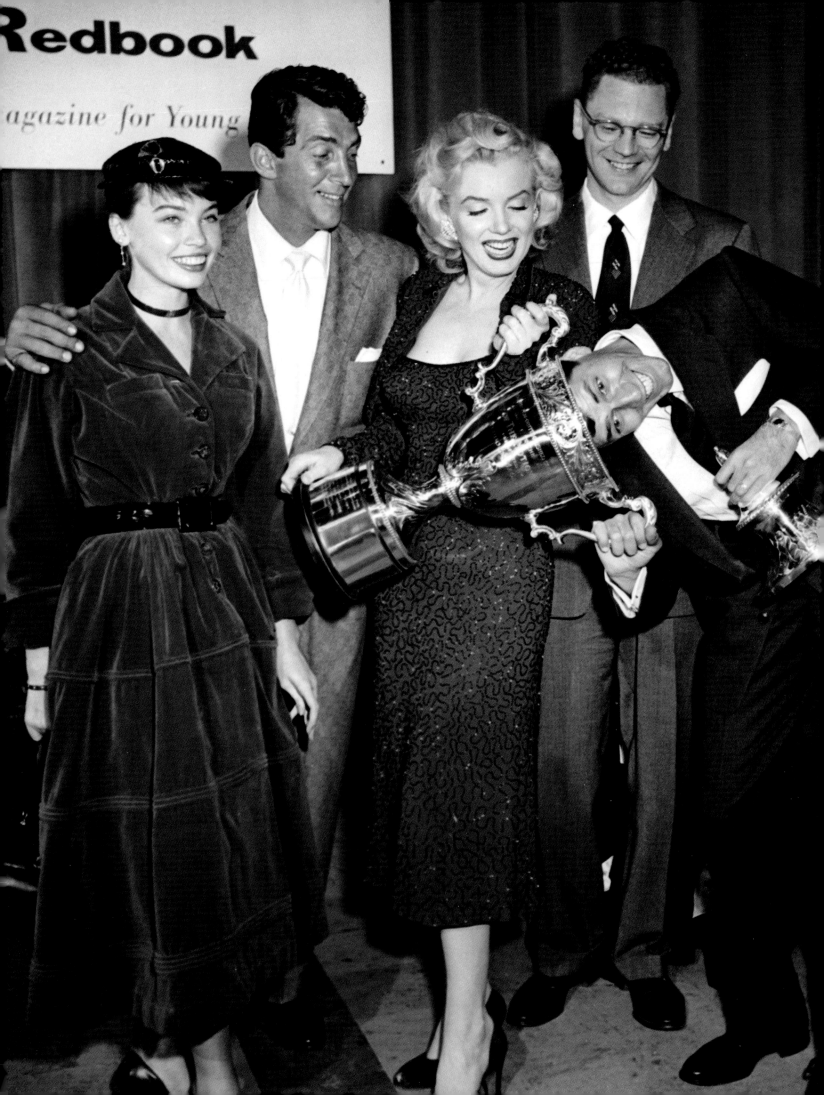

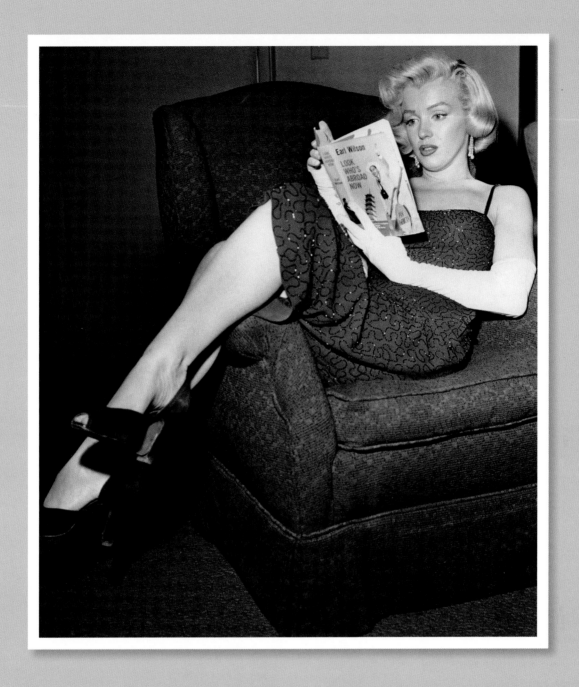

"She wasn't what she sold. You don't realize when you make these deals early in life—and she certainly did with publicity—that you have to live with them forever. And I don't think she was able to do it."

SHELLEY WINTERS

(Opposite) Marilyn receiving the Redbook Silver Cup Best Young Box Office Personality, with Leslie Caron, Dean Martin, Jerry Lewis, and *Redbook* editor Wade H. Nichols, February 24, 1953. (Above) Reading columnist Earl Wilson's book *Look Who's Abroad Now*, Beverly Hills Hotel, June 17, 1953. (Overleaf) Photo by Bert Reisfeld (Twentieth Century-Fox), 1953.

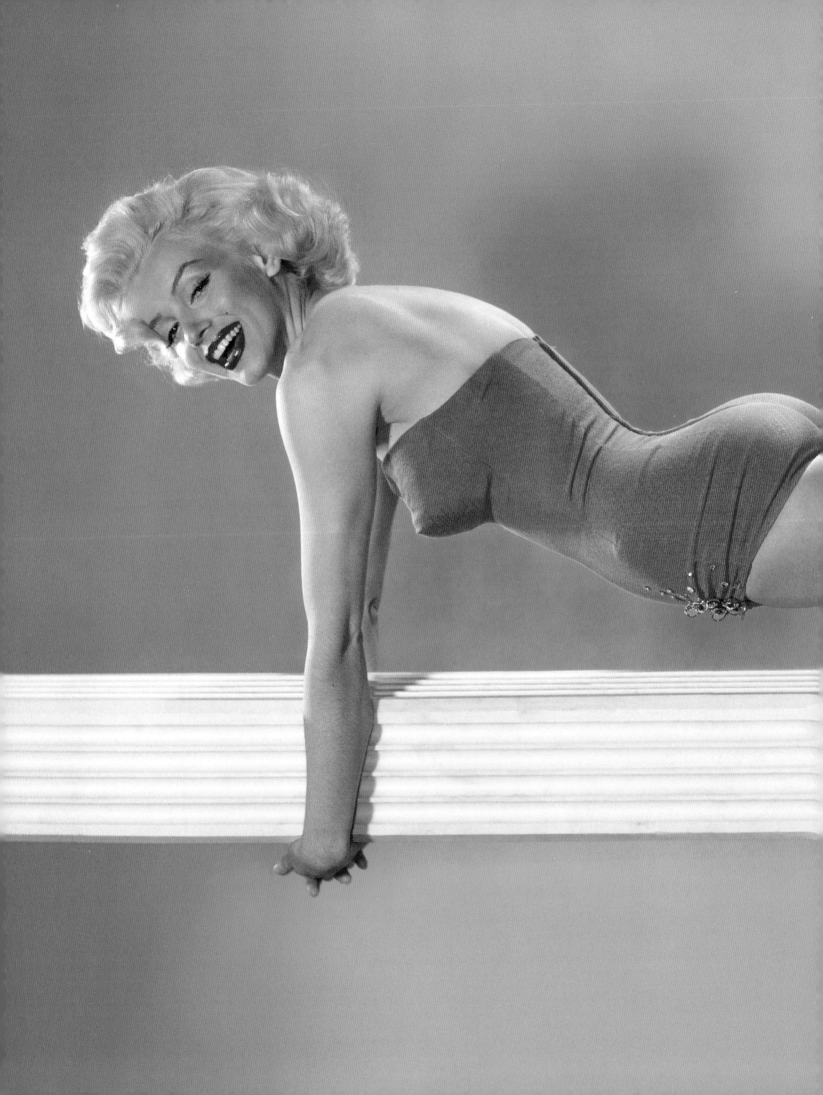

DEY ST.

ISBN 978-0-06-238970-1

$35.00 US / $43.50 CAN

Designed by Stephen Schmidt

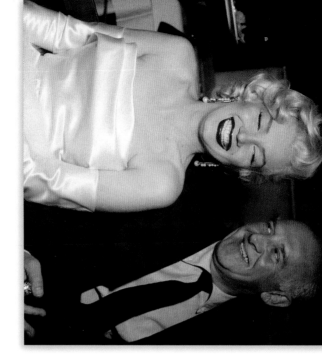

MARILYN IN THE FLASH

Her Love Affair with the Press 1945–1962

Marilyn Monroe had a unique relationship with the press—the photographers, journalists and columnists who followed her every move, helped carefully craft her public image, and made her one of the greatest stars in Hollywood history. Photographically, Marilyn was at her most electrifying at public events. She was as spectacular in the posed candids of press photographers as in studio portraits or on the movie screen. One of the most publicized actresses of her time, Marilyn actively sought out the press—which included the famous journalists and columnists Walter Winchell, Edward R. Murrow, Hedda Hopper, Louella Parsons, Earl Wilson, Pete Martin, Sidney Skolsky, Elsa Maxwell, and Dorothy Kilgallen. In *Marilyn: In The Flash*, acclaimed photographic preservationist David Wills brings together an unprecedented trove highlighting the work of some of the great press photographers and photojournalists of the twentieth century. This stunning collection includes many unpublished images, vintage magazine articles, and photographic ephemera, chronicling the media's lifelong love affair with Marilyn.

MarilynInTheFlash.com

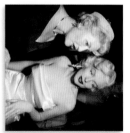

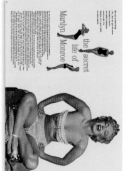

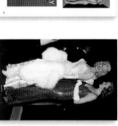

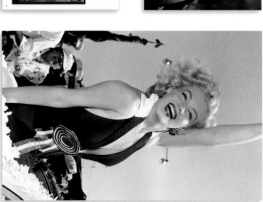

"Her measurements have been reported as 35" 24" 37", 37½" 25" 37½", and 37½" 23" 37½". Though the gentlemen who handle such matters for the magazines and newspapers of the nation seem to be working with a rich variety of statistics, their sum totals all come out the same."

PLAYBOY (December 1953)

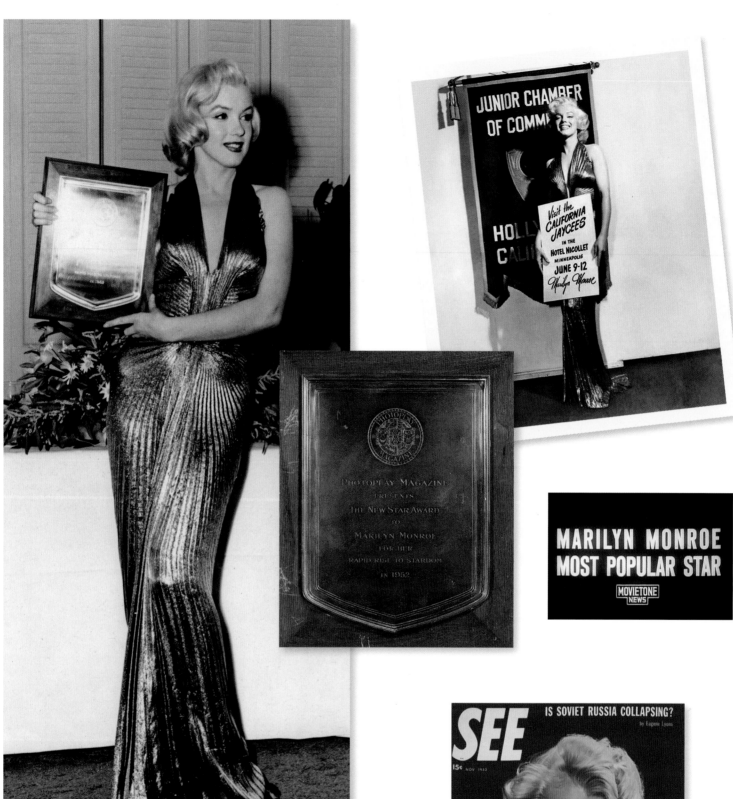

(Above left) Marilyn receiving *Photoplay*'s Rising
Star of 1952 Award, Beverly Hills Hotel, February
9, 1953. (Top right) Endorsement for the California
Jaycees, June 1953. (Bottom) *See*, November 1953.
(Opposite) 1953.

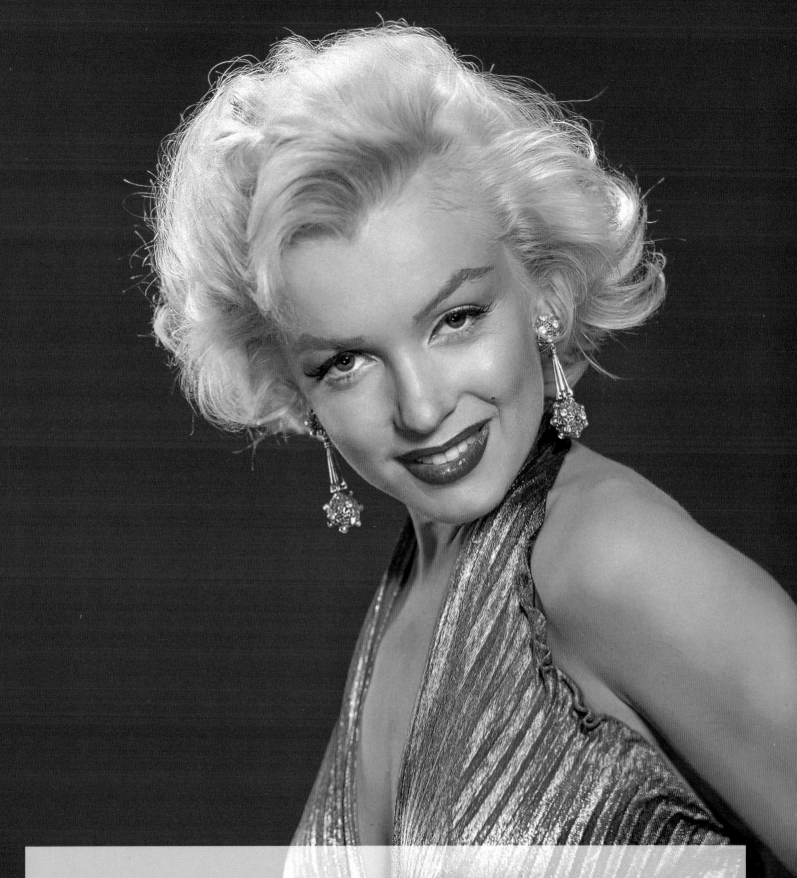

"With one little twist of her derriere, Marilyn Monroe stole the show.... Two other screen stars, Joan Crawford and Lana Turner, got only casual attention. After Marilyn, every other girl appeared dull by contrast."

FLORABEL MUIR (Columnist, on the *Photoplay* awards)

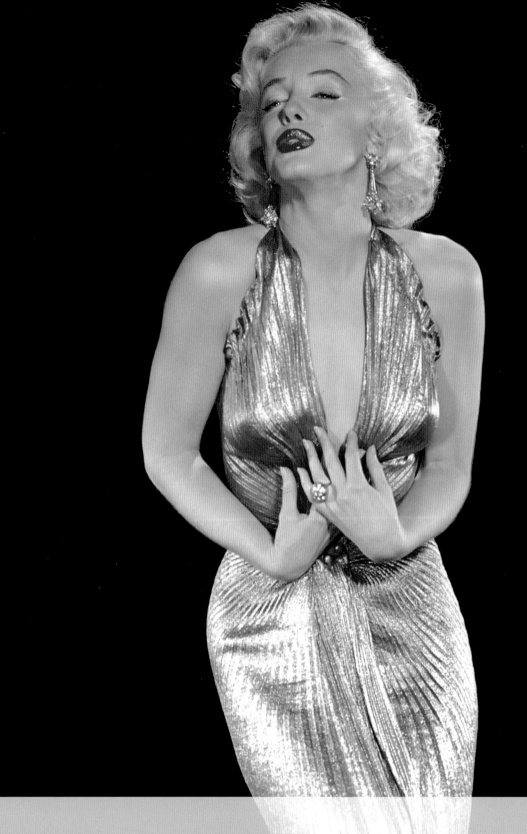

"Marilyn Monroe who has zoomed to stardom after a three-year stretch as a cheesecake queen is easily the most delectable dish of the day. . . . And every producer at Twentieth is bidding for her as box office insurance."

HEDDA HOPPER ("The Blowtorch Blonde," the *Chicago Sunday Tribune Magazine*, May 4, 1952)

(Opposite and above) *Gentlemen Prefer Blondes*, 1953.

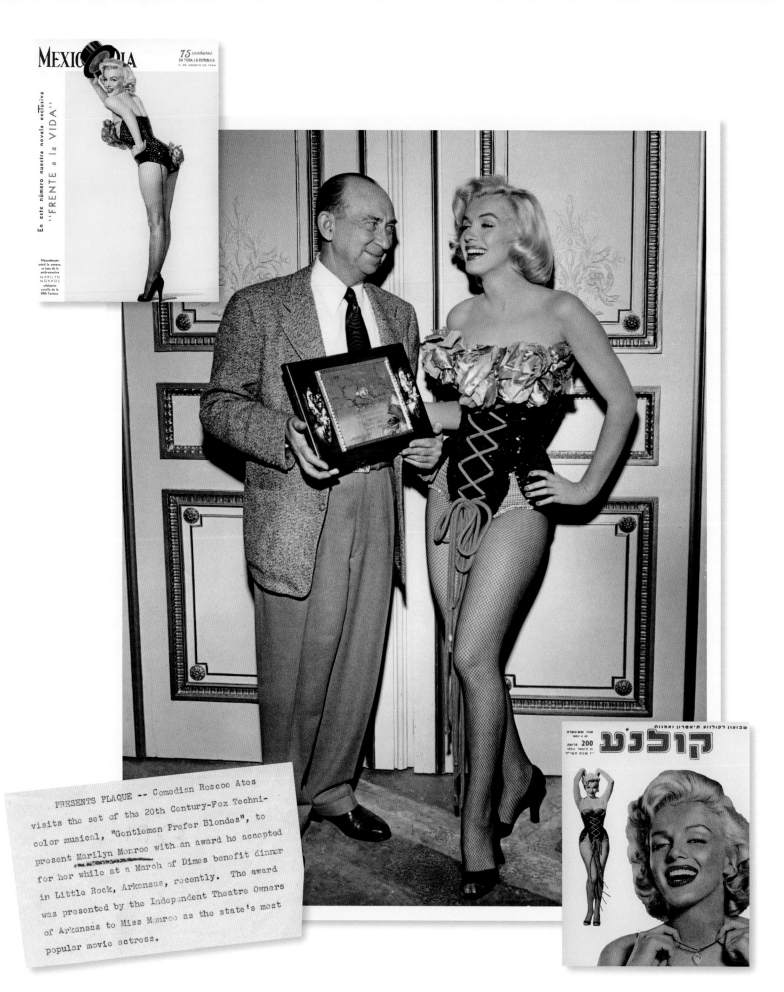

PRESENTS PLAQUE -- Comedian Roscoe Ates visits the set of the 20th Century-Fox Technicolor musical, "Gentlemen Prefer Blondes", to present Marilyn Monroe with an award he accepted for her while at a March of Dimes benefit dinner in Little Rock, Arkansas, recently. The award was presented by the Independent Theatre Owners of Arkansas to Miss Monroe as the state's most popular movie actress.

(Top) *México al Día*, August 1954. (Middle) Marilyn being presented with an award by comedian Roscoe Ates, on the set of *Gentlemen Prefer Blondes*, January 26, 1953. (Lower right) *Kolnoha* (Israel), c. 1953. (Opposite) Marilyn as Lorelei Lee, with costars Jane Russell and Charles Coburn, *Gentlemen Prefer Blondes*, 1953.

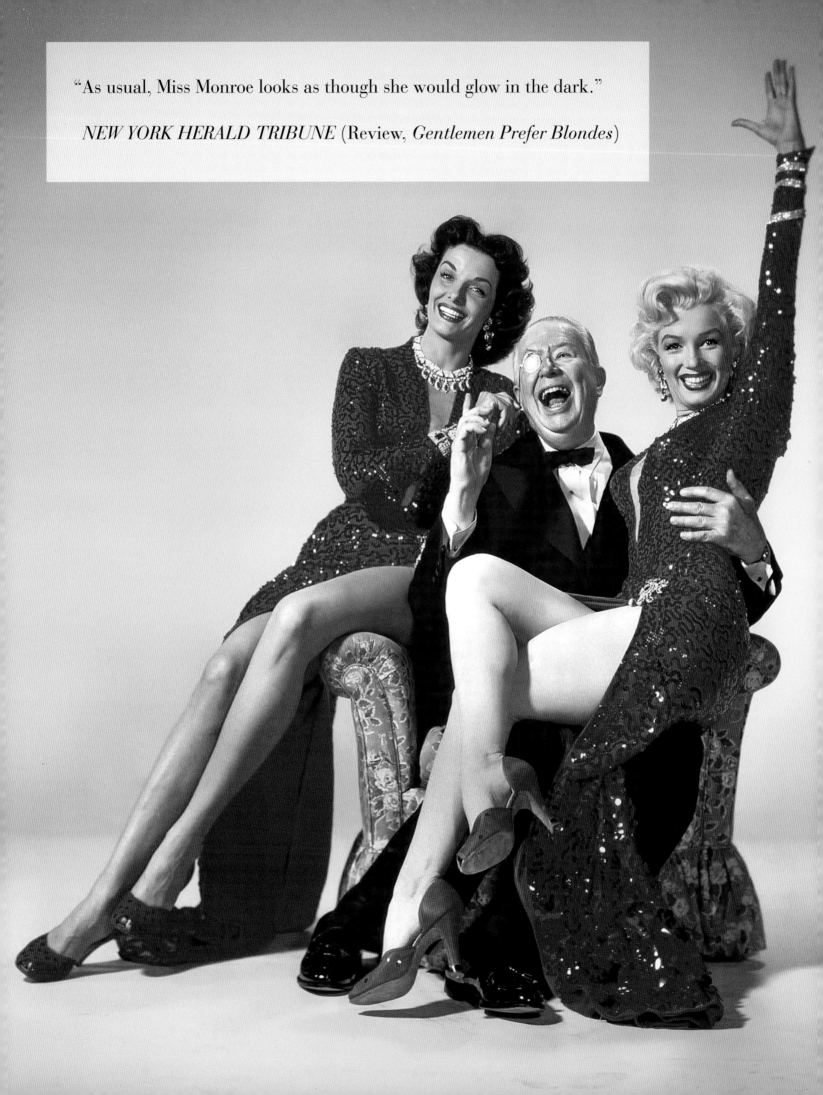

"As usual, Miss Monroe looks as though she would glow in the dark."

NEW YORK HERALD TRIBUNE (Review, *Gentlemen Prefer Blondes*)

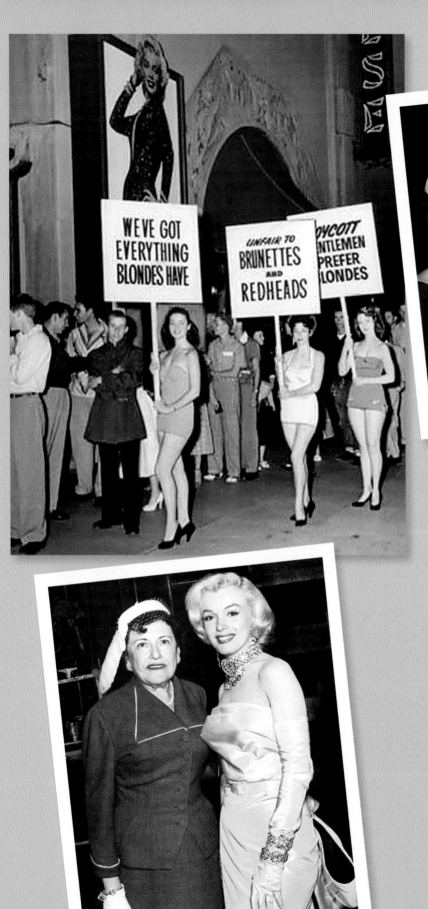

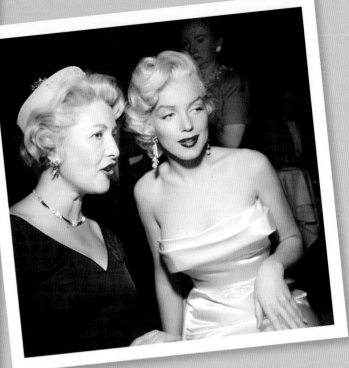

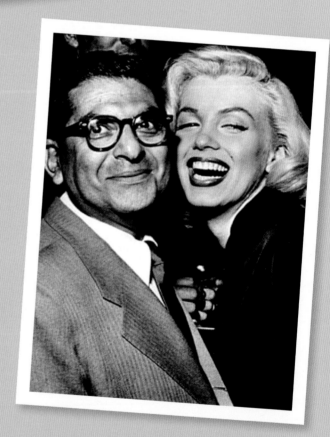

(Clockwise from top left) Promotional event for *Gentlemen Prefer Blondes*, Grauman's Chinese Theatre, 1953; with columnist Sheilah Graham, Ciro's, October 1953; with Sidney Skolsky at the wedding of Sheilah Graham, February 14, 1953; with columnist Louella Parsons, on the set of *Gentlemen Prefer Blondes*. (Opposite) Performing "Diamonds Are a Girl's Best Friend," *Gentlemen Prefer Blondes*, 1953.

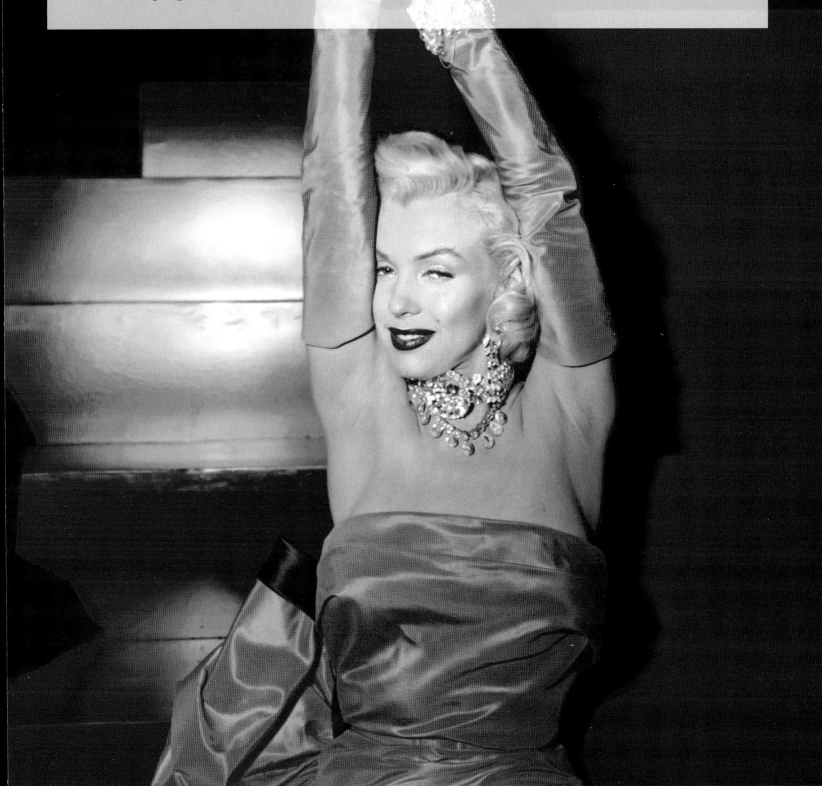

"Dear Dorothy: I am sending you herewith a little affidavit about Marilyn Monroe's singing as you asked me to tell the truth. The affidavit is my solemn oath, so you can be sure, I'm not kidding. Marilyn's voice was a surprise to me, and even more of a surprise to the MGM record company and the musicians and technicians who took part in the recording. Best personal regards, Sincerely, Darryl F. Zanuck."

(Response to Dorothy Kilgallen, who questioned the assertion that MM did her own singing in *Gentlemen Prefer Blondes*, released July 1953.)

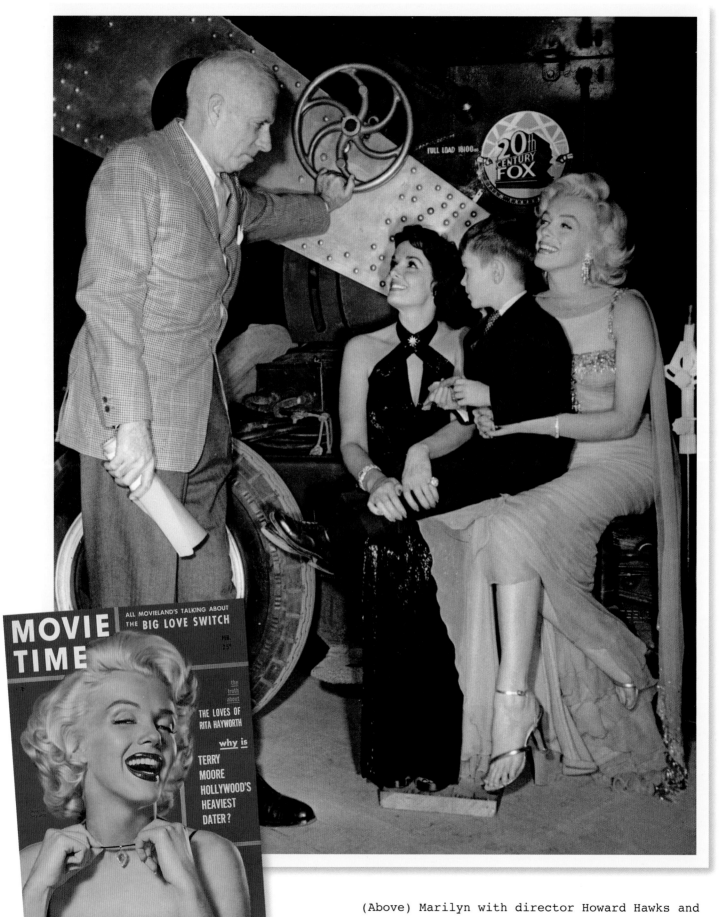

(Above) Marilyn with director Howard Hawks and costars Jane Russell and George Winslow, on the set of *Gentlemen Prefer Blondes*, 1953. (Left) *Movie Time*, February 1954. (Opposite) Outside her dressing room, *Gentlemen Prefer Blondes*.

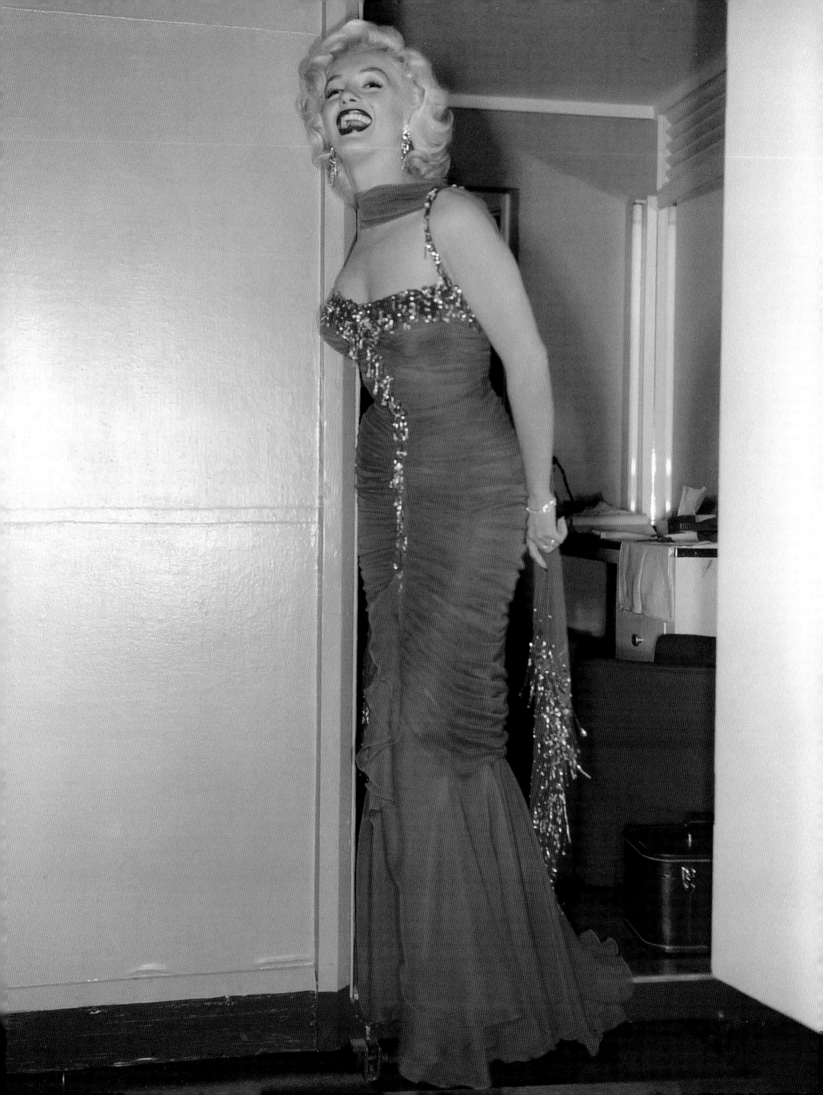

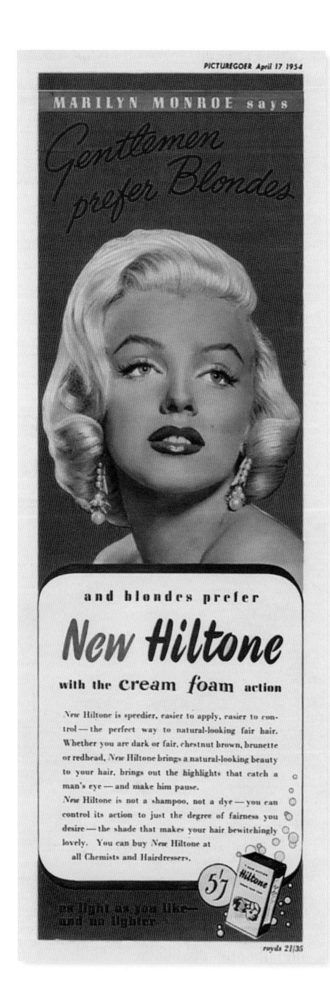

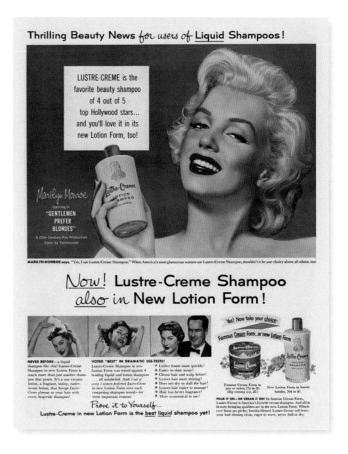

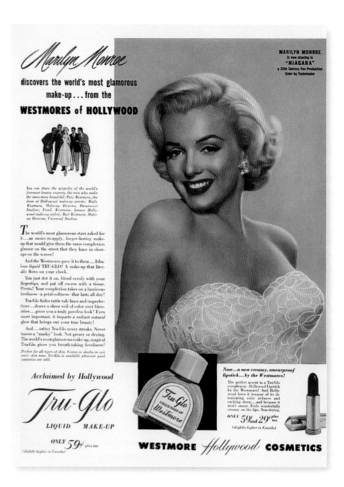

(Left) Hiltone advertisement, 1954. (Top right) Lustre-Creme shampoo advertisement, 1954. (Bottom right) Westmore Hollywood Cosmetics advertisement, 1953.

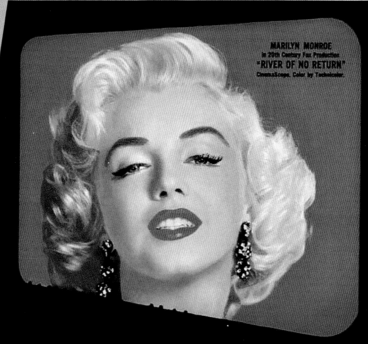

WESTMORE brings you...

"CLOSE-UP PERFECT" complexion beauty

Proved in giant-screen close-ups by movie stars...

WESTMORE
Tru-Glo
liquid make-up
59¢

Wonderful Tru-Glo all-day make-up shows how smoothly alluring your complexion can be! PROVED by movie stars in giant-screen close-ups where make-up must be perfect to keep skin looking perfectly smooth, lines and imperfections invisible.

Because others see you in close-up always, you need Tru-Glo to look your loveliest. Made for you and movie stars

by the Westmore brothers, world's most famous make-up artists, originators of liquid make-up.

SEE the thrilling difference on your skin: Simply dot on creamy Tru-Glo, blend in evenly, pat off with tissue. Now you have "close-up perfect" complexion beauty, possible only with Tru-Glo! For all types of skin—in a perfect-for-YOU shade. Get Westmore Tru-Glo now!

WESTMORE
Party Puff
creamy powder make-up

FOR INSTANT BEAUTY, carry Party Puff as movie stars do on the set, at play and evenings. Powder and base all-in-one, in gorgeous mirror compact with puff. Choose the perfect-for-YOU shade.

$1

WESTMORE
Kiss-Tested lipstick

PROVED BEST in movie close-ups where lipstick MUST NOT SMEAR, even after kissing, eating, working under hot lights. Non-drying! Perfect-for-YOU shades.

59¢ and 29¢

At all variety and drug stores.
*Prices plus tax. Slightly higher in Canada
House of Westmore, Inc., New York 11 • Hollywood

(Top) Twentieth Century-Fox advertising release.
(Bottom) Westmore Hollywood Cosmetics advertisement, 1954.

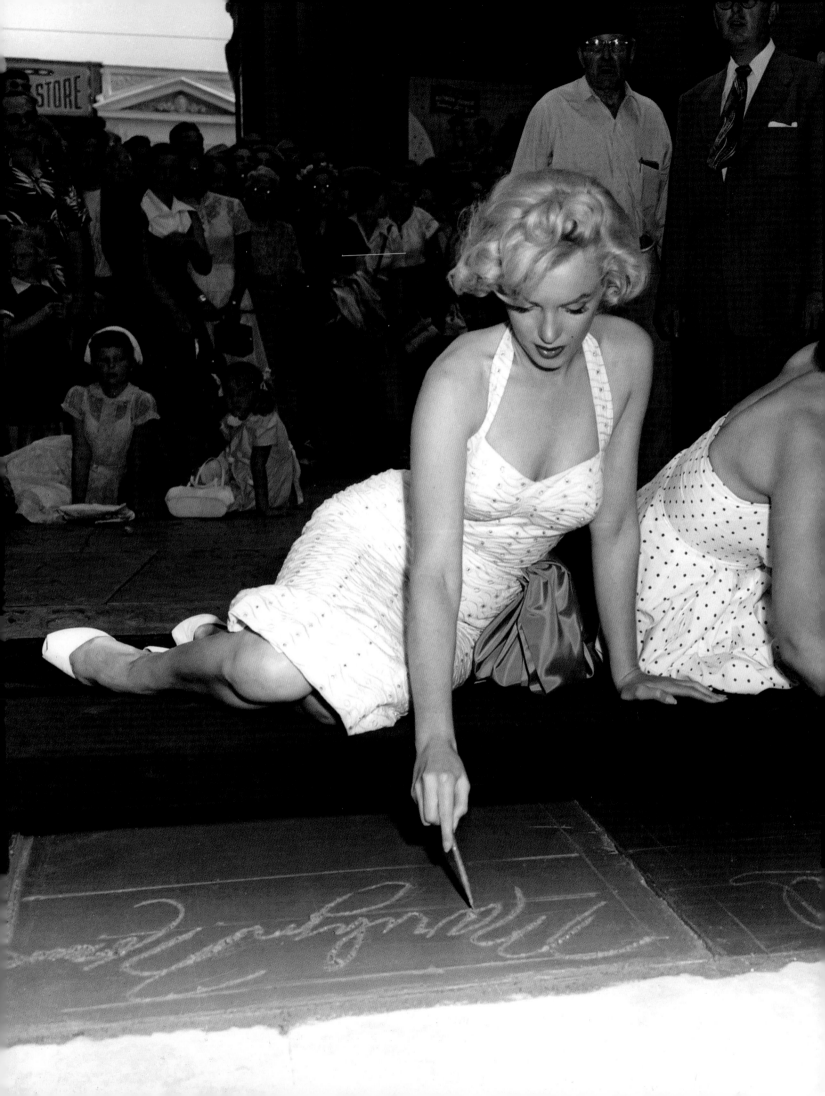

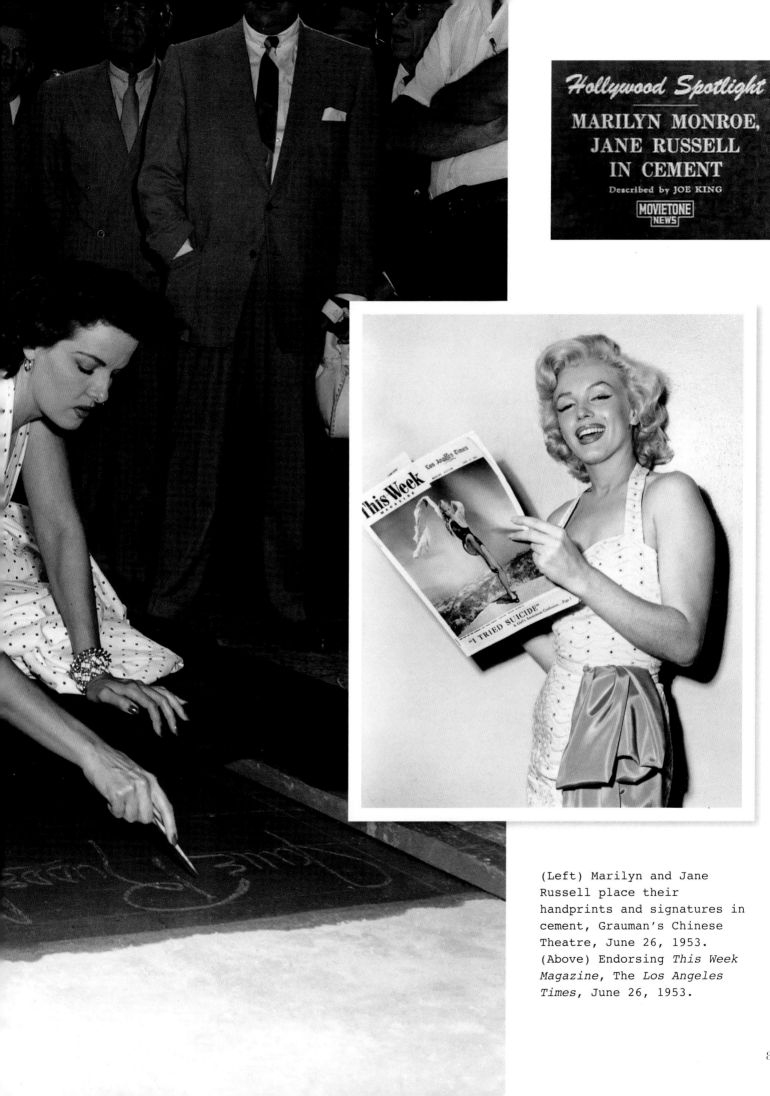

This Week
Cos Angeles Times

"I TRIED SUICIDE"
A Girl's Anonymous Confession... Page 7

(Left) Marilyn and Jane
Russell place their
handprints and signatures in
cement, Grauman's Chinese
Theatre, June 26, 1953.
(Above) Endorsing *This Week
Magazine*, The *Los Angeles
Times*, June 26, 1953.

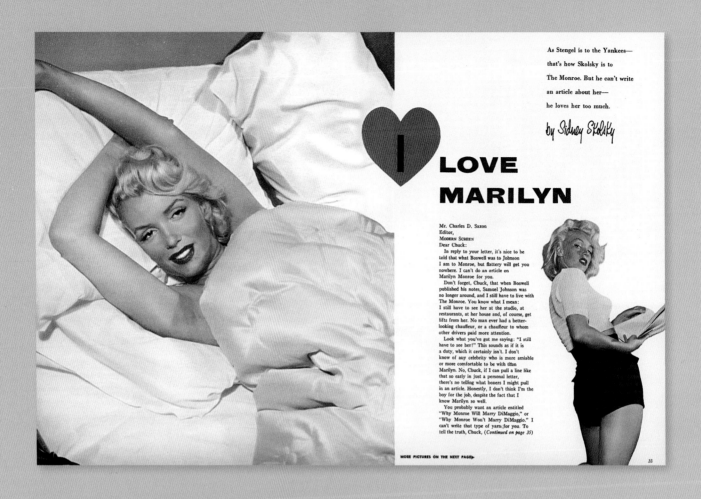

As Stengel is to the Yankees—
that's how Skolsky is to
The Monroe. But he can't write
an article about her—
he loves her too much.

by Sidney Skolsky

♥ I LOVE MARILYN

Mr. Charles D. Saxon
Editor,
MODERN SCREEN
Dear Chuck:

In reply to your letter, it's nice to be told that what Boswell was to Johnson I am to Monroe, but flattery will get you nowhere. I can't do an article on Marilyn Monroe for you.

Don't forget, Chuck, that when Boswell published his notes, Samuel Johnson was no longer around, and I still have to live with The Monroe. You know what I mean: I still have to see her at the studio, at restaurants, at her house and, of course, get lifts from her. No man ever had a better-looking chauffeur, or a chauffeur to whom other drivers paid more attention.

Look what you've got me saying: "I still have to see her!" This sounds as if it is a duty, which it certainly isn't. I don't know of any celebrity who is more amiable or more comfortable to be with than Marilyn. No, Chuck, if I can pull a line like that so early in just a personal letter, there's no telling what boners I might pull in an article. Honestly, I don't think I'm the boy for the job, despite the fact that I know Marilyn so well.

You probably want an article entitled "Why Monroe Will Marry DiMaggio," or "Why Monroe Won't Marry DiMaggio." I can't write that type of yarn for you. To tell the truth, Chuck, (Continued on page 35)

MORE PICTURES ON THE NEXT PAGE▶

33

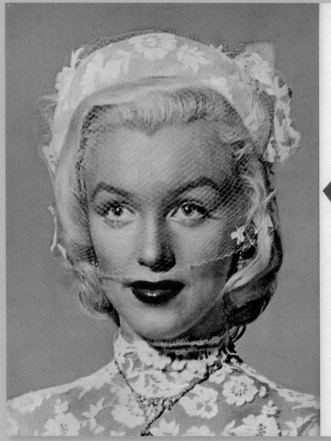

Marilyn Monroe...
lovable fake

If you saw the newsreel of the last big Hollywood premiere, you saw Marilyn Monroe make the coolest, fanciest entrance into a theater lobby since Pola Negri made the same walk ages ago leading a snarling leopard on a leash. Marilyn got out of a fancy studio limousine, dripping white mink, in a dress she had to be sewn into, and with that famous wet-lipped smile pranced a hundred feet past screaming fans and frantic photographers to the waiting arm of a studio publicist. Then, taking that arm, she tossed a last smile of genuine delight over her shoulder at her public and stepped into the theater.

That's what you saw in the newsreel. A movie star, confident as all get-out, serene and elegant as a queen, taking her bows on the way to see a movie. But the newsreel cameramen should have been beyond the door that Marilyn entered.

Inside, in the darkened foyer, Marilyn seemed to sag. She clutched tightly to the arm of the press agent and leaned against the wall.

"I've got to get out of here," she said.

She was pale and her forehead was moist and she trembled a little. The publicity man led her down the side aisle of the theater to an exit, opened it slowly and they slipped out into the cool night air. Marilyn took several deep breaths while the agent waited for her to compose herself. He was used to this. Then they walked to a side street and he opened the door of Marilyn's small car. She threw the fur in the back seat, whispered a thank you, and drove off to be swallowed up in the heavy traffic. The man looked after her sadly, then shook his head and went back to the movie.

Marilyn Monroe wasn't nervous that night. She wasn't scared. She was *terrified*. She had done this same thing, in one fashion or another in most of the big cities of the country—and she was terrified every time she had to go through it. Although she is the most photographed girl in the world, the most sought-after celebrity in Hollywood, every time Marilyn Monroe has to make an appearance in public she suffers torture. The smooth walk is something she learned to do, the warm greetings she gives are the result of hours of coaching, and the bright smile of enjoyment is a fake. Marilyn Monroe hates all of it.

Early this spring a national magazine had a party at one of the swank Hollywood hotels. The occasion was the acknowledgement of the performances of stars during the preceding year and the awards had been made a few days previously on a radio program. [*Please turn to page 67*]

So you think
you know all
about this girl?
Well, you never
really knew her
as you will
after you've read
this truly
heartwarming story

BY JIM HENAGHAN

(Top) *Modern Screen*, October 1953. (Bottom) *Motion Picture*, November 1953.

I think the more completely
natural your beauty
appears to a man, the more
he responds to it

MY BEAUTY SECRETS

BY MARILYN MONROE

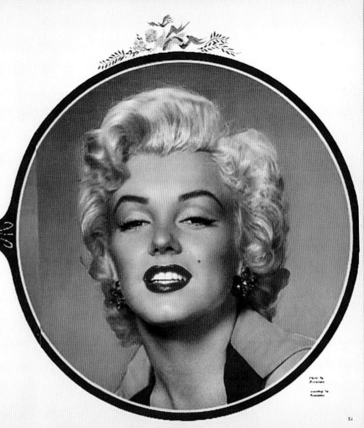

● It's a rare night when I don't get nine hours sleep, and more often ten, and I usually get a nap in during the day, too. It's a real crazy work when I don't wash my hair at least five times, and when I'm working, I shampoo it daily.

I once in a while drink a glass of wine, but I never have anything stronger, and I never have more than one glass an evening. Spring, summer, autumn, winter, I sunbathe in the privacy of my garden—with as little on as possible.

For my breakfast I have two raw eggs beaten up in a glass of hot milk. That's all. For lunch I have a green salad, sometimes with a little chicken shredded in it, or tongue, and a light French dressing. For dinner I have a small, rare steak or a couple of small, rare lamb chops and one green vegetable. I never eat desserts.

I get letters asking me how I keep my skin so clear, and I'm sure many of the girls who write me expect I'll come up with some name of a miracle cream or lotion. Well, let me tell you that while cream and lotion can keep your complexion soft

and smooth, they can't hide the dullness that over-eating and over-drinking, particularly of alcoholic drinks, will give your skin. And there's nothing like your face scrubbed clean with good soap and water, the glow you can only get from plenty of rest, an easy-to-digest diet, and cleanliness, cleanliness about your face, figure, hair and clothes. I honestly know what I'm talking about.

When a man looks into your eyes, he doesn't like looking into an over-heavy mess of mascara and eyeshadow. On screen, I do have to make up my eyes considerably, but offscreen I use eye make-up so that it looks completely natural. Following the same principle, I use natural-colored fingernail polish, but I do use bright red toenail polish. And I use toilet water, lavishly.

Subtlety, that's what. Men like sweet scents, I believe, but they don't like to be so overwhelmed by a perfume that instead of thinking of you, they are thinking "What's that she's wearing?" Personally, I like to seek out a fragrance that isn't too popular but which is *(Continued on page 76)*

(Continued on page 76)

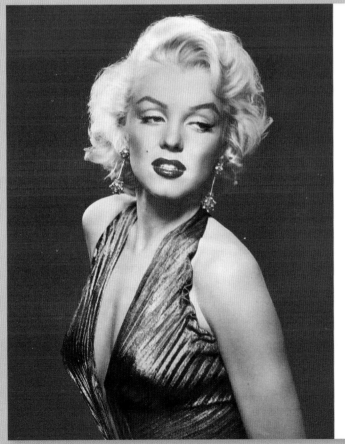

Sexy stars like Marilyn, few but fabulous, were unquestionably the most flamboyantly fascinating women in all Hollywood history. Yet fame and misfortune proved their common lot!

By Dorothy Gulman

will Marilyn escape the SEX HEX?

"**P**oor Marilyn Monroe—I wouldn't swap futures with her for a million dollars!"

Suppose you heard another actress make that remark? Would you call it Sour Grapes and say she was lying? In that case, you could be doing the lady a rank injustice. If she knows her Hollywood history and happens to take it seriously, honesty, rather than envy, prompted her words. A superstition is not to be laughed at or lightly dismissed when overwhelming statistics support it. According to Hollywood's strongest superstition of this sort, Marilyn Monroe has inherited a tradition of trouble and tragedy.

Even those who neither approve nor understand agree Marilyn is the hottest property in pictures today, following "Gentlemen Prefer Blondes." She outdraws estab-

lished favorites at the box-office and overshadows them in the press. Both as topic and target, she is the most talked-about personality in Hollywood. Not in spite of but actually because of her very present popularity, old settlers in the film colony pity the poor girl. They regard her future with positive pessimism. They dig deep into their memories and come up with a vast store of eerie evidence to explain why. . . .

Hollywood is practically packed with beautiful women, but the Marilyn Monroes are something else again. Girls with that indefinable extra ingredient are hard to find. In almost 50 years of film-making, there have been only a handful of other stars who have had what Marilyn's got. So far, everything is happening to her exactly as it happened to them; the same fast *(CONTINUED ON PAGE 62)*

(CONTINUED ON PAGE 62)

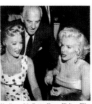

Marilyn with Betty Kean, Walter Winchell, at Ciro party. Can she lick sex jinx? · Her romance with Joe DiMaggio has been handled with intelligence, dignity. · Women who know Marilyn like her. Co-star Jane Russell is friend and adviser.

(Top) *Photoplay*, October 1953. (Bottom) *Screenland Plus TV-Land*, October 1953.

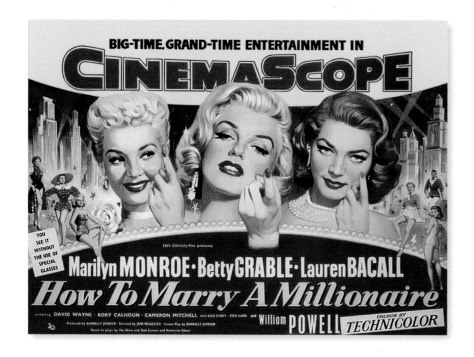

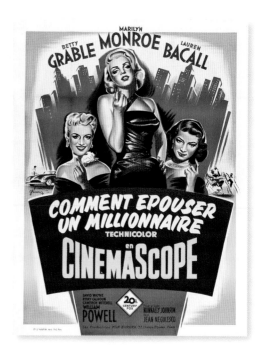

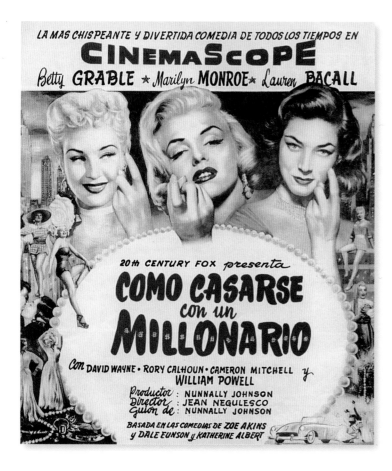

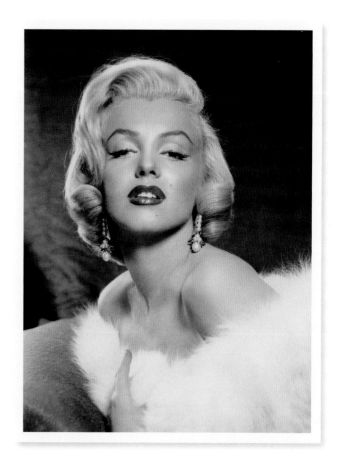

(This page) International posters for *How to Marry a Millionaire*, 1953, and original studio photograph used as reference for the poster artwork. (Opposite) Studio portrait featured on the cover of *Photoplay*, December 1953. Photo by John Florea (Twentieth Century-Fox).

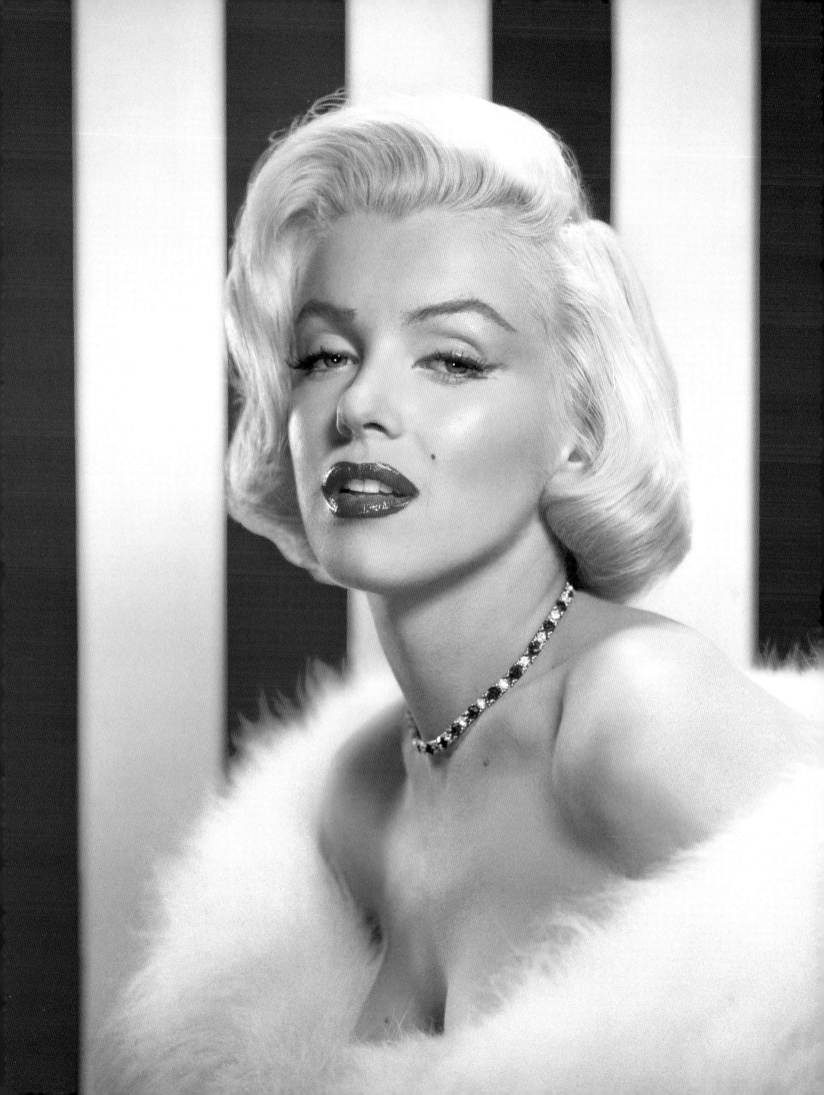

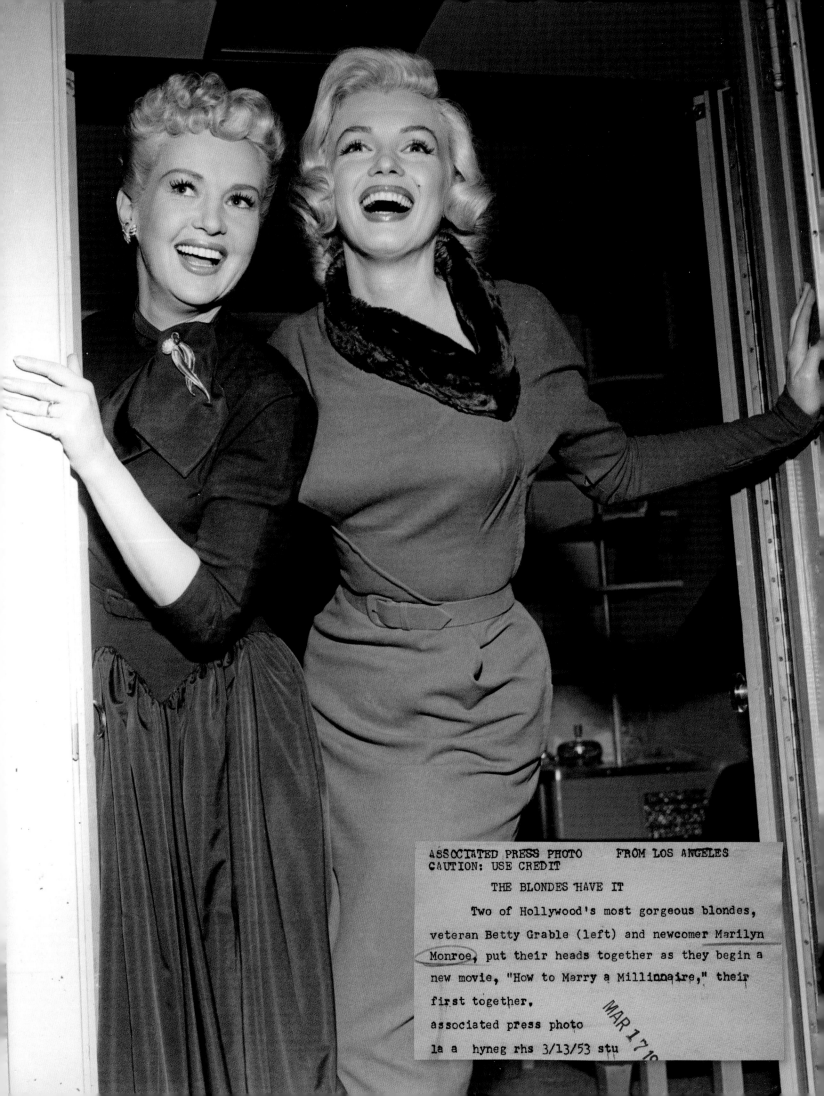

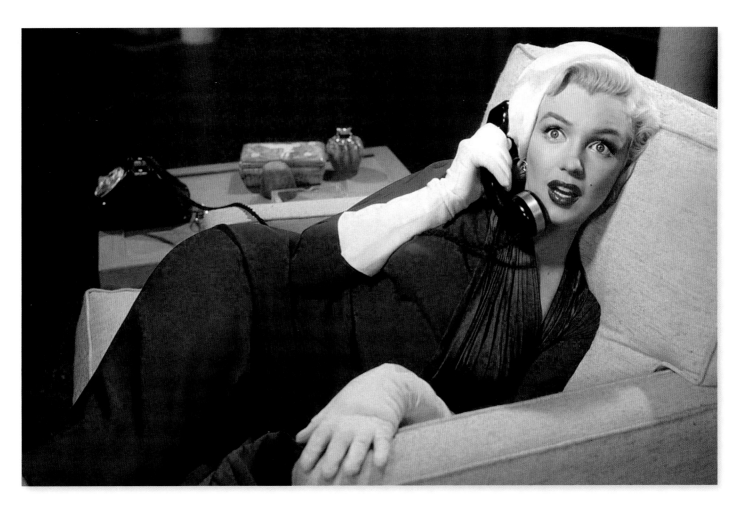

(Opposite) With costar Betty Grable on the set of *How to Marry a Millionaire*,
March 13, 1953. (Top) With costar Lauren Bacall. (Bottom) Marilyn as Pola
Debevoise, *How to Marry a Millionaire.* Photo by Earl Theisen for *Look* magazine.

(Above) Marilyn with Fox
publicist Roy Craft, 1953.
(Right) With Lauren Bacall,
Betty Grable, and an unidentified
admirer on the set of *How to
Marry a Millionaire*, 1953.

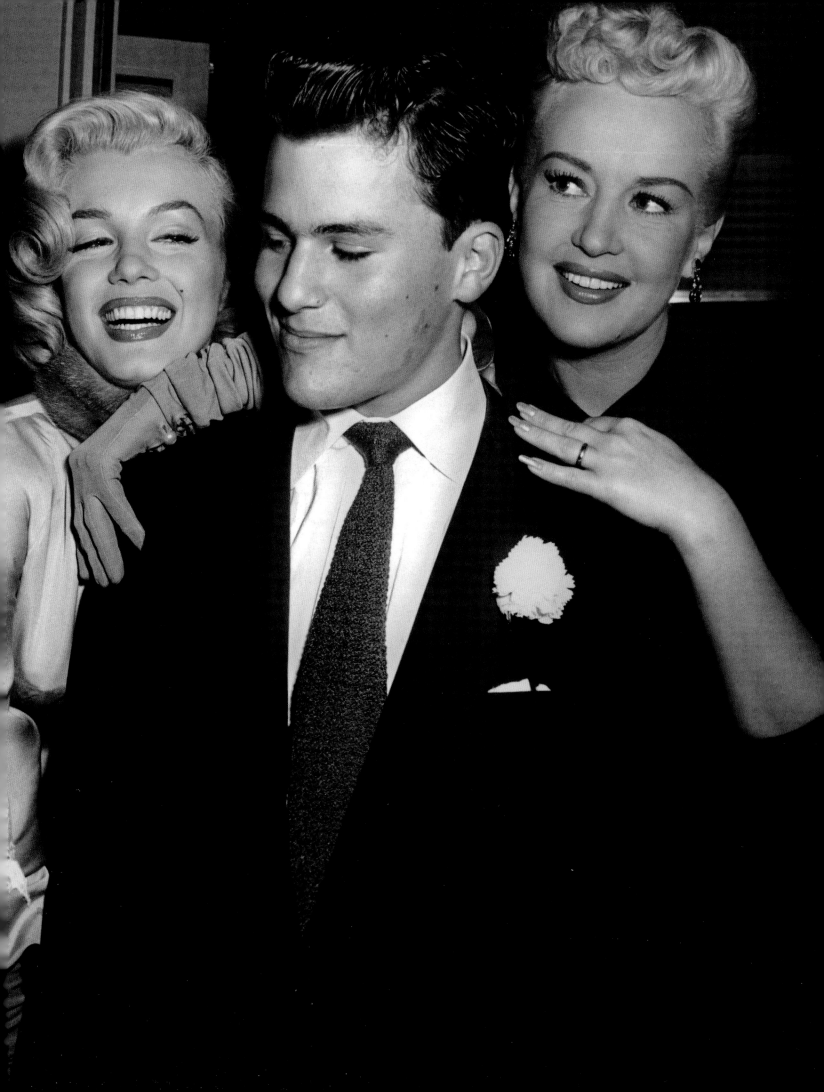

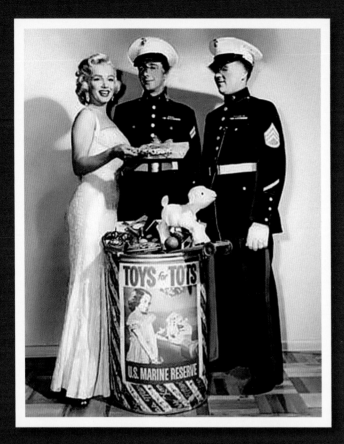

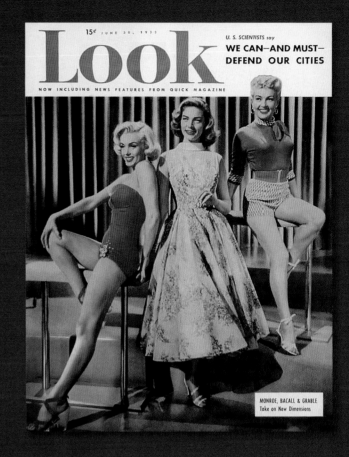

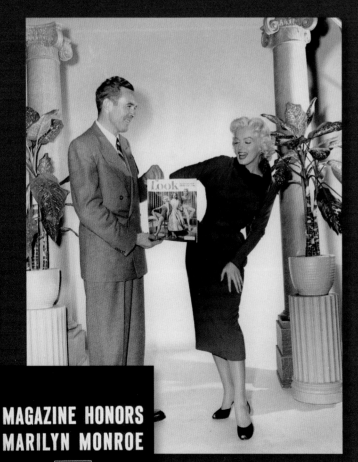

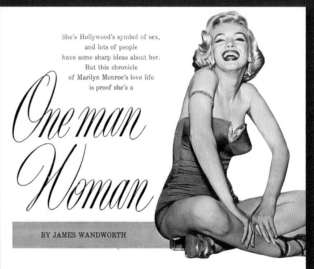

She's Hollywood's symbol of sex,
and lots of people
have some sharp ideas about her.
But this chronicle
of Marilyn Monroe's love life
is proof she's a

One man Woman

BY JAMES WANDWORTH

Early last fall, a Los Angeles truant officer was cruising around in the rain on the outskirts of Beverly Hills looking for a group of boys who had failed to answer roll call at school that morning. A veteran at his job, he could not understand why the youths had chosen that particular day to play hooky. It was dismal and gloomy, and there were no exciting events in the vicinity calculated to cause an outbreak of absenteeism among the younger set. None of it made sense.

Stopping his car at a signal light 100 feet from the gates of the 20th Century-Fox studios, he saw his five boys. They were huddled underneath the jutting edge of a studio roof trying to keep dry.

Quickly, the officer pulled his car to the curb, jumped out and cried, "Aha! Caught you!"

The boys didn't move, made no attempt to run.

"Okay, fellows," said the truant officer, "into the car."

"Let's stay here for just another five minutes," pleaded the oldest boy, who was about 12. "She'll be out in a minute."

"Who'll be out in a minute?" demanded the truant officer.

"Marilyn Monroe," said the boy. "She comes this way to lunch. We've been here for two hours."

"To see Marilyn Monroe?" asked the officer.

"Yeah," said the boy with excitement in his voice. "Ain't she something?"

The truant officer was a man as well as a civil servant, so he stepped back into the shelter and joined the hooky players, and in a few minutes Marilyn Monroe came by

and they all stood and gaped at her, and they all nearly fell down in a heap when she waved at them. And later on, as they munched hamburgers at a drive-in down the street, the man sipped his own coffee and meditated on the change that had taken place in small boys—and truant officers, for that matter—since he was a youngster.

The object of this anecdote is to illustrate the strange status occupied by Marilyn Monroe in the male mind of the U.S.A. She is the first movie star, glamor girl or cowboy, who has captured the imagination of American men, young and old, completely. She is the first girl in the movies to win an audience composed of every male citizen able to get himself into his own long trousers. She is indeed a man's woman on a grand scale. But the strange part of the matter is that Marilyn, herself, in her private life, is without a doubt the only beautiful woman in films who has never in her life ever been anything else but a one man woman. Never, since she was a small girl, has she ever played the siren except on the screen.

Turn your pin-up picture or that famous calendar to the wall for a moment. Tear your eyes away from the face with the half-closed eyes and the moist, parted lips, and think of that face and make it mobile. Let it relax. You can then in the magic of your mind maybe see Marilyn Monroe as she really is, as she actually looks in repose.

Marilyn Monroe's natural expression is one of serious friendliness. Her eyes, wide open, are soft and interested. Her mouth is generally wide in a smile or pursed slightly, with just the glimmer of a grin [*Please turn to page 62*]

(Clockwise from top left) Toys for Tots charity event, December 1953; *Look*, June 30, 1953, photo by Earl Theisen; *Motion Picture* magazine, September 1953; *Look* magazine promotion, 1953. (Opposite) Photo by Earl Theisen, 1953.

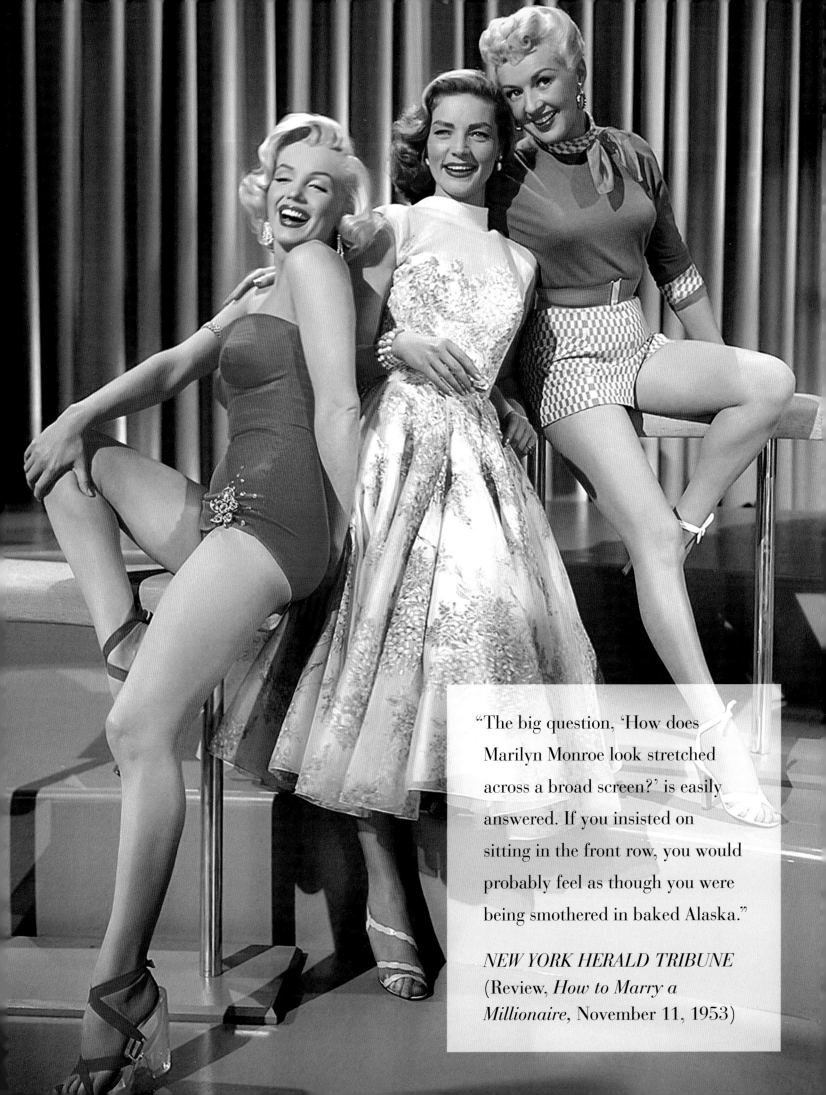

"The big question, 'How does Marilyn Monroe look stretched across a broad screen?' is easily answered. If you insisted on sitting in the front row, you would probably feel as though you were being smothered in baked Alaska."

NEW YORK HERALD TRIBUNE (Review, *How to Marry a Millionaire*, November 11, 1953)

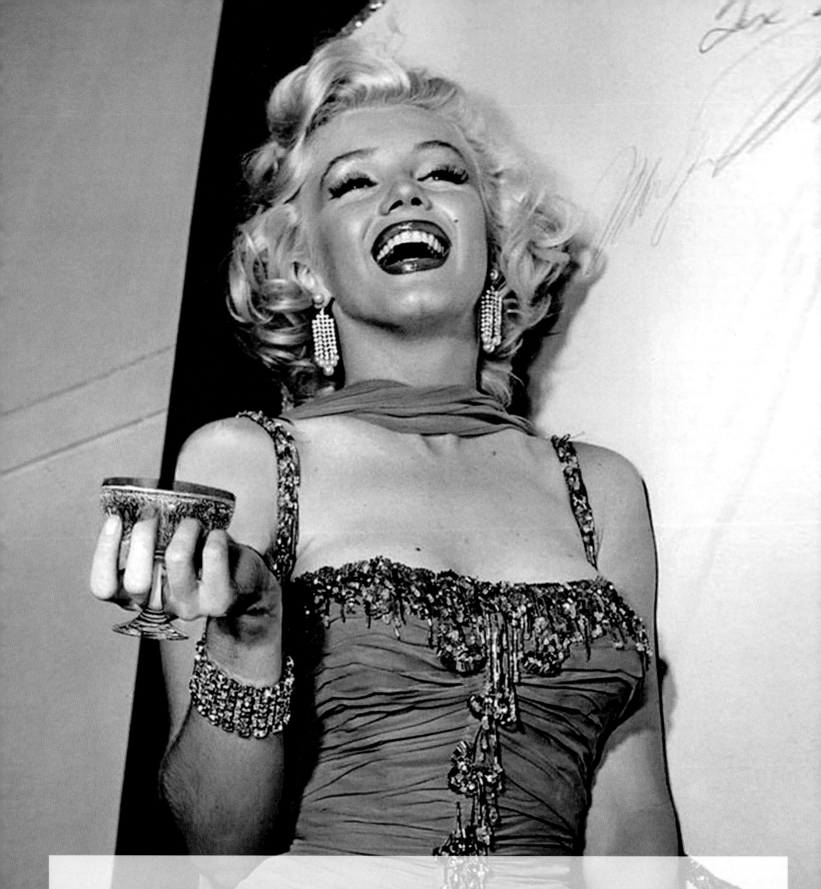

"There were more questions asked about Marilyn Monroe than any other star, male or female. Marilyn is the most exciting movie personality of this generation. She possesses the star quality that has to be natural, that can't be manufactured."

LOUELLA PARSONS (October 1952)

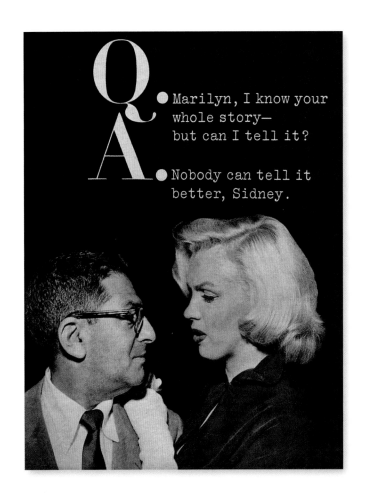

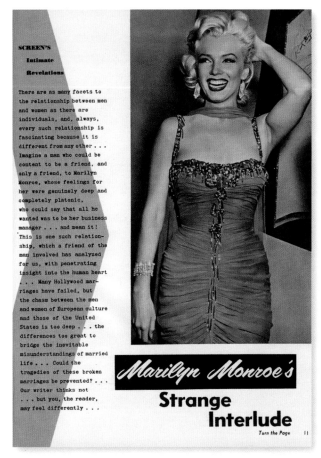

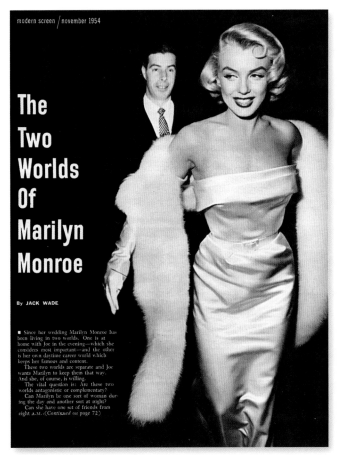

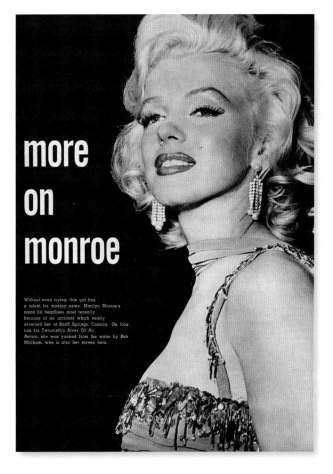

(Opposite) Hollywood Bowl, July 1953. Photo by Bernard of Hollywood.
(Clockwise from top left) With Sidney Skolsky, 1953; *Screen* magazine,
1953; *Movies*, c. 1953; *Modern Screen*, November 1954.

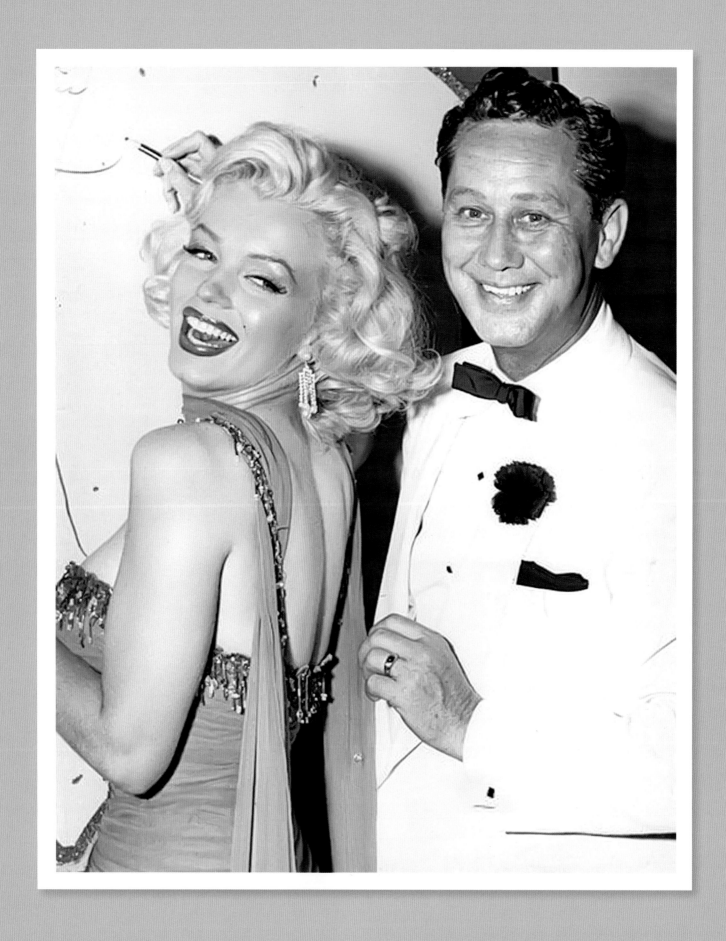

(Above) Marilyn with radio personality Peter Potter at a benefit for the St. Jude Children's Research Hospital in Memphis, Tennessee, held at the Hollywood Bowl, July 1953. Photo by Bernard of Hollywood. (Opposite) With Robert Mitchum. Photos by Janice Sargent.

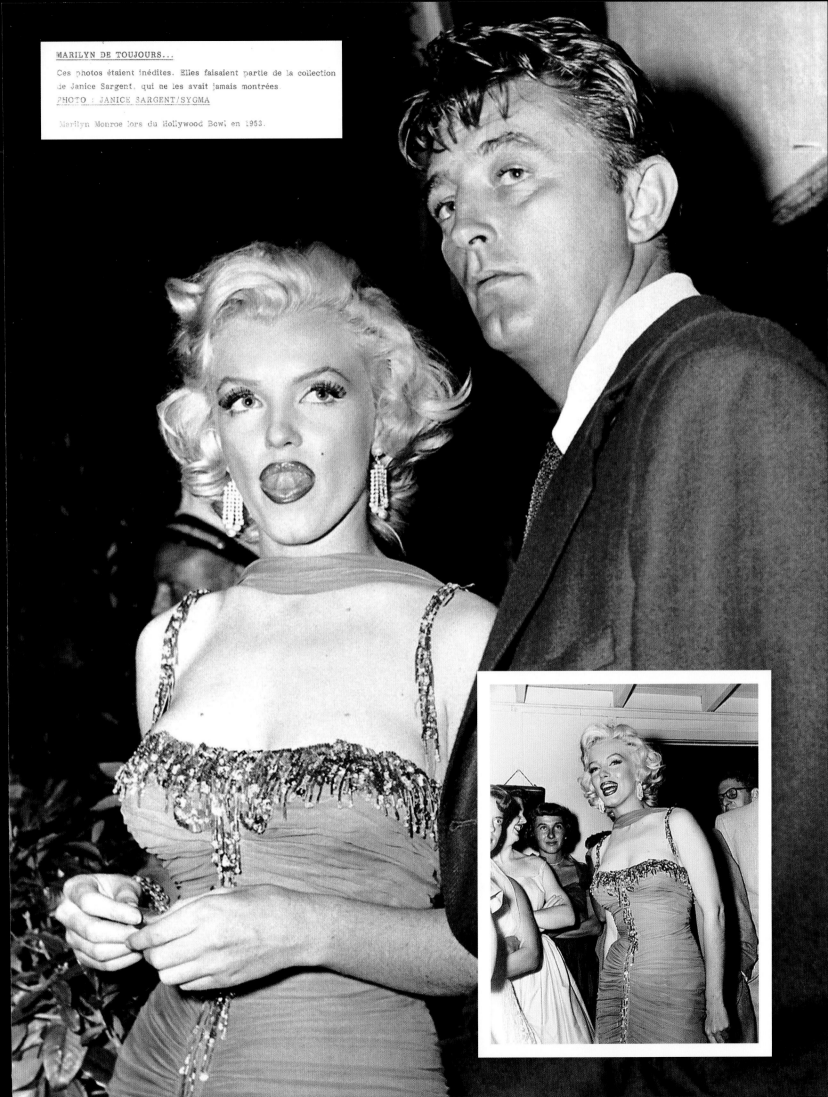

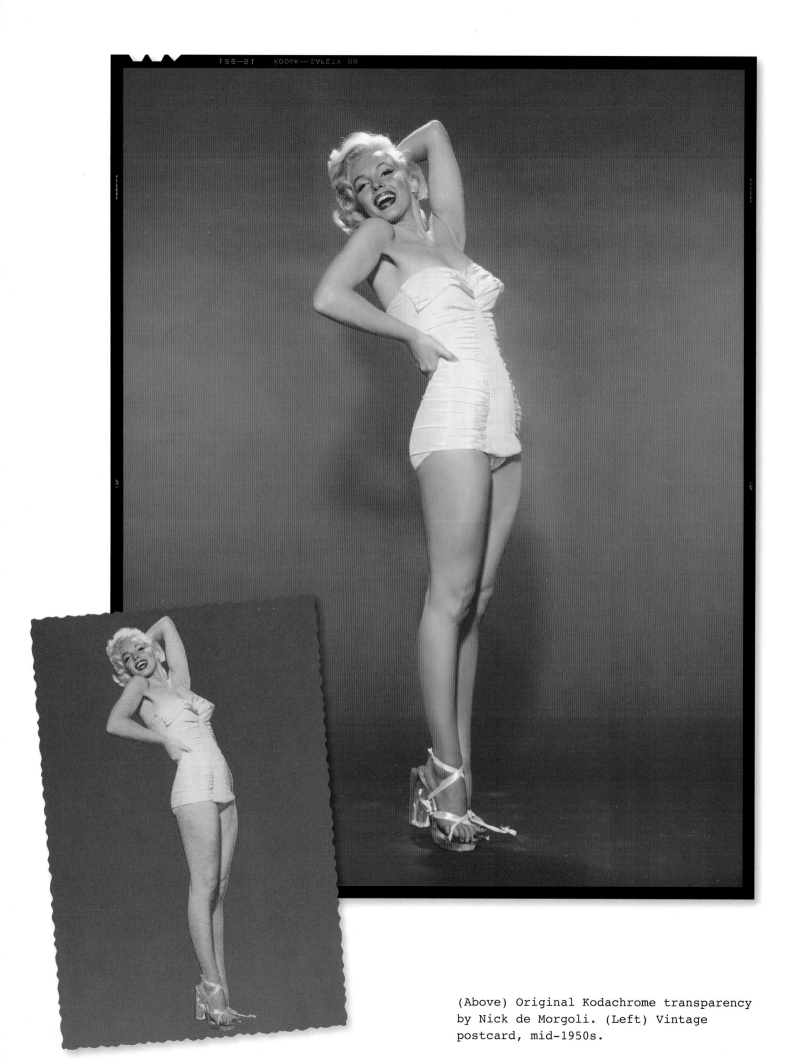

(Above) Original Kodachrome transparency
by Nick de Morgoli. (Left) Vintage
postcard, mid-1950s.

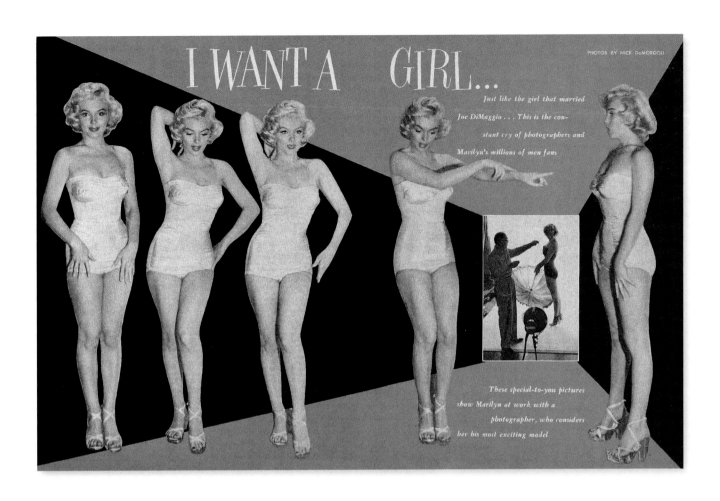

(Top) *Movie Play*, July 1954. (Bottom)
Photoplay, March 1954. Photos by Nick
de Morgoli.

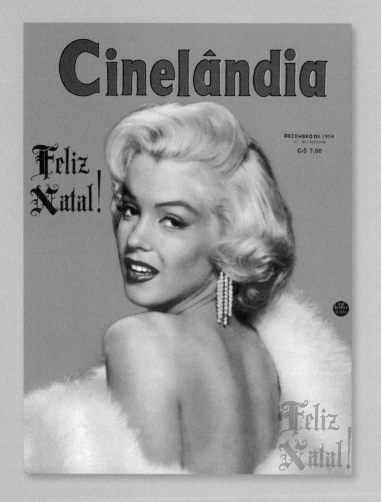

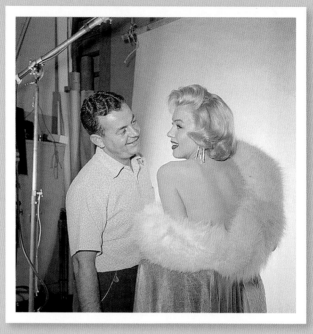

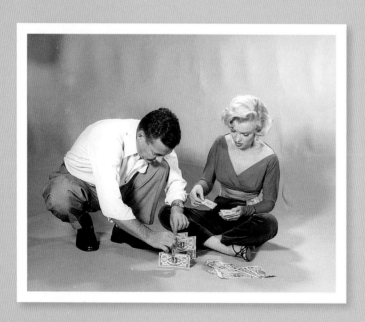

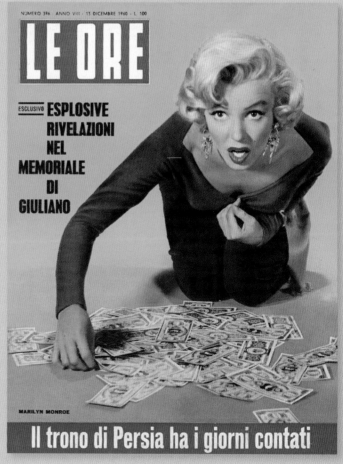

(Clockwise from top left) *Cinelândia*, December 1954; with photographer John Florea, 1953; *Le Ore*, December 1960; with John Florea, 1953.

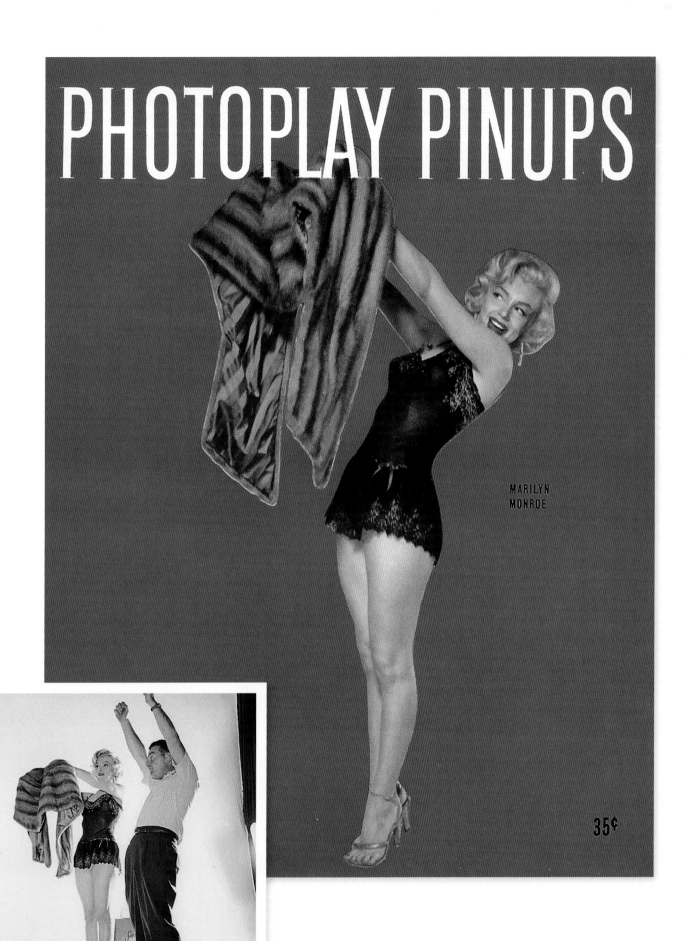

(Above) *Photoplay Pinups*, 1953. (Left) With photographer John Florea, 1953.

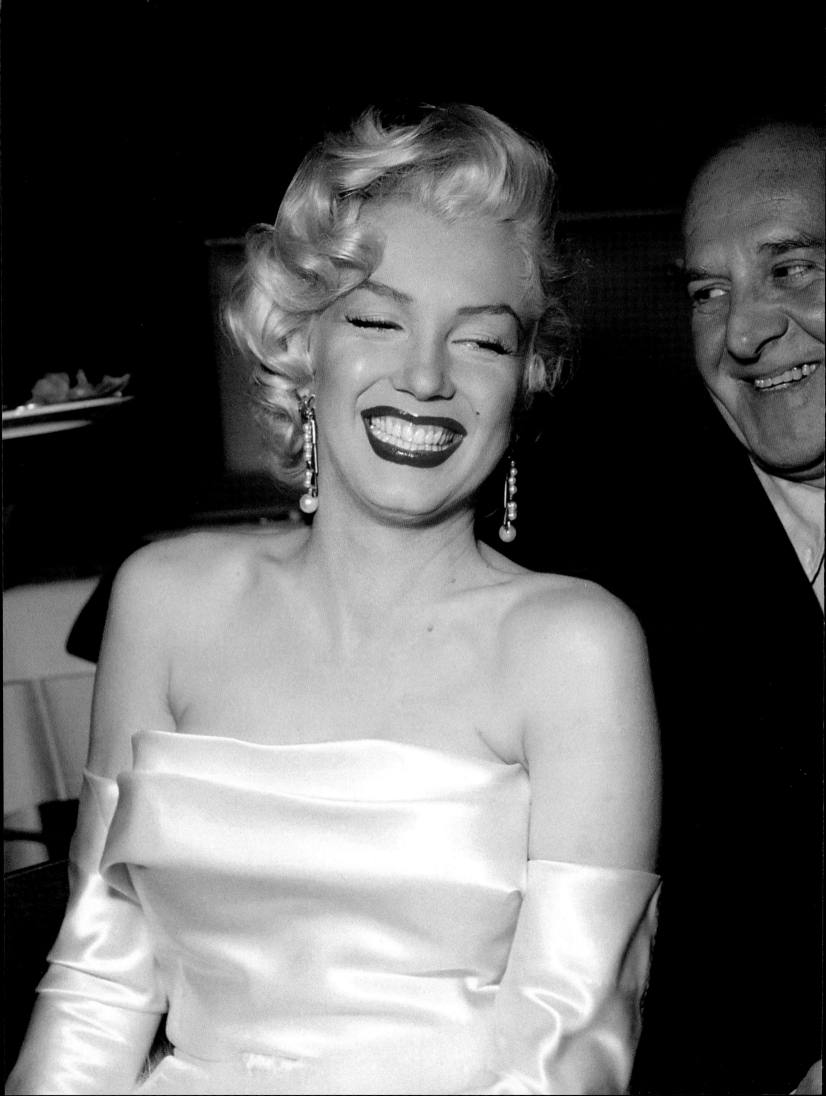

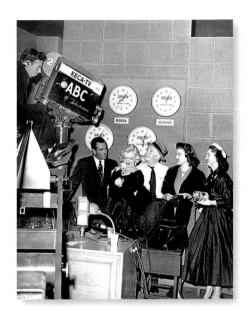

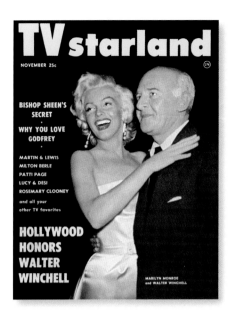

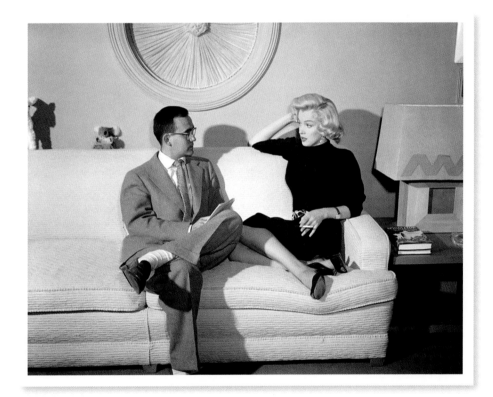

"She was a terrific interview. She was very bright, witty, responsive, and very easy to talk to. She was an interviewer's dream."

BOB THOMAS (Journalist, Associated Press)

(Left) Marilyn with journalist Walter Winchell at Ciro's, October 1953. (Top left) With Walter Winchell at an ABC affiliate station, 1953. (Top right) With Walter Winchell on the cover of *TV Starland*, November 1953. (Bottom) Being interviewed by United Press International journalist Vernon Scott, December 18, 1953.

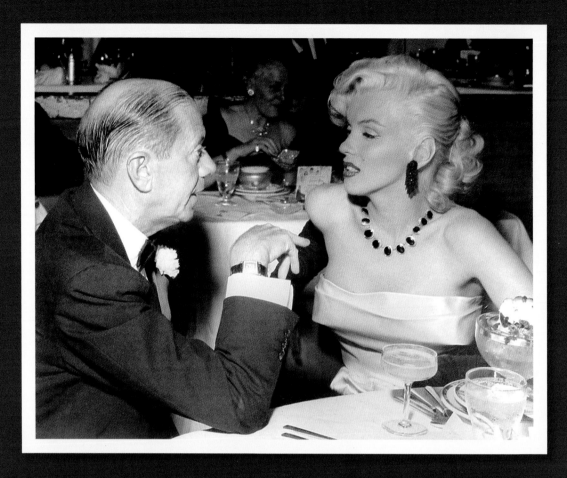

LOUELLA PARSONS' GOOD NEWS

Good "medicine" for Mario Lanza . . . What's the matter with Arlene Dahl? . . . Liz Taylor has a narrow escape . . .

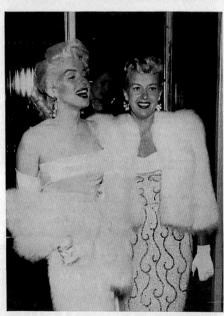

Betty Grable and Marilyn Monroe caused a sensation when they arrived together arm in arm, both dressed in tight white gowns and white fur pieces. Walter Winchell's fabulous party for colleague Louella Parsons was held at Ciro's in Hollywood.

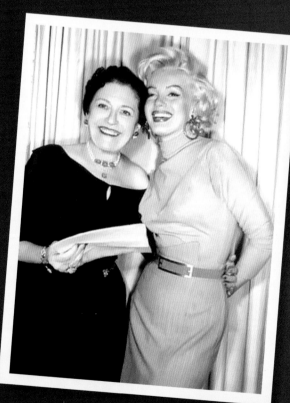

(Top) Marilyn with Cole Porter at the CinemaScope party, Cocoanut Grove, Ambassador Hotel, Los Angeles, January 1953. (Bottom left) Louella Parson's article about Walter Winchell's Ciro's event in her honor, October 1953. (Bottom right) With Louella Parsons at the studio for broadcast of Parsons's Radio Show, May 20, 1953. (Opposite) With Betty Grable at Ciro's.

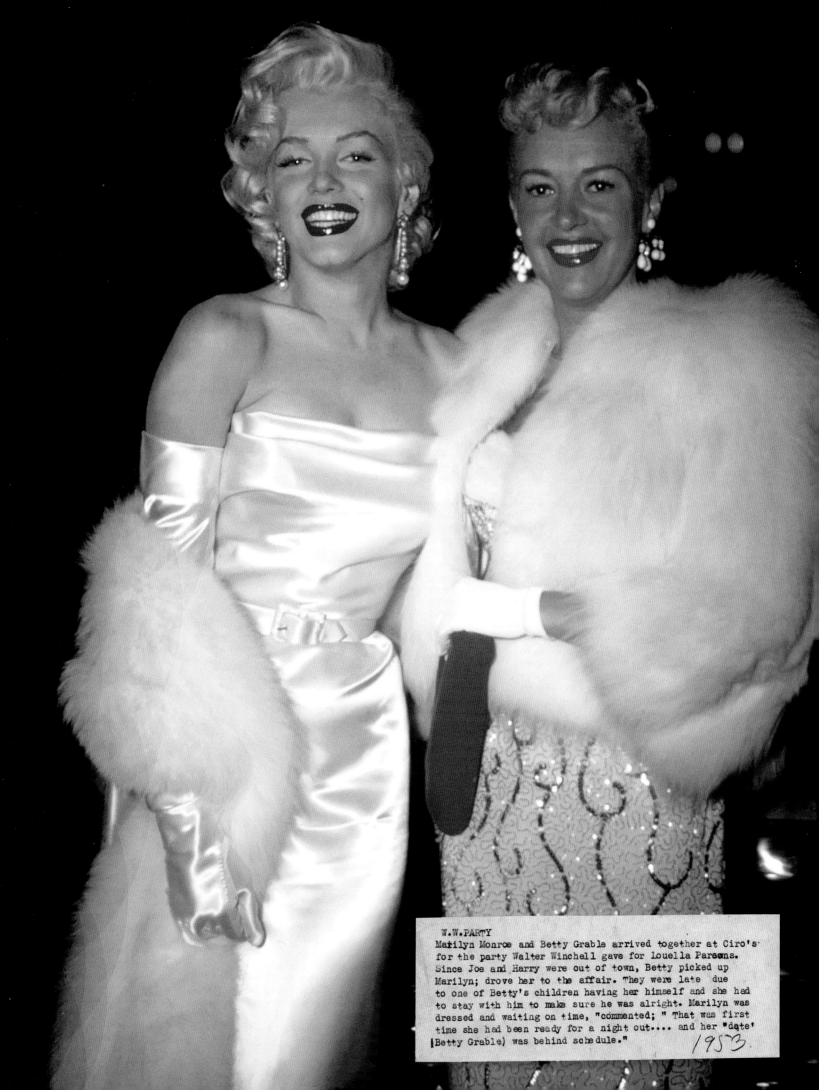

W.W.PARTY
Marilyn Monroe and Betty Grable arrived together at Ciro's
for the party Walter Winchell gave for Louella Parsons.
Since Joe and Harry were out of town, Betty picked up
Marilyn; drove her to the affair. They were late due
to one of Betty's children having her himself and she had
to stay with him to make sure he was alright. Marilyn was
dressed and waiting on time, "commented; " That was first
time she had been ready for a night out.... and her "date'
(Betty Grable) was behind schedule."

1953

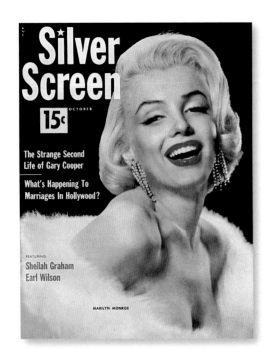

Silver Screen

15¢ OCTOBER

The Strange Second
Life of Gary Cooper

What's Happening To
Marriages In Hollywood?

FEATURING:
Sheilah Graham
Earl Wilson

MARILYN MONROE

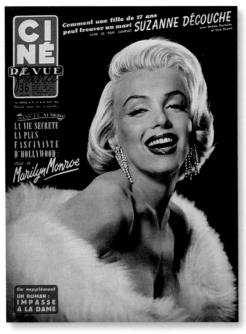

CINÉ REVUE
France 136

Comment une fille de 17 ans
peut trouver un mari SUZANNE DÉCOUCHE
DANS LE FILM COMPLET
avec Debbie Reynolds et Dick Powell

(DANS CE NUMÉRO)
LA VIE SECRÈTE
LA PLUS
FASCINANTE
D'HOLLYWOOD:
CELLE DE
Marilyn Monroe

En supplément
UN ROMAN:
IMPASSE
À LA DAME

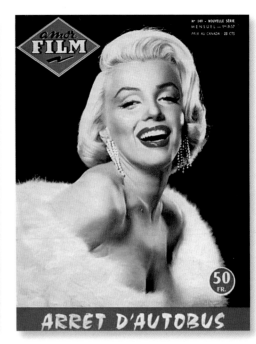

amor FILM

N° 149 - NOUVELLE SÉRIE
MENSUEL - 1er-9-57
PRIX AU CANADA 25 CTS

50 FR.

ARRÊT D'AUTOBUS

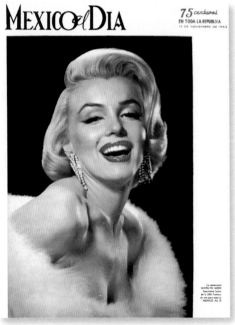

MEXICO el DIA

75 centavos
EN TODA LA REPUBLICA
15 DE NOVIEMBRE DE 1953

La sensacional
MARILYN MON
Importante figura
de la 20th Century
en una nota especial
"MEXICO AL DÍA"

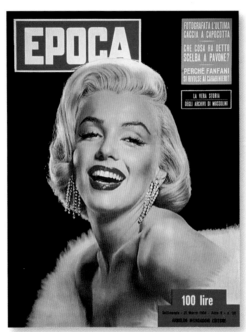

EPOCA

FOTOGRAFATA L'ULTIMA
CACCIA A CAPOCOTTA

CHE COSA HA DETTO
SCELBA A PAVONE?

PERCHÉ FANFANI
SI RIVOLSE AI CARABINIERI?

LA VERA STORIA
DEGLI ARCHIVI DI MUSSOLINI

100 lire

Settimanale - 21 Marzo 1954 - Anno V - n. 4, 180
ARNOLDO MONDADORI EDITORE

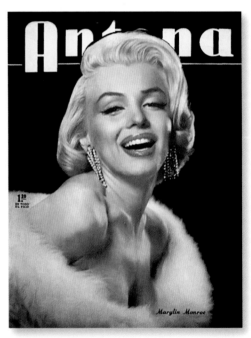

Antena

1.20
EN TODO EL PAÍS

Marylin Monroe

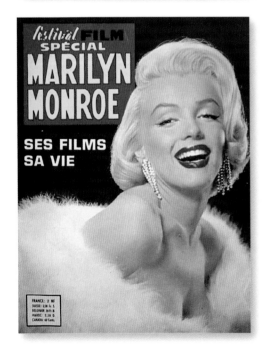

festival FILM SPÉCIAL
MARILYN MONROE

SES FILMS
SA VIE

FRANCE: 2 NF
SUISSE: 2,90 fr. S
BELGIQUE: 26 Fr. B
MAROC: 2,30 D
CANADA: 60 Cents

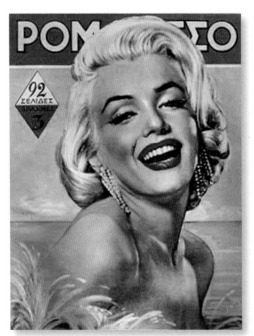

POM ΤΣΟ

92 ΣΕΛΙΔΕΣ
ΔΡΑΧΜΕΣ **3**

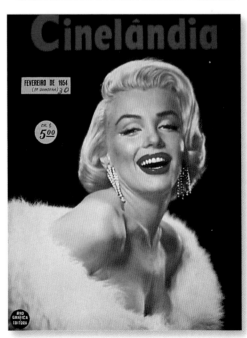

Cinelândia

FEVEREIRO DE 1954
(1ª QUINZENA) 30

CR. $
5,00

RIO
GRÁFICA
EDITORA

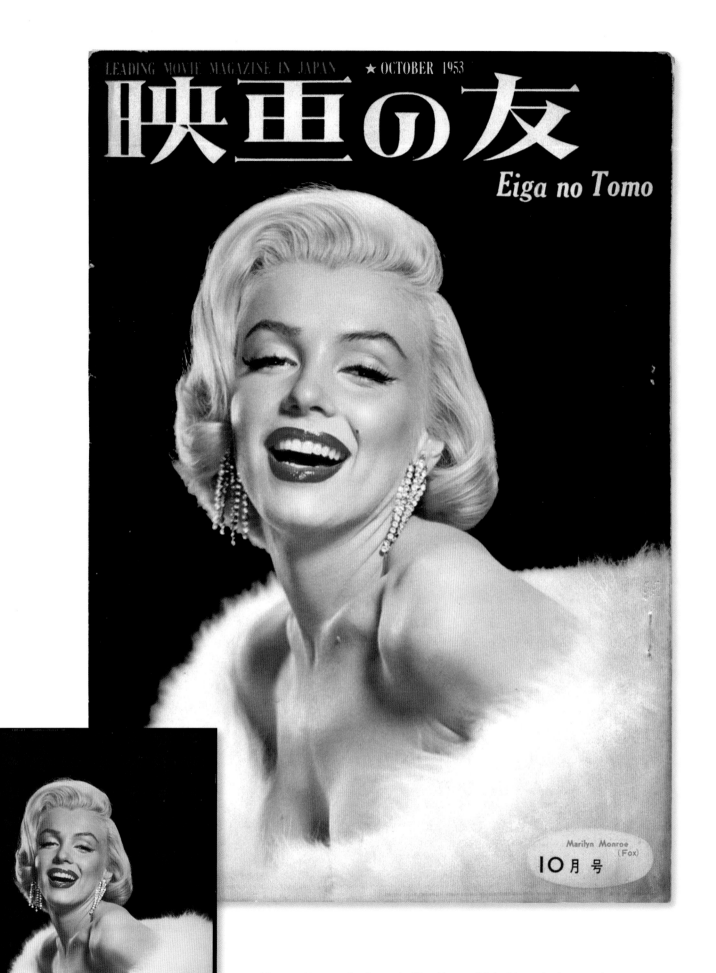

LEADING MOVIE MAGAZINE IN JAPAN ★ OCTOBER 1953

映画の友

Eiga no Tomo

Marilyn Monroe (Fox)

10月号

(Opposite and above) Studio publicity photograph
featured on international magazine covers, 1953.
(Left) Original 8x10" Kodachrome transparency
showing color loss due to deterioration of the
cyan and yellow pigments.

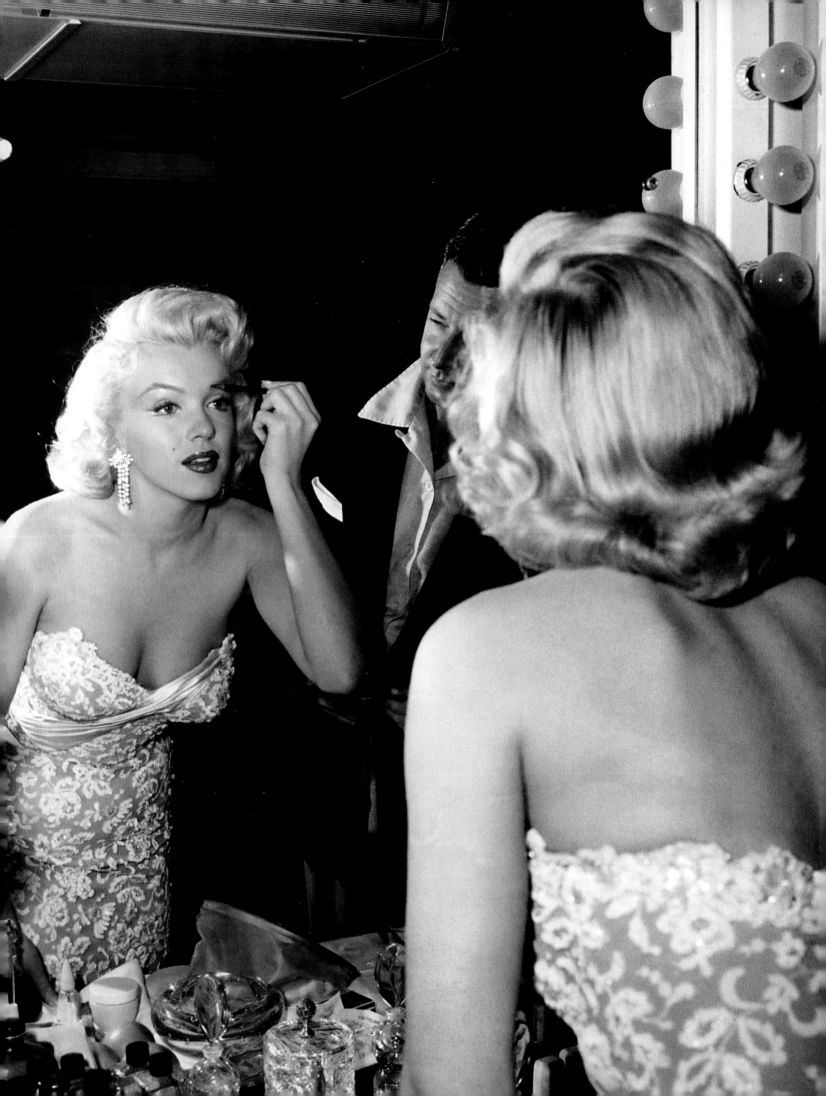

"Columnist Kendis Rochlen turned up to watch the big event. When Miss Monroe attends a premiere, that's news—and the papers know it! It's true that to look like Marilyn Monroe you first have to be born that way…but when millions of studio money are invested in one gorgeous gal, Hollywood doesn't mind trying, if it can improve on nature."

MOVIE WORLD (On MM's preparations for the *Millionaire* premiere, May 4, 1954)

(Opposite) Marilyn preparing for the premiere of *How to Marry a Millionaire*, with her makeup man Allan "Whitey" Snyder, November 4, 1953.

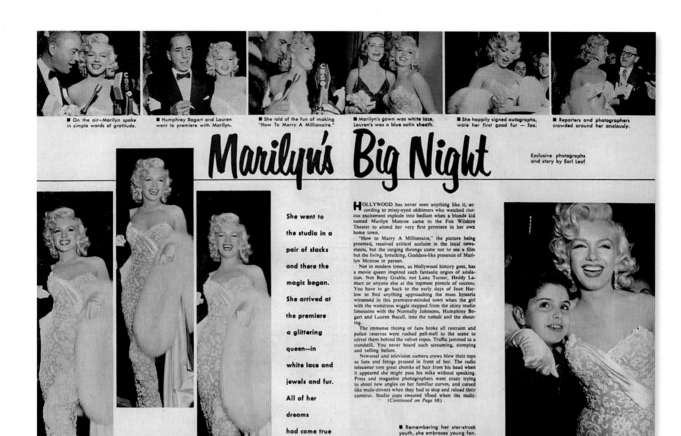

■ On the air—Marilyn spoke in simple words of gratitude.　　■ Humphrey Bogart and Lauren went to premiere with Marilyn.　　■ She told of the fun of making "How To Marry A Millionaire."　　■ Marilyn's gown was white lace, Lauren's was a blue satin sheath.　　■ She happily signed autographs, wore her first good fur — fox.　　■ Reporters and photographers crowded around her anxiously.

Marilyn's Big Night

Exclusive photographs and story by Earl Leaf

She went to the studio in a pair of slacks and there the magic began. She arrived at the premiere a glittering queen—in white lace and jewels and fur. All of her dreams had come true

HOLLYWOOD has never seen anything like it, according to misty-eyed oldtimers who watched riotous excitement explode into bedlam when a blonde kid named Marilyn Monroe came to the Fox Wilshire Theater to attend her very first premiere in her own home town.

"How to Marry A Millionaire," the picture being preemed, received critical acclaim in the local newssheets, but the surging throngs came not to see a film but the living, breathing, Goddess-like presence of Marilyn Monroe in person.

Not in modern times, as Hollywood history goes, has a movie queen inspired such fantastic orgies of adulation. Not Betty Grable, not Lana Turner, Heddy Lamarr or anyone else at the topmost pinacle of success. You have to go back to the early days of Jean Harlow to find anything approaching the mass hysteria witnessed in this premiere-minded town when the girl with the wondrous wiggle stepped from the shiny studio limousine with the Nunnally Johnsons, Humphrey Bogart and Lauren Bacall, into the tumult and the shouting.

The immense throng of fans broke all restraint and police reserves were rushed pell-mell to the scene to corral them behind the velvet ropes. Traffic jammed to a standstill. You never heard such screaming, stomping and yelling before.

Newsreel and television camera crews blew their tops as fans and fotogs pressed in front of her. The radio telecaster tore great chunks of hair from his head when it appeared she might pass his mike without speaking. Press and magazine photographers went crazy trying to shoot new angles on her familiar curves, and cursed like mule-drivers when they had to stop and reload their cameras. Studio cops sweated blood when the multi-

(Continued on Page 68)

■ Remembering her star-struck youth, she embraces young fan.

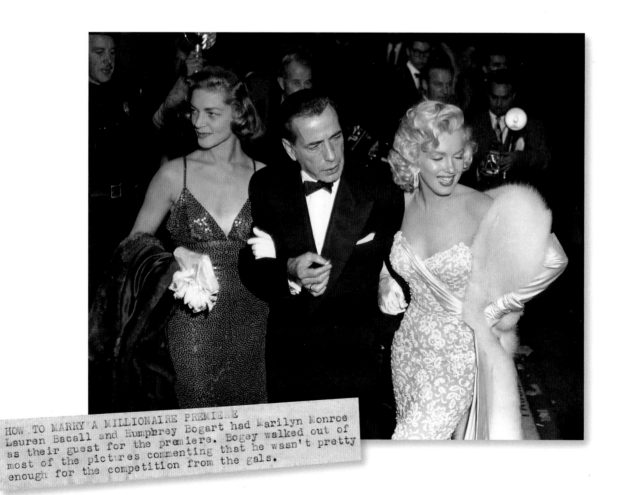

HOW TO MARRY A MILLIONAIRE PREMIERE
Lauren Bacall and Humphrey Bogart had Marilyn Monroe as their guest for the premiere. Bogey walked out of most of the pictures commenting that he wasn't pretty enough for the competition from the gals.

(Top) *Movie Spotlight*, April 1954. Photos and story by Earl Leaf. (Bottom) Marilyn with Lauren Bacall and Humphrey Bogart, at the premiere of *How to Marry a Millionaire*, Fox Wilshire Theatre, Beverly Hills, California, November 4, 1953. (Opposite) With Lauren Bacall.

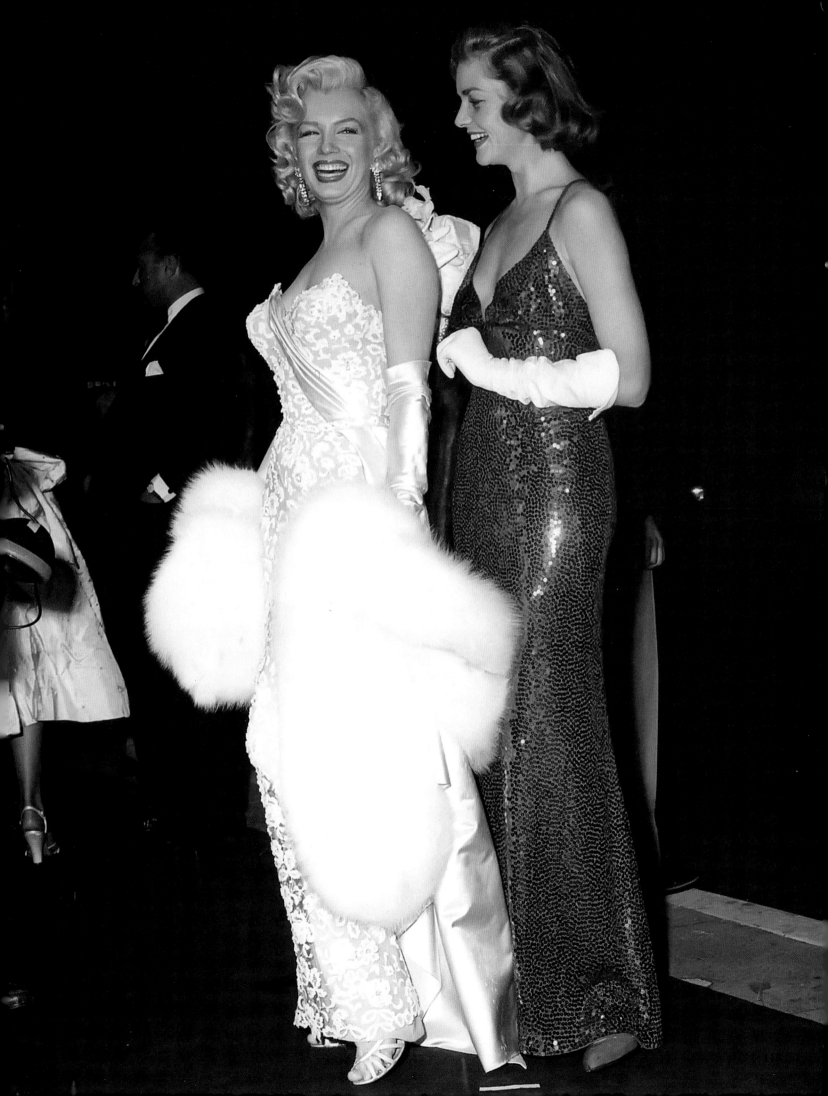

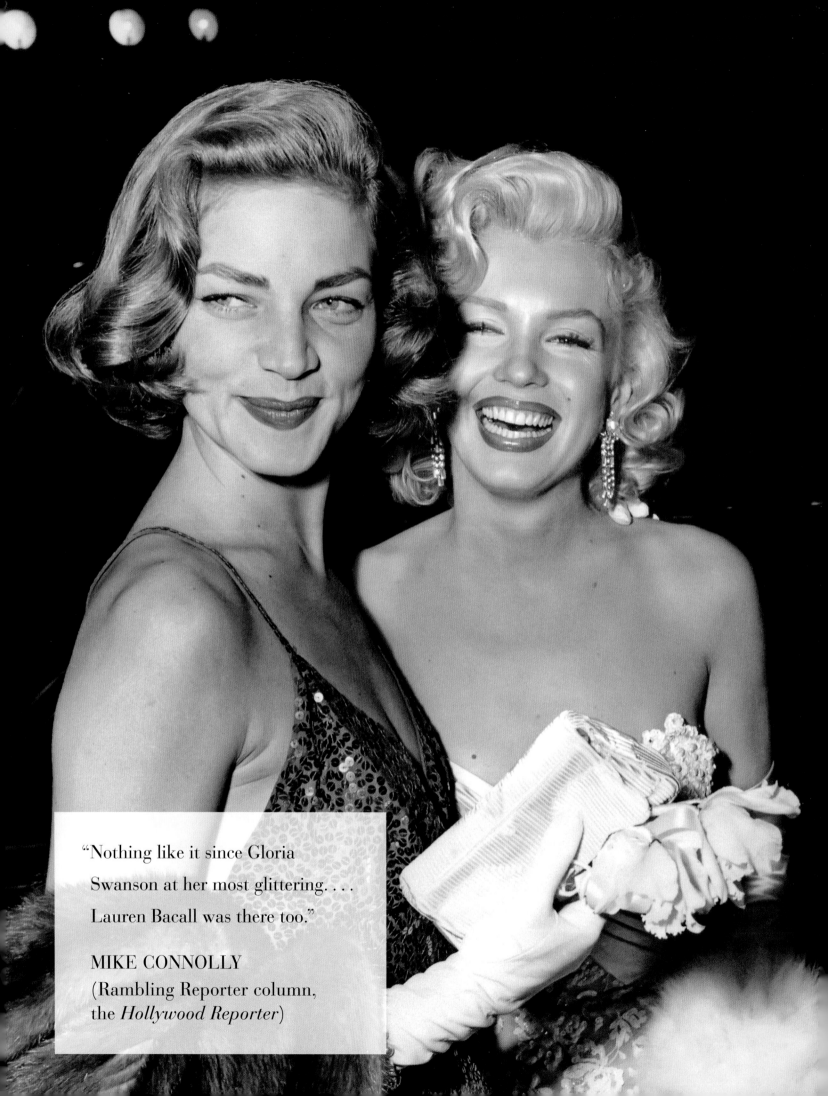

"Nothing like it since Gloria Swanson at her most glittering. . . . Lauren Bacall was there too."

MIKE CONNOLLY
(Rambling Reporter column, the *Hollywood Reporter*)

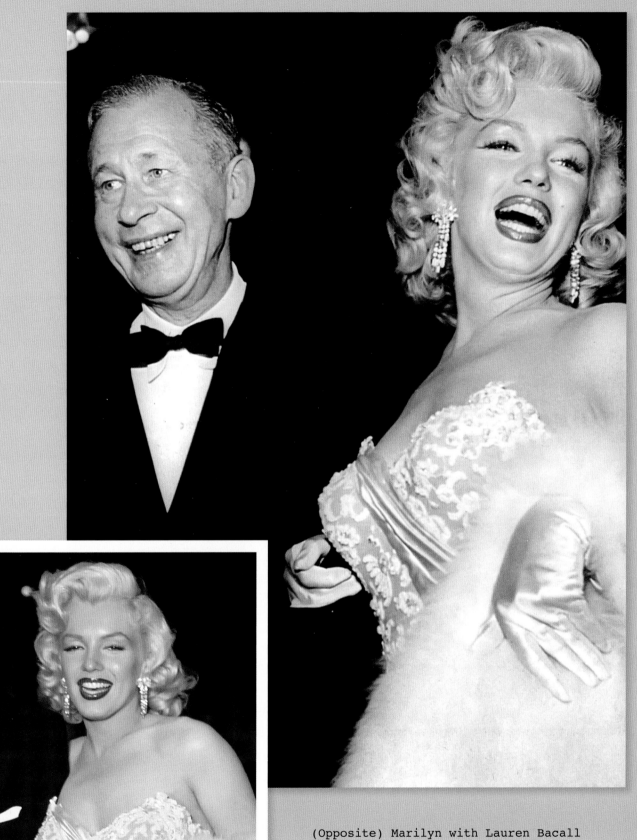

(Opposite) Marilyn with Lauren Bacall at the premiere of *How to Marry a Millionaire*, Fox Wilshire Theatre, Beverly Hills, California, November 4, 1953. (Top) With screenwriter Nunnally Johnson at the premiere. (Left) Marilyn at the premiere.

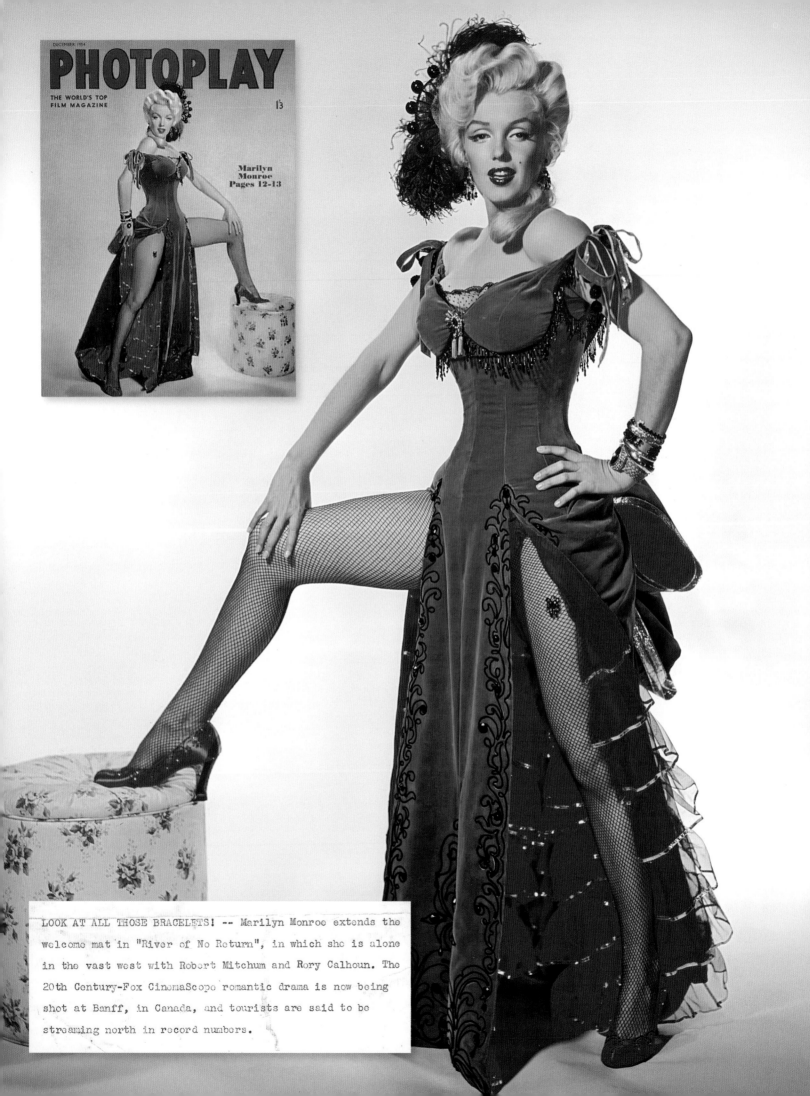

LOOK AT ALL THOSE BRACELETS! -- Marilyn Monroe extends the
welcome mat in "River of No Return", in which she is alone
in the vast west with Robert Mitchum and Rory Calhoun. The
20th Century-Fox CinemaScope romantic drama is now being
shot at Banff, in Canada, and tourists are said to be
streaming north in record numbers.

On the spot with Marilyn!

BY STERLING SMITH

When PHOTOPLAY told me that I was going to Canada to shoot pictures of Marilyn Monroe, I wasn't excited. After all, in my eight years with the magazine I've shot every glamour girl in Hollywood—Lana Turner, Jane Russell, Ava Gardner and the rest—so the idea of traveling 3,800 miles to take pictures of Marilyn Monroe didn't excite me. Not much. Except that I almost forgot my camera.

I might just as well have left it at home, too, for all the workout it got. You see, Marilyn is still a little cross with PHOTOPLAY because of a story we ran last year.

Marilyn may not know until she reads this that the story she so disliked did a lot to win the women in the audience over to her side. No sooner had the issue hit the newsstands than we had thousands of letters suggesting that a gentleman shouldn't write stories about his former wife, criticizing us for publishing it, and defending Marilyn to the last woman.

But I wasn't the only photographer on the "River of No Return" location who wore a long face. By no means! The other guys had their fingers crossed, too. One morning we all arrived on the set at 8:30 A.M. to wait for Marilyn. At 10:00 A.M. we were told that she was getting ready for us. At 3:45 P.M. we began to shoot and at 4:00 P.M. we had to stop because Marilyn had a studio call. That was it for the day. Man, were we overworked!

I did have one distinction, though: I was the photographer least likely to get an exclusive picture layout from Marilyn. She never said "No," exactly, but she got the idea across. For instance, she always introduced the other boys as representatives of magazines that "did so much for me," or have "always been so wonderful to me," but I was just Sterling Smith, period.

When I came home from Canada, my wife thought I had a hangdog look. I did. And I got it from following Marilyn around. When Joe DiMaggio put in an appearance, of course, I was twice as busy following both of them around. Joe never ran around the bases at Yankee Stadium any faster than he ran from my camera and me while we were in Banff.

In the end, I got my chance. A night scene was being shot, and to Marilyn, I was only one more dim figure. She sat opposite a campfire, playing a guitar and singing softly in a warm voice; she looked little and lonely, as I squatted there, taking pictures to my heart's content.

I had a fine vacation those two weeks, but I would rather have had my pictures. Marilyn had a heavy shooting schedule and an injured ankle, as well. That's partly why photographers had it so rough. But she also had a mad on at PHOTOPLAY. I hope she gets it over soon, because I'd have walked that 3800 miles to Banff Springs just to shoot Marilyn.

Marilyn was so mad at me—us—that I had to hover in the shadows to get these shots. If she'd had an idea I was there, it would have been "no dice"

30 31

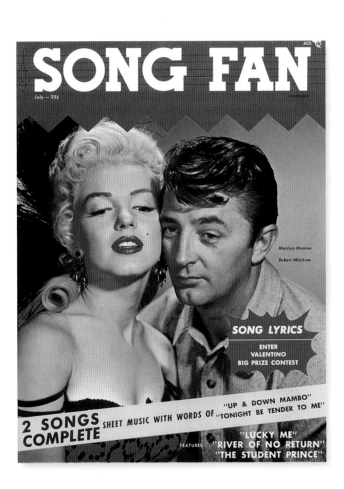

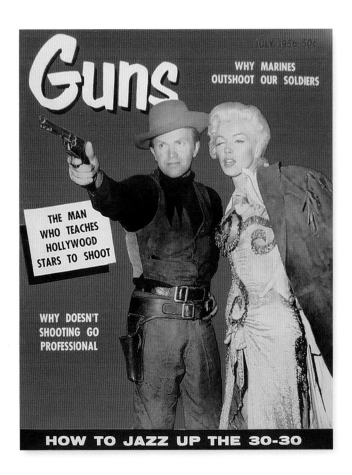

(Opposite) Marilyn as Kay Weston in *River of No Return*, 1954;
(inset) *Photoplay*, December 1954. (Top) *Photoplay*, January 1954.
(Bottom left) *Song Fan*, July 1954. (Bottom right) *Guns*, July 1956.

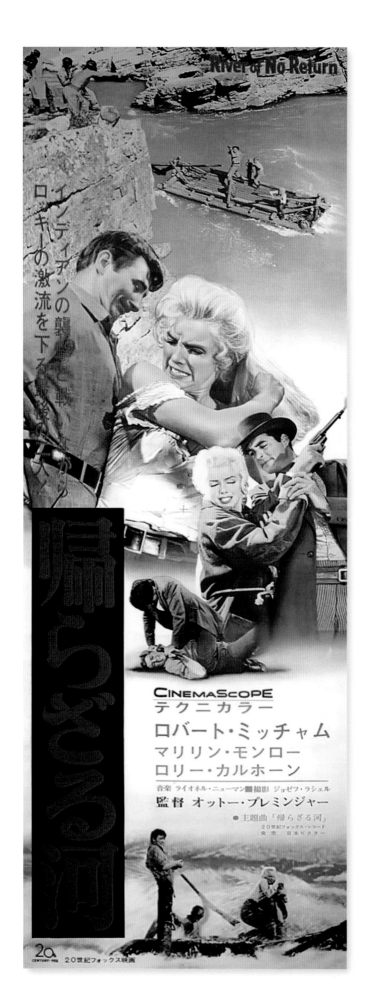

(Above and opposite) International posters, *River of No Return*, 1954.

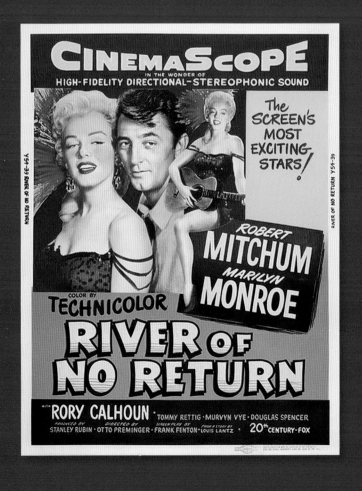

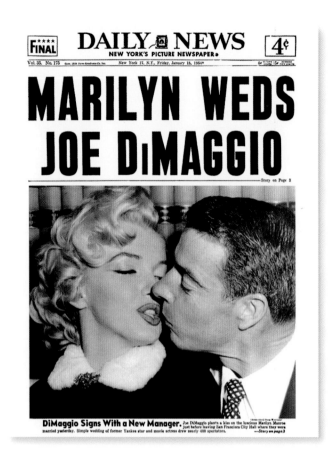

(Top) *Daily News*, January 15, 1954. (Bottom) Marilyn at Bob Hope's house with unidentified guest, Joe DiMaggio, General William Dean, and Bob Hope, December 1953. (Opposite) With Joe DiMaggio, at Bob Hope's party.

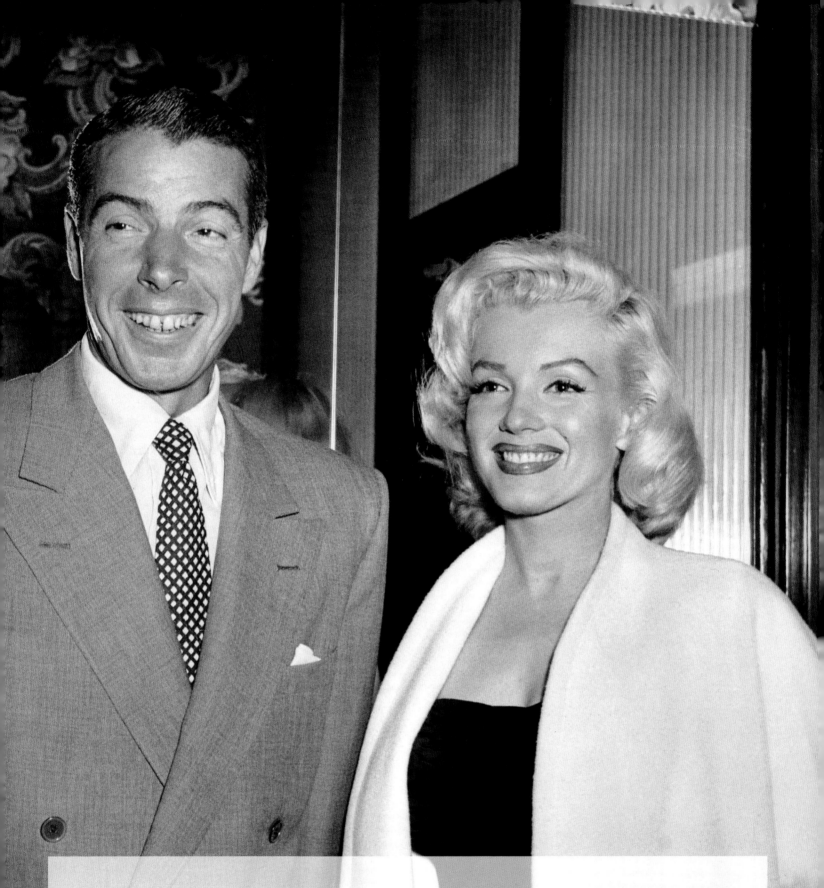

"It could only happen here in America, this storybook romance. . . . Both of them had to fight their way to fame and fortune and to each other; one in a birthday suit, as a calendar girl; the other in a baseball suit."

LOS ANGELES HERALD-EXPRESS

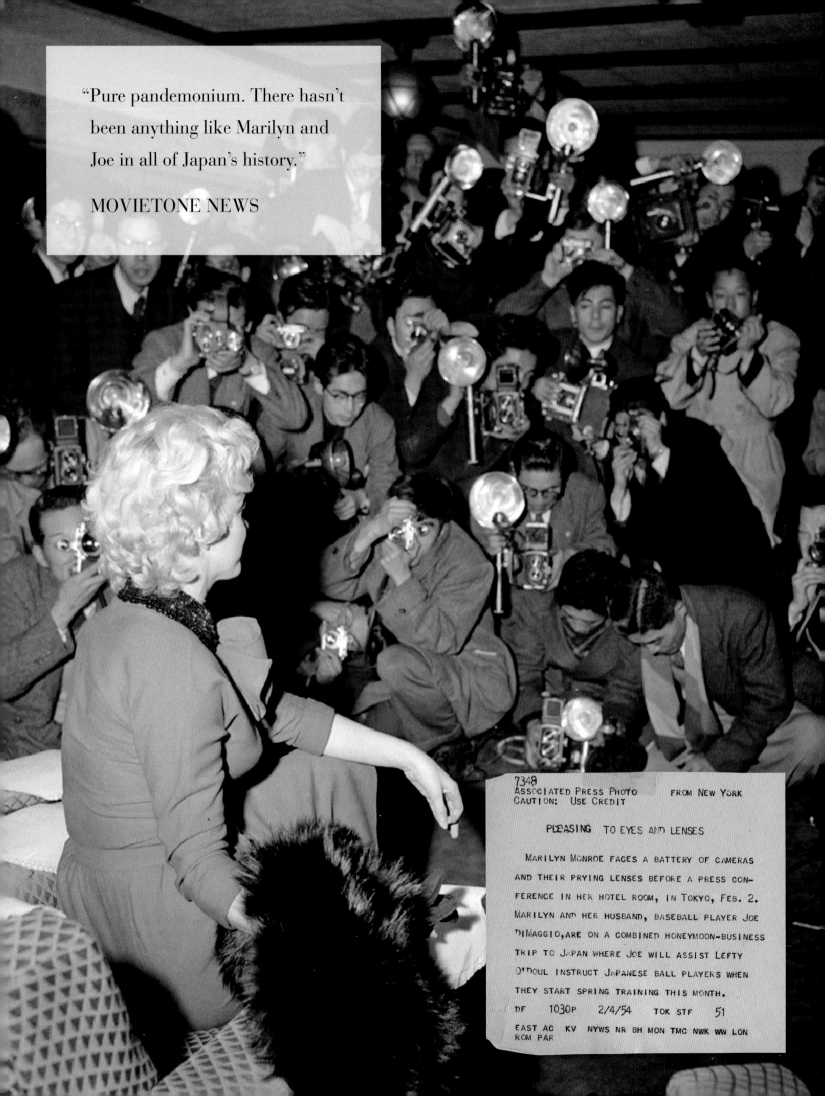

"Pure pandemonium. There hasn't been anything like Marilyn and Joe in all of Japan's history."

MOVIETONE NEWS

7348
ASSOCIATED PRESS PHOTO FROM NEW YORK
CAUTION: USE CREDIT

PLEASING TO EYES AND LENSES

 MARILYN MONROE FACES A BATTERY OF CAMERAS
AND THEIR PRYING LENSES BEFORE A PRESS CON-
FERENCE IN HER HOTEL ROOM, IN TOKYO, FEB. 2.
MARILYN AND HER HUSBAND, BASEBALL PLAYER JOE
DIMAGGIO, ARE ON A COMBINED HONEYMOON-BUSINESS
TRIP TO JAPAN WHERE JOE WILL ASSIST LEFTY
O'DOUL INSTRUCT JAPANESE BALL PLAYERS WHEN
THEY START SPRING TRAINING THIS MONTH.
DF 1030P 2/4/54 TOK STF 51
EAST AC KV NYWS NR BH MON TMC NWK WW LON
ROM PAR

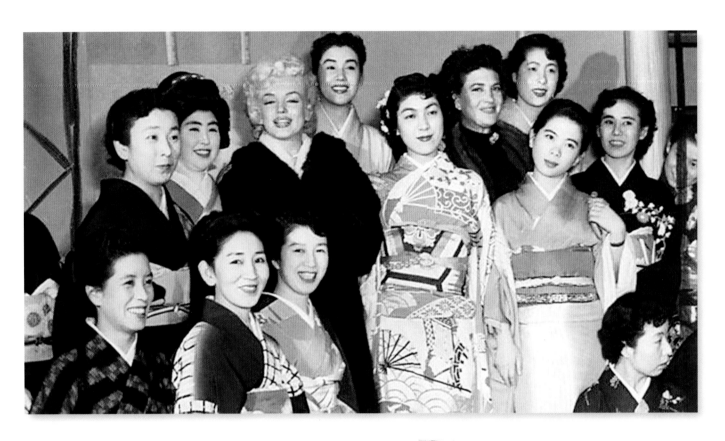

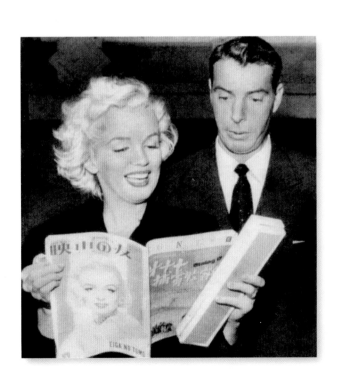

(Opposite) Marilyn meets the press, Kobe, Japan, February 4, 1954.
(Top) With Jean O'Doul (fourth from right), wife of baseball player
Lefty O'Doul, and geishas, Kobe, February 1954. (Bottom left) With Joe
DiMaggio, Japan, February 1954. (Bottom right) *Eiga No Tomo*, March 1954.

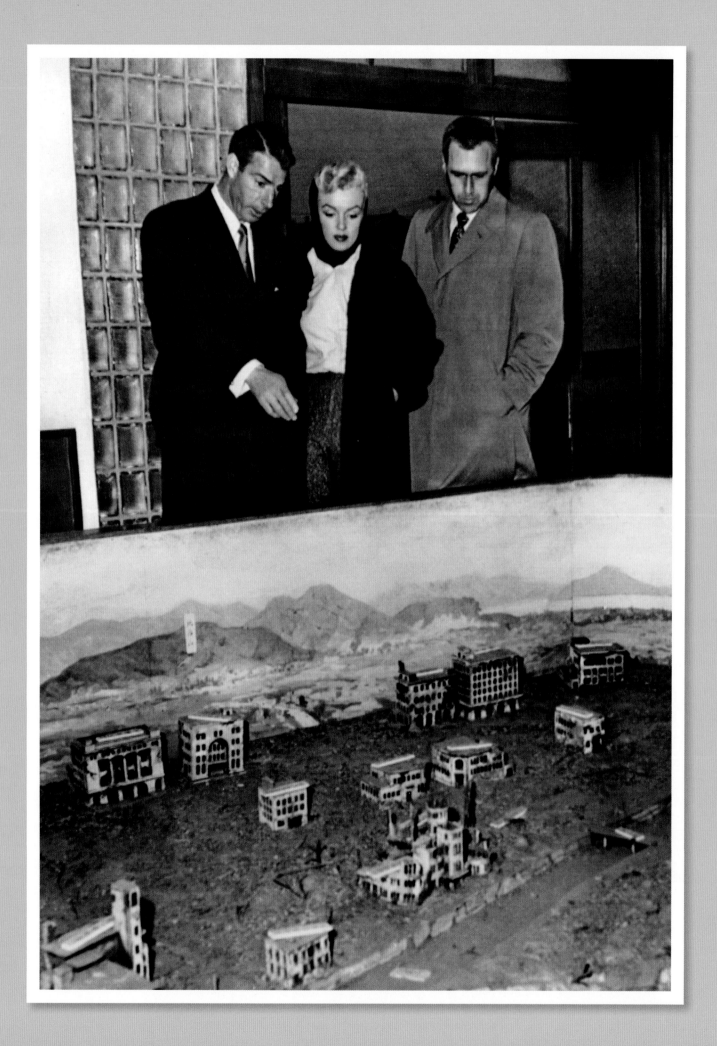

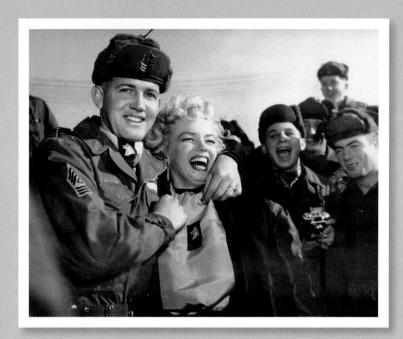

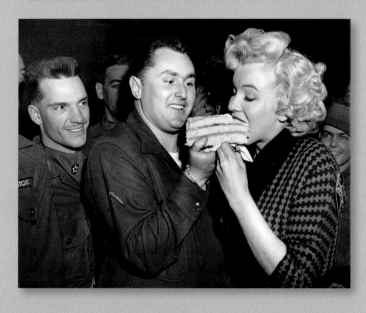

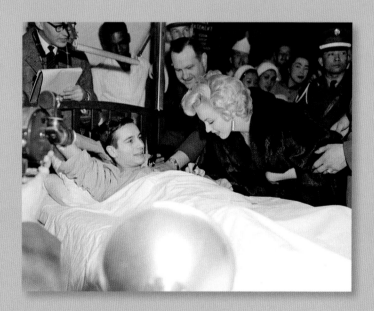

(Opposite) Marilyn with Joe DiMaggio and former New York Yankee Bobby Brown viewing a memorial replica of Hiroshima, Japan, February 14, 1954. (Clockwise from top left) With Sgt. Guy Morgan, Korea, February 21, 1954; with brothers Ernest and Monroe Manuel Abril, Korea, February 19, 1954; visiting injured soldiers, Toyko Army Hospital, February 5, 1954; with PFC Stanley Closter of Brooklyn, New York, in Korea, February 19, 1954.

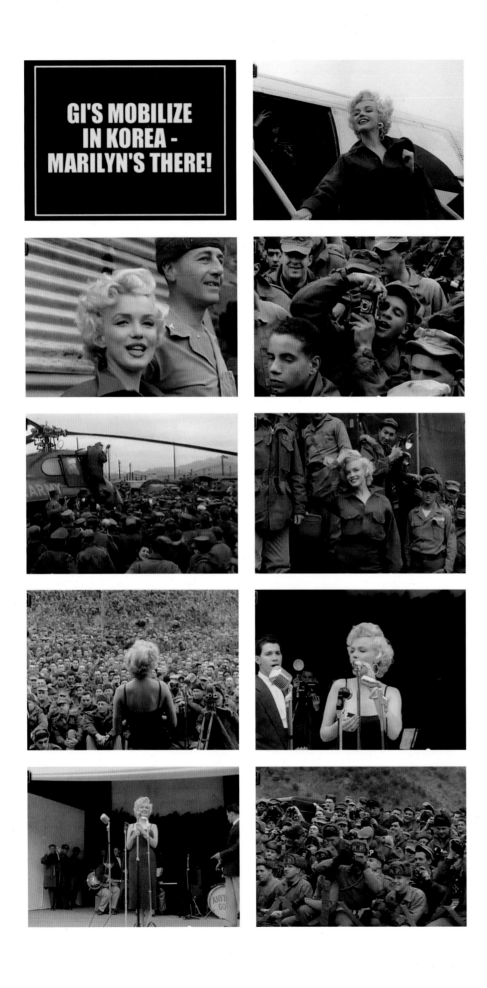

GI'S MOBILIZE
IN KOREA -
MARILYN'S THERE!

(Above) Movietone newsreel, 1954. (Right) Visiting
American armed forces, Seoul City Airport, Korea,
February 17, 1954. Photo by Walt Durrell.

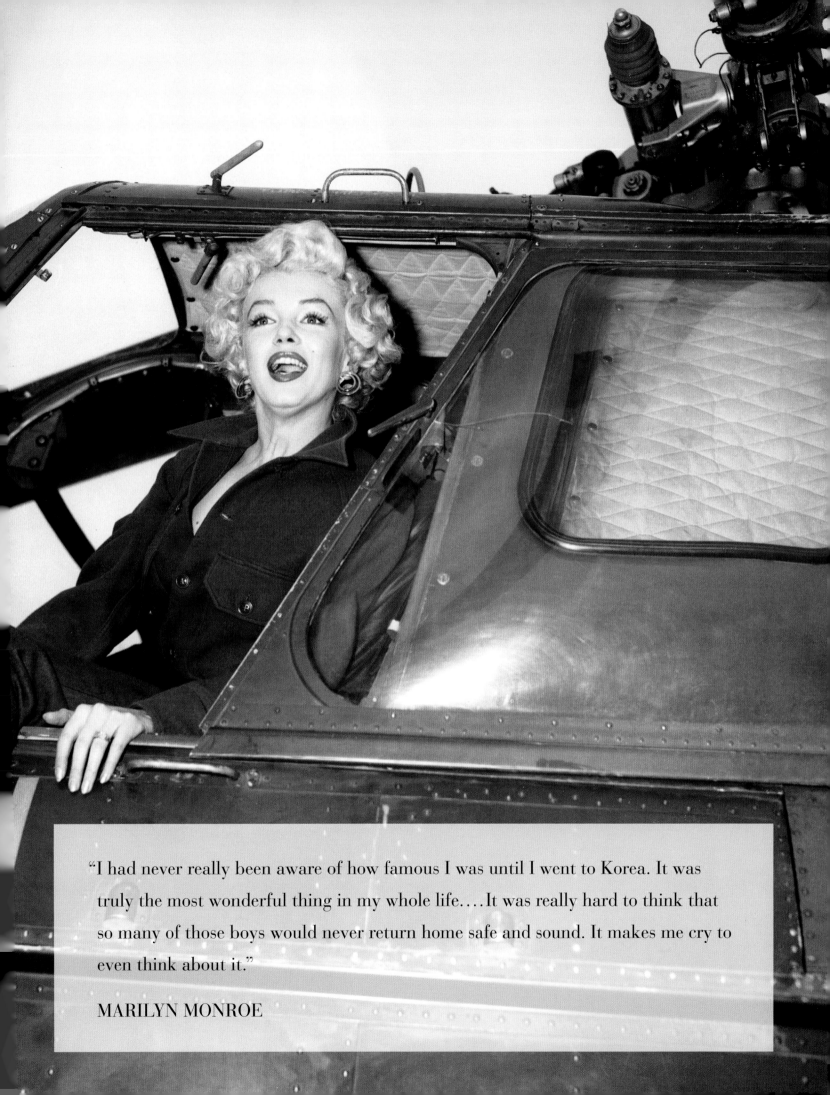

"I had never really been aware of how famous I was until I went to Korea. It was truly the most wonderful thing in my whole life....It was really hard to think that so many of those boys would never return home safe and sound. It makes me cry to even think about it."

MARILYN MONROE

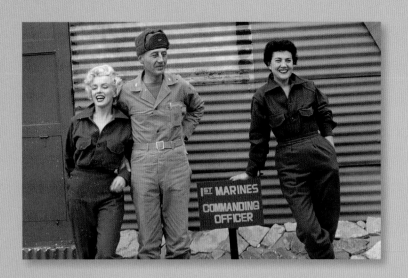

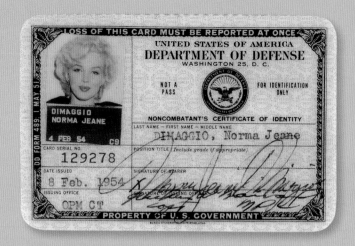

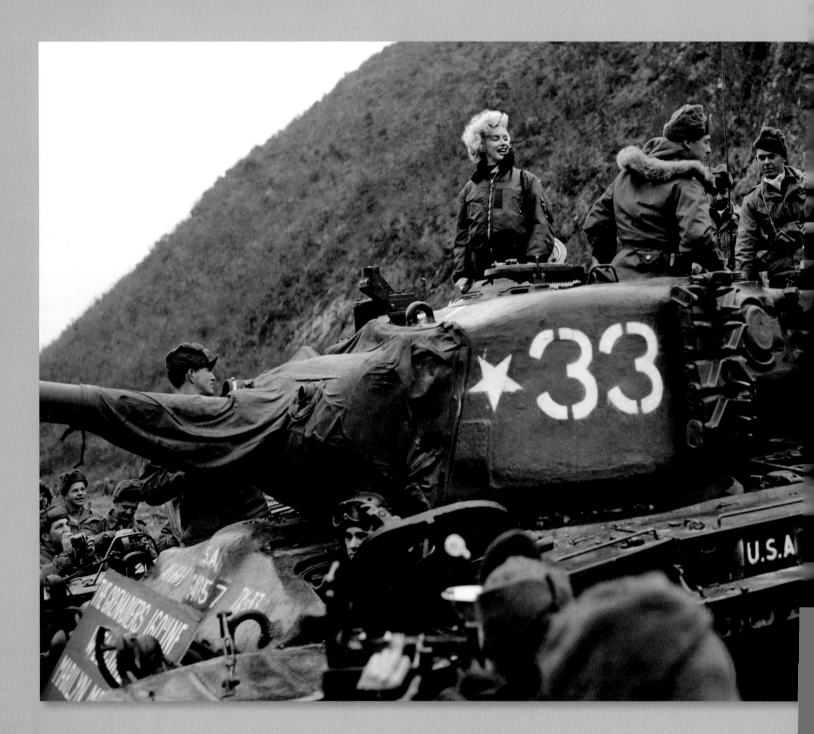

(Clockwise from top left) Marilyn with Col. William K. Jones, 1st Marine Regiment, and Jean O'Doul, Korea, February 21, 1954; Marilyn's U.S. Department of Defense ID card; visiting the 2nd Division Club, February 19, 1954; Korea, February 1954; riding in an American tank, February 1954.

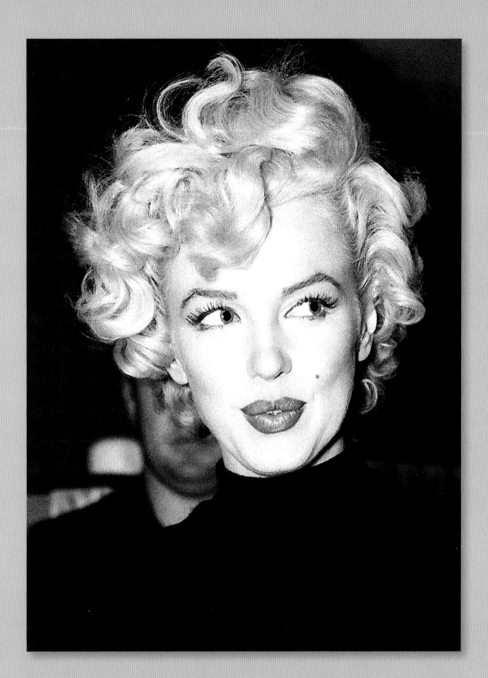

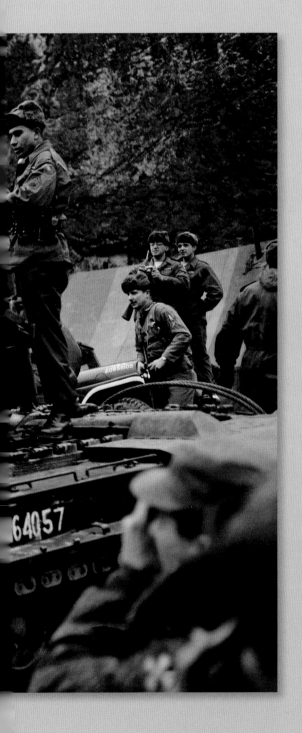

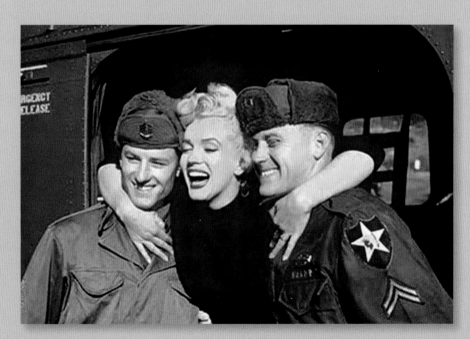

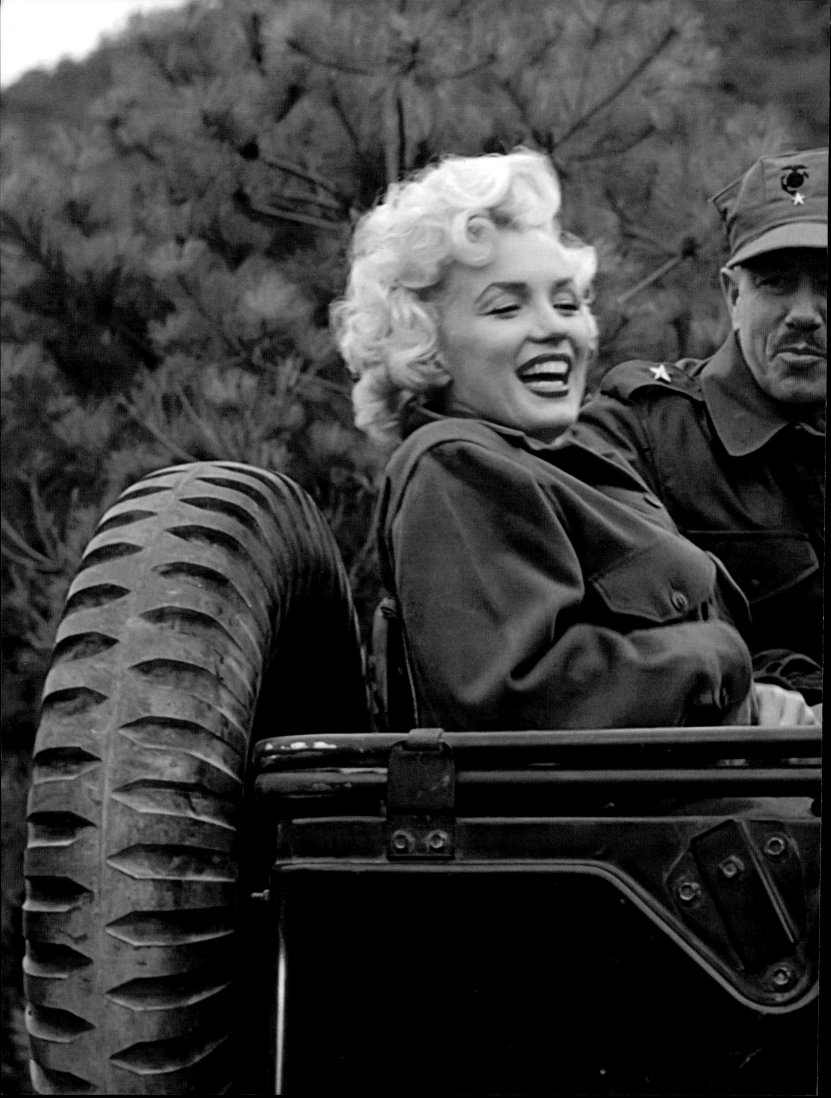

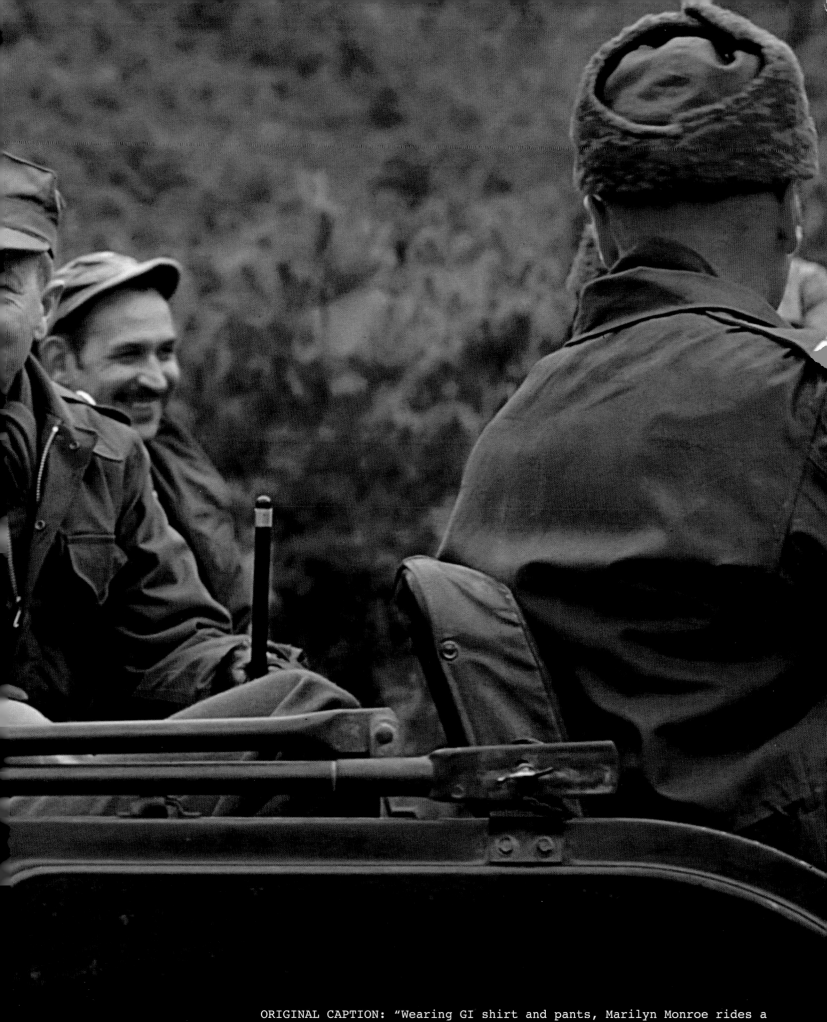

ORIGINAL CAPTION: "Wearing GI shirt and pants, Marilyn Monroe rides a jeep with Brigadier General Robert Hogaboom, who acted as her escort during one of her shows for troops in Korea. February 20, 1954."

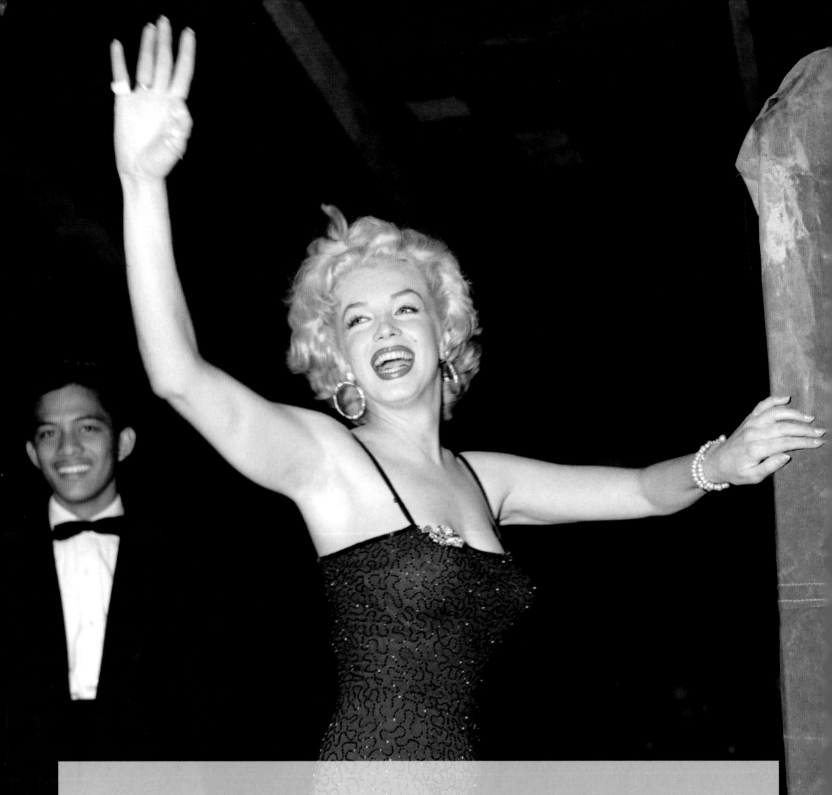

"This wasn't an obligation she had to fulfill, and it wasn't self-promotion. Of all the performers who came to us in Korea . . . she was the best. When a few of us photographers were allowed to climb up on the stage after her show, she was very pleasant . . . and told us how glad she was to be with us. She took her time, speaking with each of us about our families and our civilian jobs. It was bitter cold, and she was in no hurry to leave."

TED CIESZYNSKI (Army Corps of Engineers photographer)

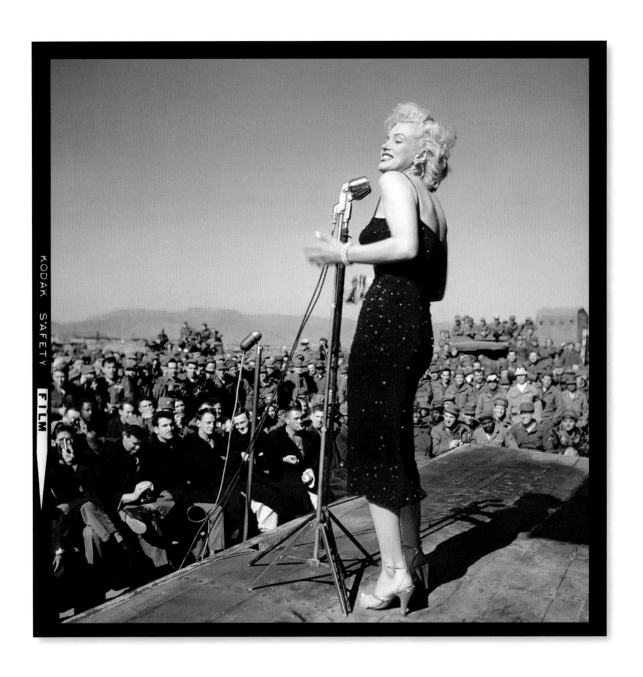

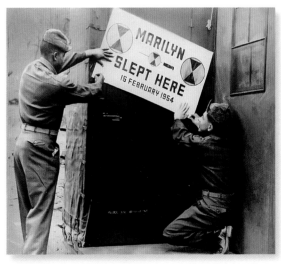

(Opposite) Marilyn at a night show for the 25th Marine
Division, February 18, 1954. Photo by Walt Durrell.
(Top) Performing onstage, Korea. (Right) U.S. troops
posting a sign at Marilyn's sleeping quarters, Korea.

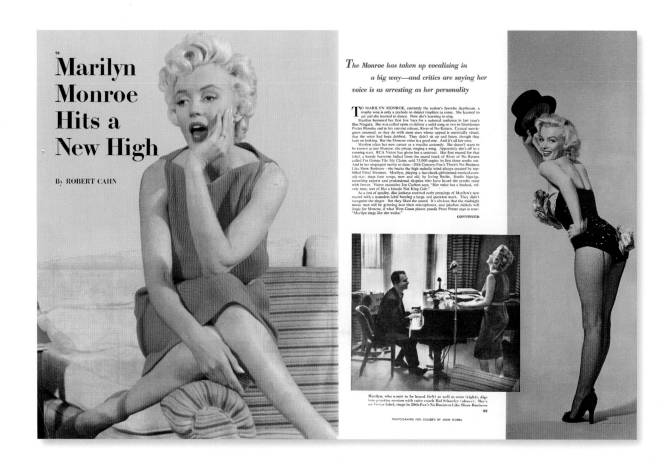

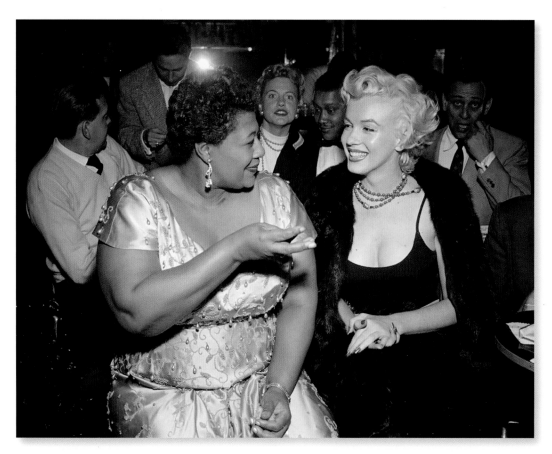

(Top) *Collier's*, July 9, 1954. (Bottom) ORIGINAL CAPTION: "February 19, 1954—Hollywood, California: Marilyn meets Ella. Looking fit and well-groomed after her recent hospitalization, actress Marilyn Monroe (right) attends a jazz session at the Tiffany Club in Hollywood. Singer Ella Fitzgerald chats with Marilyn, who was escorted by columnist Sidney Skolsky."

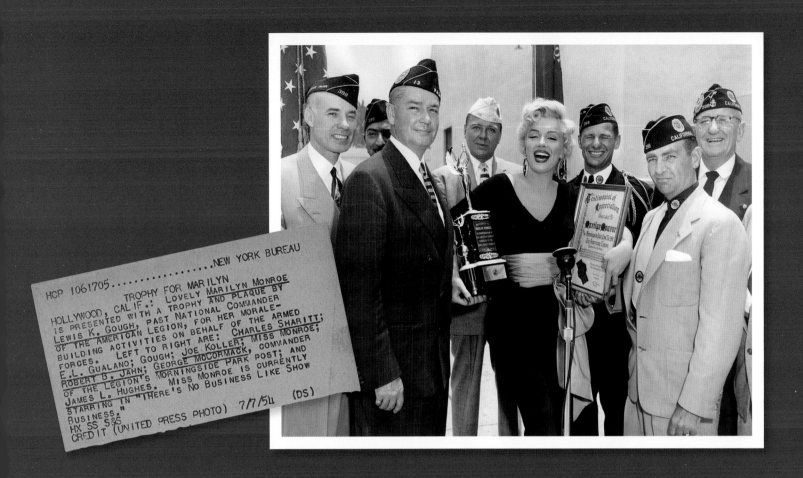

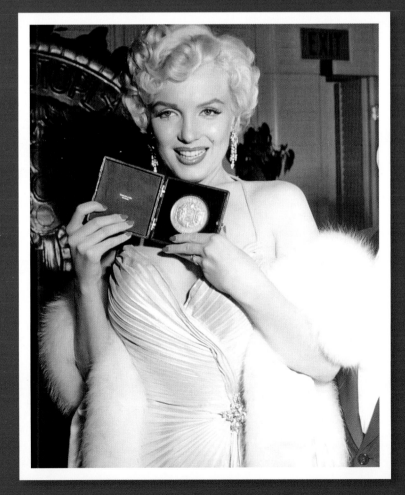

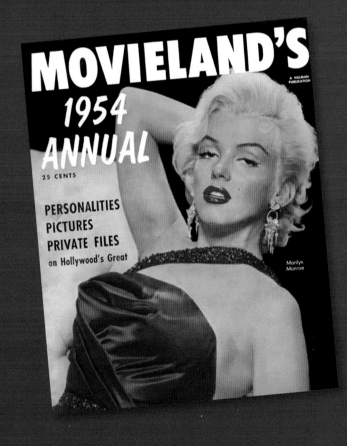

(Top) Receiving trophy and plaque from American Legionnaires, July 7, 1954.
(Bottom left) Receiving the Photoplay Gold Medal Award for Most Popular
Actress of 1953, March 8, 1954. (Bottom right) *Movieland*, 1954.

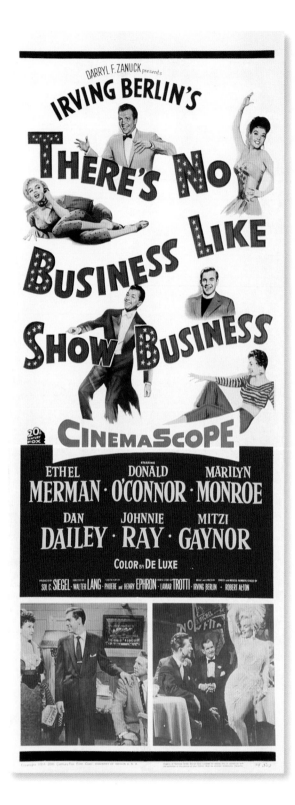

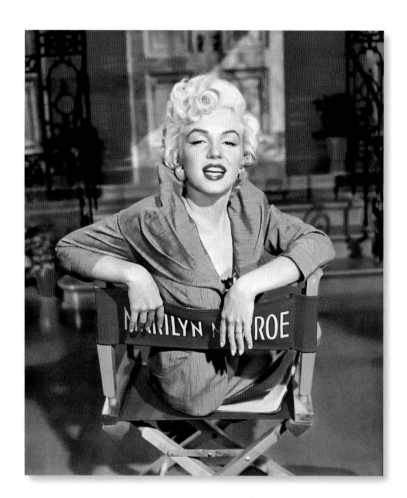

(Left) Insert poster, *There's No Business Like Show Business*, 1954. (Top right) Marilyn on set. (Bottom right) Costume test for the "Heat Wave" musical number. (Opposite) Marilyn as Vicky Parker, with costar Donald O'Connor, 1954.

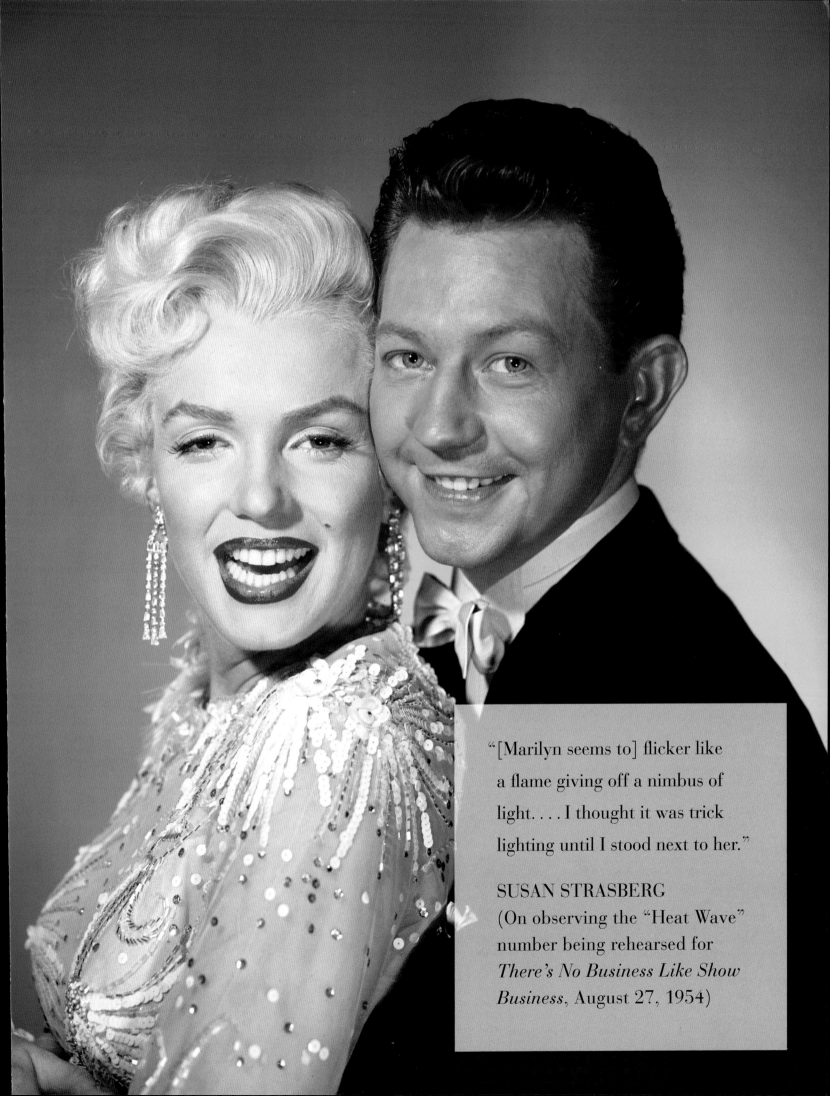

"[Marilyn seems to] flicker like a flame giving off a nimbus of light. . . . I thought it was trick lighting until I stood next to her."

SUSAN STRASBERG
(On observing the "Heat Wave" number being rehearsed for *There's No Business Like Show Business*, August 27, 1954)

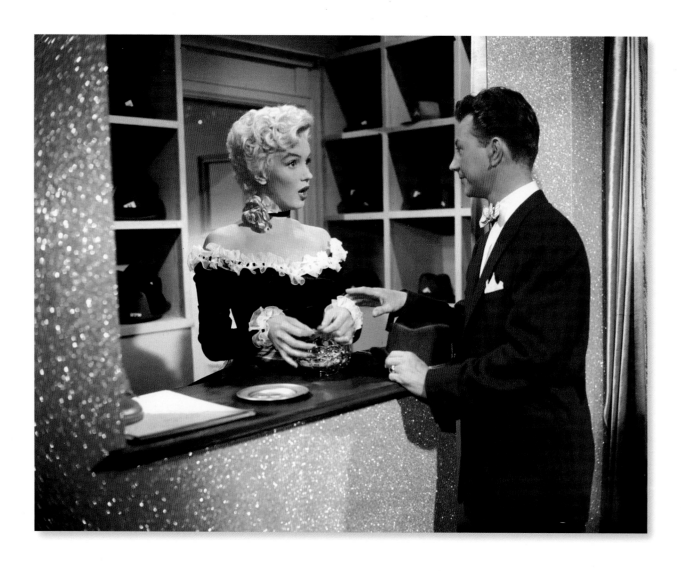

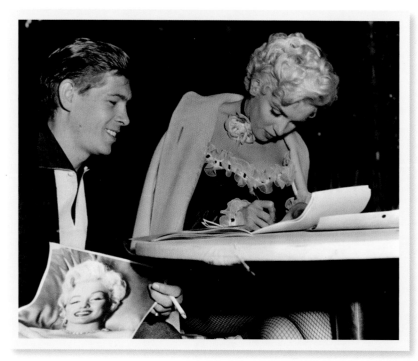

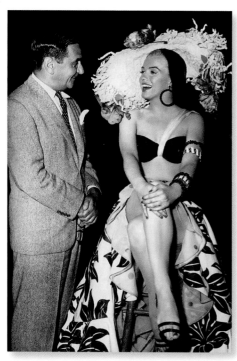

(Top) Marilyn with Donald O'Connor, *There's No Business Like Show Business*, 1954. (Bottom left) With costar Johnnie Ray. (Bottom right) With composer Irving Berlin. (Opposite) With guests on set.

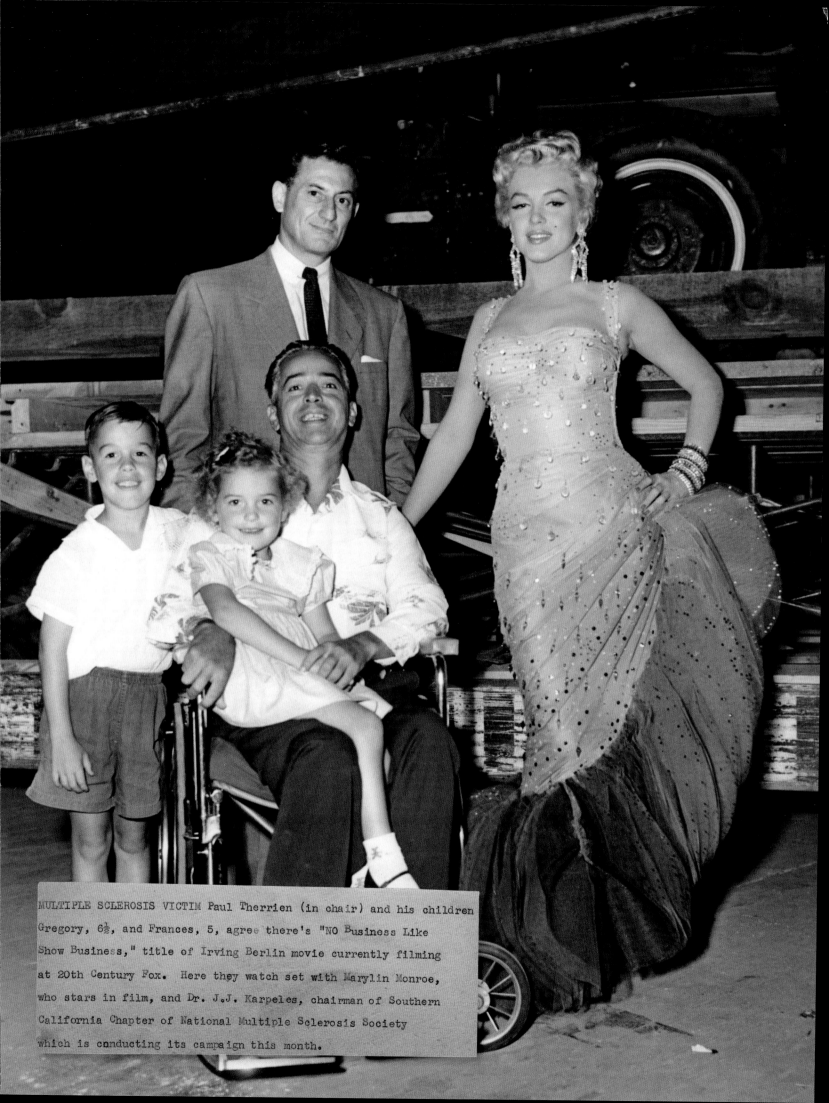

MULTIPLE SCLEROSIS VICTIM Paul Therrien (in chair) and his children
Gregory, 6½, and Frances, 5, agree there's "NO Business Like
Show Business," title of Irving Berlin movie currently filming
at 20th Century Fox. Here they watch set with Marylin Monroe,
who stars in film, and Dr. J.J. Karpeles, chairman of Southern
California Chapter of National Multiple Sclerosis Society
which is conducting its campaign this month.

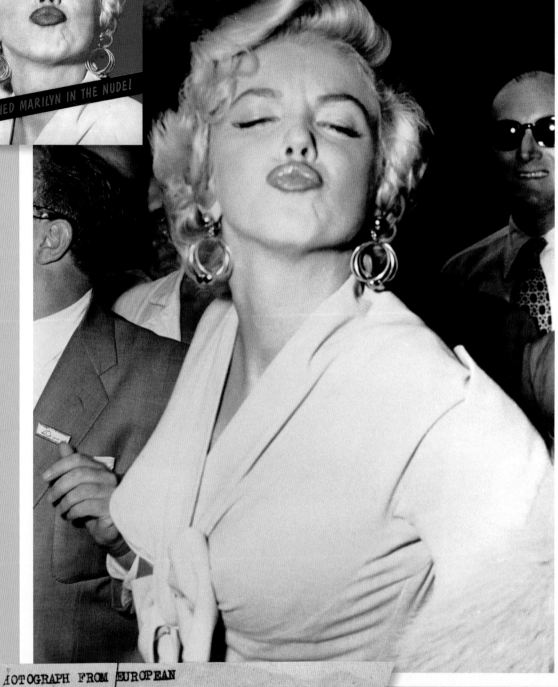

PHOTOGRAPH FROM EUROPEAN

MARILYN MONROE, the luscious blonde actress is in New York
to mix business and pleasure. She will appear in person
at the Roxy Theatre. PHOTO SHOWS: MARILYN MONROE
arrival at La Guardia Airport from Hollywood. 8

(Top left) *Modern Man*, March 1955. (Above) Marilyn arrives in New York to begin
work on *The Seven Year Itch*, September 10, 1954. Photo by Weegee. (Opposite)
Waving to fans and the press on her arrival at Idlewild Airport, New York.

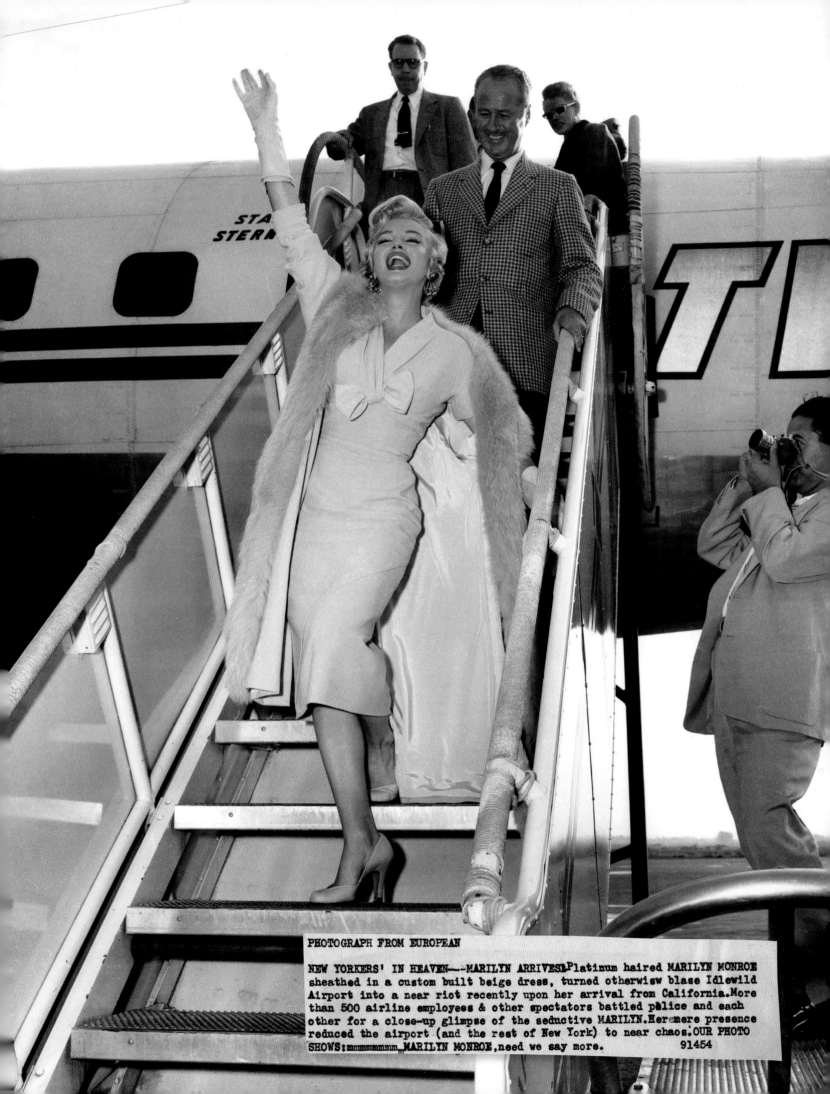

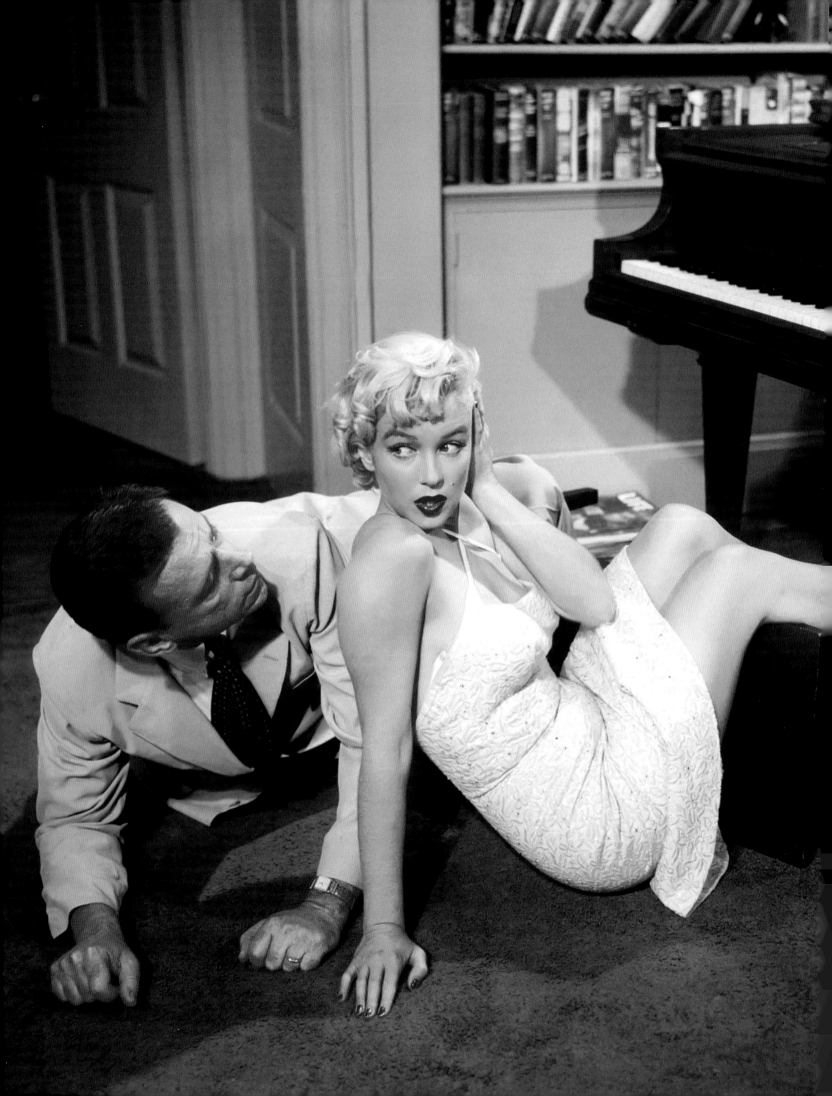

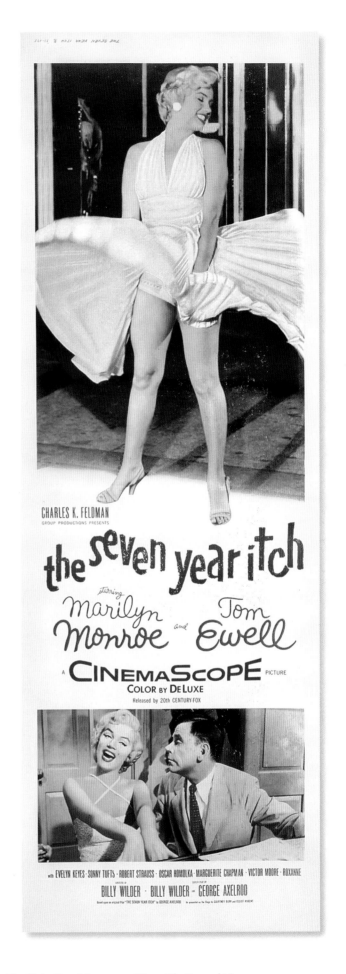

(Left) Marilyn as The Girl, with
costar Tom Ewell, *The Seven Year
Itch*, 1955. (Above) Insert poster,
The Seven Year Itch.

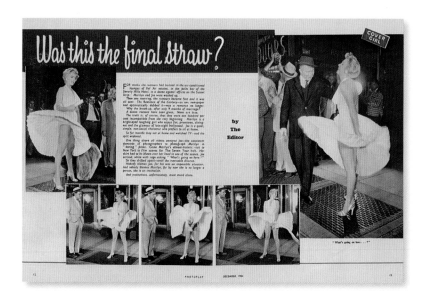

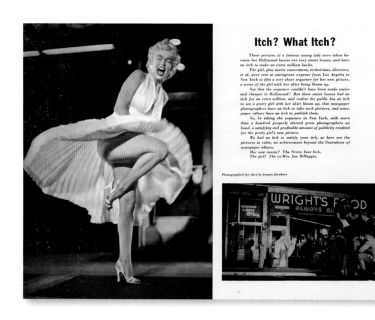

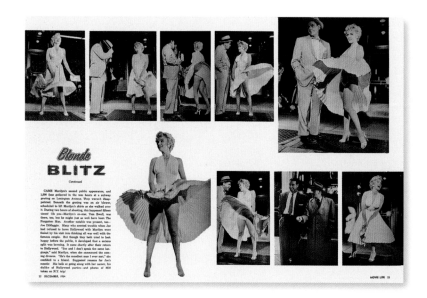

(Top) *Photoplay*, December 1954. (Center) *True*, January 1955.
(Bottom) *Movie Life*, December 1954. (Right) On location,
The Seven Year Itch, New York, September 15, 1954.

146

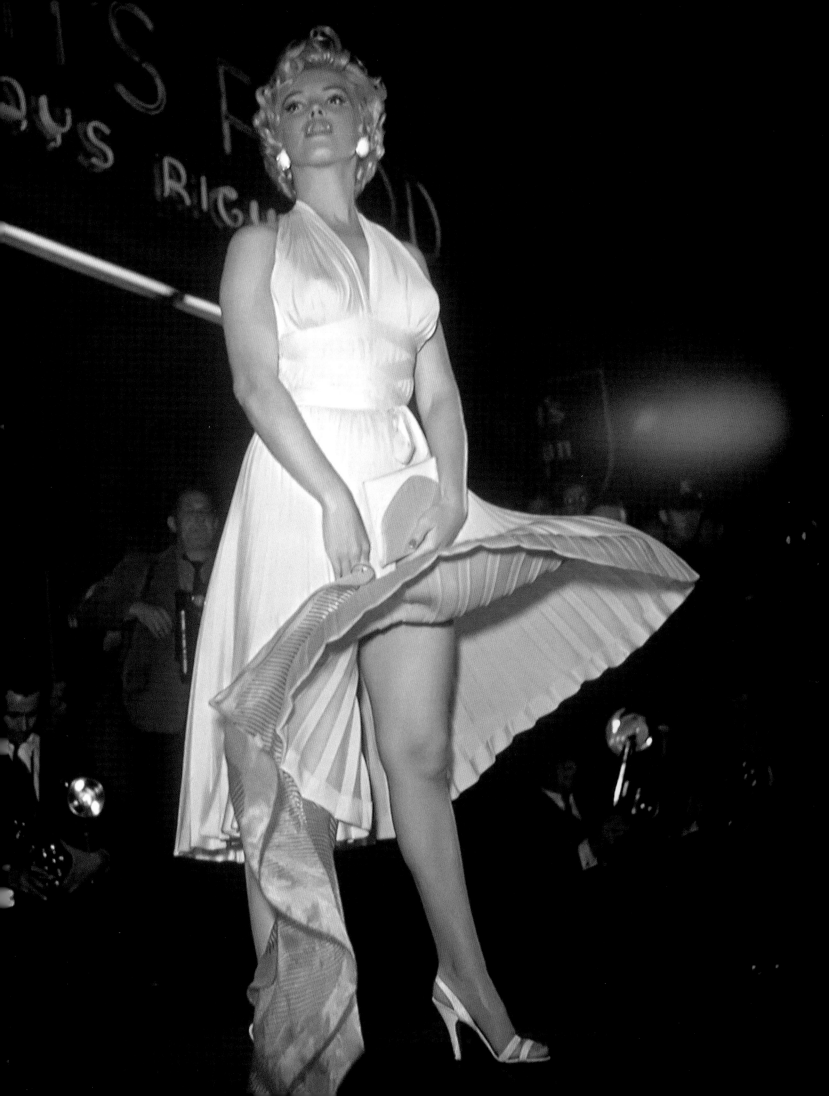

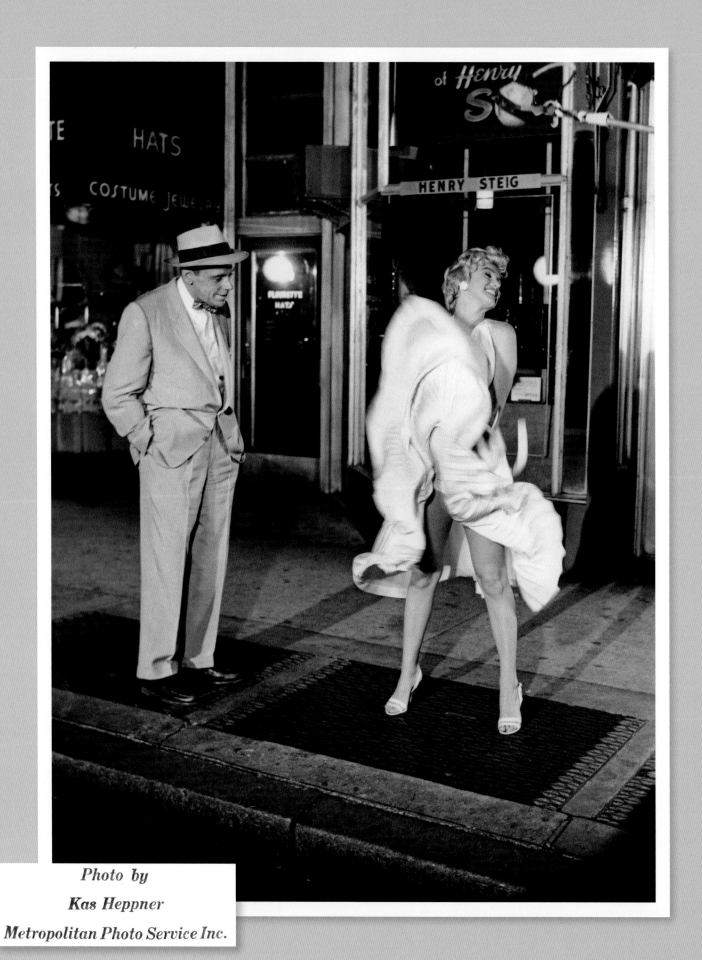

(Above) Marilyn with Tom Ewell, *The Seven Year Itch*,
New York, September 15, 1954. Photo by Kas Heppner.
(Opposite) Between takes with Tom Ewell.

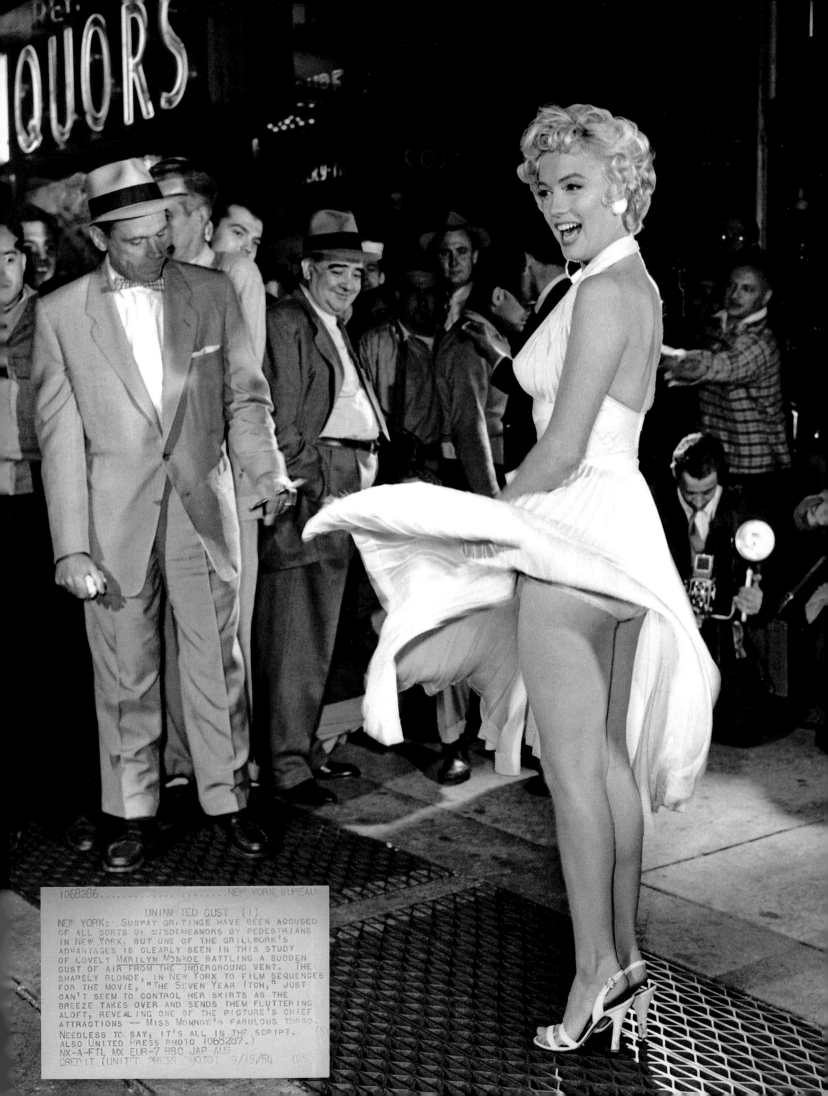

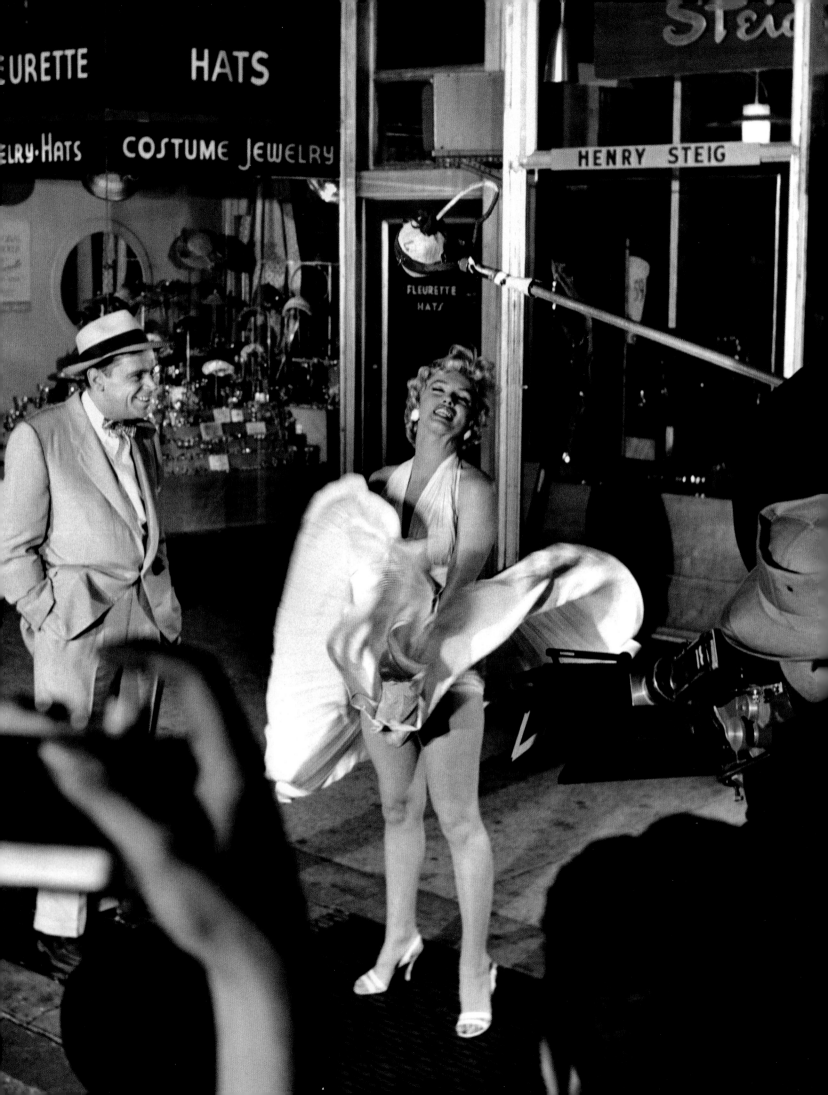

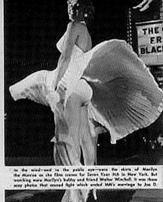

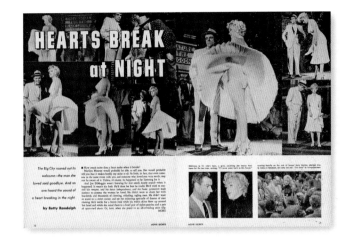

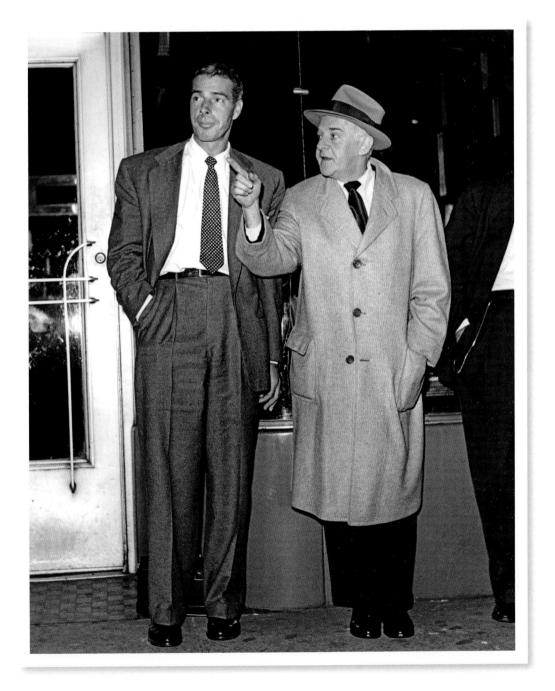

(Opposite) Marilyn with Tom Ewell, *The Seven Year Itch*, New York, September 15, 1954. Photo by Joe Coudert. (Top left) Unidentified magazine article, c. 1955. (Top right) *Movie Secrets*, February 1955. (Above) Joe DiMaggio on set with columnist Walter Winchell. Photo by Bernard of Hollywood.

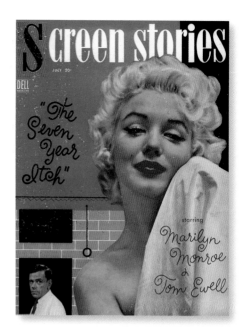

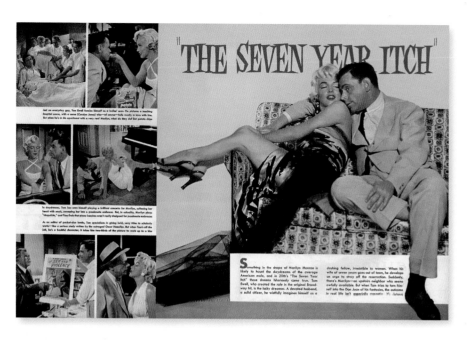

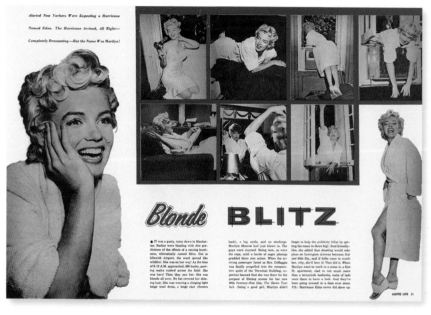

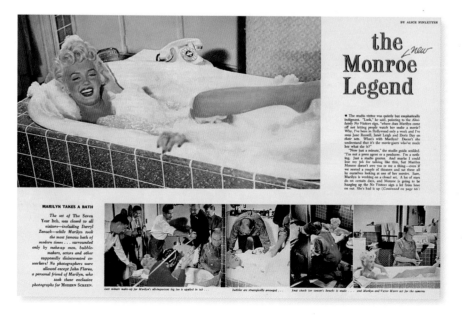

(Top) *Screen Stories*, July 1955; *Photoplay*, July 1955. (Middle) *Movie Life*, December 1954; *Filmland*, December 1954. (Bottom) *Who's Who in Hollywood*, December 1955; *Modern Screen*, March 1955. (Opposite) *Le Ore*, 1955; *Correo de la Radio*, August 1955; *Ricu Ritas*, 1955.

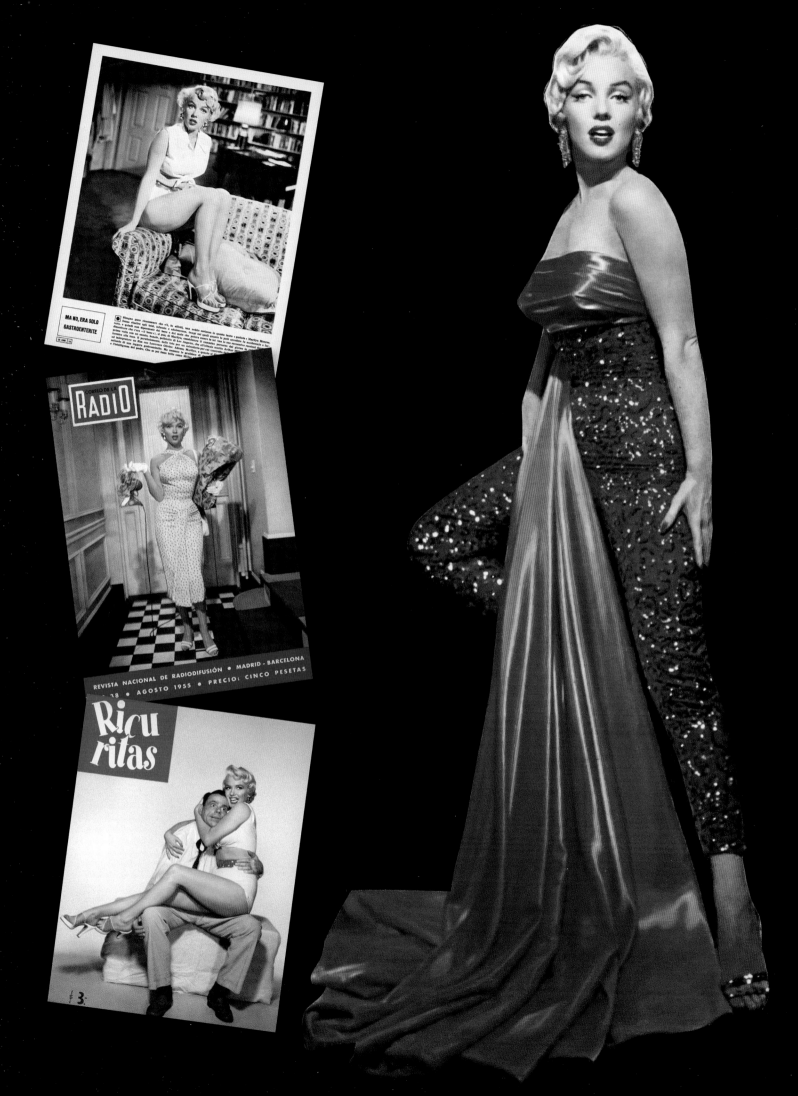

MA NO, ERA SOLO
GASTROENTERITE

CORREO DE LA
RADIO

REVISTA NACIONAL DE RADIODIFUSIÓN • MADRID - BARCELONA
38 • AGOSTO 1955 • PRECIO: CINCO PESETAS

Ricu
ritas

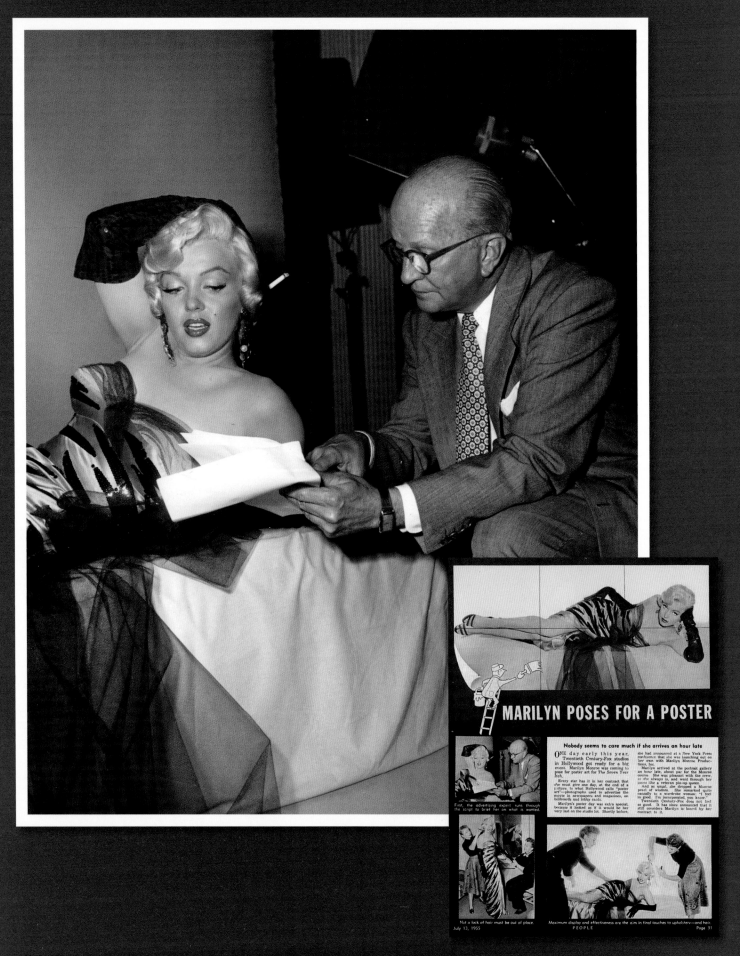

(Top) Marilyn is briefed by an advertising official prior to a poster photo shoot for *The Seven Year Itch*, 1955. (Bottom) *People Today*, July 13, 1955. (Opposite) Marilyn on the set of *The Seven Year Itch*, 1954. Photo by Frank Hurley.

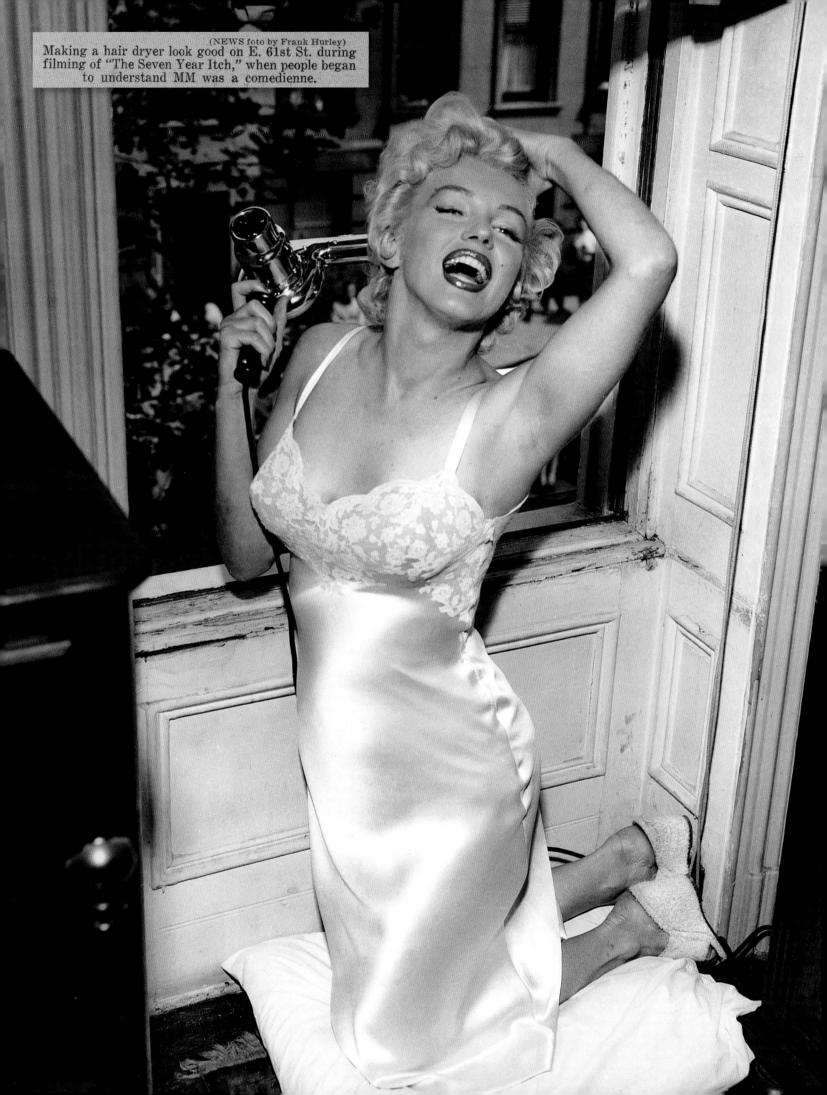

Making a hair dryer look good on E. 61st St. during filming of "The Seven Year Itch," when people began to understand MM was a comedienne.

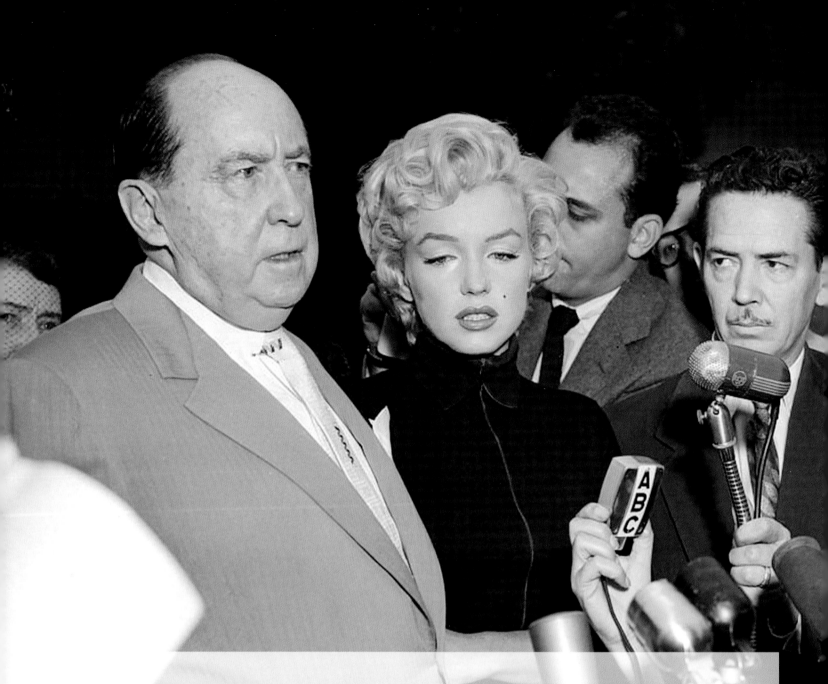

"The public was all worked up, and the press was, too, and they're circling the house like Indians loping around a wagon train, waiting for somebody to poke a head out. . . . and what would Snow White say when she was breaking up with Prince Charming?. . . So forty or fifty of the press congregated. In addition, there were several hundred volunteer reporters and photographers in the trees and trampling the lawn. The newsreel guys were grinding away [as] Marilyn came down the stairs sobbing. A lady columnist kicked the crime reporter for the *Los Angeles Mirror*."

FLACK JONES (Fox publicist, describing the scene as the press swarmed the rented home of Marilyn and Joe DiMaggio on Palm Drive in Beverly Hills, waiting for news on the state of the couple's marriage, October 6, 1954)

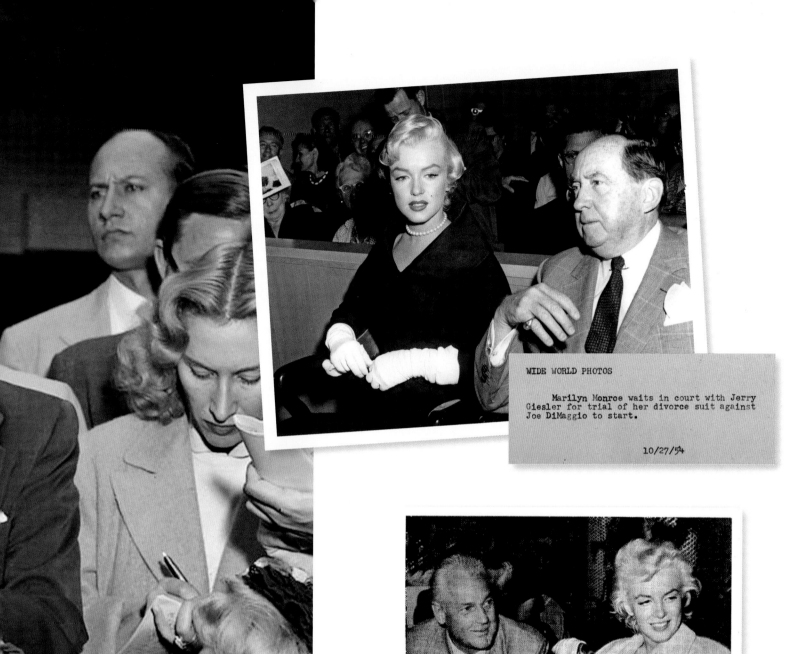

TOUSLED TEMPTRESS—Marilyn Monroe has a wind-blown look with her famous blonde hair tousled as she chats with ex-screen star Charles Farrell in his fashionable Palm Springs (Cal.) Racquet Club. (UP Photo)

(Left) ORIGINAL CAPTION: "October 7, 1954, Beverly Hills, California. Glamour girl Marilyn Monroe DiMaggio holds on to her attorney, Jerry Giesler, as she posed briefly for photographers after leaving the Beverly Hills home which Joe leased as a 'Honeymoon Cottage' nine months ago. Miss Monroe has filed suit for a divorce on the grounds of 'Mental Cruelty' against the Yankee Clipper." (Top) With attorney Jerry Giesler at her divorce trial, October 27, 1954. (Bottom) With Charles Farrell, Palm Springs Racquet Club, December 4, 1954.

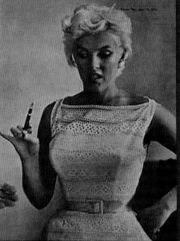

COME-HITHER VOICE? THAT'S A THING OF THE PAST. A PRESIDENT'S GOT TO WATCH HER STEP.

Marilyn is Big Business

As all the world knows Marilyn Monroe has turned herself into a limited company. JACK WINOCOUR takes a look at its assets and describes their owner's transformation from pinup to president and the co-star-to-be of Sir Laurence Olivier.

Photographed by EVE ARNOLD

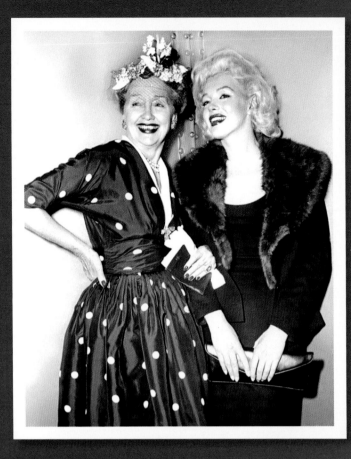

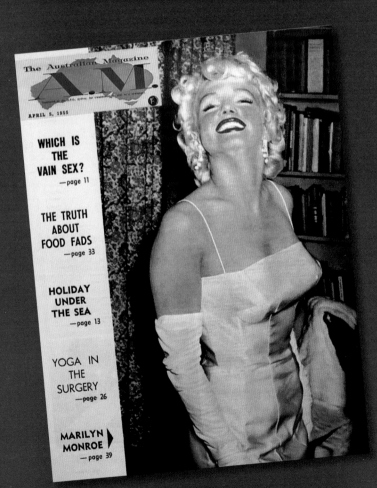

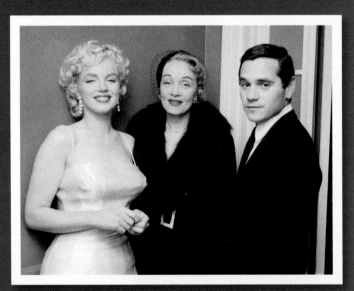

She's a Producer Now Actress Marilyn Monroe enjoyed being the center of attraction in New York (as the picture above will attest). Dressed in a dazzling skin-tight white satin sheath dress, Miss Monroe held a conference to announce formation of Marilyn Monroe Productions, Inc., with herself as president of the film company. Denying she still was under contract to 20th Century Fox, Miss Monroe said her new firm would "go into all fields of entertainment."

(Clockwise from top left) *Picture Post*, 1955; with Hedda Hopper, April 26, 1955; with Marlene Dietrich and Milton Greene following a press conference to announce the formation of Marilyn Monroe Productions, New York, January 8, 1955; *A.M.*, April 5, 1955. (Opposite) At Madison Square Garden, New York, March 30, 1955.

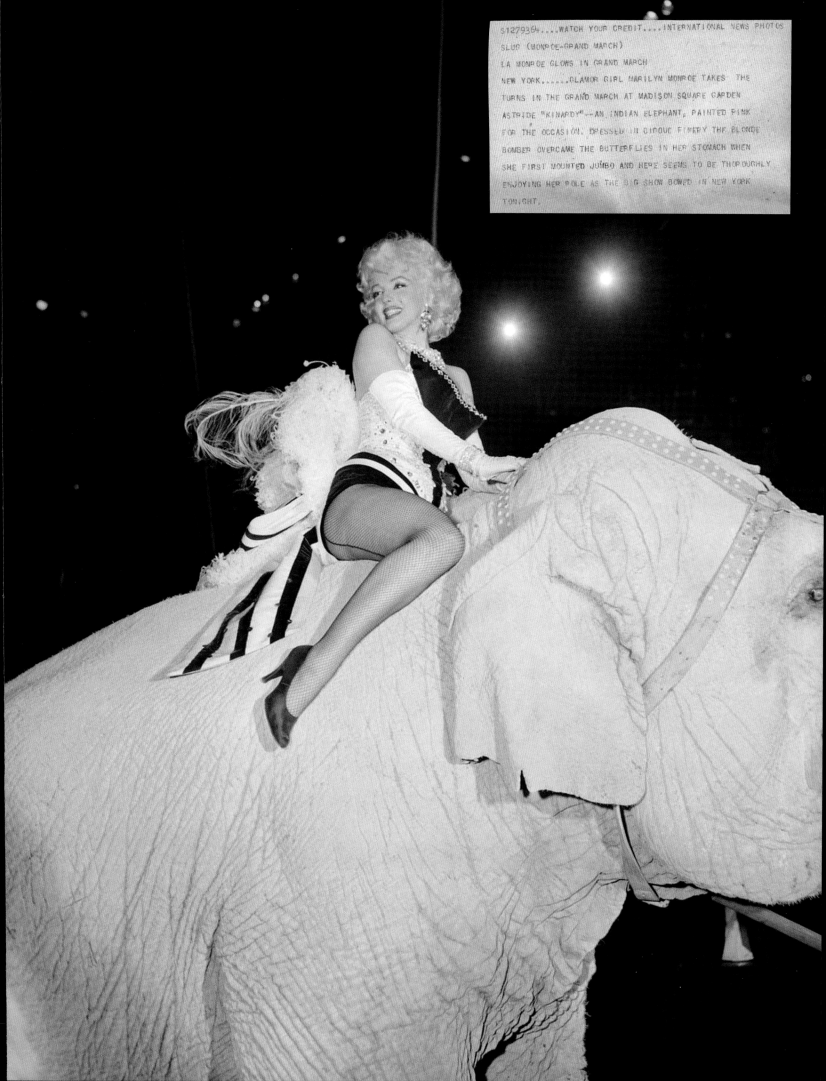

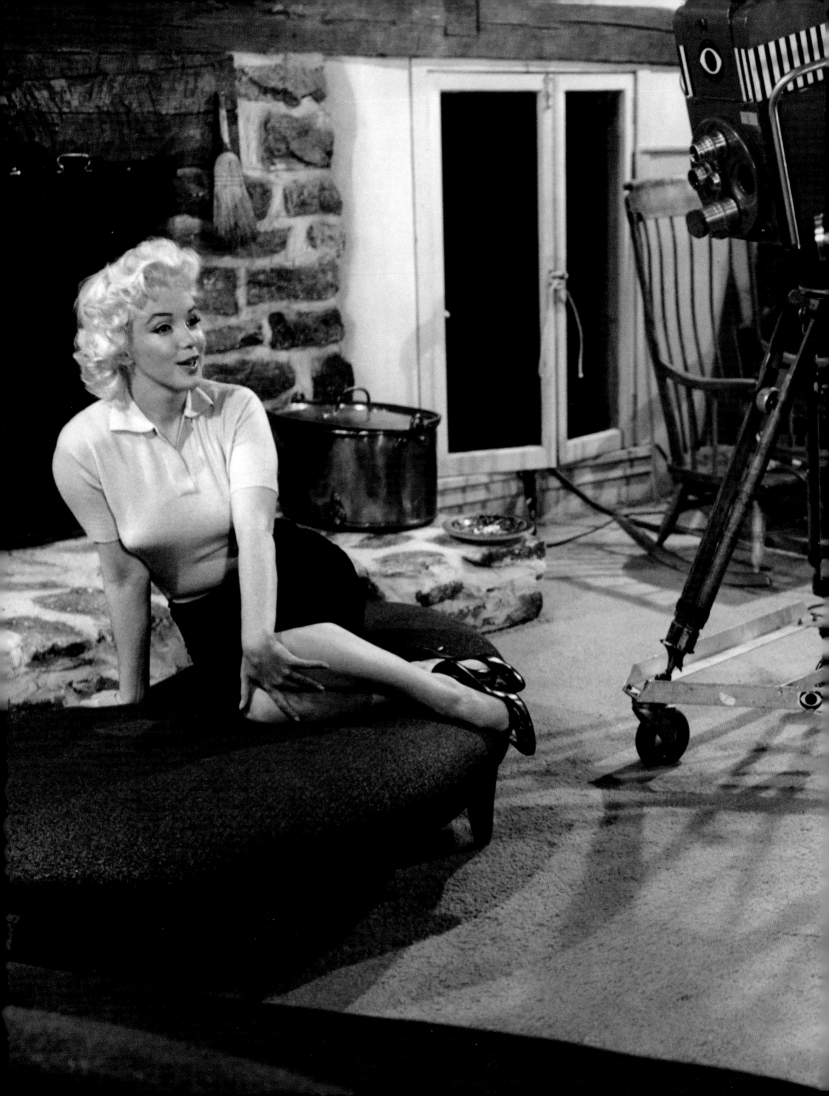

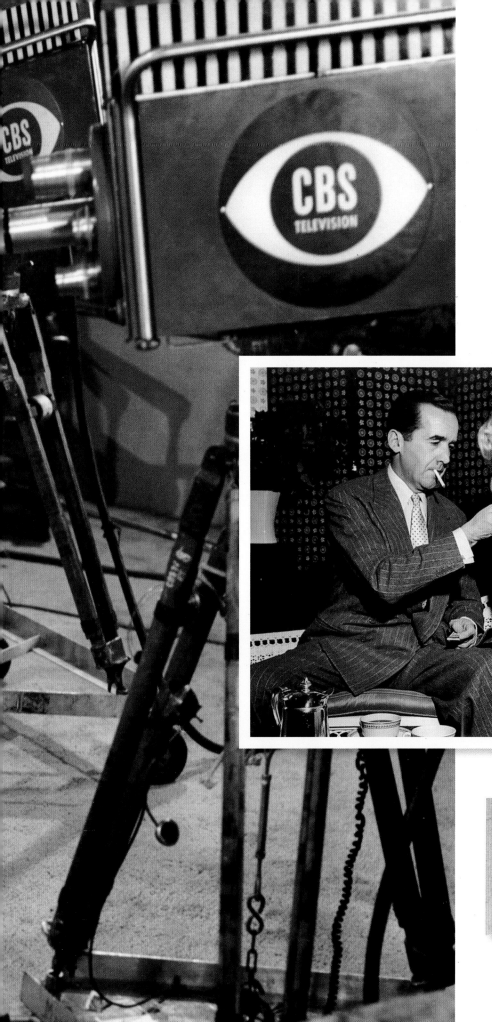

(Left) Marilyn on *Person to Person*, April 1955. (Below) With the program's host broadcast journalist Edward R. Murrow.

161

The strange new life of
Marilyn Monroe

Typical of New York literati parties which Marilyn now prefers is Actors' Studio party. In simple dress, little make-up, she mixes with shirt-sleeved men and gay girls, eats from paper plates in bare room where arty talk is top lure.

Minus all makeup, Marilyn was so absorbed in class at Actors' Studio she didn't notice cameramen. She is determined to show everyone that she isn't merely a symbol of sex, can really act. Sympathetic understanding she gets here has helped.

MOVIE LIFE 43

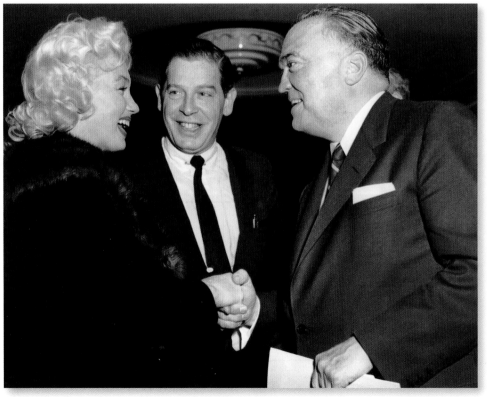

(Top left) Marilyn at the Actors Studio, New York, c. 1956. (Top right) *Movie Life*, March 1956. (Bottom) With Milton Berle meeting J. Edgar Hoover at the annual Banshees Luncheon. Nearly 2,000 of the nation's leading newspapermen were guests at the luncheon held in the grand ballroom of the Waldorf-Astoria, New York, April 26, 1955.

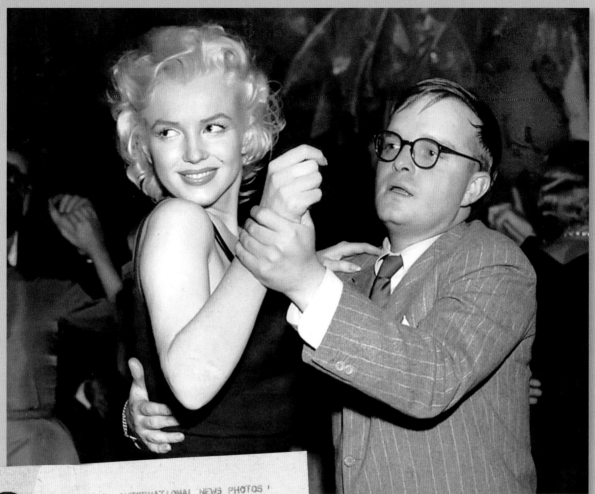

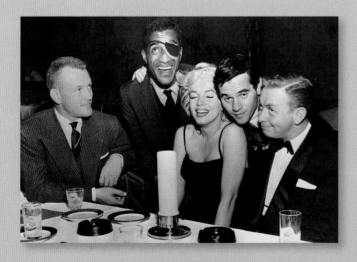

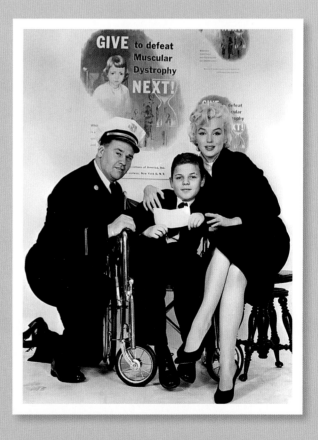

(Top) Marilyn with Truman Capote, at El Morocco, May 24, 1955. (Bottom left) With Jacques Sernas, Sammy Davis Jr., Milton Greene, and Mel Tormé, at the Crescendo nightclub, Los Angeles, December 6, 1954. (Bottom right) Attending the annual Thanksgiving March of Muscular Dystrophy Drive, organized by the International Association of Fire Fighters, November 17, 1955.

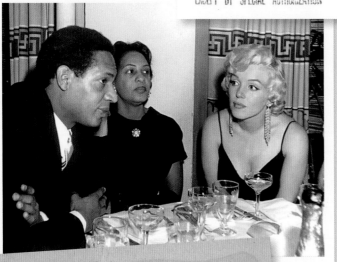

PHOTOGRAPH FROM EUROPEAN

MR. BILL DENBY, who is a writer, and his sister DOROTHY DENBY, who is a Girl Scout leader, are shown with America's sexiest blonde, MARILYN MONROE at the champagne supper party which followed the premier of "The Rose Tattoo" in New York last night. The film stars Burt Lancaster and Itlay's Anna Magnani. 12/13/55

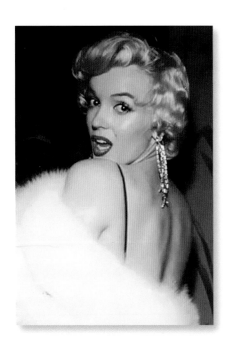

(Top) With William Denby and Dorothy Denby, at the *Rose Tattoo* premiere party, New York, December 13, 1955. (Above) At the premiere. (Near right) With Marlon Brando. (Far right) Arriving at the Astor Theatre, New York.

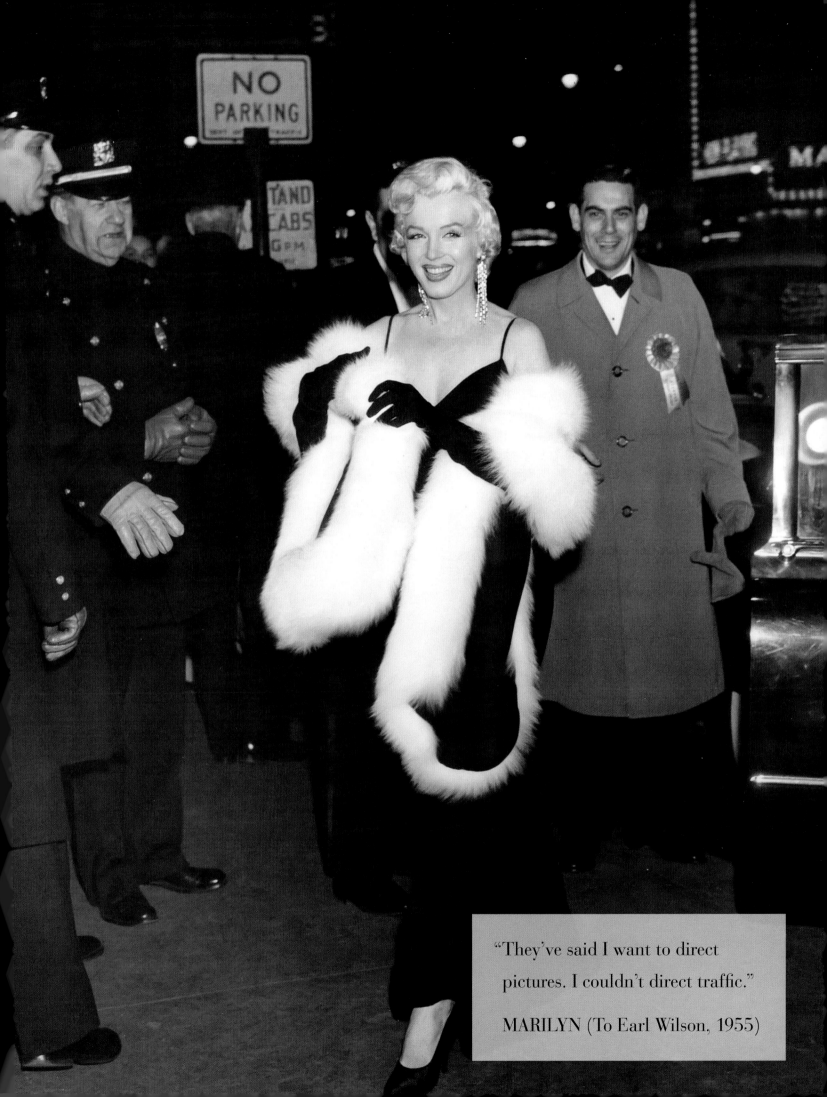

"They've said I want to direct pictures. I couldn't direct traffic."

MARILYN (To Earl Wilson, 1955)

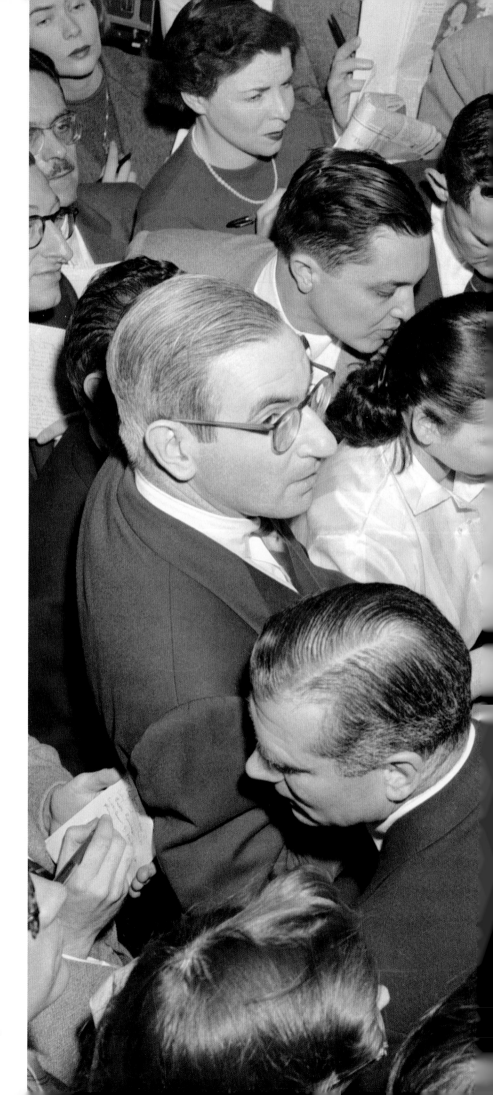

MARILYN STARTS
A NEW DEAL
IN HOLLYWOOD

Camera: Van der Veer
WARNER PATHE NEWS

(Right) Marilyn attends a
press conference to announce
plans to produce *The Prince
and the Showgirl*, Plaza Hotel,
New York, February 9, 1956.

166

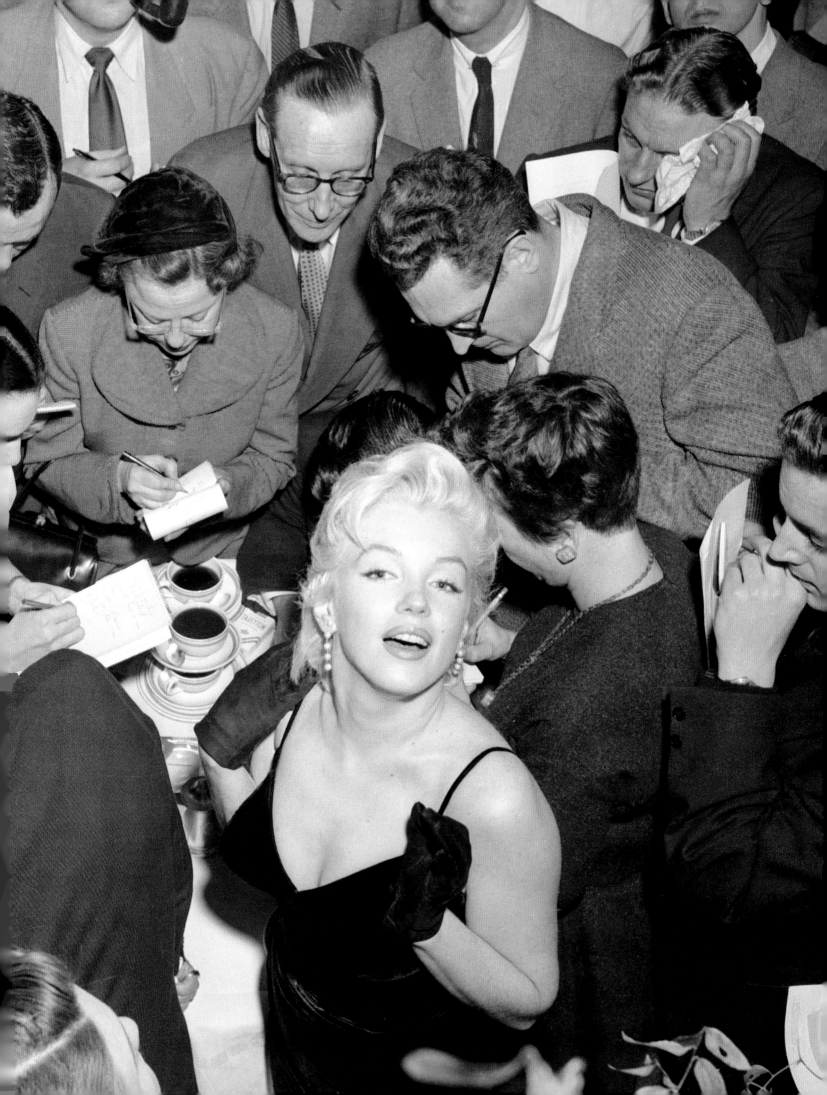

(Top) *The Saturday Evening Post*, May 1956. (Above left) *Movie Life*, April 1956.
(Above right) With journalist Pete Martin, 1956. (Opposite) *Time*, May 14, 1956.

MARILYN: It's good to be back. After all, it's my hometown.

REPORTER: You said you wanted to grow—do you feel you've grown?

MARILYN: Well, I hardly know how to answer that—seeing they can misinterpret that, in inches or something...

REPORTER: Is it true that you submitted a list of directors that you would work with? We only know the rumors we hear, you know.

MARILYN: I would rather say that I have director approval, and that is true.

REPORTER: You think this is important?

MARILYN: Yes, it is very important to me.

REPORTER: You're wearing a high-neck dress. Now the last time I saw you, you weren't. Is this a new Marilyn? A new style?

MARILYN (smiling): No, I'm the same Marilyn—it's just a different suit.

Press conference upon Marilyn's return to Los Angeles from New York for the filming of *Bus Stop*, 1956.

(Opposite) ORIGINAL CAPTION: "February 1956, Hollywood, California. Marilyn talks to reporters following her return to Hollywood to play Chérie in Joshua Logan's film of William Inge's critically acclaimed Broadway play *Bus Stop*."

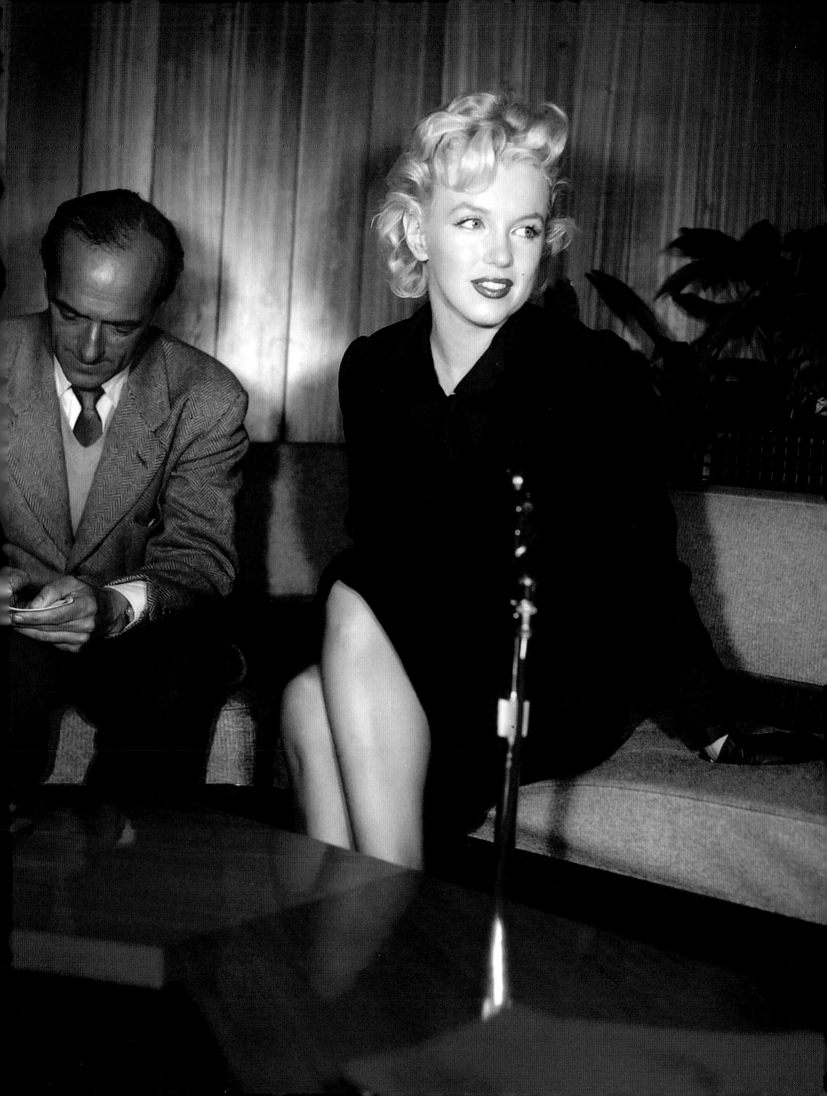

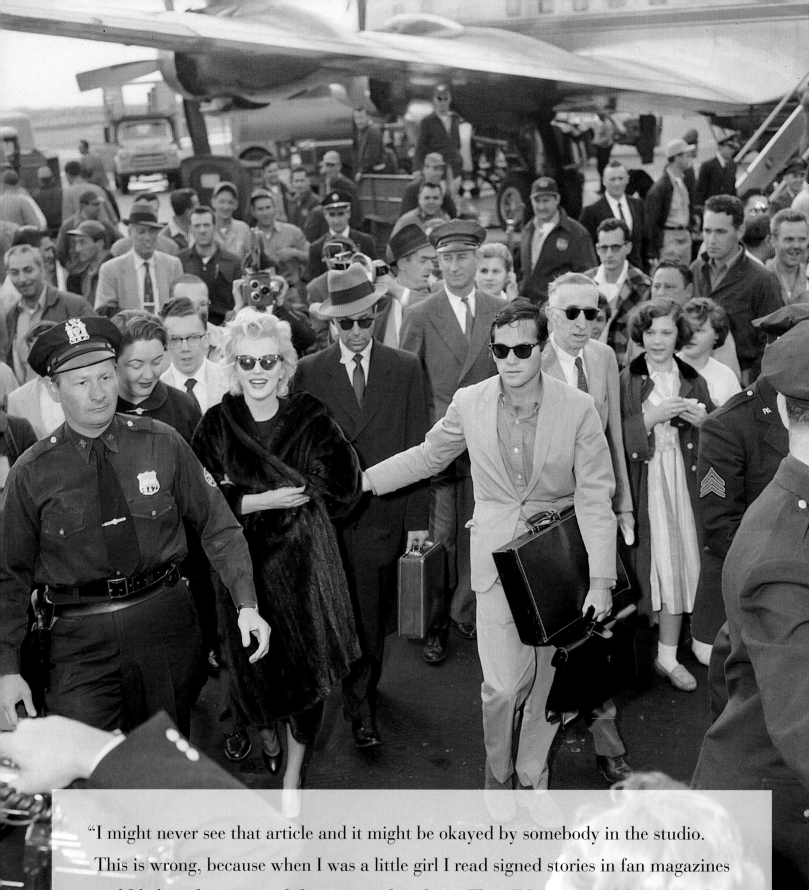

"I might never see that article and it might be okayed by somebody in the studio. This is wrong, because when I was a little girl I read signed stories in fan magazines and I believed every word the stars said in them. Then I'd try to model my life after the lives of the stars I read about. If I'm going to have that kind of influence, I want to be sure it's because of something I've read or written."

MARILYN (To Pete Martin, for the *Saturday Evening Post*, May 5, 1956)

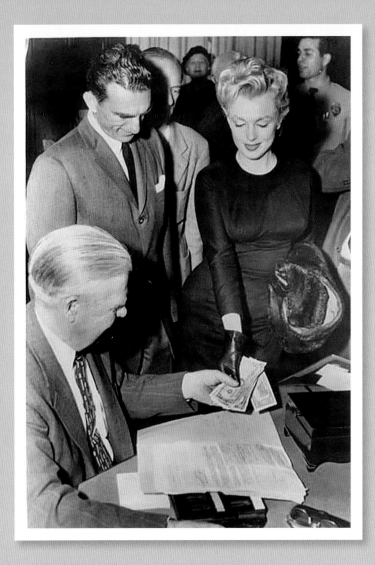

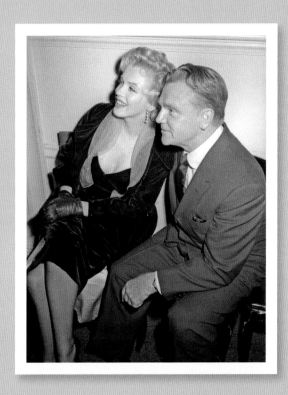

(Opposite) With Milton Greene,
Idlewild Airport, New York, June
2, 1956. (Above) Beverly Hills
Municipal Court, February 29,
1956. (Right) With James Cagney,
at a party given by *Look* magazine,
March 1956. (Below) With Indonesian
president Sukarno and director
Joshua Logan, Beverly Hills Hotel,
June 15, 1956.

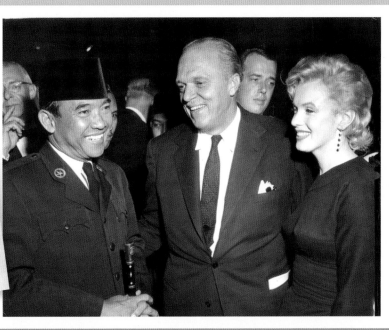

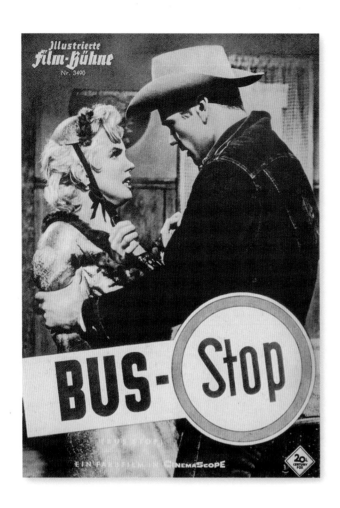

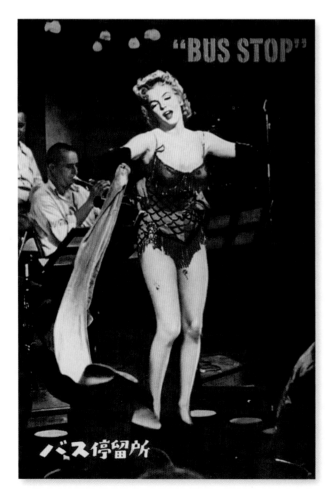

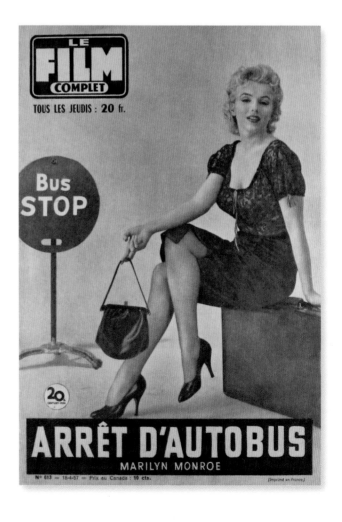

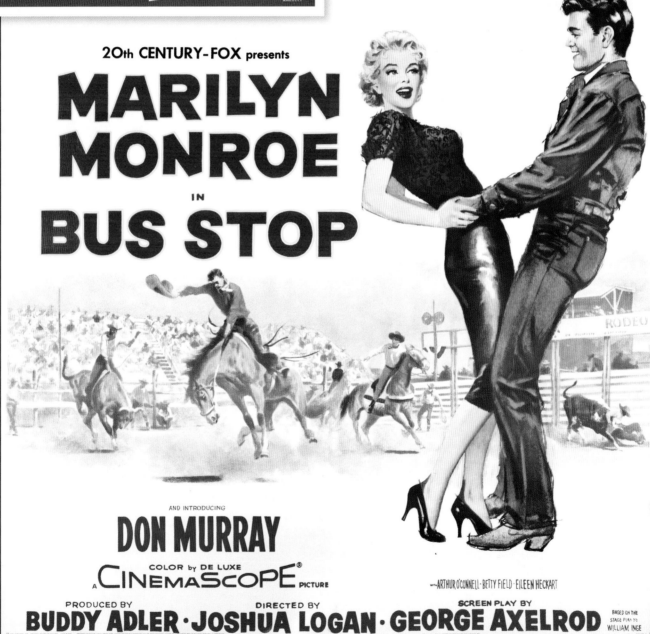

(Opposite, clockwise from top left) *Illustrierte Film-Bühne*; *Kolnoha*, Israeli movie magazine; *Le Film Complet*; Japanese pressbook. (Top) Exhibitors' pressbook, *Bus Stop*. (Bottom) Six sheet poster, *Bus Stop*.

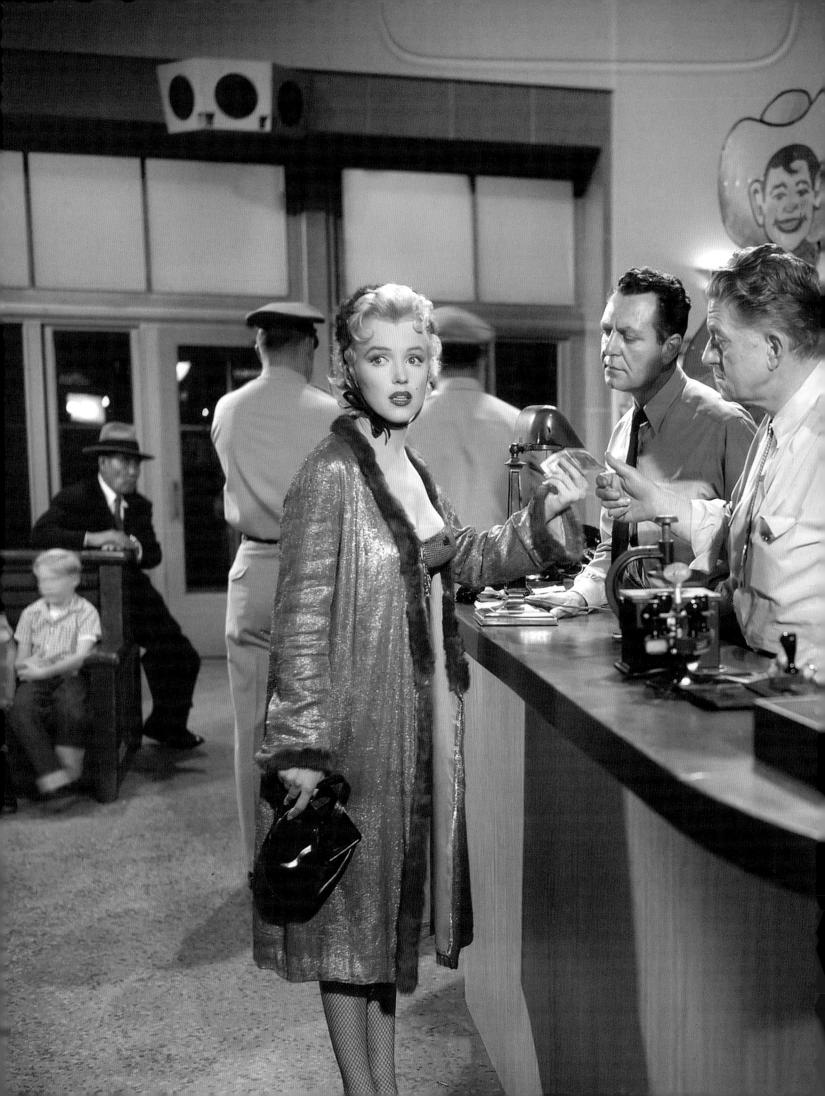

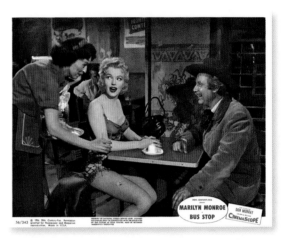

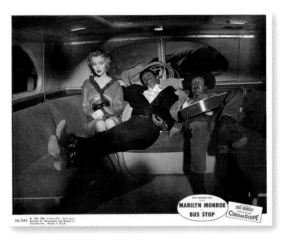

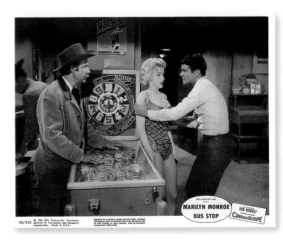

(Left) As Chérie, *Bus Stop*, 1956.
(Above) Lobby cards, *Bus Stop*.

177

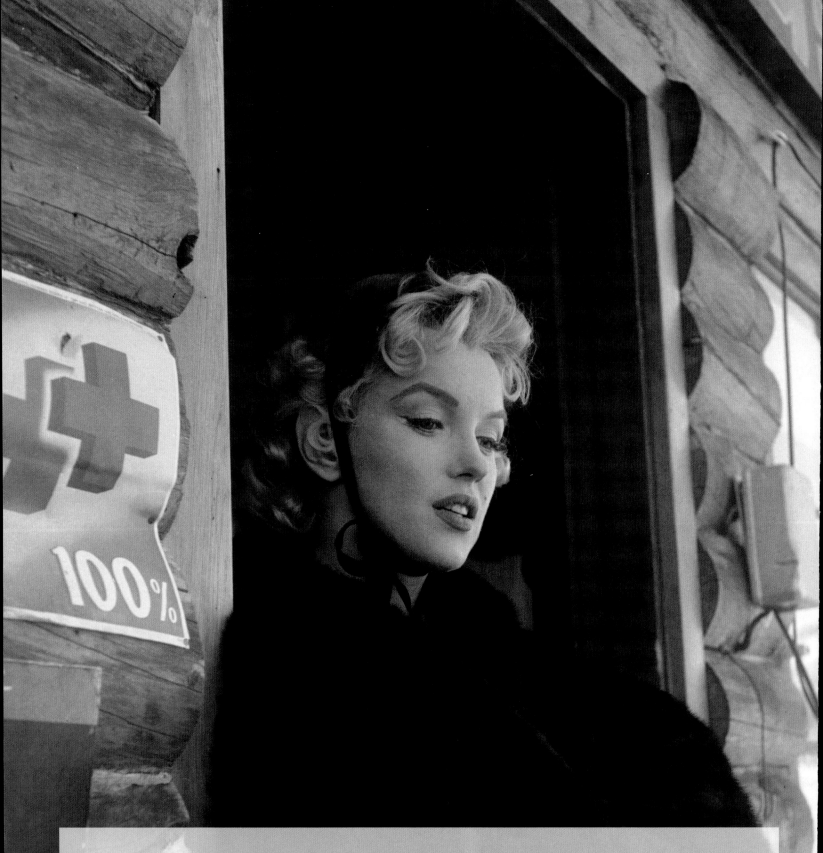

"This is Marilyn's show, and, my friend, she shows plenty in figure, beauty and talent. The girl is a terrific comedienne as the bewildered little 'chantoose' of the honky-tonk circuit. Her stint at the Actors Studio in New York certainly didn't hurt our girl."

DOROTHY MANNERS (Review of *Bus Stop*, in the *Los Angeles Examiner*)

photo by
BOB BEERMAN 1956

PHOTO FROM
PICTORIAL PARADE INC.
formerly PHIL BURCHMAN AGENCY
130 WEST 42nd ST., N. Y. 36, N. Y. OXford 5-0353—4
THIS PHOTOGRAPH IS SOLD FOR ONE TIME USE ONLY,
AND IT MAY NOT BE USED FOR ADVERTISING PURPOSES
WITHOUT THE WRITTEN RELEASE FROM THE SUBJECTS.
THE PHOTO MUST BE RETURNED AFTER PUBLICATION.
PLEASE CREDIT
PICTORIAL PARADE

(Left) On set, *Bus Stop*, 1956.
Photo by Bob Beerman. (Above)
Original 2¼ inch negatives,
taken by Bob Beerman. (Right)
Idaho Journal article about
photographer Bill Bach, 1956.
(Overleaf) Marilyn, Roxbury,
Connecticut, June 29, 1956.

Marilyn Puts Photographer On Hate List

BOISE (UP)— Marilyn Monroe, doing her best to travel incognito and incommunicada, scratched one photographer off her list Friday.

Dressed in toreador pants, a coarse sweater, a Panama hat with the brim turned down and without make-up, Miss Monroe stopped at Boise Municipal airport en route from Sun Valley to Los Angeles. She immediately was surrounded by newsmen.

A very protective Milton Greene, her business associate, said Miss Monroe's picture was not to be taken.

This didn't deter Bill Bach, Idaho Statesman photographer. He cocked his camera and was set to fire when Marilyn shielded herself with her coat. Bach relaxed for a moment then shot from the hip when Marilyn dropped her guard.

"You'll never get another picture of me," Marilyn shouted. Reporters suggested she primp a bit and let Bach shoot again when she was more like her old photogenic self. Again Marilyn said no and Greene concurred.

Miss Monroe just finished shooting winter scenes near Sun Valley for her new movie, "Bus Stop."

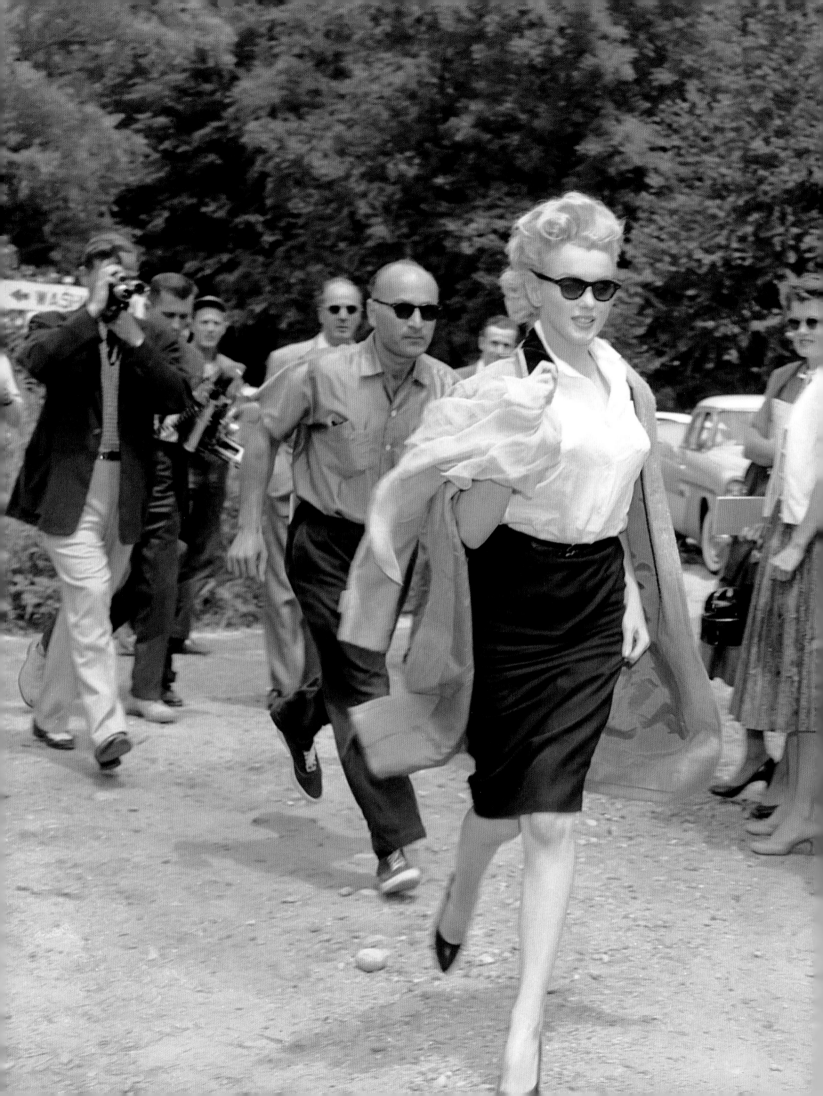

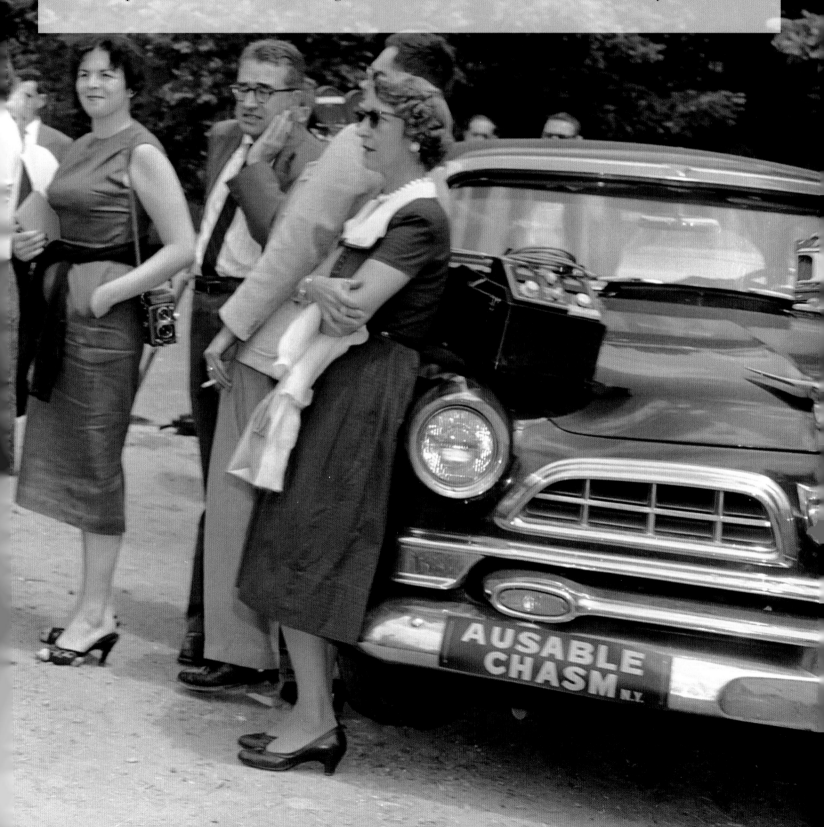

ORIGINAL CAPTION: "June 29, 1956, Roxbury, Connecticut. A group of press representatives stand by watching Marilyn Monroe rushing to the home of her groom to be playwright Arthur Miller. Miss Monroe was ashen faced and quivering after witnessing a car accident in which a pair of magazine correspondents were racing to catch up with Miller and Monroe as they headed for Miller's home. Sarah Scherbatoff, correspondent for the French magazine *Paris Match*, died later from her injuries."

5 NEW YORK POST, WEDNESDAY, MAY 9, 1956

Will Marilyn Marry Arthur Miller?

YES

By SIDNEY SKOLSKY

Hollywood, May 9—There IS a romance between Marilyn Monroe and Arthur Miller.

I can't say where or when the wedding will take place, but as it looks now I would bet there will be one.

While Marilyn was ill and in the hospital recently, Miller phoned her every day—even on those days when she wasn't allowed any visitors and wasn't supposed to talk in order to protect her voice.

Their shortest conversation was half an hour long.

Of course, Marilyn insists there is no romance. They're just good friends—that's what they both say.

But it's my opinion that if things continue as they are, Marilyn and Arthur will be married.

NO

By JOSEPH KAHN

Are you, Mr. Miller?

"I don't have any plans to get married to ANYONE," said Arthur Miller, the Pulitzer Prize playwright.

The author of "Death of a Salesman," biding his time at a rustic Reno, Nev., cabin until a divorce from his first wife comes through, pooh-poohed reports that he would cast himself as bridegroom to Marilyn Monroe.

"If anyone says that there is romance between us, it just wouldn't be true," he told The Post by telephone.

"I've talked with her on the phone several times in the last few weeks, but I haven't seen her for some time. I haven't the faintest idea where these rumors started."

MAYBE

By EARL WILSON

One principal in the Marilyn Monroe-Arthur Miller romance came right out and admitted today that he didn't know whether they were going to get married.

"Nobody tells me anything—least of all my friend Arthur Miller," said poet-playwright Norman Rosten.

Described as the Cupid of the affair, Rosten said:

"We knew Marilyn through Cheryl Crawford and she was here when Arthur dropped in. It turned out they had met in Hollywood."

Rosten's wife, Hedda, was skeptical about the suggestion that Marilyn's frequent trips to Brooklyn during her stay here were to visit Miller.

"Maybe, she came to Brooklyn to get away from Manhattan."

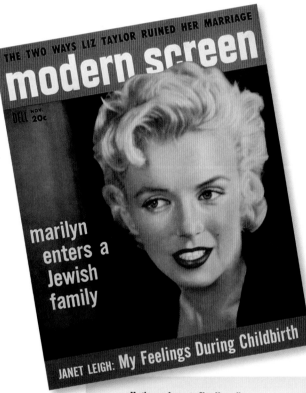

THE TWO WAYS LIZ TAYLOR RUINED HER MARRIAGE

modern screen

DELL NOV. 20c

marilyn enters a Jewish family

JANET LEIGH: My Feelings During Childbirth

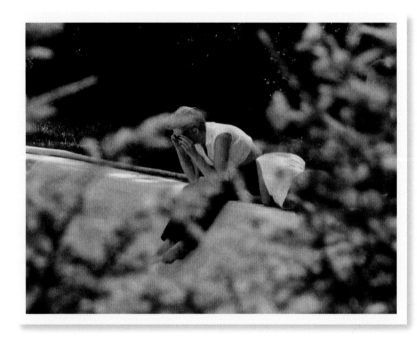

Marilyn confesses to Elsa Maxwell:

"I'LL NEVER BE THE SAME"

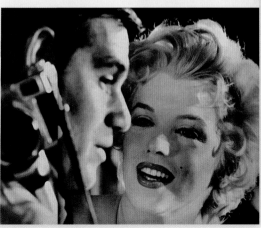

(Top) *New York Post*, May 9, 1956. (Center left) *Modern Screen*, July 1956. (Center right) Roxbury, Connecticut, 1956. Photo by Paul Slade. (Bottom) *Modern Screen*, July 1956. (Opposite) New York, June 22, 1956. (Overleaf) Waving to fans outside the Savoy Hotel, during a press conference to announce the start of filming for *The Prince and the Showgirl*, costarring Laurence Olivier, London, July 15, 1956.

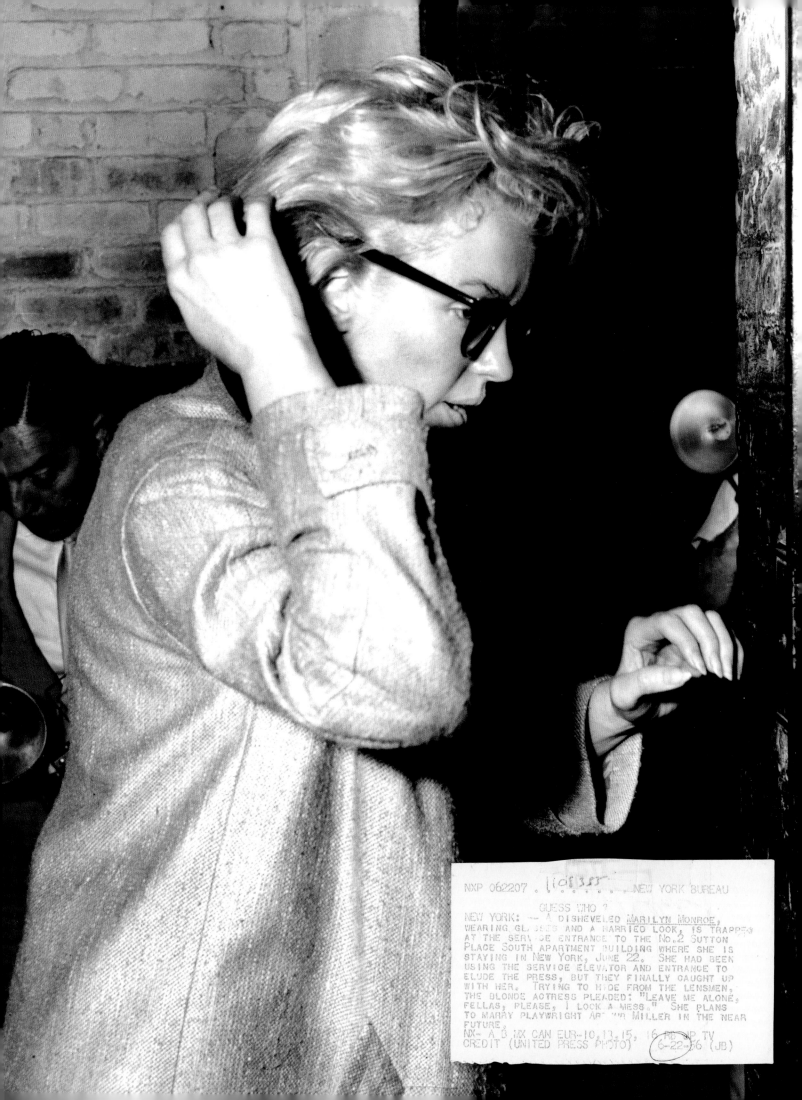

"She was enormously popular all over Europe, arguably the best known and most popular American actress. I found her to be an utter delight. Full of vitality and wonder, she also had an unquenchable desire to learn, to pick up knowledge and process it."

KURT LAMPRECHT (Journalist; from an interview for the German press)

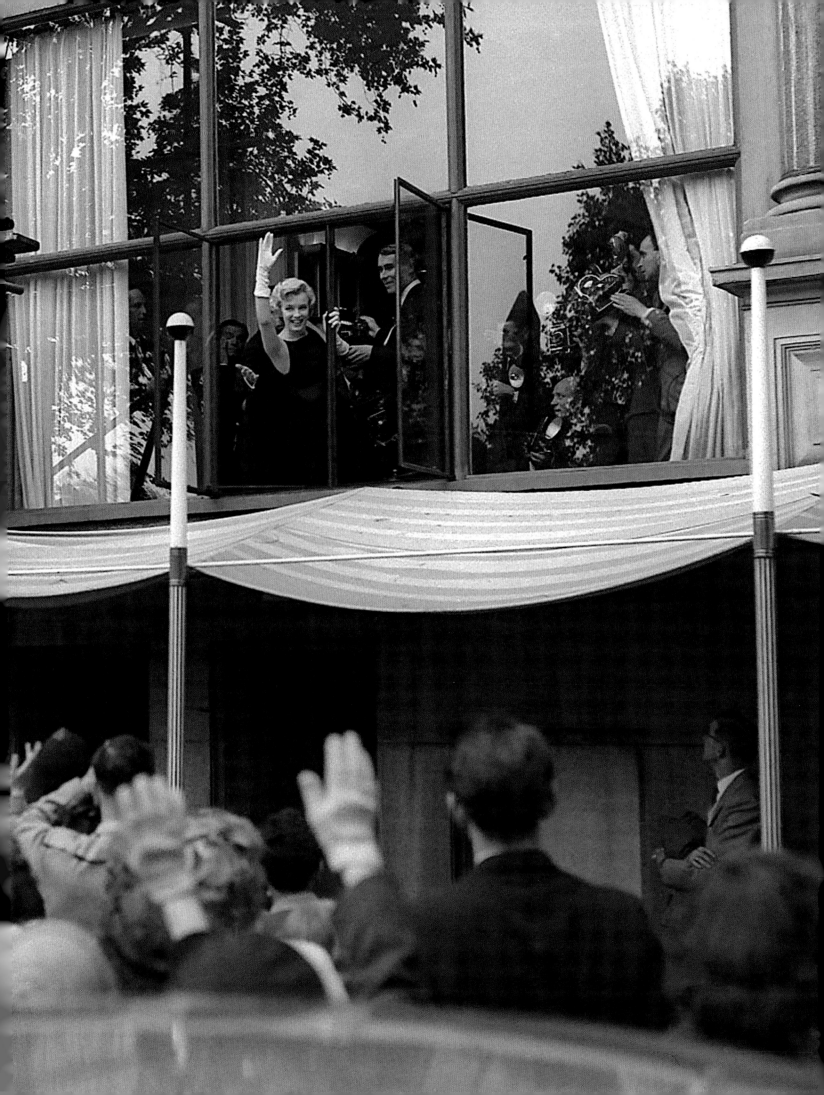

There's only one Marilyn Monroe but there isn't one Marilyn Monroe picture that teases and tickles like Marilyn Monroe co-starring with Laurence Olivier in "The Prince and the Showgirl"!

International posters, *The Prince and the Showgirl*, 1957. (Opposite) As Elsie Marina, with costar Laurence Olivier, *The Prince and the Showgirl*. Photo by Milton Greene.

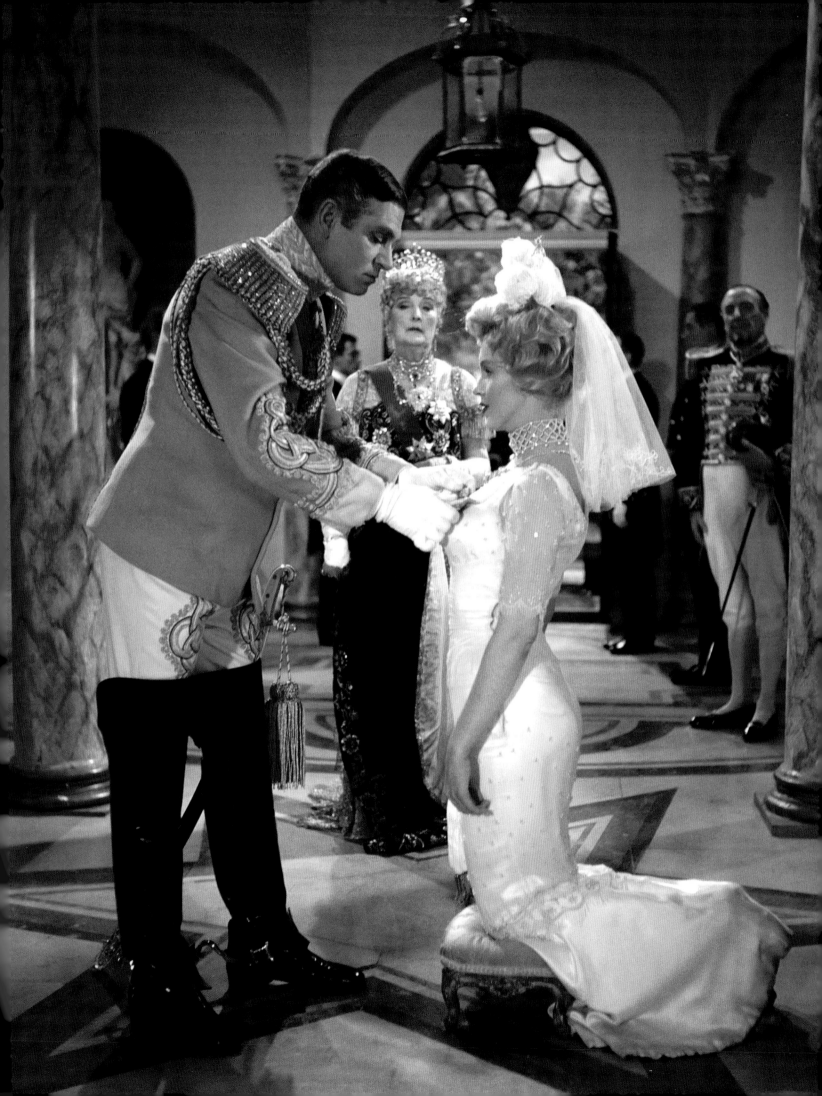

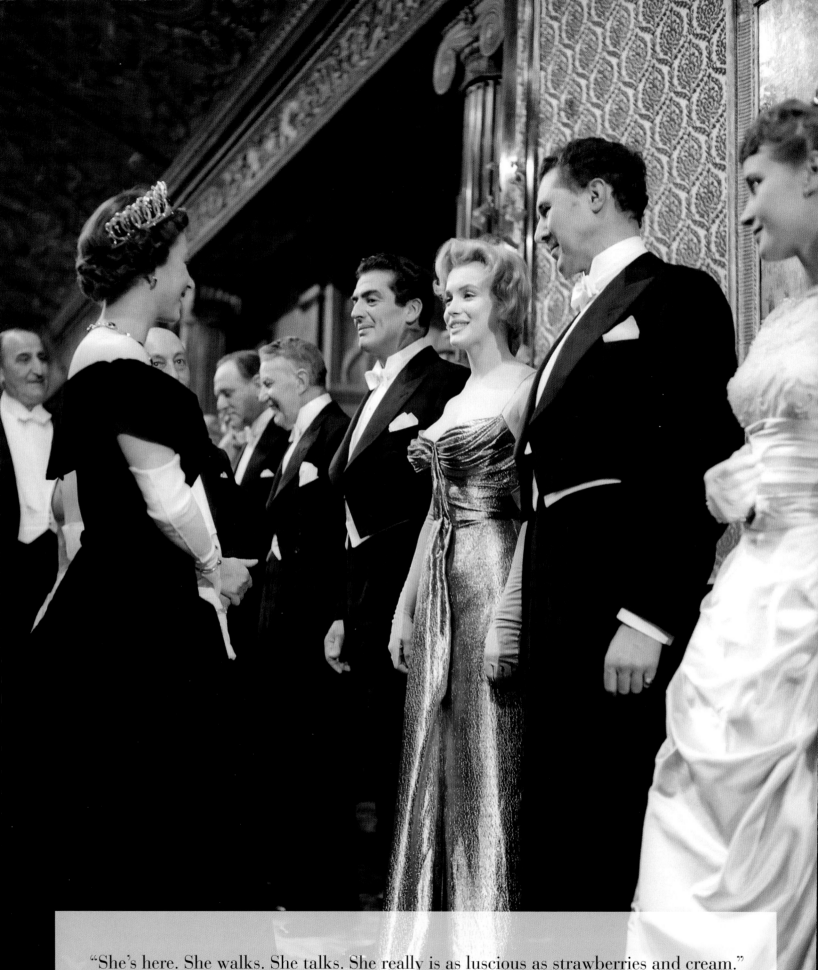

"She's here. She walks. She talks. She really is as luscious as strawberries and cream."

LONDON EVENING NEWS

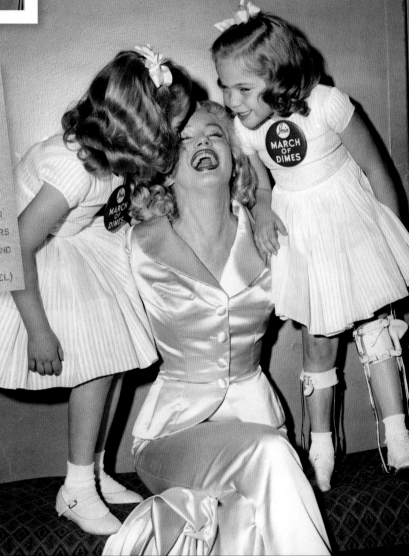

51362745-WATCH YOUR CREDIT.....INTERNATIONAL NEWS PHOTOS
SLUG (MARILYN MONROE-POSTER TWINS)
MARILYN PUTS FASHION FOOT FORWARD FOR MARCH OF DIMES
NEW YORK.....ACTRESS MARILYN MONROE MILLER IS KISSED
BY THE MARCH OF DIMES POSTER TWINS, SIX-YEAR-OLD LINDY
AND SANDY SUE SOLOMON AT TODAY'S ANNUAL MARCH OF DIMES
FASHION SHOW IN THE WALDORF-ASTORIA, MISS MONROE WORE
A LONG CHAMPAGNE TONED SILK SATIN DINNER COSTUME OF
A FORM FITTING DRESS AND FITTED JACKET DESIGNED BY JOHN
MOORE FOR TALMACK. THE SHOW FEATURED FASHIONS BY MEMBERS
OF THE COUTURE GROUP OF THE NEW YORK DRESS INSTITUTE AND
OTHER DESIGNERS OF NEW YORK, CALIFORNIA AND ITALY. (SEL)
D.1.28.58 PHOTO BY H.J. REINHART

(Opposite) Marilyn is presented
to Queen Elizabeth II at the
Royal Film Performance, London,
October 1956. (Top left) With
William Metzler at a charity
event for the Milk Fund, June
12, 1957. (Top right) New York,
1957. Photo by Gene Dauber.
(Right) Marilyn kissed by the
March of Dimes poster twins,
at the annual March of Dimes
fashion show, Waldorf-Astoria,
New York, January 28, 1958.

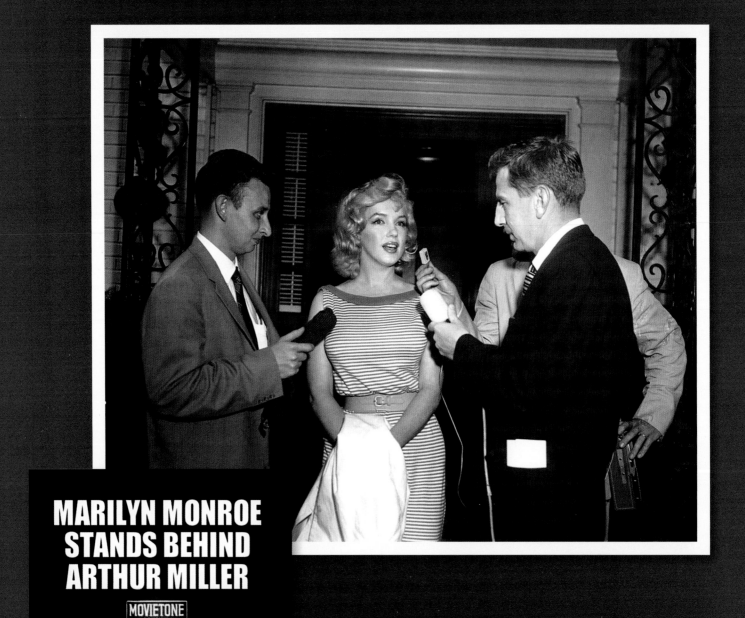

MARILYN MONROE STANDS BEHIND ARTHUR MILLER

MOVIETONE NEWS

"I am very happy for my husband, but I am even happier for truth and justice that does exist in our country."

Marilyn's statement to the press, August 8, 1958, after the US Court of Appeals reversed Miller's contempt of Congress conviction.

(Top) ORIGINAL CAPTION: "May 23, 1957. Actress Marilyn Monroe, who has been dodging newsmen ever since her arrival here, came out of seclusion today and confidently predicted her playwright husband will 'win in the end.' Hubby Arthur Miller's contempt of Congress trial ended here today. Marilyn poses here at the home of Miller's attorney, Joseph Rauh, where she revealed she has been staying all along." (Opposite top) With Arthur Miller on vacation in Jamaica, January 18, 1957. (Opposite bottom) News articles, 1957.

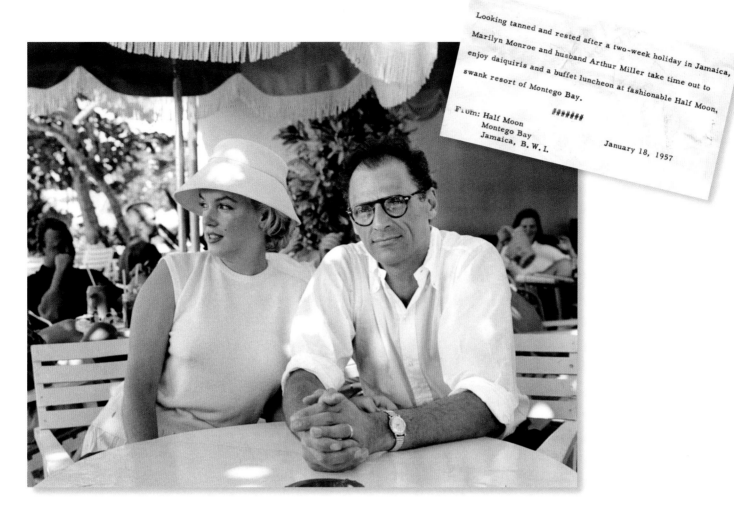

Looking tanned and rested after a two-week holiday in Jamaica, Marilyn Monroe and husband Arthur Miller take time out to enjoy daiquiris and a buffet luncheon at fashionable Half Moon, swank resort of Montego Bay.

######

From: Half Moon
Montego Bay
Jamaica, B.W.I.

January 18, 1957

The Millers on Vacation

Film star Marilyn Monroe and her husband, playwright Arthur Miller, walk toward their plane for a flight to Kingston, Jamaica, for a two-week vacation. When asked whether they expect a child, Miller told newsmen at New York's International Airport: "We resolved to make no comment on that."
—AP Photo

Will She Say Yes?

Marilyn Monroe
. . . a scene from 'The Brothers Karamazov'
—INP

Marilyn Is Offered $75,000 For 3 Minutes on Television

By SHEILAH GRAHAM

HOLLYWOOD — Marilyn Monroe can have $75,000 for a three-minute appearance on the new Galen Drake TV variety show. Drake asked Marilyn to do a scene from "The Brothers Karamazov"—what else! They would also like to show a three-minute clip from her movie with Sir Laurence Olivier, "The Prince and the Chorus Girl." All Marilyn has to do is say yes but will she?

theater. The demand for stories is gigantic when you add up all the half-hours on TV.

It's later than we think. Eve (Our Miss Brooks) Arden posed with her family this week for a next-Christmas layout in the Saturday Evening Post Glamorous star Lana Turner, whose Metro movies get high ratings, has been offered several fortunes to make live appearances on tele-

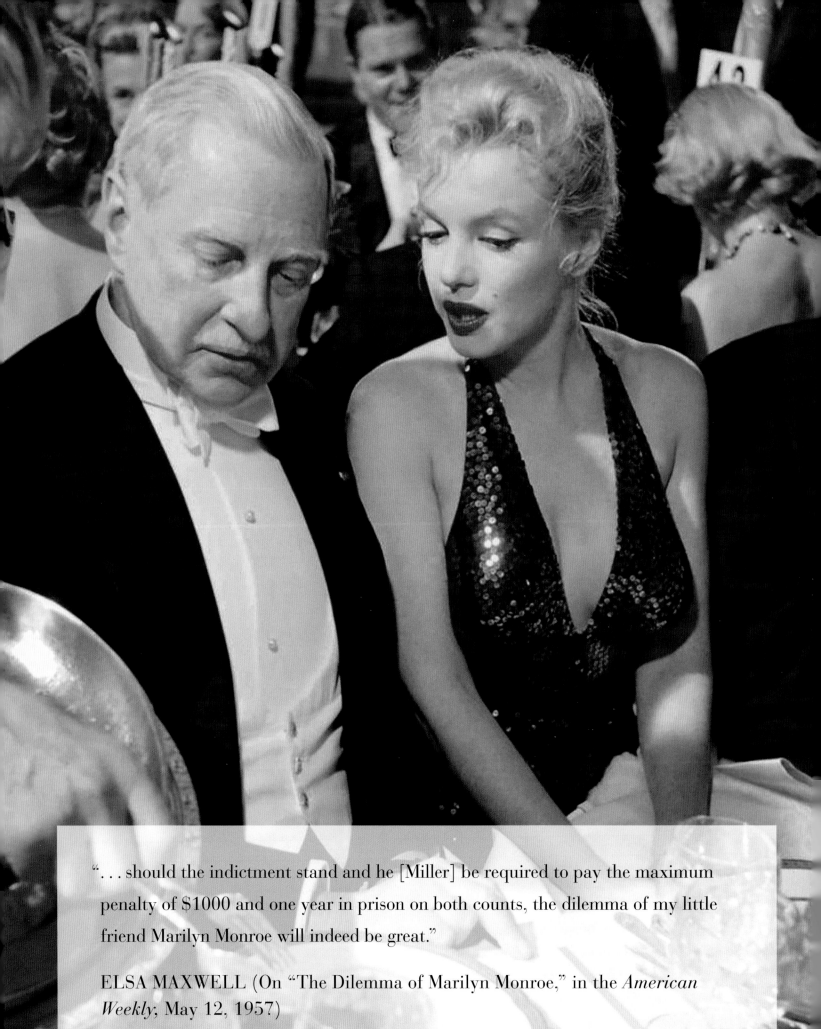

"... should the indictment stand and he [Miller] be required to pay the maximum penalty of $1000 and one year in prison on both counts, the dilemma of my little friend Marilyn Monroe will indeed be great."

ELSA MAXWELL (On "The Dilemma of Marilyn Monroe," in the *American Weekly*, May 12, 1957)

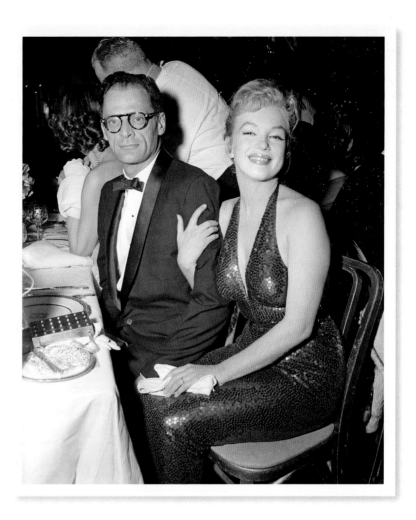

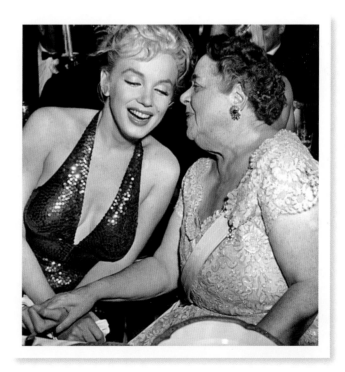

(Left) Marilyn with Winthrop W. Aldrich, former United
States ambassador to England, and Arthur Miller at the
April in Paris Ball, a benefit for the French Hospital held
at the Waldorf-Astoria, New York, April 11, 1957. (Top)
With Arthur Miller at the April in Paris Ball. (Bottom)
With columnist Elsa Maxwell at the April in Paris Ball.

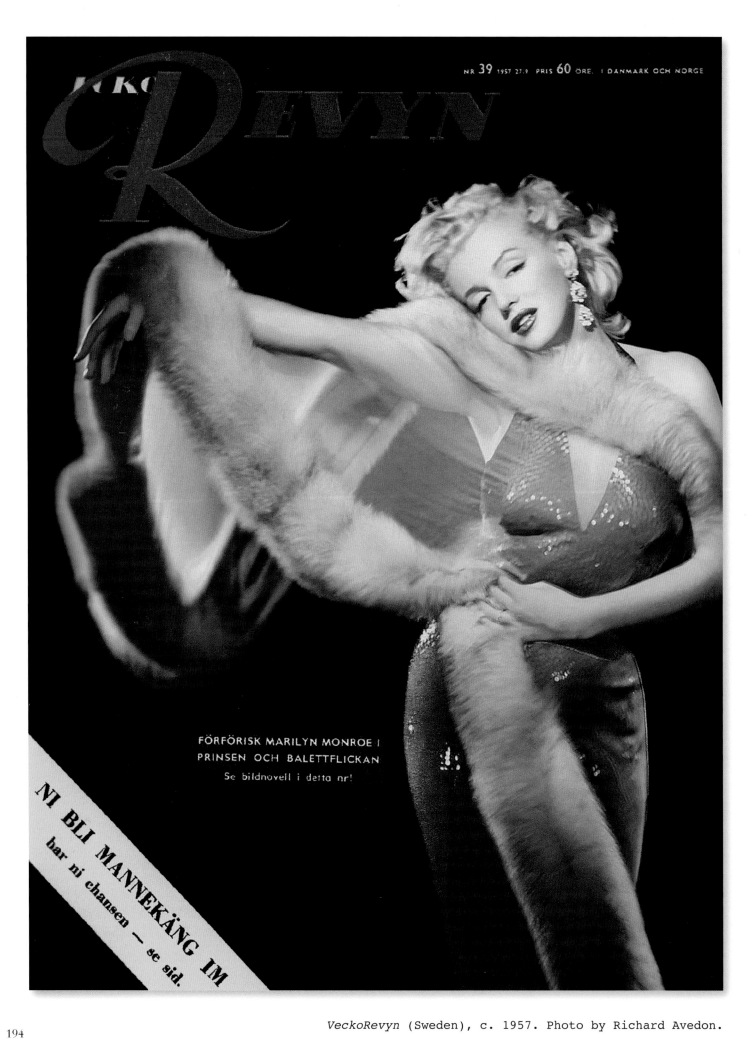

VeckoRevyn (Sweden), c. 1957. Photo by Richard Avedon.

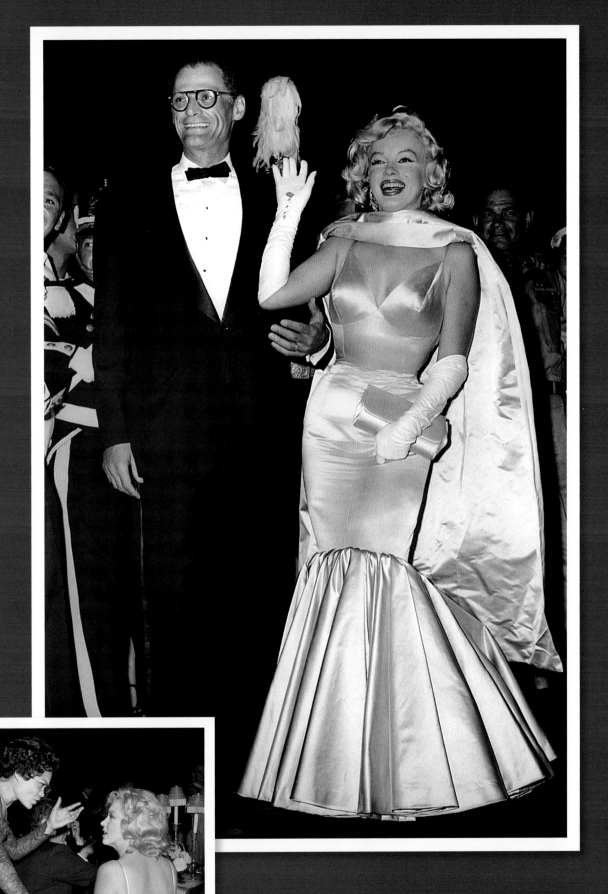

(Above) With Arthur Miller at the premiere of *The Prince and the Showgirl*, Radio City Music Hall, New York, June 13, 1957. (Left) With Eartha Kitt at the premiere of *The Prince and the Showgirl*.

Marilyn Monroe Loses Her Baby After 106-Mile Dash In Ambulance

MARILYN MONROE

Associated Press

New York, Aug. 2 — Movie star Marilyn Monroe lost her baby last night by miscarriage. An emergency operation was performed.

The wife of playwright Arthur Miller was reported today "as feeling as well as can be expected."

After the operation in Doctors Hospital a medical source who declined the use of his name said "the baby was unsavable and it was urgent to protect the life of the mother."

Miss Monroe was rushed here yesterday by ambulance from the Millers' summer home at Amagansett on the eastern end of Long Island. It was a 106-mile trip.

Miller, who drove to New York in the ambulance with his wife, was at her bedside this morning.

The film star's press representative, Warren Fisher, issued a statement which said:

"Marilyn was operated on last night at 11 p.m. The operation was for the result of a miscarriage. She expects to be in the hospital for another 9 to 10 days and then will probably return to Long Island. She is feeling as well as can be expected."

Miss Monroe was described as "slightly groggy" and seemed tired.

Dr. Hilliard Dubrow, one of two gynecologists who performed the operation, said he was "not at liberty to divulge the medical aspects" of the case but he said "she certainly can have more children and she's very anxious to have more children."

He said "her condition is as good as can be expected."

Miss Monroe's condition became apparent yesterday morning and an emergency call for the East Hampton ambulance service was made from the Miller home at 11 a.m.

When she was admitted to the hospital one of her doctors said Miss Monroe was "five or six weeks pregnant and is expecting her child at the end of March."

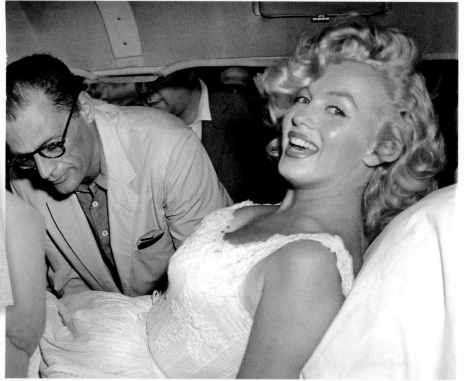

MARILYN LEAVES HOSPITAL

MARILYN MONROE IS MADE COMFORTABLE IN A CAR BY HER HUSBAND ARTHUR MILLER FOLLOWING HER RELEASE FROM DOCTORS HOSPITAL, NEW YORK CITY, AUGUST 10. SHE WILL BE TAKEN TO THEIR SUMMER HOME IN AMAGANSETT ON LONG ISLAND. MARILYN WAS HOSPITALIZED FOR A MISCARRIAGE AND SPENT 10 DAYS IN THE HOSPITAL.

HGB 8/10/57 4:20PED STF 74
A LIST NYSW15 MON ASB NRNWS HTMS YON TOK LON
ROME PAR GER SS STOCK ZUR COPEN SAMER MEX FR
TMC NWSK WW

(Top left) Associated Press article, August 2, 1957. (Top right) Marilyn arriving at Doctors Hospital with Arthur Miller, New York, August 1, 1957. (Bottom) With Arthur Miller, leaving Doctors Hospital, following a miscarriage, August 10, 1957. (Opposite) New York, 1957. Photo by Sam Shaw.

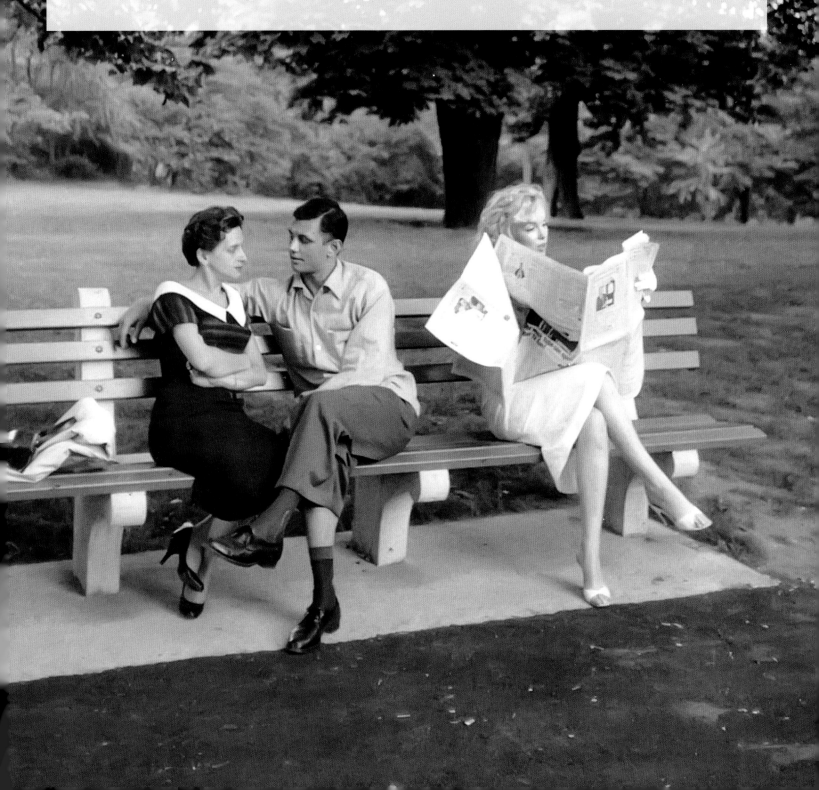

"She was the most photographed motion picture star . . . and she loved being photographed. She gave all of herself to the camera whether the photographer was a teenage fan or a wire service staffer or one of the high fashion magazine's aces. The only photographer she ever ducked was one from *Paris Match* who intruded on her honeymoon with Arthur Miller."

SAM SHAW (Photographer and friend)

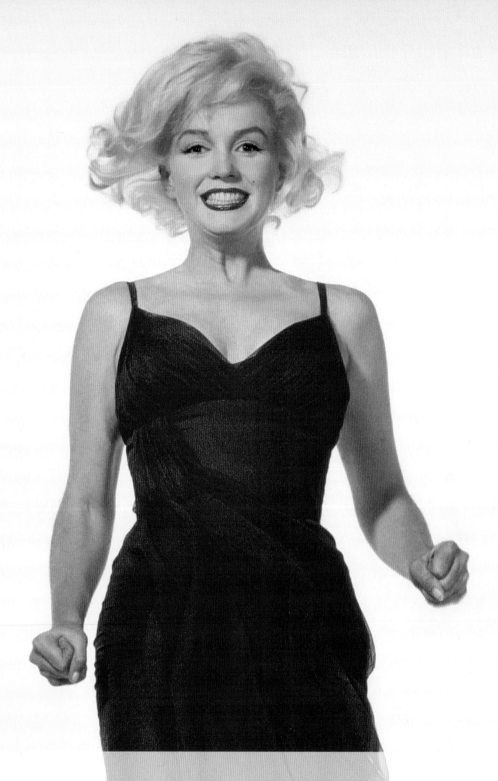

"*Life* sent a helicopter to take her to be photographed at a promotional celebration in their New York headquarters; she was back in a few hours, descending past my studio window and stepping out onto the lawn.... There could not have been another woman in the country they would have flown to New York and back like this for a couple of photographs; there was some madness to the desperation of their need for her. What frightening power she had!"

ARTHUR MILLER

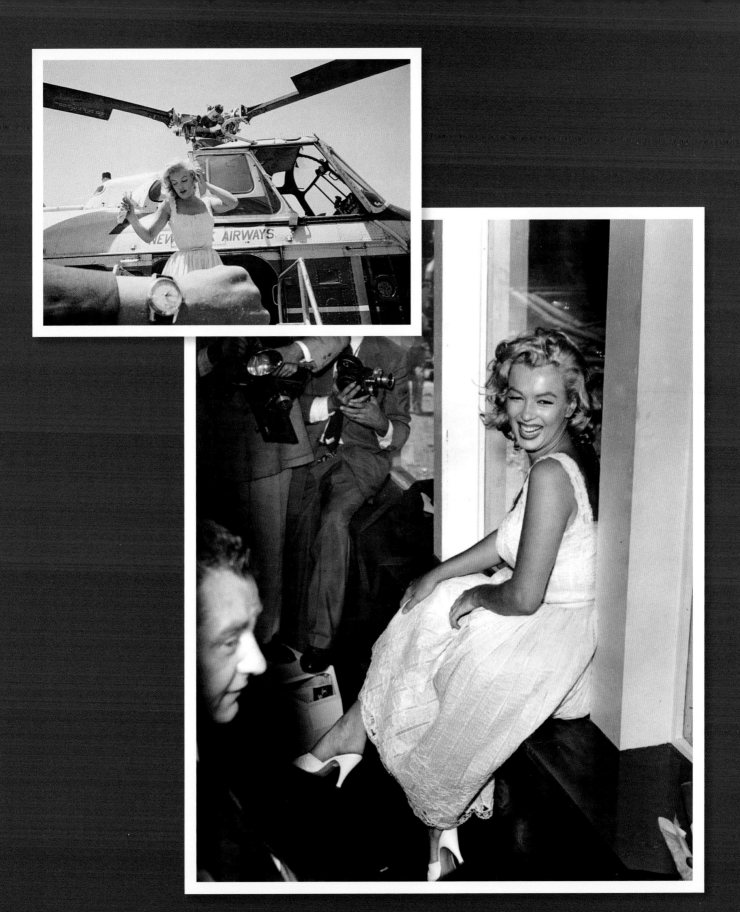

(Opposite) *Life*, 1959. Photo by Philippe Halsman. (Top) ORIGINAL CAPTION: "July 2, 1957, New York. Marilyn Monroe smiles as she alights from a helicopter July 2. The watch in foreground pinpoints her arrival time. Marilyn was 2½ hours late for a ceremony marking the start of construction of a new building in Rockefeller Center. Laurence D. Rockefeller, member of the Board of Directors of Rockefeller Center, was slated to greet Marilyn on her arrival. But, after waiting until just five minutes before Marilyn's appearance, he left for a luncheon date. 'I've never waited that long for anyone,' Rockefeller was quoted as saying." (Bottom) Rockefeller Center, New York, July 2, 1957.

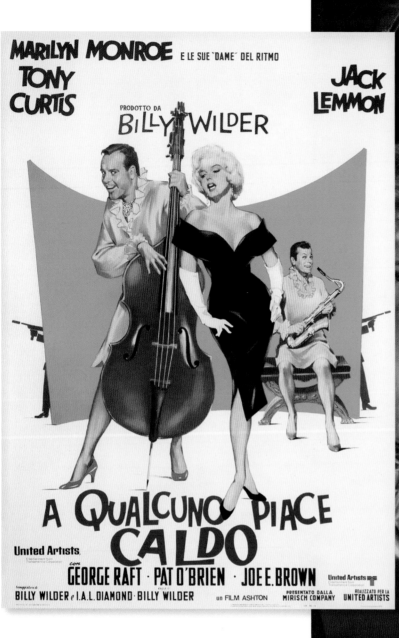

(Top) One sheet poster, *Some Like It Hot*, 1959. (Right) Marilyn performing "Running Wild" in *Some Like It Hot*.

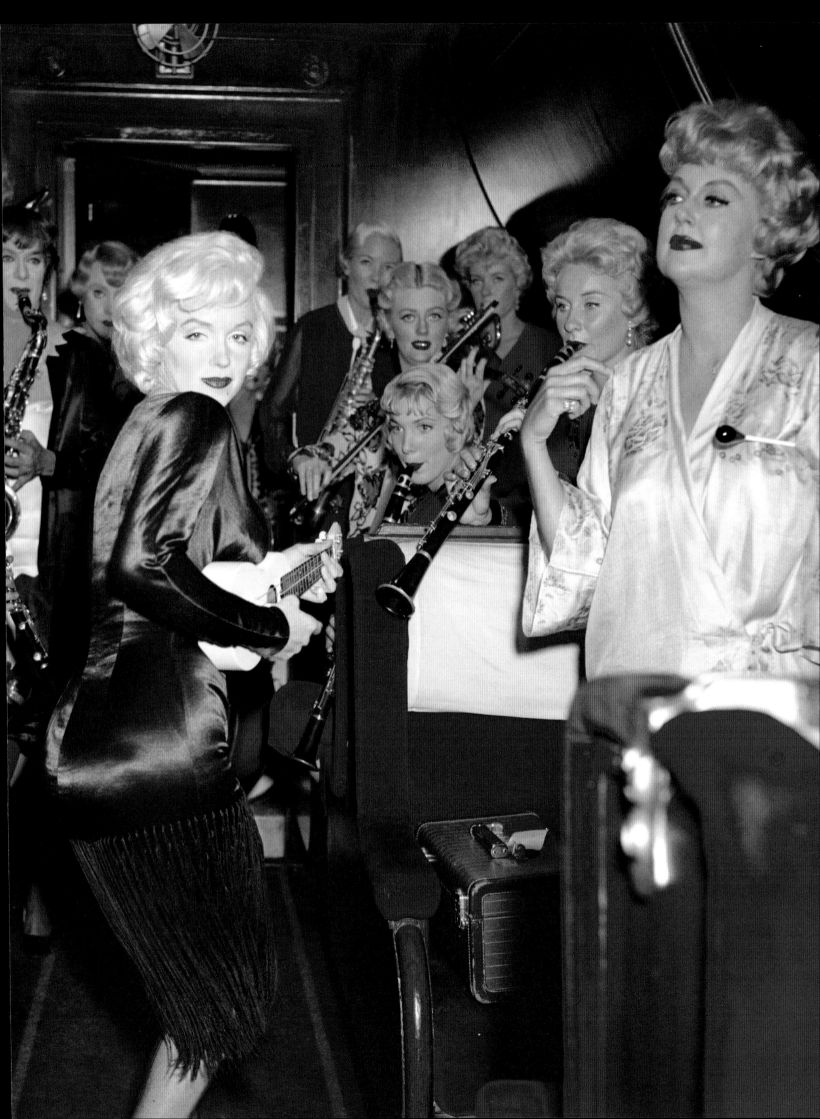

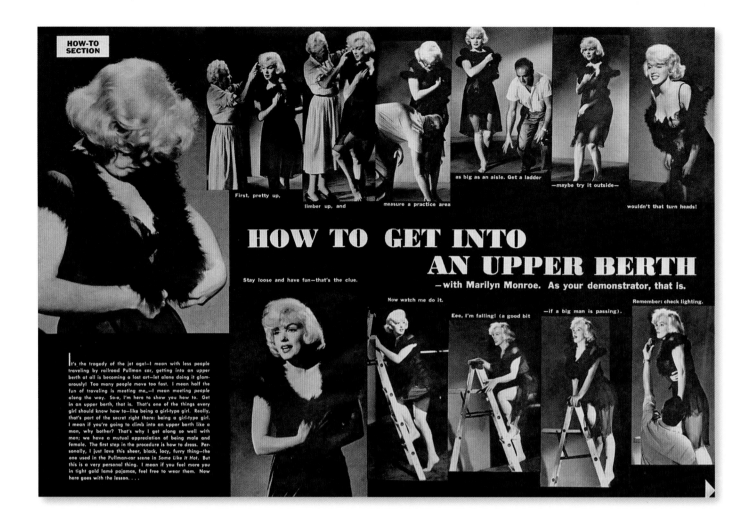

"It was a cross-cut of what America was about....Toward the end, when it went to entertainment, I gave [designer Charles Eames] a close-up of Monroe from *Some Like It Hot*, where she smiles, and it appeared on sixteen screens....Forty thousand people a day would come to see her in this sequence....The Russians had not seen a Monroe film before....And they broke into applause."

BILLY WILDER (On the American National Exhibition in Moscow, July 1959)

(Top) *Movie Life*, March 1959. (Opposite) Marilyn as Sugar Kane Kowalczyk in *Some Like It Hot*.

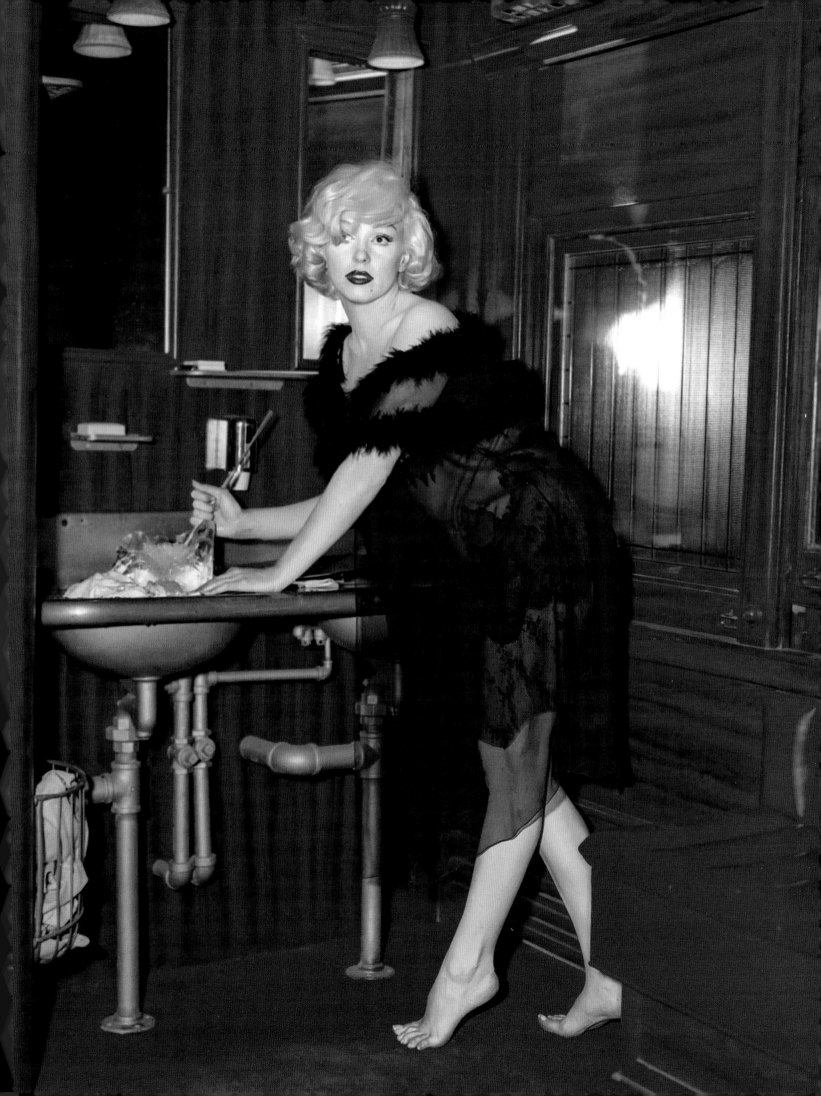

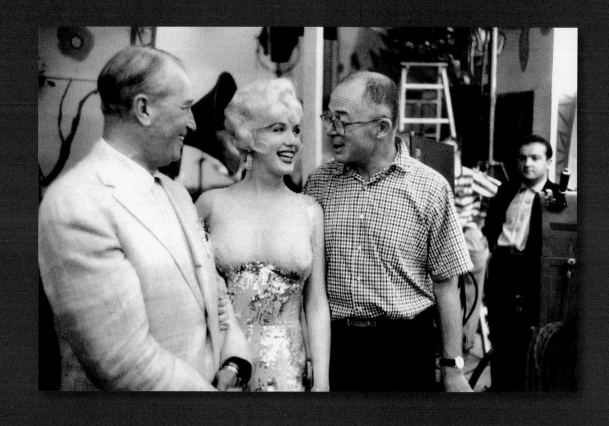

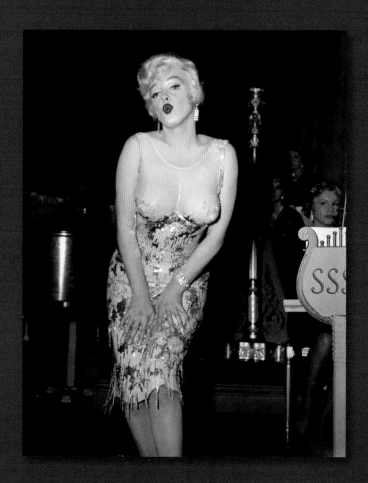

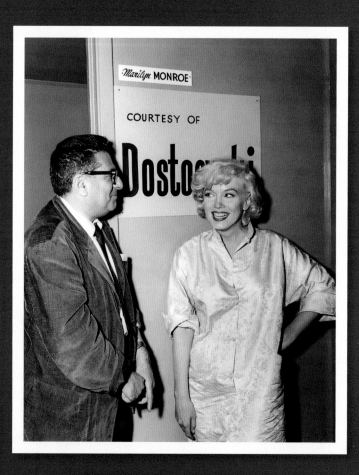

(Top) Marilyn with Maurice Chevalier and director Billy Wilder on the set of *Some Like It Hot*, 1959. (Bottom left) Performing "I Wanna Be Loved by You," *Some Like It Hot*. (Bottom right) With columnist Sidney Skolsky, 1959. (Opposite) As Sugar Kane Kowalczyk, *Some Like It Hot*.

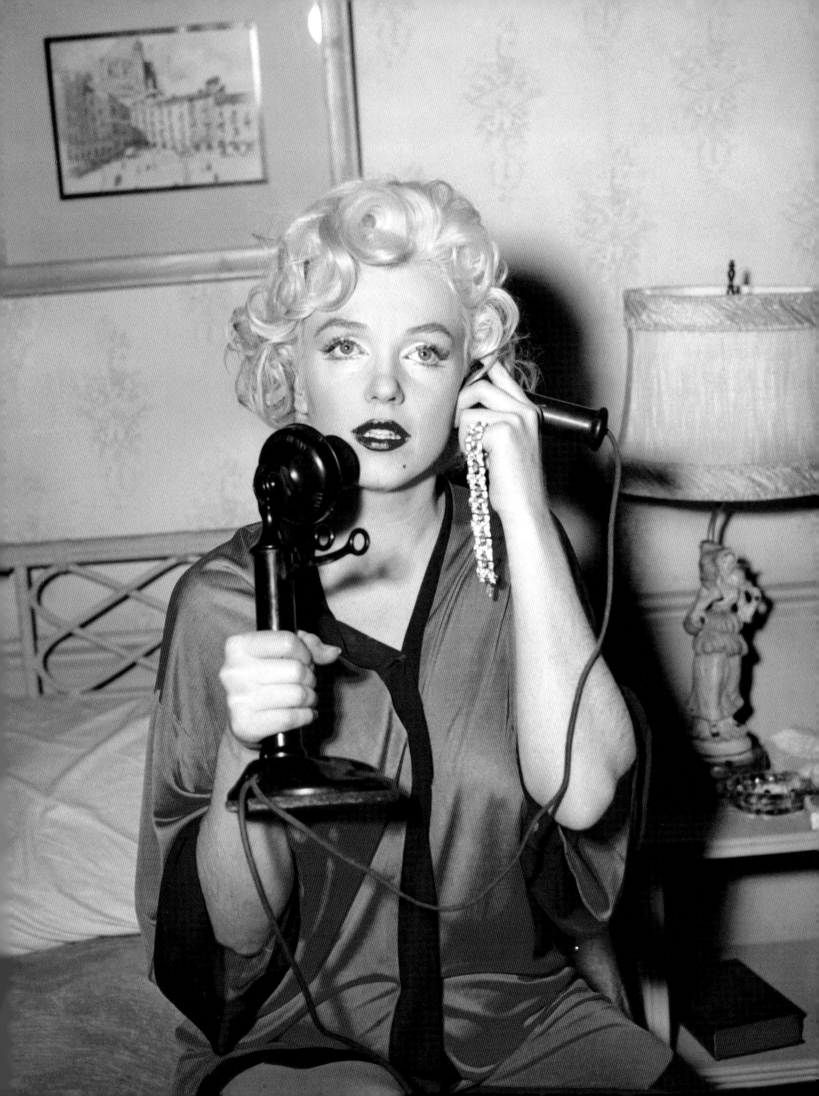

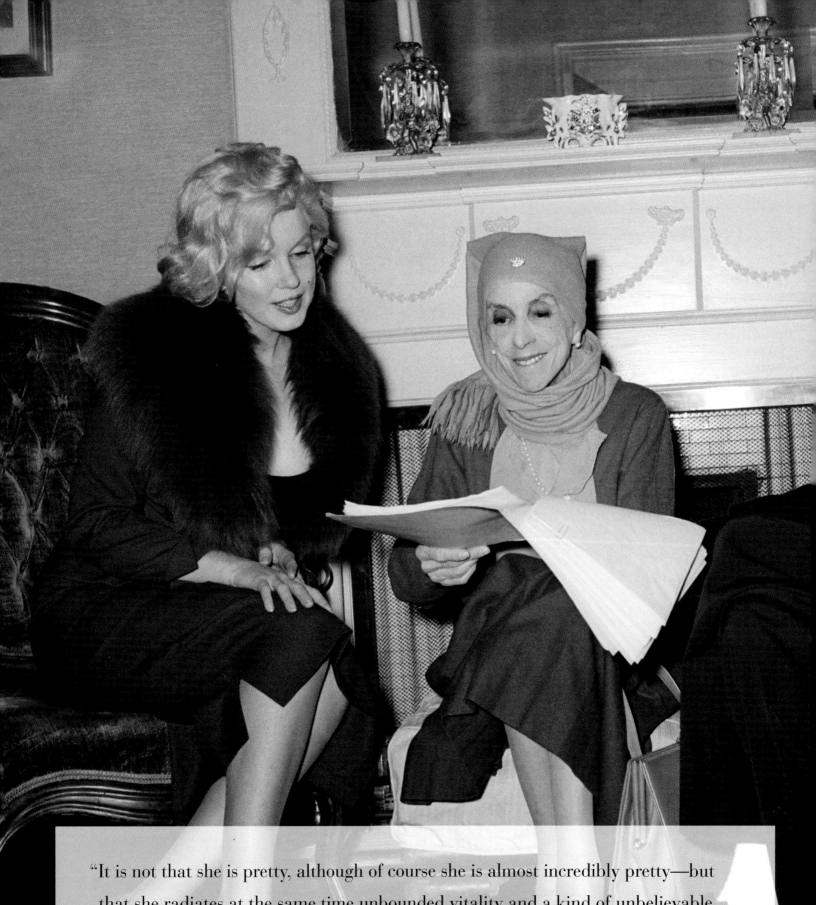

"It is not that she is pretty, although of course she is almost incredibly pretty—but that she radiates at the same time unbounded vitality and a kind of unbelievable innocence. I have met the same in a lion cub that my native servants in Africa brought me. I would not keep her."

ISAK DINESEN (Author, *Out of Africa*)

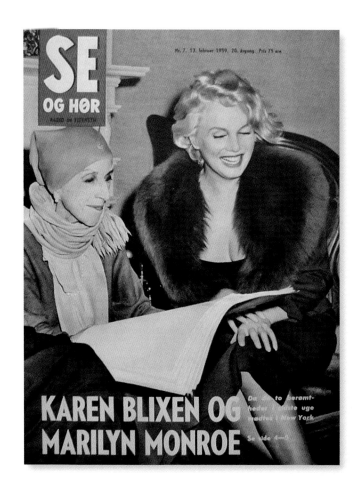

(Left) ORIGINAL CAPTION: "February 5, 1959, Nyack NY. Marilyn Monroe (left) watches as famed Danish author Isak Dinesen (*Out of Africa*) examines a manuscript at the home of U.S. writer Carson McCullers. The occasion was a luncheon given by Miss McCullers in honor of the Danish writer, whose real name is the Baroness Karen Blixen. Miss Dinesen is currently on a lecture tour of the U.S. Marilyn was on hand for the affair with husband Arthur Miller." (Above) *Se og Hør* (Denmark), February 1959.

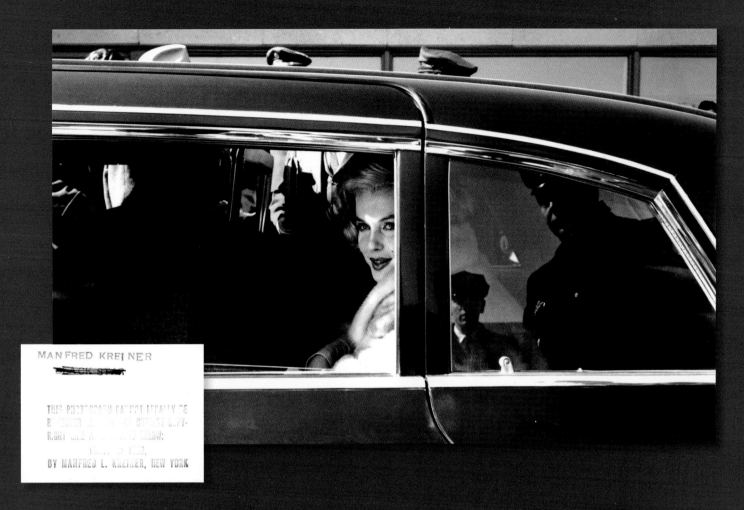

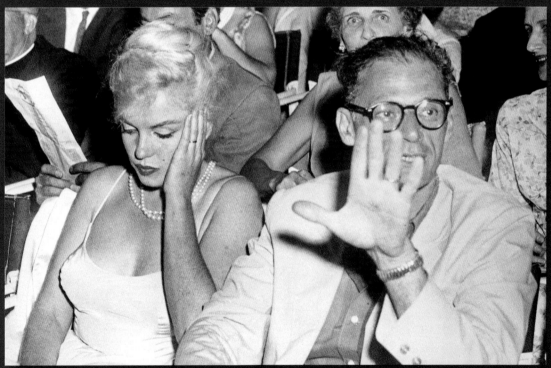

(Top) Marilyn arriving at the world premiere of *Some Like It Hot,* Chicago, March 17, 1959. Photo by Manfried Kreiner. (Bottom) ORIGINAL CAPTION: "August 15, 1959, Boston, Massachusetts. Movie queen Marilyn Monroe wears a bored expression as her playwright-husband Arthur Miller shoos photographers away at the Boston Arts Center Theater on the banks of the Charles River. They motored from their home at Roxbury, Conn., to see a performance of Macbeth." (Opposite) At the New York premiere of *Some Like It Hot,* Loew's State Theatre, March 29, 1959. Photo by Paul Slade.

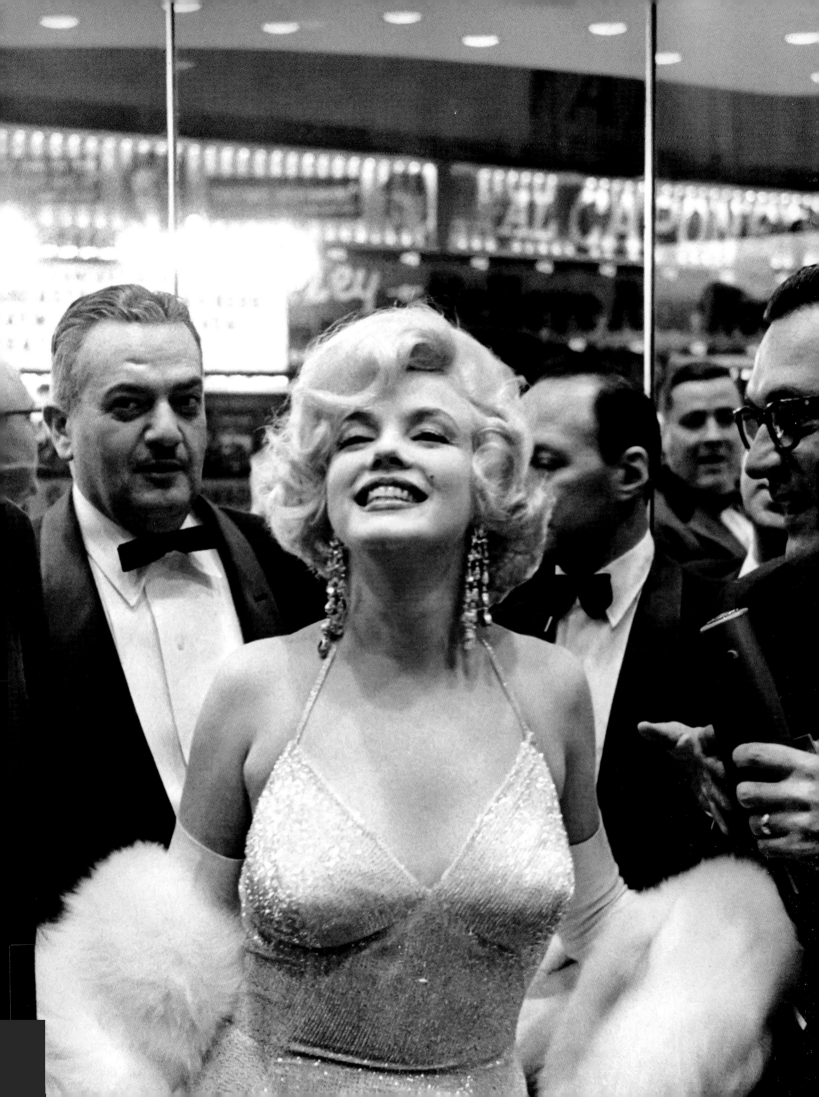

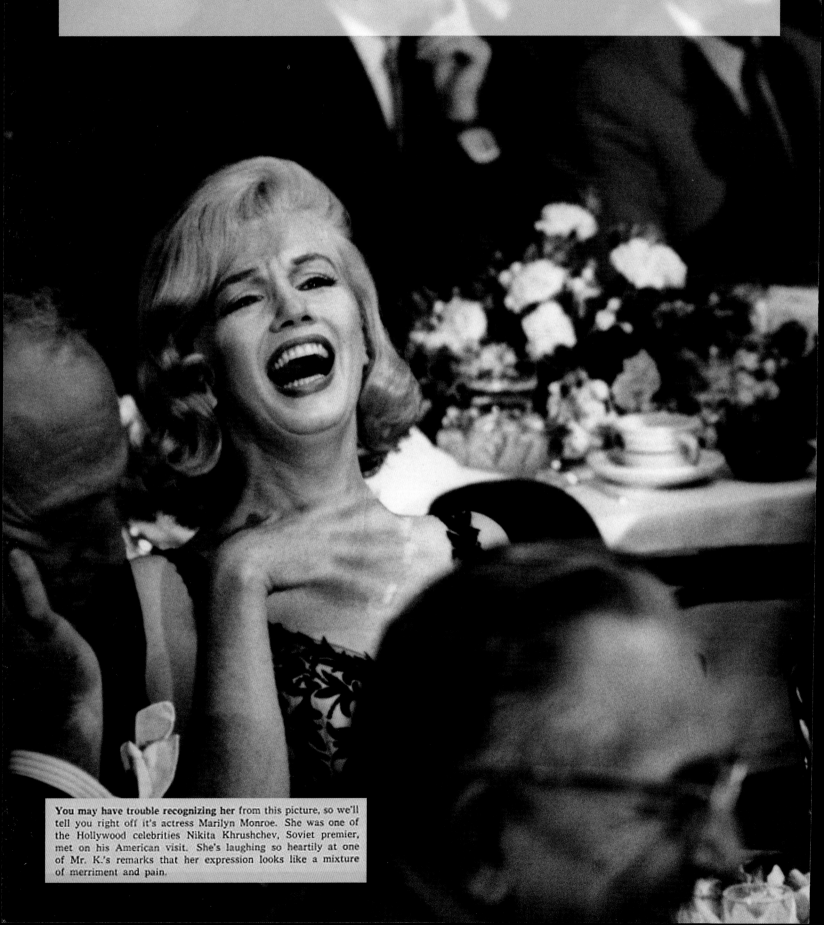

Khrushchev to Marilyn: You are a lovely young lady.

Marilyn: My husband, Arthur Miller, sends you his greetings. There should be more of this kind of thing. It would help both our countries understand each other.

You may have trouble recognizing her from this picture, so we'll tell you right off it's actress Marilyn Monroe. She was one of the Hollywood celebrities Nikita Khrushchev, Soviet premier, met on his American visit. She's laughing so heartily at one of Mr. K.'s remarks that her expression looks like a mixture of merriment and pain.

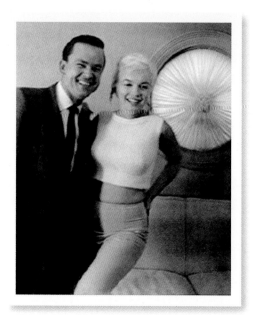

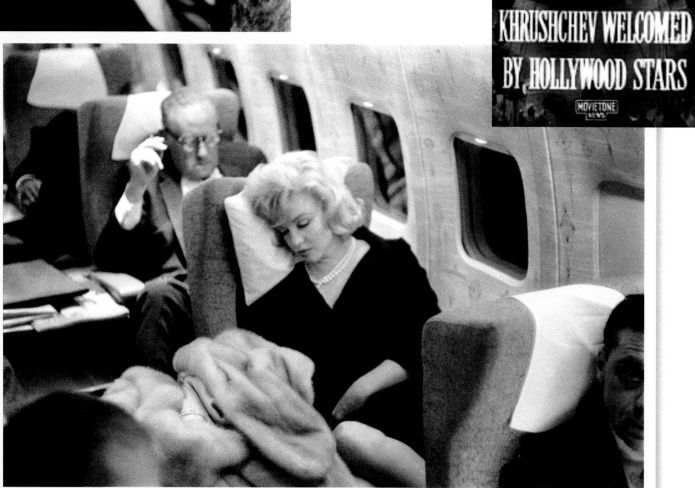

(Top) With Bob Crane as a guest on his radio show, Los Angeles, 1960. (Left) Marilyn attends a luncheon for Soviet premier Nikita Khrushchev at Twentieth Century-Fox, September 19, 1959. (Above) Traveling from New York to Los Angeles for the Kruschev event. Photo by Irving Haberman.

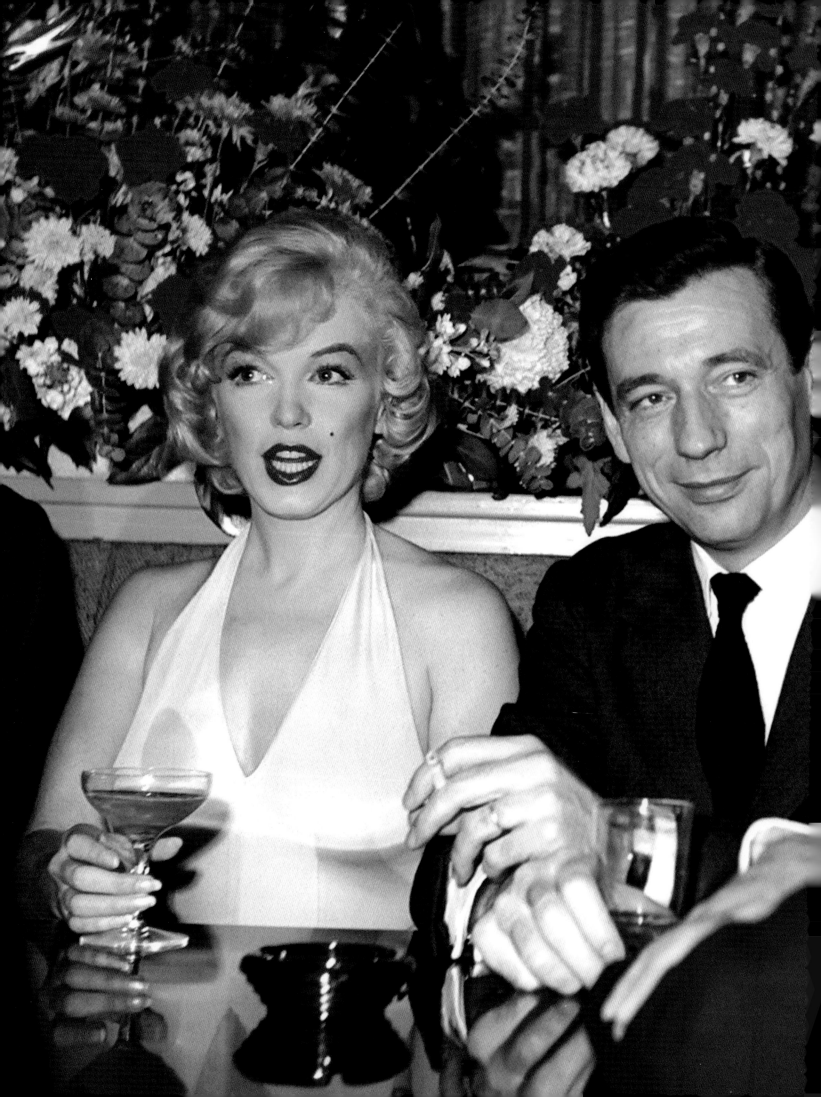

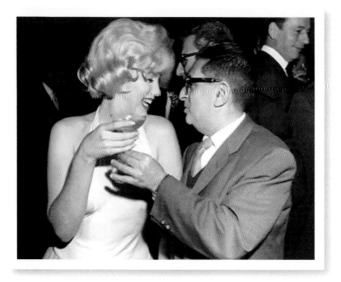

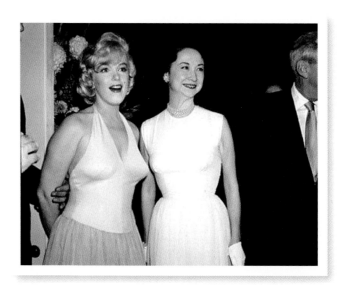

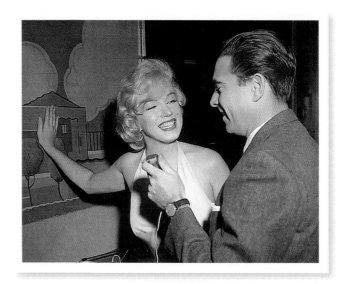

(Left) Marilyn with costar Yves Montand and director George Cukor at a party for *Let's Make Love*, Beverly Hills Hotel, January 15, 1960. (Top) With columnists Sidney Skolsky, (center) Dorothy Kilgallen, and (bottom) Army Archerd at the same event.

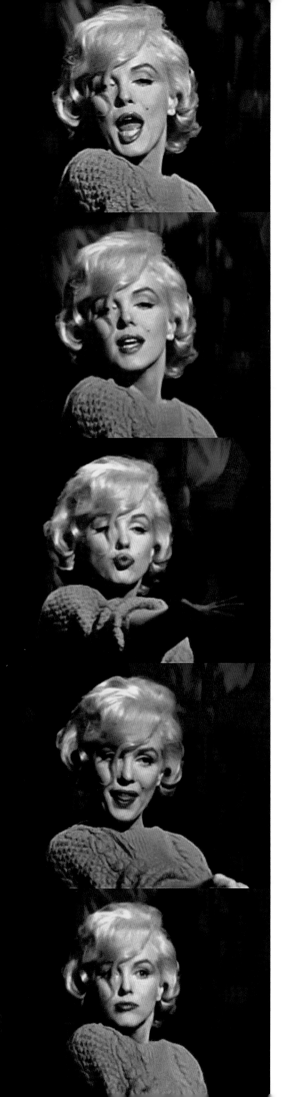

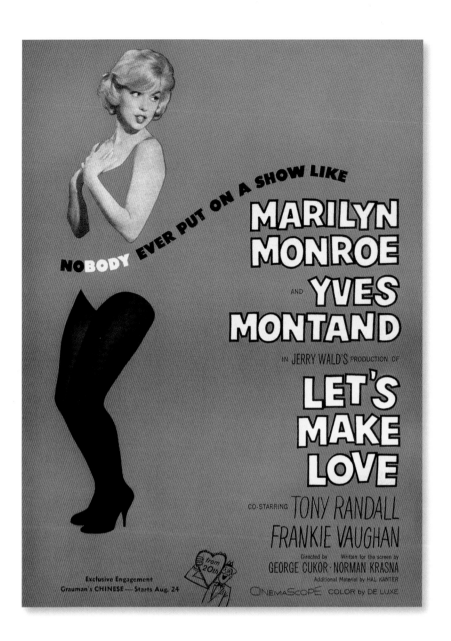

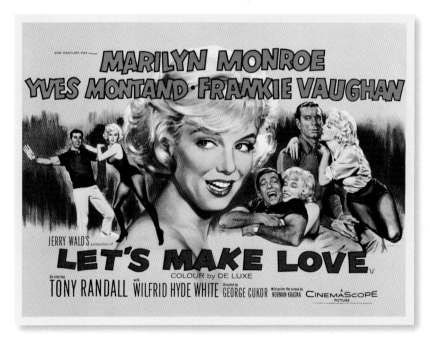

(This page) Scene stills, trade advertisement, and half sheet poster, *Let's Make Love*, 1960. (Opposite) One sheet poster, *Let's Make Love*, 1960.

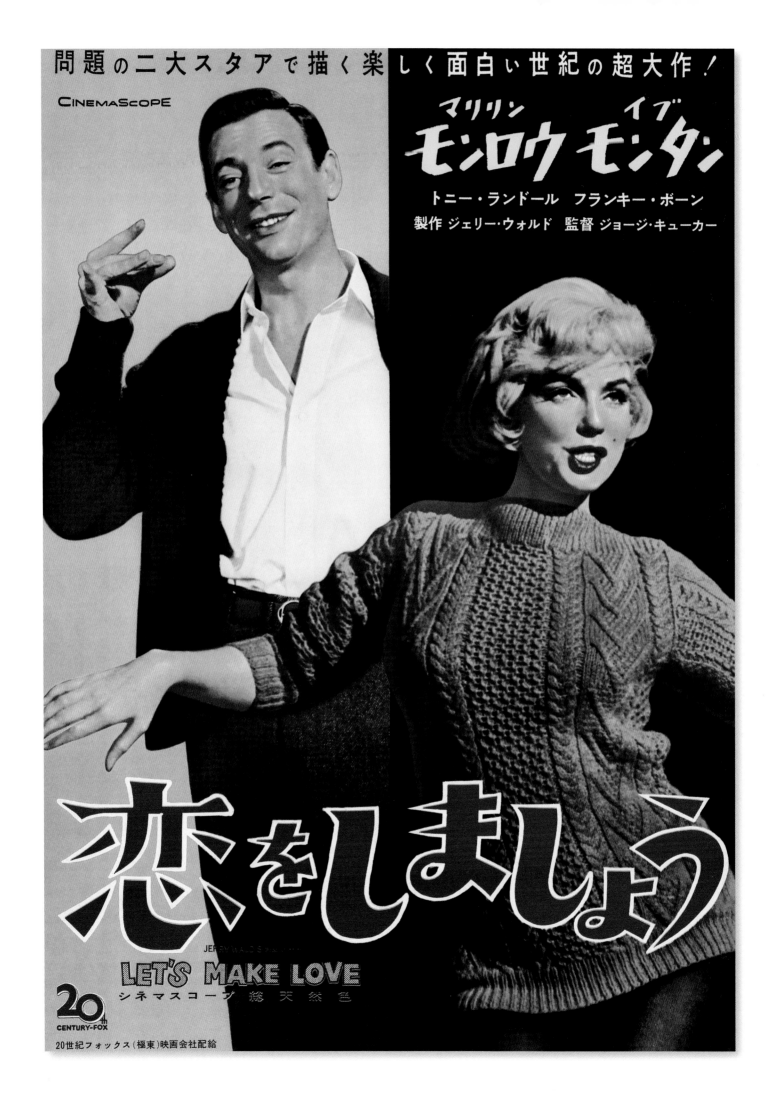

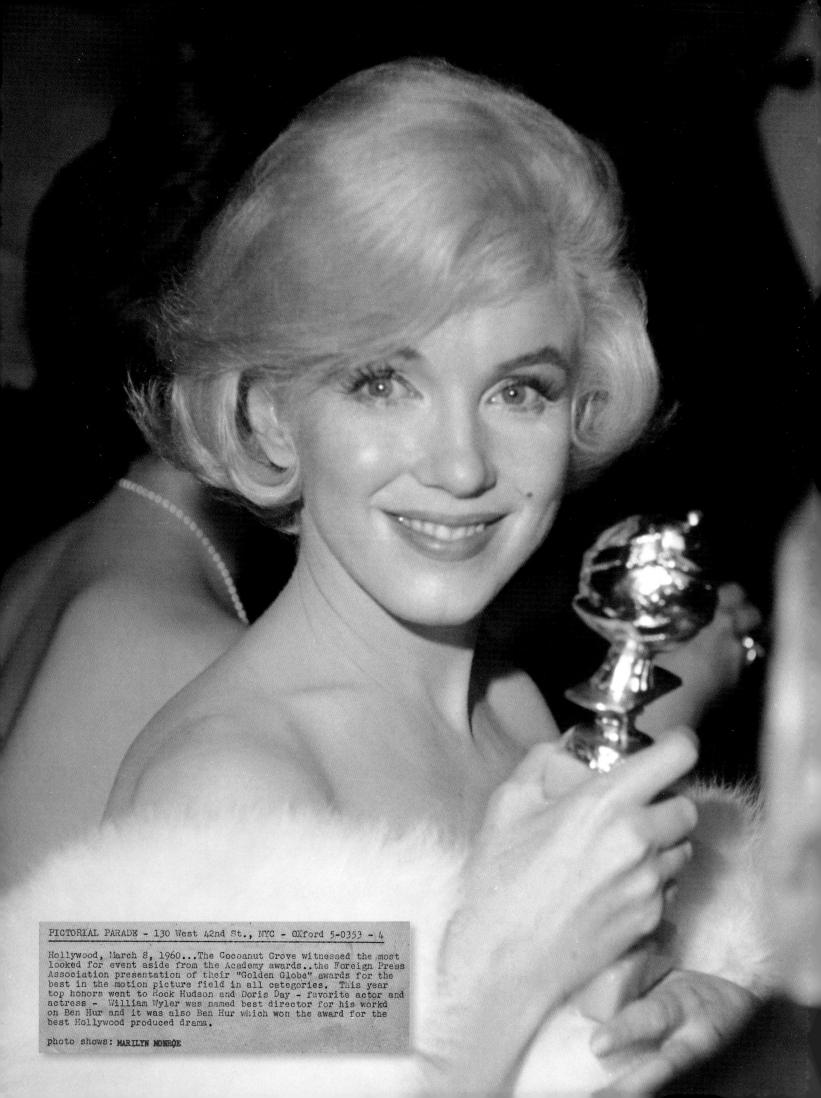

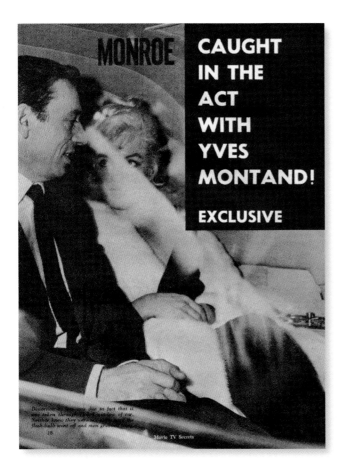

(Opposite) At the 1960 Golden Globes, with her award for Lead Actress in a
Comedy for *Some Like It Hot*, 1959. (Clockwise from top left) *Modern Screen*,
December 1960; Yves Montand reading the July 1960 issue of *Look*; *Woman's
Mirror*, October 1, 1960; *Movie TV Secrets*, c. 1960.

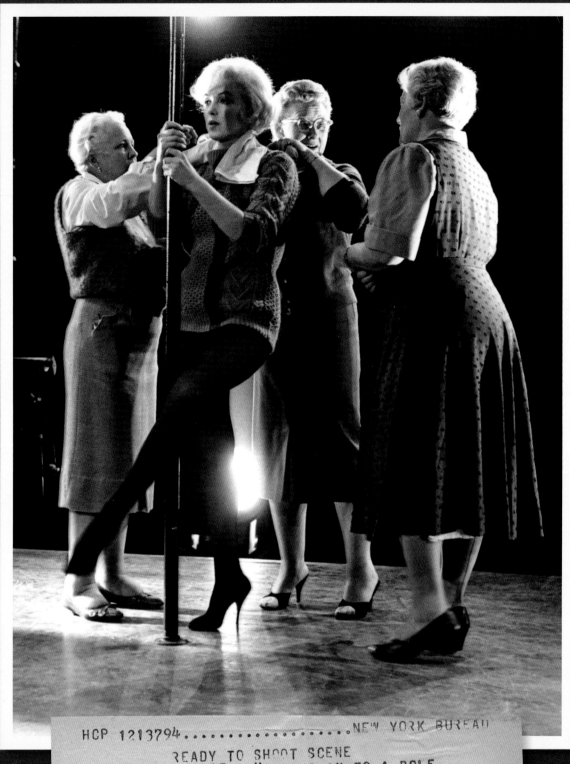

(Above) Marilyn preparing for the "My Heart Belongs to Daddy" musical number, *Let's Make Love*, January 27, 1960. (Opposite) Marilyn as Amanda Dell in the "Specialization" musical number, *Let's Make Love*, 1960.

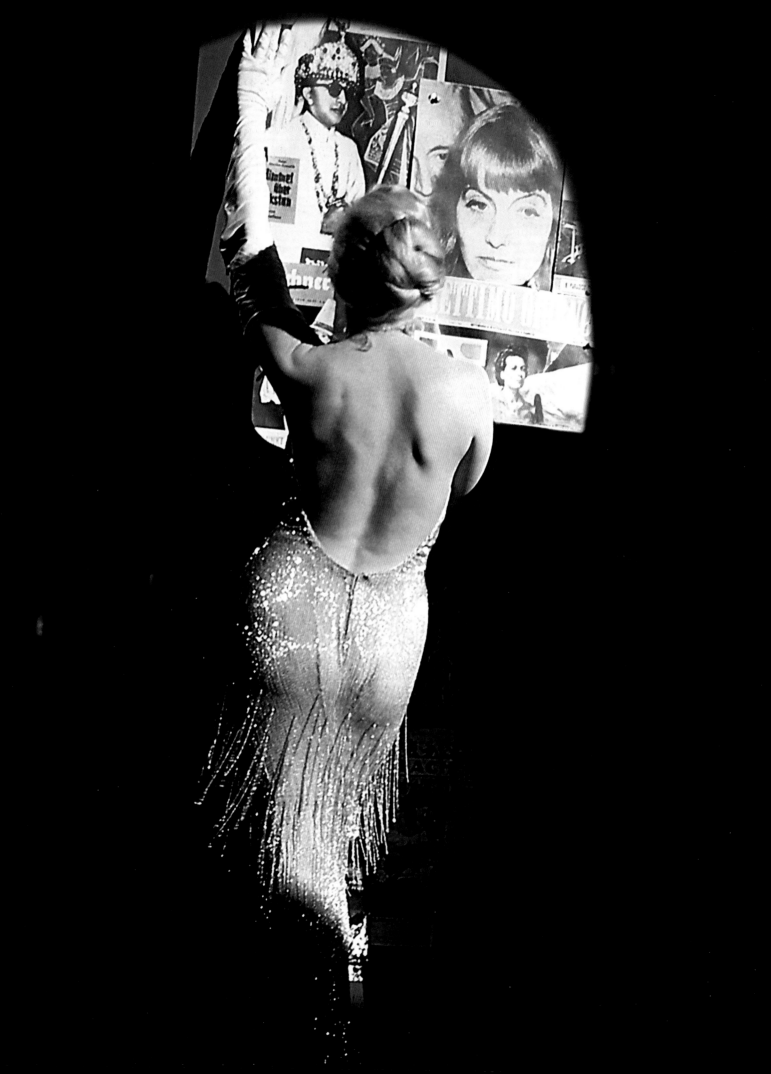

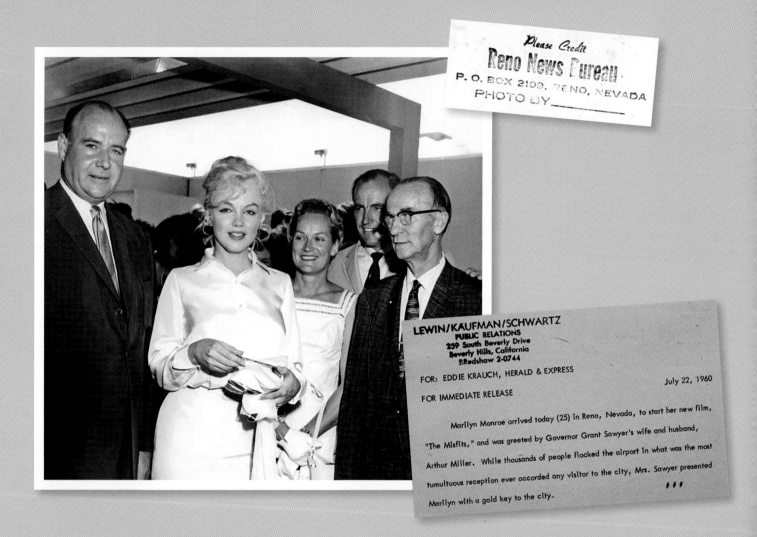

LEWIN/KAUFMAN/SCHWARTZ
PUBLIC RELATIONS
259 South Beverly Drive
Beverly Hills, California
P.Redshaw 2-0744

FOR: EDDIE KRAUCH, HERALD & EXPRESS July 22, 1960

FOR IMMEDIATE RELEASE

Marilyn Monroe arrived today (25) in Reno, Nevada, to start her new film,
"The Misfits," and was greeted by Governor Grant Sawyer's wife and husband,
Arthur Miller. While thousands of people flocked the airport in what was the most
tumultuous reception ever accorded any visitor to the city, Mrs. Sawyer presented
Marilyn with a gold key to the city. ###

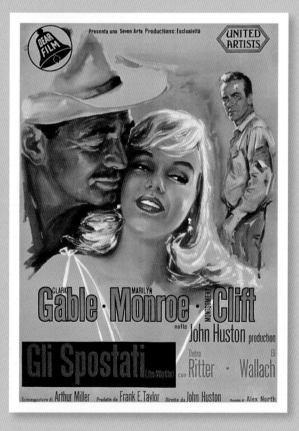

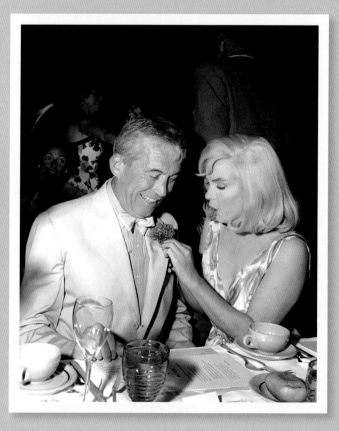

(Top) Marilyn arrives in Reno, Nevada, to begin work on *The Misfits,* July 22, 1960. (Bottom left) One sheet poster, *The Misfits,* 1960. (Bottom right) With director John Huston at his birthday party, August 5, 1960. (Opposite) With Arthur Miller, Reno, Nevada, 1960.

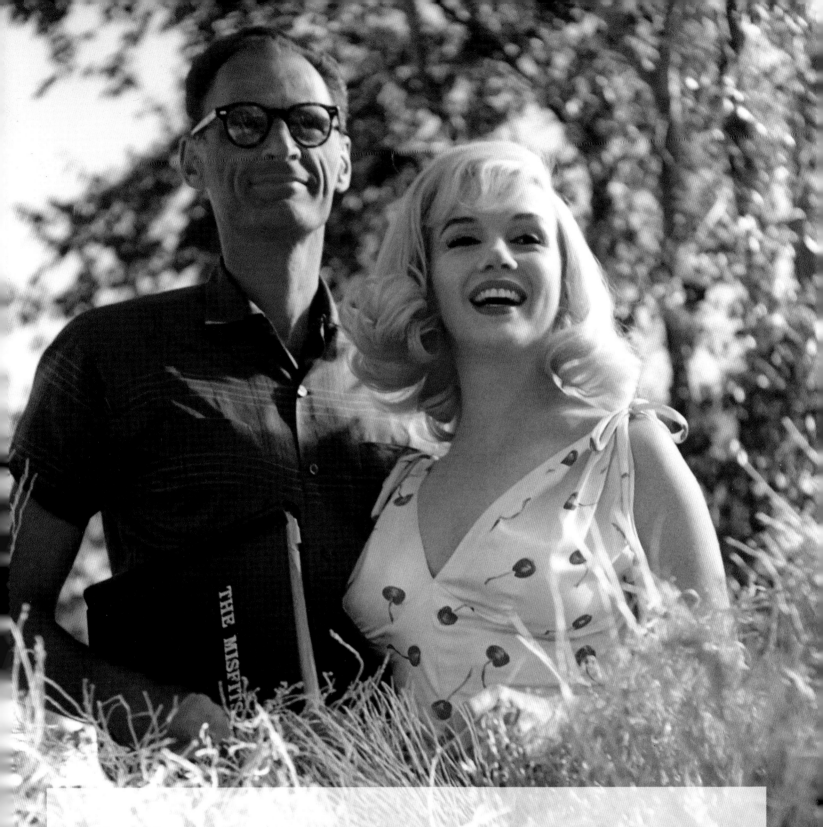

"I never felt Marilyn's much-publicized sexual attraction in the flesh, but on the screen it came across forcefully. But there was much more to her than that. She was appreciated as an artist in Europe long before her acceptance as anything but a sex symbol in the United States. Jean-Paul Sartre considered Marilyn Monroe the finest actress alive. He wanted her to play the leading female role in *Freud*."

JOHN HUSTON (Director)

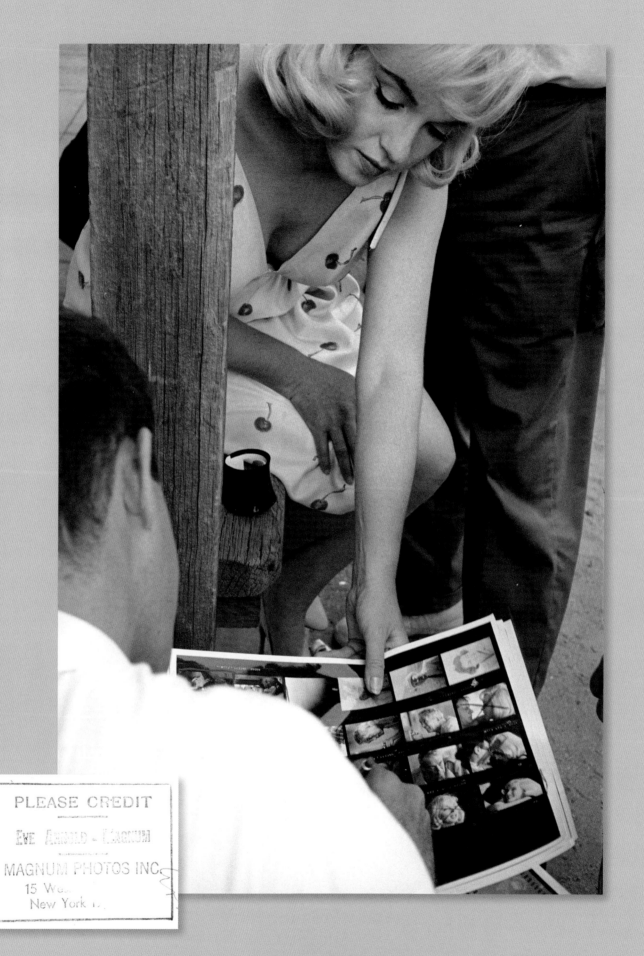

(Above) Marilyn reviews contact sheets of herself
with Magnum photographer Dennis Stock between takes
on the set of *The Misfits*, 1960. Photo by Eve Arnold.

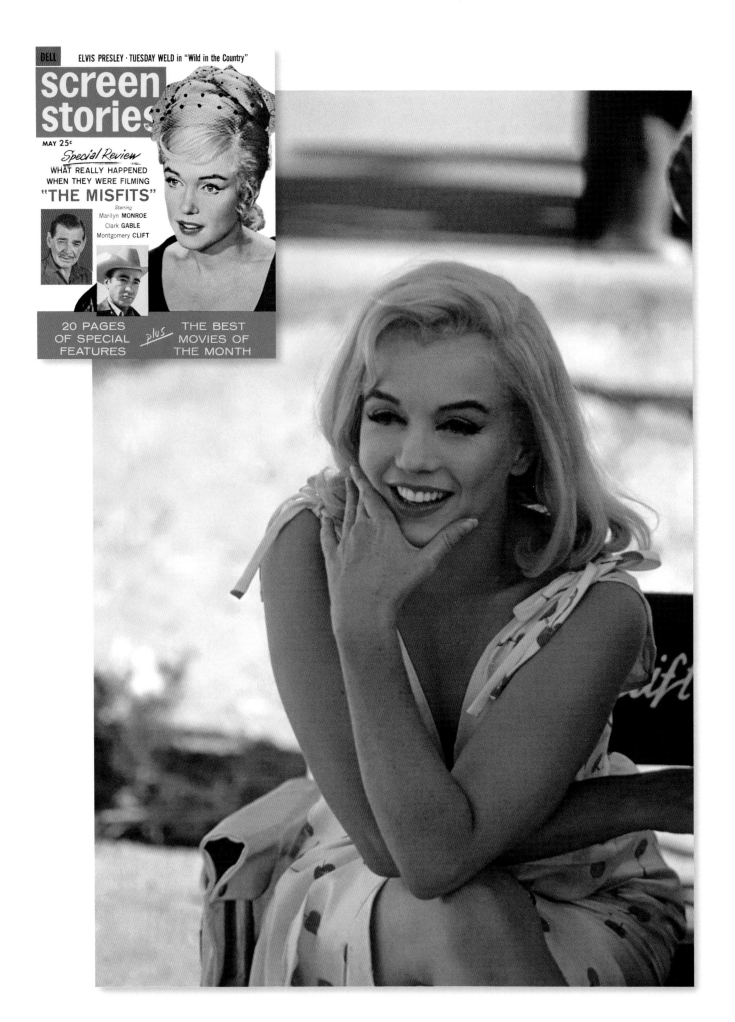

DELL

ELVIS PRESLEY · TUESDAY WELD in "Wild in the Country"

screen stories

MAY 25¢

Special Review

WHAT REALLY HAPPENED
WHEN THEY WERE FILMING
"THE MISFITS"

Starring
Marilyn MONROE
Clark GABLE
Montgomery CLIFT

20 PAGES
OF SPECIAL
FEATURES *plus* THE BEST
MOVIES OF
THE MONTH

(Top) *Screen Stories*, May 1960. (Bottom)
Marilyn on the set of *The Misfits*, 1960.

223

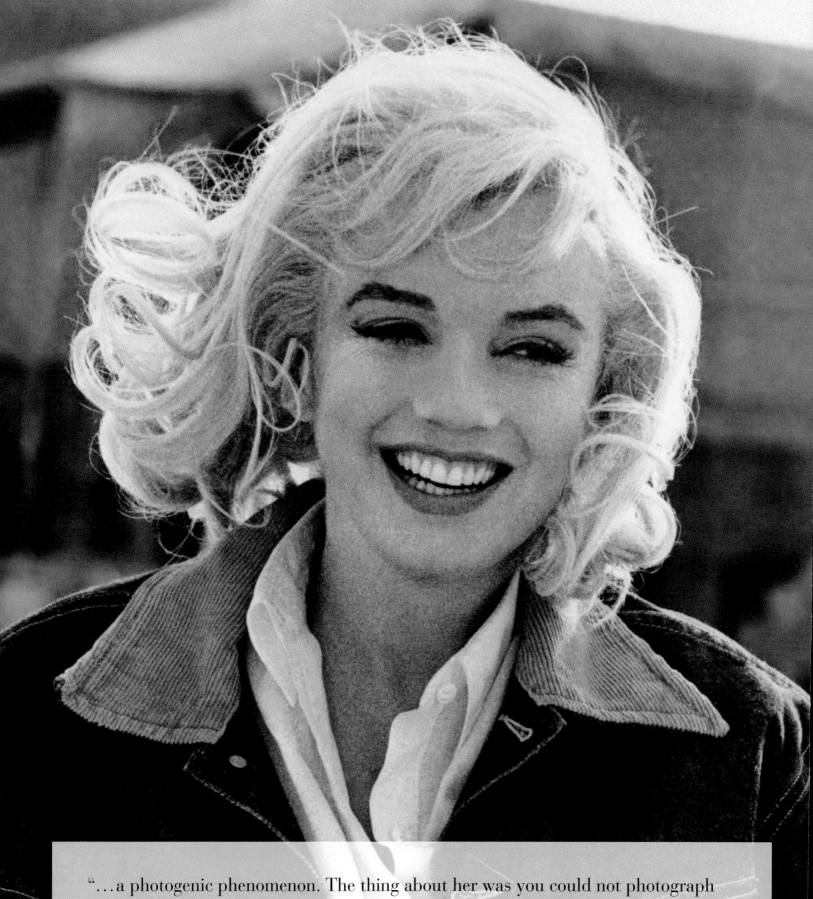

"…a photogenic phenomenon. The thing about her was you could not photograph her badly if you tried. She would surpass the expectations of the lens. She had a shimmering quality like an emanation of water, and she moved lyrically."

INGE MORATH (Magnum photographer)

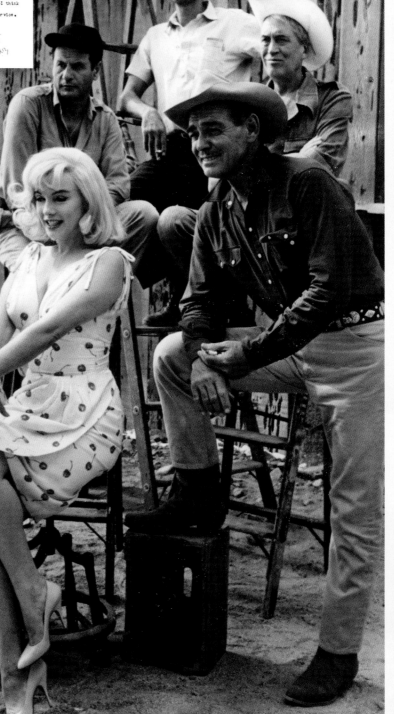

(Opposite) Marilyn as Roslyn Taber in *The Misfits*, 1960. (Top) Handwritten note from columnist Earl Wilson to Marilyn, 1960. (Bottom) On set with (clockwise from left) Montgomery Clift, Eli Wallach, Arthur Miller, John Huston, and Clark Gable, *The Misfits*, 1960.

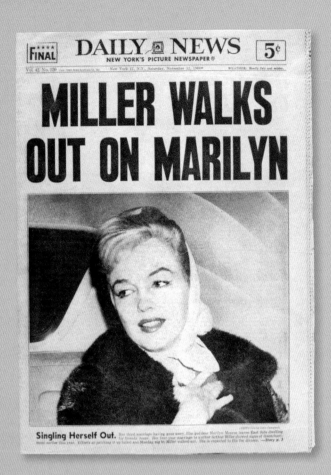

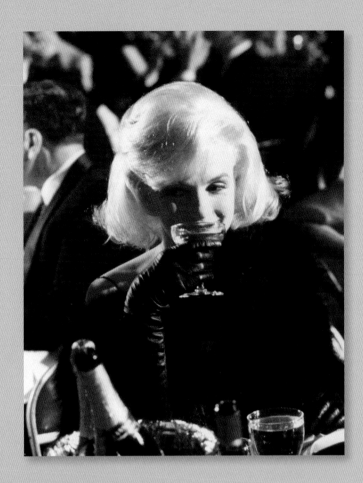

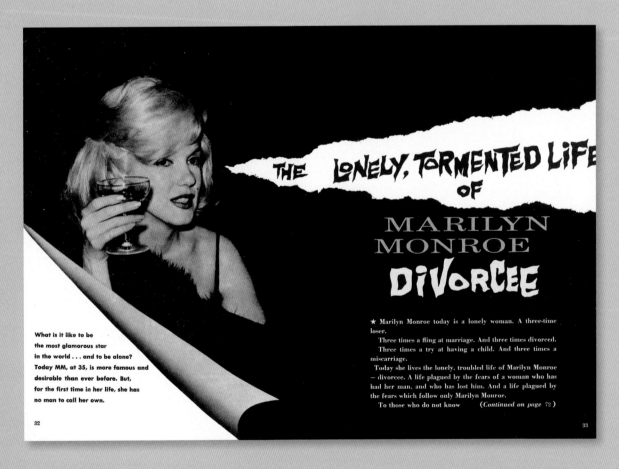

(Top left) *Daily News*, November 12, 1960. (Top right) Marilyn at a party to benefit the Actors Studio, New York, March 13, 1961. (Bottom) *Movie World*, November 1961. (Opposite) With Montgomery Clift at the premiere of *The Misfits*, Capitol Theatre, New York, January 31, 1961.

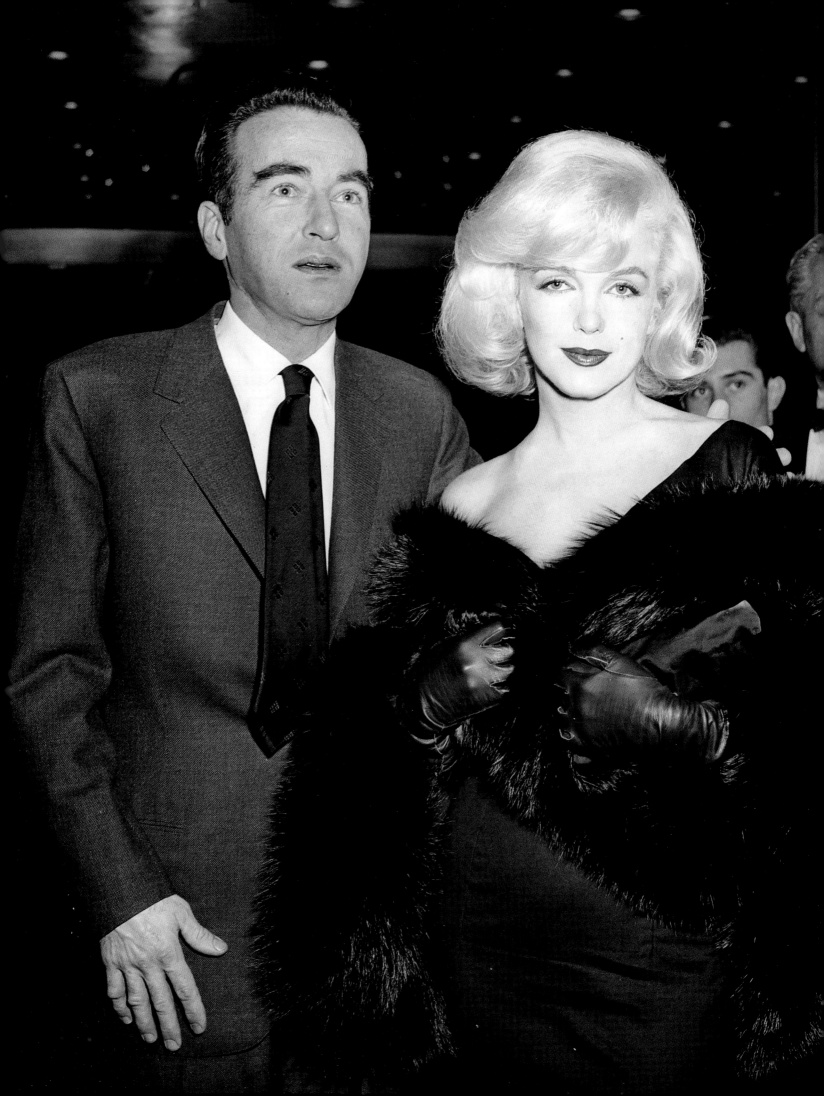

(Right) At the christening of Clark Gable's son, John, St. Cyril's Church, Sherman Oaks, California, June 11, 1961. (Below left) Letter to Marilyn from author W. Somerset Maugham. (Below right) With Elizabeth Taylor and Dean Martin, watching Joey Bishop and Frank Sinatra onstage at the Sands Hotel, Las Vegas, June 7, 1961. (Opposite) Proof sheet, 1961. Photos by Eric Skipsey.

VILLA MAURESQUE,
ST. JEAN · CAP FERRAT,
A.M.

31st January, 1961.

Dear Miss Monroe,

Thank you for your charming telegram of good wishes on my birthday. It was extremely kind of you to think of me; I was touched and much pleased.

I am so glad to hear that you are going to play Sadie in the T.V. production of "Rain." I am sure you will be splendid. I wish you the best of luck.

Yours very sincerely,

W Somerset Maugham

 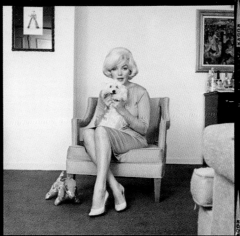 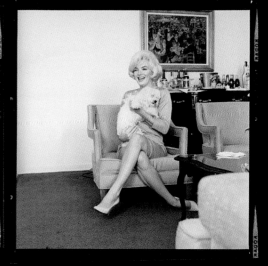

 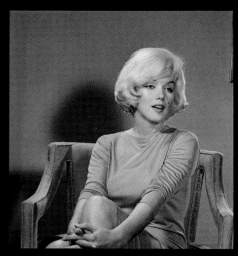

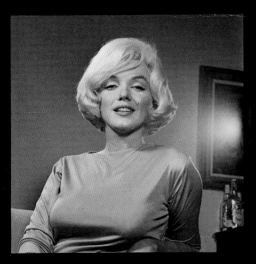 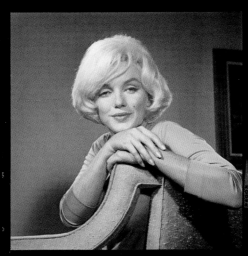 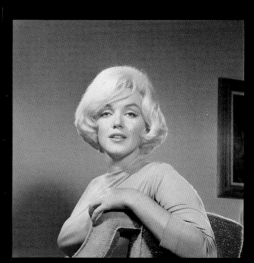

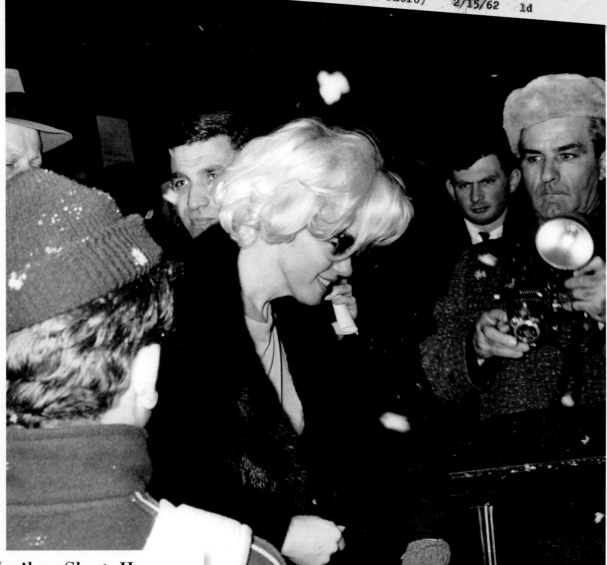

Marilyn Slept Here

SHE JUST CAME TO SEE 'DAD' AND LEFT

By SANFORD SCHNIER

Gloria Lavell has forsaken Miami Beach for Mexico City.

And just WHO was Gloria Lavell?

Well, seasoned guests at the swank Fontainebleau Hotel needed to take only one glance at the blonde with the 37-23-37 figure and they knew right off.

It was Marilyn Monroe, Hollywood's "Goddess of Love," that's who it was.

She just wasn't using her screen name.

The 35-year-old MM checked into a $125-a-day suite at the hotel Sunday night, signing the register "Gloria Lavell."

ONE-DAY VISIT

She specifically asked for no publicity and no interviews during the one-day visit — and her request was granted.

Marilyn, whose third husband was Pulitzer - Prize - winning playwright Arthur Miller, was here solely to visit her ex-father-in-law, Isadore Miller, who is staying at the Sea Isle Hotel, 14 blocks south on Collins Ave.

Marilyn Monroe With Ex-Father-In-Law Isadore Miller

(Top) Marilyn leaving Theatre de Lys, New York, February 15, 1962. (Bottom) With ex-father-in-law Isadore Miller, Club Gigi, Fontainebleau Hotel, Miami, February 18, 1962. (Opposite) Boarding a Pan Am flight for Mexico City, Miami Airport, February 21, 1962. Photo by Bob East.

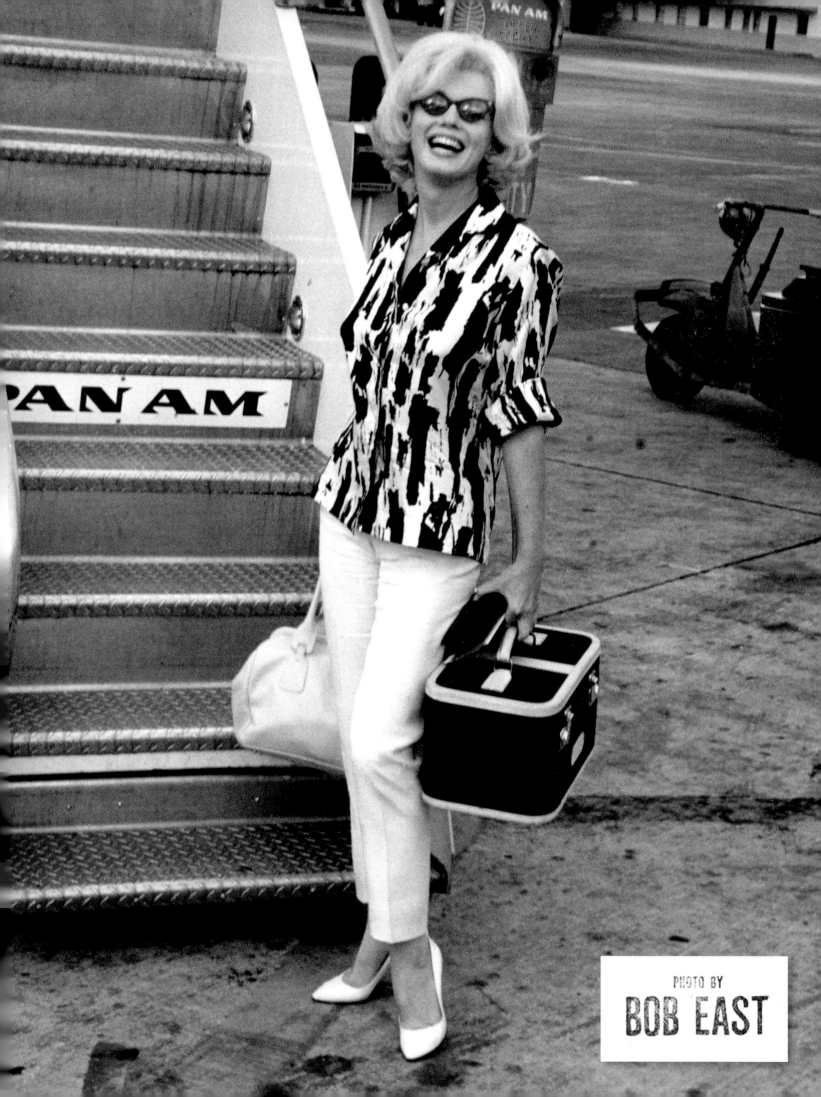

PAN AM

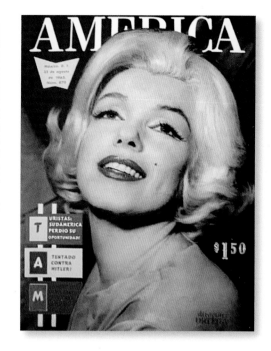

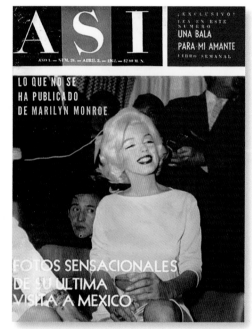

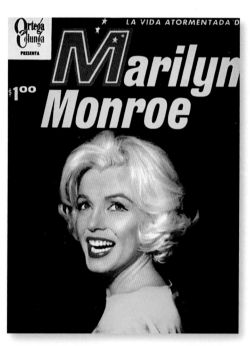

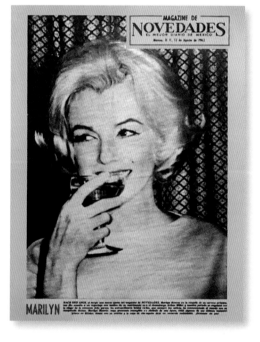

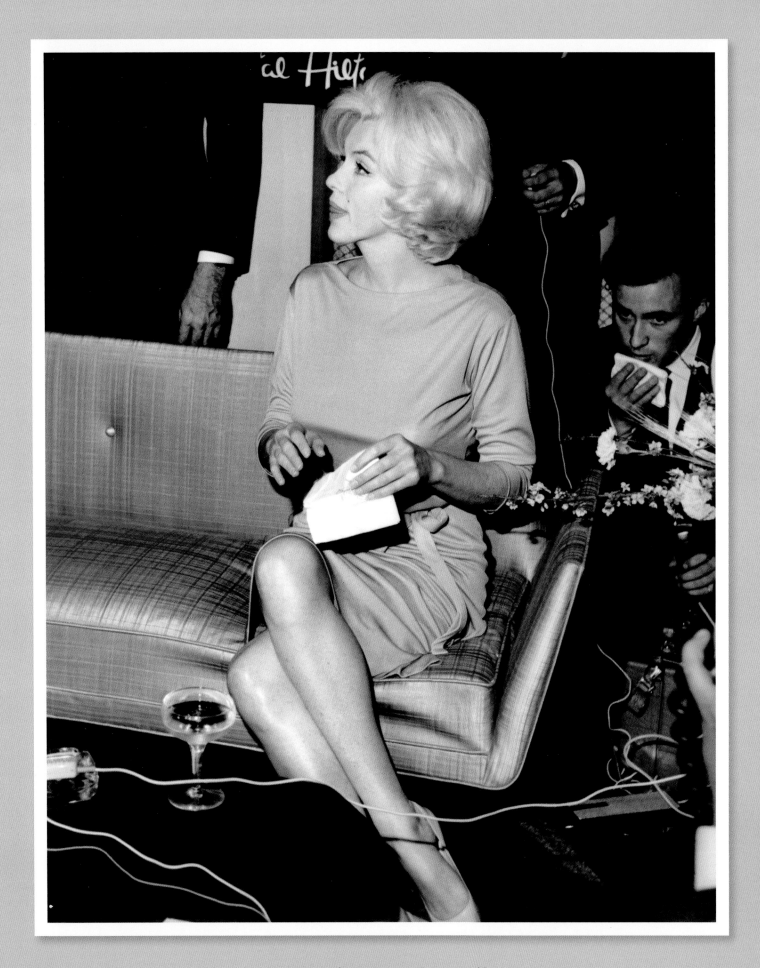

(Opposite) Mexican magazine covers featuring photos from Marilyn's press
conference at Hotel Continental Hilton, Mexico City, February 22, 1962.
(Above) Marilyn meets the Mexican press, Hotel Continental Hilton.

(Right, below left, bottom left) Marilyn visiting the Catholic National Institute for the Protection of Children, Mexico City, March 1, 1962. (Bottom right) With Eva Sámano, First Lady of Mexico, March 1, 1962.

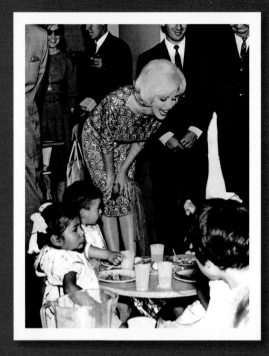

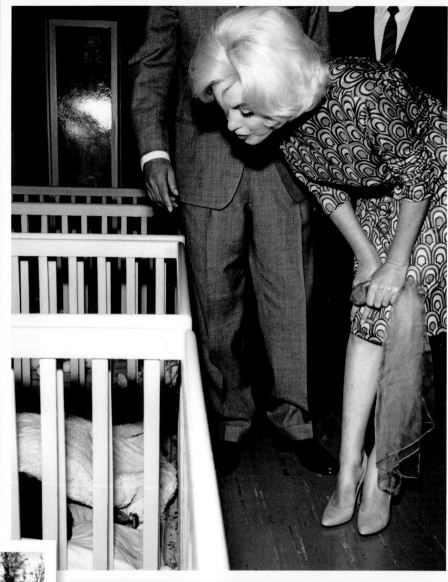

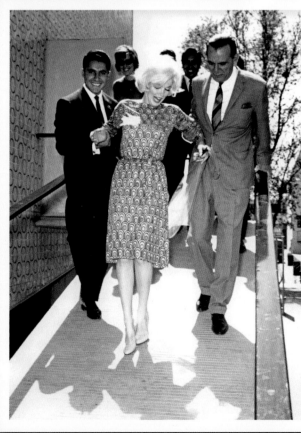

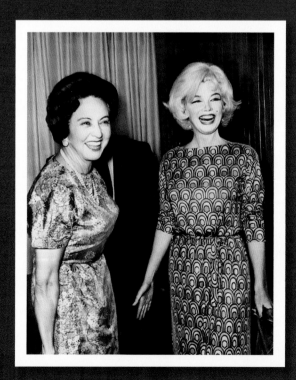

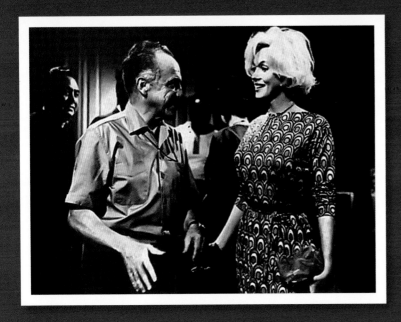

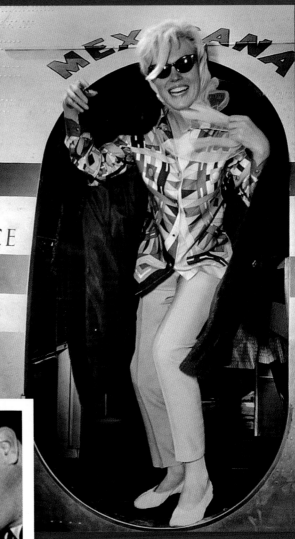

(Above left) With director Luis
Buñuel on the set of *El Ángel
Exterminador*, March 1, 1962.
(Above right) Arriving home to
Los Angeles, March 3, 1962.
(Left) At a dinner in her honor
at Hotel Continental Hilton,
Mexico City, February 28, 1962.

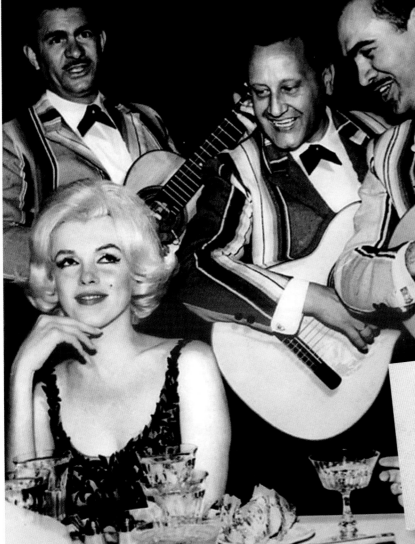

WIDE WORLD PHOTO PLEASE USE CREDIT

MEXICAN SERENADE FOR MARILYN

Mexico City....A group of Mexican trouhadors
known as "Los Costenos" dedicate song to
visiting Marilyn Monroe, during reception
offered to the famed blond star last night
at Hotel Continental Hilton here.

2/28/62

THE 1962 GOLDEN GLOBE AWARDS

A RECOLLECTION BY STEFANIE POWERS

I remember the evening vividly, as it was one of the most embarrassing moments of my life. I was still a teenager and under contract at Columbia. It was the very tail end of the studio system. In those days the Golden Globes weren't the media event they are today. It wasn't televised and stars only went if they knew they had won. The awards were presented by the Hollywood Foreign Press Association, which was established in the 1940s. The organization was basically a great way for foreigners—anyone with an accent and groomed to the teeth—to call themselves a journalist. These people were known as "stringers." They usually held other jobs and were just part-time journalists on the side.

Columbia had asked me to be a presenter at the event. I went into the studio for a fitting and they gave me a beaded gown that seemed so matronly to me at the time. It wasn't my style at all and made me feel very uncomfortable and out of place. I was, however, absolutely overwhelmed to be in the company of the people there—particularly the gorgeous Rock Hudson who later became a close friend. I never spoke to Marilyn that night, but we met not long after at Dean Martin's house.

When I first saw Marilyn, I was struck by how slim she was. In the last years of her career her weight could fluctuate considerably—go up and down—but that night she just looked so extraordinarily beautiful and slender. She glowed. I really think some of the best photographs ever taken of her were in that last year of her life.

The press photographers milled about the tables discreetly taking photos of the stars. In those days it was much more controlled. The paparazzi as such came about more with Cannes and the filming of *Cleopatra*. Marilyn, who was present to receive the award for World Film Favorite—Female, was certainly at the center of their attention.

The event was in March and unfortunately she passed away in August. In reflecting on the complexity of Marilyn's nature, and her insecurities, I can only think that she could never have imagined how much of a cultural icon she would become. It may not have pleased her, given her stormy relationship with the press, but there is no denying she had a rare magic in front of the camera that radiates even today.

(Opposite) Stefanie Powers, Rock Hudson, and Marilyn onstage at the Golden Globe Awards. Marilyn had just been named as World Film Favorite—Female.

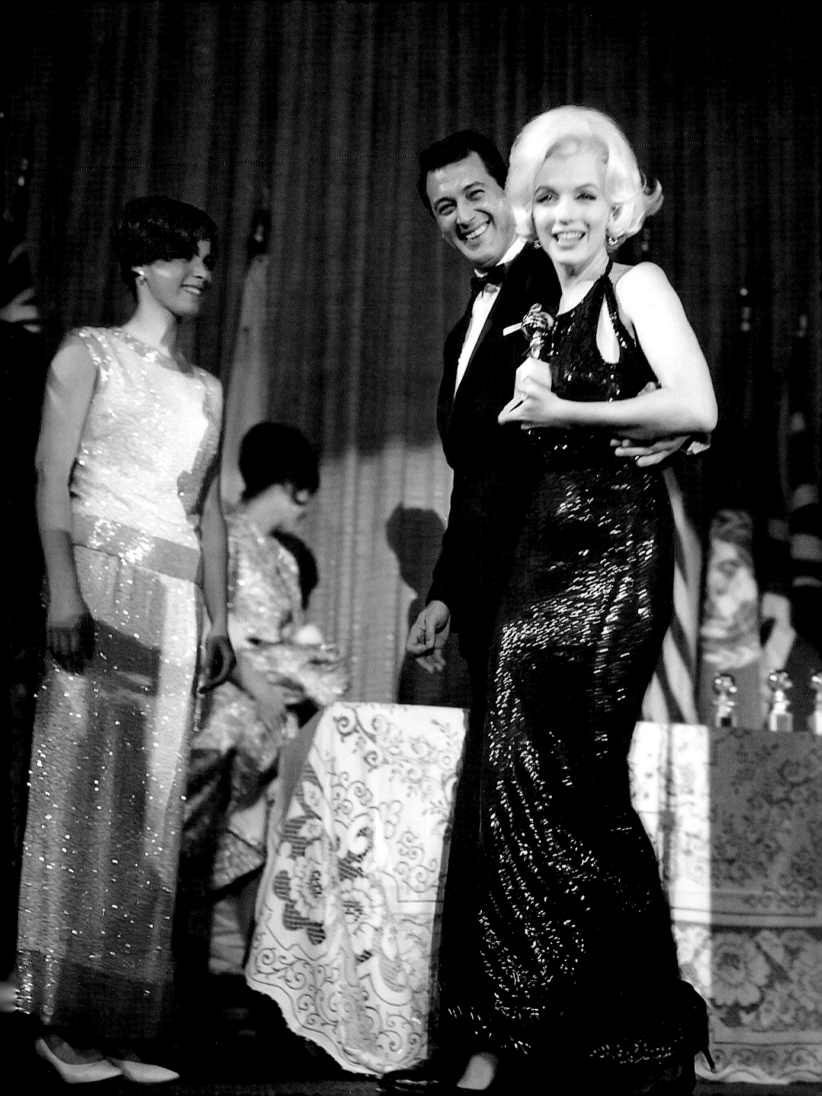

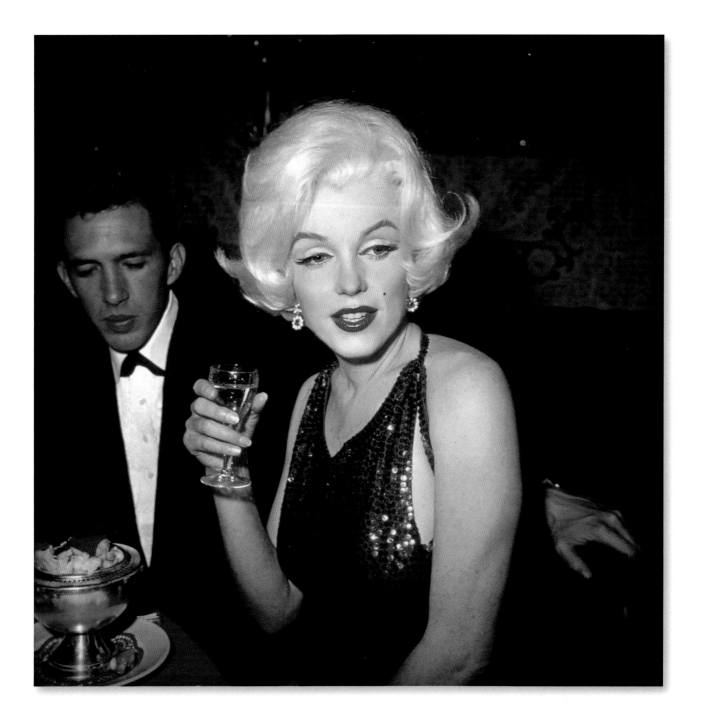

DESPERATE?

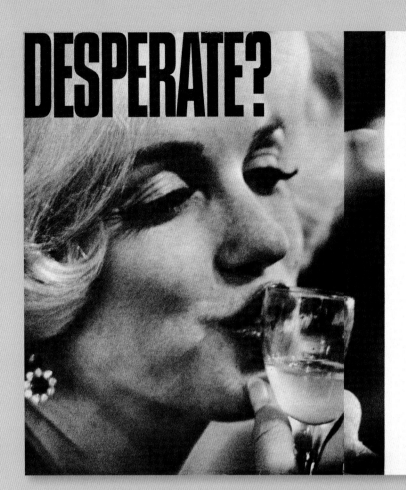

At 36 — without a husband, a job or faith in herself — what will happen to Marilyn next?

The men stood around gaping quietly as Marilyn Monroe began to slip out of the flesh-colored net panty-bra. As the thin, silky material slid down around her soft, white shoulders she paused for a moment. She closed her eyes as though she were reluctant to do what she was about to do—strip to the stark naked. She knew some of the men would look at her the wrong way. But she also knew she couldn't help it. They were men and she, better than most women, knew there were all kinds. Men who would, in a few seconds, look on her body in lust. Men who would look on her body with professional disinterest. But there were a few, she hoped, who would look on her nudity with eyes that were concerned only for the true beauty of a woman's body. She opened her eyes and shivered slightly in the chill and silence of the great sound stage. Then, in movements that seemed a mixture of defiance and resolution, she moved her shoulders back and forth until the top of the suit dropped down further, within an inch of baring her bosom. She stopped, raised her head and stared back at the transfixed gazes of the men of the crew. She smiled through half-closed eyes, and then she waggled a forefinger at them.

"Gentlemen," she said, "I think it's time you turned the other way—except the cameramen, of course. There really wouldn't be much sense to all this if you didn't get the picture."

Most of the crew turned their backs. There were a few who didn't. There always are.

Then, with perfect composure, Marilyn Monroe, the conceded sex symbol for millions of men, shimmied out of the netting and stood in complete nakedness. She walked toward the swimming pool around which the scene was to be shot. She poised on its edge for a moment, turned to the cameramen and smiled, "All right, I'm ready."

The scene, for the now scrapped "Something's Got To Give," took the rest of the day to shoot. When it was over, Marilyn, wet and shivering, though the pool water had been warmed, slipped into a robe and returned to her dressing room.

Before the day had died the whole world knew that Marilyn Monroe had, for the second time in her tumultuous career, *(Please turn the page)*

49

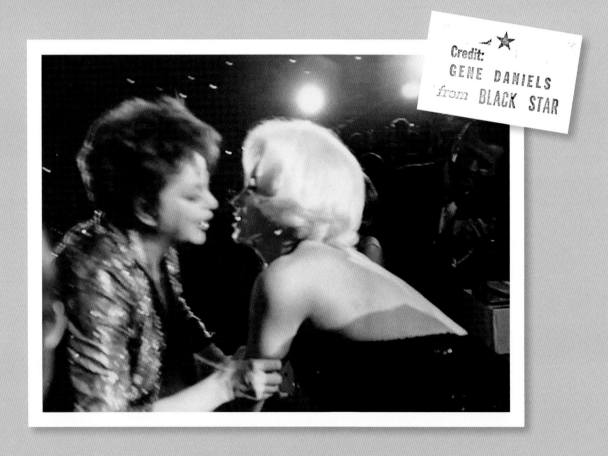

Credit: GENE DANIELS from BLACK STAR

(Opposite top) With her date Mexican screenwriter José Bolaños, at the Golden Globe Awards, Beverly Hilton Hotel, March 5, 1962. (Opposite bottom) With José Bolaños. (Top) *Photoplay*, September 1962. (Bottom) Marilyn with Judy Garland, at the Golden Globe Awards. Photo by Gene Daniels.

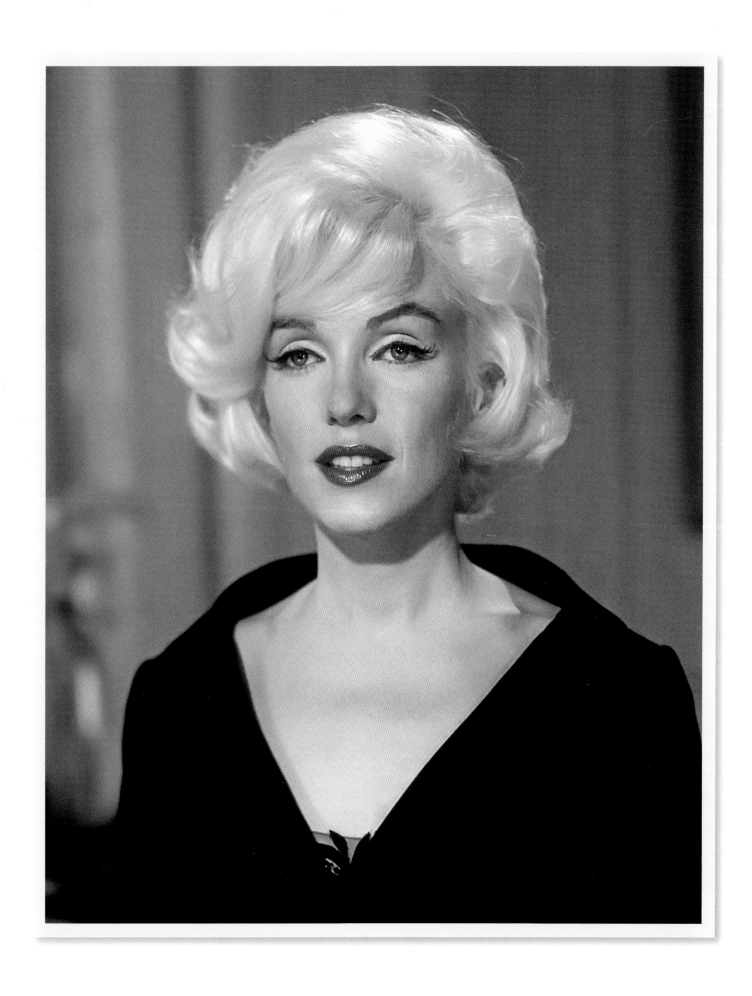

(Above and opposite) Hair and costume tests,
Something's Got to Give, April 10, 1962.

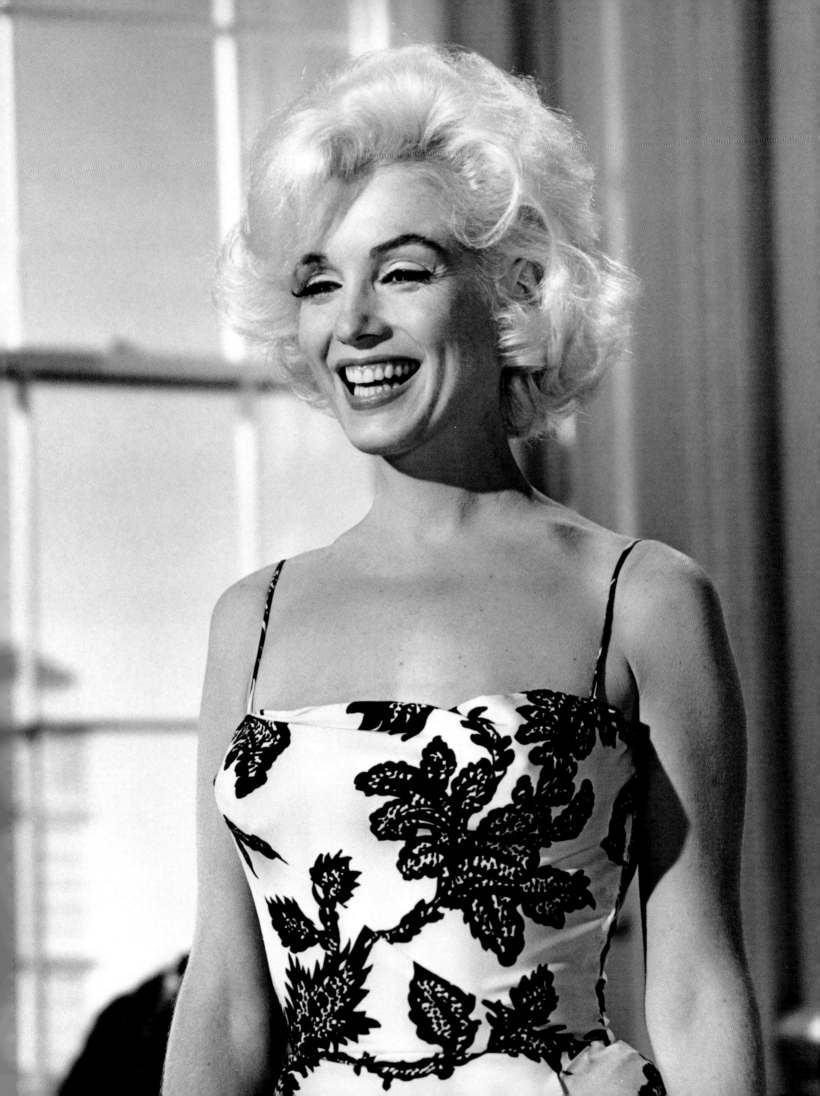

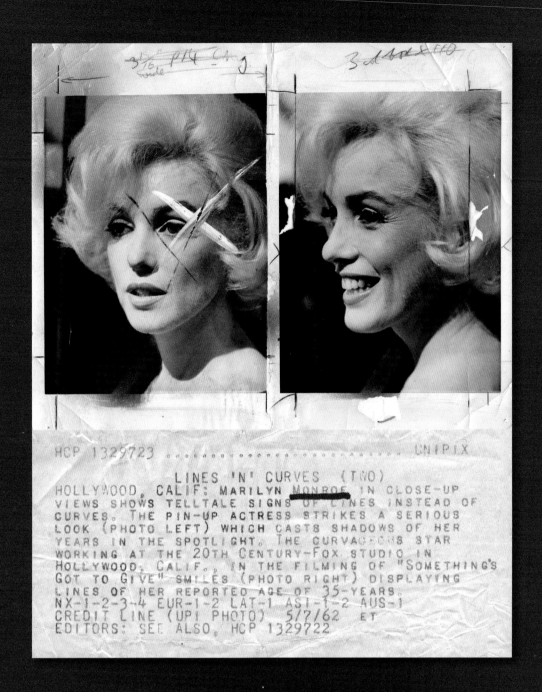

(Top) UPI photographs taken on the set of *Something's Got to Give*, May 7, 1962. (Bottom) Marilyn with costar Dean Martin on set. (Opposite) Marilyn as Ellen Wagstaff Arden in *Something's Got to Give*.

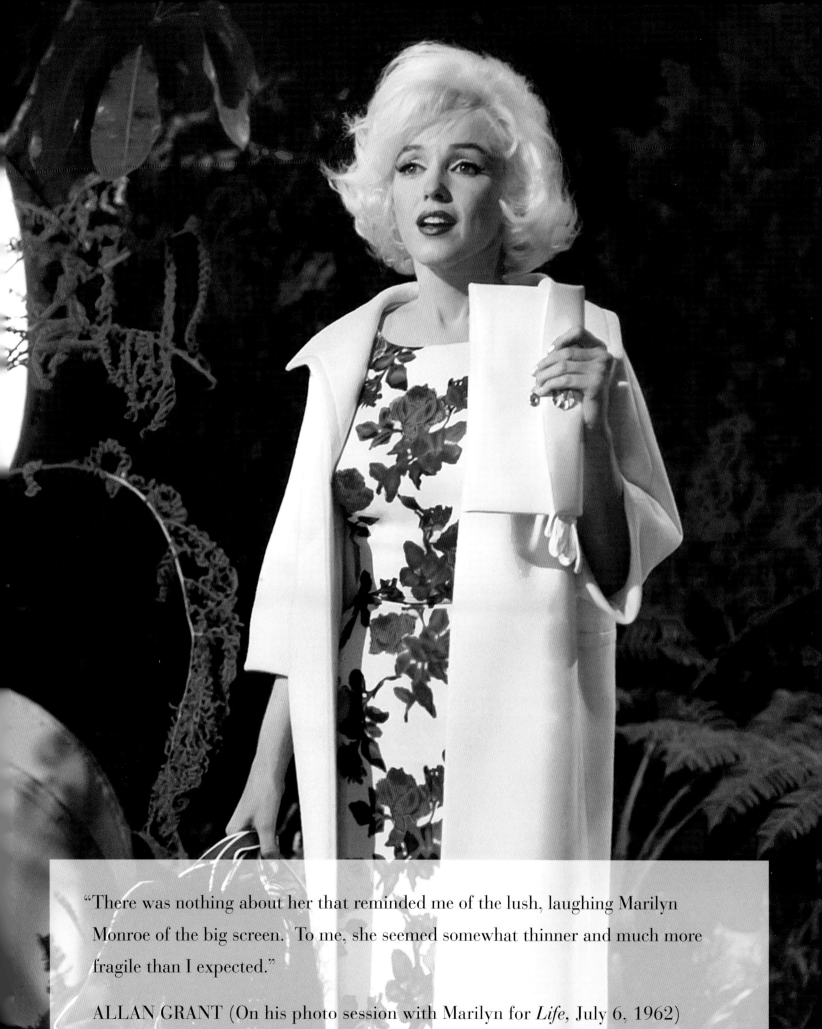

"There was nothing about her that reminded me of the lush, laughing Marilyn Monroe of the big screen. To me, she seemed somewhat thinner and much more fragile than I expected."

ALLAN GRANT (On his photo session with Marilyn for *Life*, July 6, 1962)

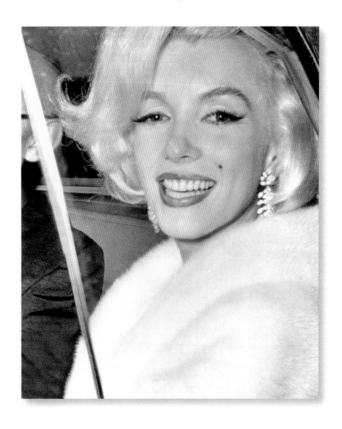

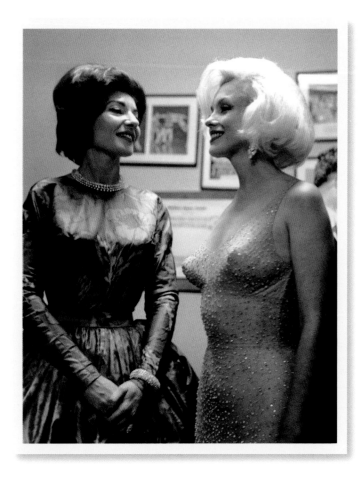

THE WHITE HOUSE

WASHINGTON

April 11, 1962

Dear Miss Monroe:

Many, many thanks for your acceptance of the invitation to appear at the President's Birthday Party in Madison Square Garden on May 19.

Your appearance will guarantee a tremendous success for the affair and a fitting tribute to President Kennedy.

With every good wish,

Sincerely,

Kenneth O'Donnell
Kenneth O'Donnell
Special Assistant to the President

Miss Marilyn Monroe
12-305 Fifth Helena Drive
Los Angeles 49, California

(Clockwise from top left) Marilyn with promoter Earl Blackwell backstage at President John F. Kennedy's birthday celebration, Madison Square Garden, New York, May 19, 1962; arriving at the event; backstage with Maria Callas, photo by Victor R. Helou; letter to Marilyn, from Kenneth O'Donnell, special assistant to the president, April 11, 1962.

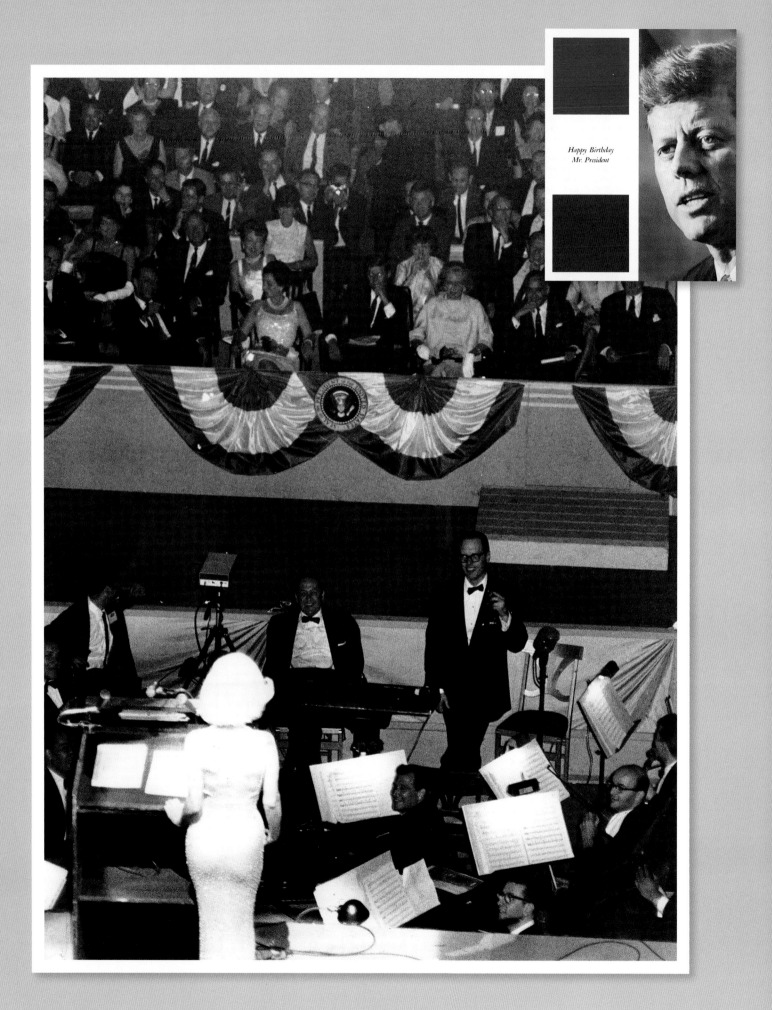

Happy Birthday
Mr. President

(Above) Marilyn singing "Happy Birthday" to President Kennedy,
Madison Square Garden, May 19, 1962. (Top right) Event program.

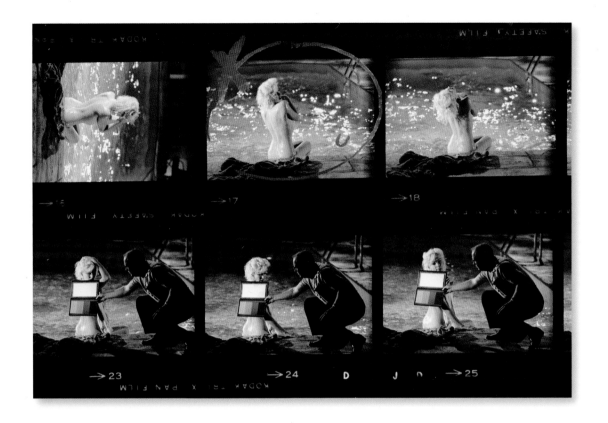

"When it came to looking at photographs of herself, Marilyn was all business....As an actress she was enormously insecure, but as a model she was totally self-assured....She never told me how to take pictures, and I never told her how to pose. Sure, on our very first day together, 1960 on the movie set of *Let's Make Love*, she did give me some direction. I was 23 years old and nervous, and she could tell. But here's the thing: At that point in her life, she had been photographed by every major photographer in the world. So this 23-year-old kid comes to photograph her, and she had to protect her asset—and her asset was Marilyn Monroe. She taught me a lot in the first five minutes and I never forgot it—ever."

LAWRENCE SCHILLER (Photographer)

(Above and opposite) On set, *Something's Got to Give*, 1962. Photos by Lawrence Schiller.

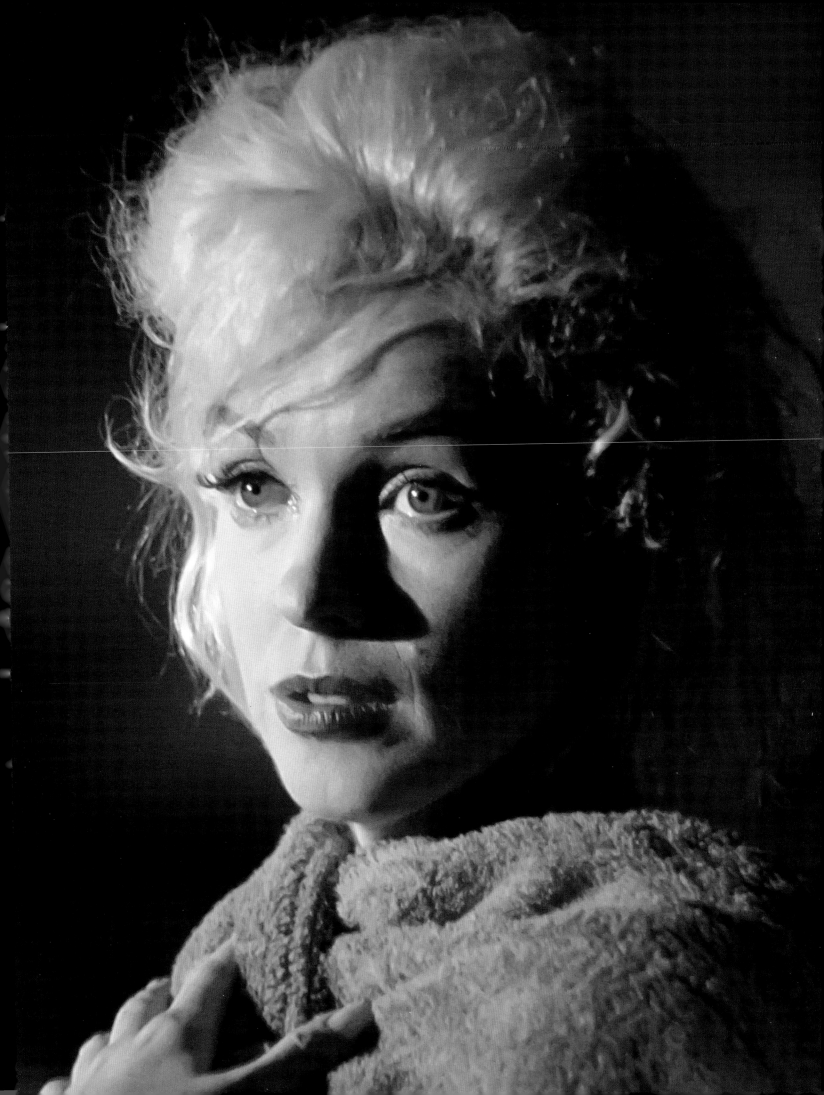

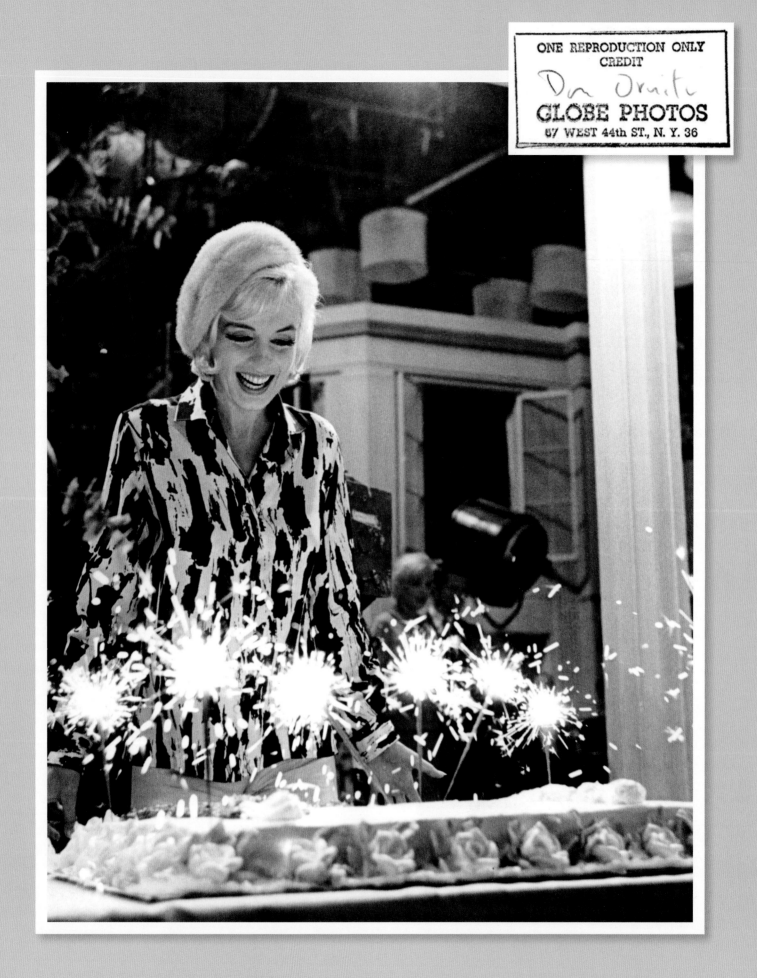

(Above) Marilyn celebrating her thirty-sixth birthday on the set of *Something's Got to Give*, June 1, 1962. Photo by Don Ornitz. (Opposite) On set with Wally Cox, *Something's Got to Give*.

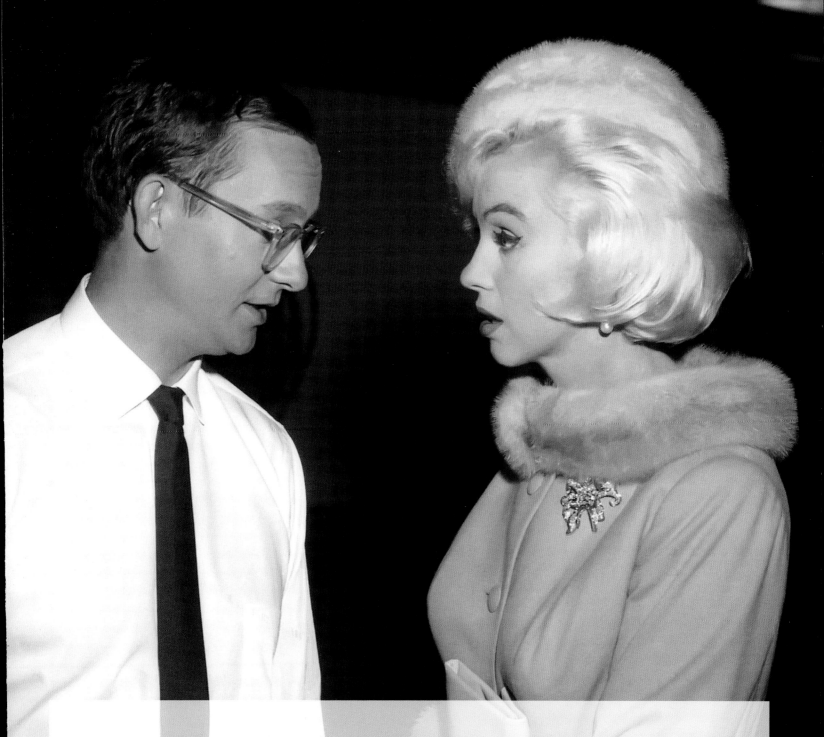

"When Marilyn shows up for work on Monday, she will find that she has been fired and replaced—perhaps with Kim Novak. Twentieth Century-Fox doesn't want her anymore. [Quoting an unnamed Fox executive] 'Marilyn hasn't shown up for days, even though she's been out on the town doing the night spots. We gave her everything she wanted, including Dean Martin as her costar, two of her favorite cameramen, her favorite dress designer, Jean-Louis, and Sydney Guilaroff for her hair. If this sort of thing continues, there will be no movie industry at all.'"

SHEILAH GRAHAM (In her column, published June 8, 1962 in London)

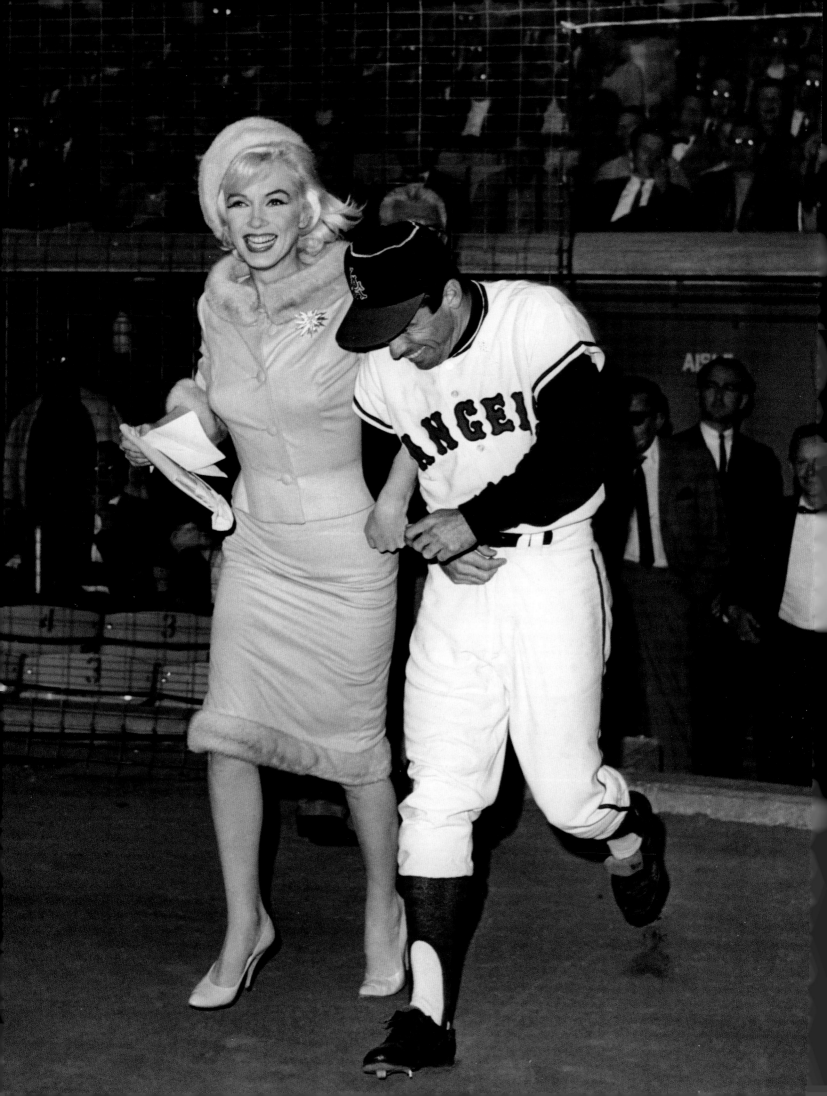

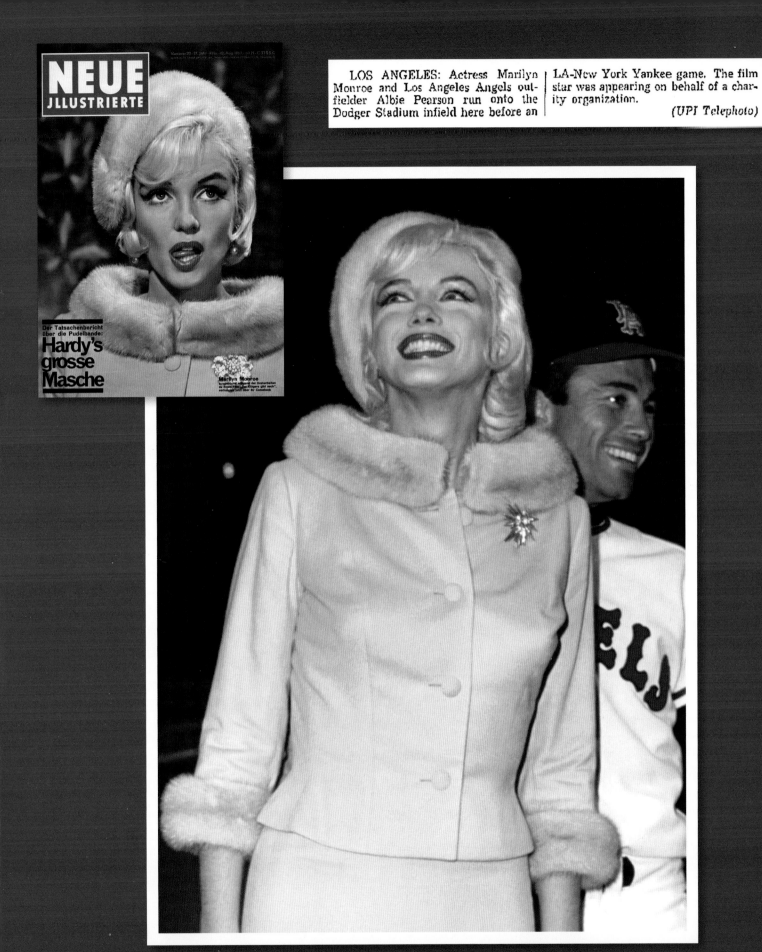

NEUE JLLUSTRIERTE

Der Tatsachenbericht
über die Pudelbande:
**Hardy's
grosse
Masche**

Marilyn Monroe

LOS ANGELES: Actress Marilyn Monroe and Los Angeles Angels outfielder Albie Pearson run onto the Dodger Stadium infield here before an LA-New York Yankee game. The film star was appearing on behalf of a charity organization.

(UPI Telephoto)

(Opposite and above right) ORIGINAL CAPTION: "June 1, 1962. Actress Marilyn Monroe runs into the field at Chavez Ravine (Dodger Stadium) accompanied by Los Angeles Angels outfielder Albie Pearson before the Yankees-Angels game here. Miss Monroe made a plea for donations to the Muscular Dystrophy fund in pregame ceremonies. A record crowd of 51,584 fans saw the New York Yankees beat the Angels." (Top) *Neue Illustrierte*, August 1962.

"In private she was not in the least what her calumniators would have wished her to be. She was very quiet, had a great natural dignity, and was extremely intelligent. She was also exceedingly sensitive. In repose her face was at moments strangely, prophetically tragic, like the face of a beautiful ghost—a little spring ghost, an innocent fertility daemon, the vegetation spirit that was Ophelia—a visitor from some other plane; only here visiting."

DAME EDITH SITWELL (Poet)

(Above) With Dame Edith Sitwell, 1953. Photo by George Silk. (Opposite) *Something's Got to Give*, 1962.